ON
CHRISTIAN
ORIGINS

Paul George

Copyright © 2020 Paul George

ISBN: 978-1-922409-18-8
Published by Vivid Publishing
A division of Fontaine Publishing Group
P.O. Box 948, Fremantle
Western Australia 6959
www.vividpublishing.com.au

 A catalogue record for this
book is available from the
National Library of Australia

For Ray

Whence also Peter, in his Preaching, speaking of the apostles, says:

> "But we, unrolling the books of the prophets which we possess, who name Jesus Christ, partly in parables, partly in enigmas, partly expressly and in so many words, find His coming and death, and cross, and all the rest of the tortures which the Jews inflicted on Him, and His resurrection and assumption to heaven … Recognising them, therefore, we have believed in God in consequence of what is written respecting Him."

Clement of Alexandria, Stromata, Book 6.15

Then he [Jesus] said to them,

> "These are my words that I spoke to you while I was still with you— that everything written about me in the law of Moses, the prophets, and the psalms must be fulfilled."

Luke 24:44

About the Author

BROUGHT UP IN A STRICT CHRISTIAN HOUSEHOLD I ADOPTED THE religion of my parents becoming particularly zealous in my late teens and early twenties. After attending university, it wasn't long before cracks began to appear in the edifice of faith and I drifted into a milder version of evangelical Christianity before agnosticism took hold and finally atheism. I have always been the questioning type and after recently coming across some radical literature was left unsatisfied by the bland assurances of the faithful and faithless that there once had been a misunderstood sage called Jesus. In 2015 a discussion with a preacher in the local city mall made me consider putting down on paper the reasons why and just as importantly how the religion of Jesus without Jesus had come about. The result is this book.

Preface to this book

MORE THAN TWO YEARS HAVE PASSED SINCE THE PUBLICATION OF Jesus of the Books. Since then I have been studying coursework at a local university in Roman and Greek history, Greek mythology and New Testament Greek language. This study has not diminished my enthusiasm for the basic premise — that the Roman-Jewish War was the catalyst that launched Christianity. If anything, I am now more confident. Thinking about and discussing my ideas with others has refined my opinions on a few points and has suggested some new ones. The result is this edition, which is more extensive, more consistent and I dare to assert, as far as the evidence will allow, even closer to the truth.

I would like to thank all those who took a punt on an unknown author and a radical idea and bought the first book upon which this one is based. After publishing I discovered that I was not the first to propose the idea that the year 70 was the critical date in the institution of Christianity. It was suggested by Whittaker in 1904.[1] However as he failed to provide any evidence, his thesis was not taken up. Now, more than a hundred years later great strides in information technology have enabled me in a relatively short space of time to find and make public the evidence that Whittaker's proposal lacked.

1 Whittaker, 1904, p.29.

Contents

List of Illustrations .. xix

List of Tables ... xx

Notes ... xxi

Maps ... xxii

Introduction .. 1

PART 1

CHAPTER ONE

The baptism of Jesus 7

No good evidence 9

How religions arise 10

How religions are defended 11

CHAPTER TWO

The official church historian Eusebius 15

The earliest evidence 16

The absence of evidence 19

The big three: Philo, Seneca and Josephus 20

Other writers .. 21

Crematius Cordus and Ancient Censorship 23

Other sources that fail to mention Jesus or Christians 24

Artefacts .. 25

Archaeology .. 28

The testimony of the Emperor Julian 29

CHAPTER THREE

The Jewish legacy 31

The Temple ... 32

How was a Jew to live? 34

The critical event 35

CHAPTER FOUR

The causes of the War .. 42

Anti-Jewish sentiment ... 45

The scale of the War ... 46

Deaths .. 47

Transfer of wealth ... 48

Slaves .. 49

Economic benefits lost ... 50

Implications for the diaspora Jews 50

The human cost .. 51

The end of Temple Judaism ... 52

CHAPTER FIVE

God's punishment .. 54

The Jewish War as trauma .. 58

The Jewish War and mental disorder 60

Psychotrauma in the New Testament 61

Cures conducted by World War 1 therapists 64

CHAPTER SIX

Human pattern seeking strategy .. 67

Finding Jesus on toast .. 68

Magical thinking .. 69

Illusory pattern perception and lack of control 70

Worshipping in high places .. 70

The sensed presence ... 72

The auditory verbal hallucination 74

Imagining a saviour ... 75

Morale boosting stories ... 76

Rationalizing beliefs ... 78

The persistence of false beliefs 79

CHAPTER SEVEN

The spontaneous belief ... 80

How the catastrophic event helped religious recruitment ... 80

A contest of opinions ... 81

Early Christian practices mimic the Roman army 82

Symbols and Power ... 86

Prisoners for God ... 87

Who was attracted to the new faith? 90

A Christian conspiracy theory 92

The gospel forgeries—a reinterpretation of events 94

Accommodating the change psychologically 95

Saving the world ... 96

CHAPTER EIGHT

Essenes, Jewish Christians and Ebionites 98

The name Ebion ... 99

James the leader of the Jewish Christians 100

The Essene connection 101

Essenes lived in Jerusalem 102

Doctrines of the Ebionites 105

Jewish Christianity was forged in the Jewish War 105

Making virtues out of necessity 106

CHAPTER NINE

The Messiah King ... 109

The mission of Jesus ... 110

The nondescript slave 111

A brief life of Paul (c.48–c.83) 112

Paul and the War ... 118

Hillel and Shammai ... 118

CHAPTER TEN

What is faith? ... 120

Paul's bare Messiah ... 121

The secret Messiah ... 122

The deliberately hidden message 123

Paul's mystery gospel 124

—if you are a true saveman then you must
hide yourself ... 125

The Messiah came but no one noticed 125

Where was the evidence? 126

The modern equivalent of an unwitnessed
death and resurrection 126

The invisible saviour 127

The legacy of the origins of Christianity
in Catholic doctrine 129

CHAPTER ELEVEN

The death of Jesus as atonement 130

The purpose of the statute 131

The basic rite ... 131

Exemplars from the time of the Maccabean revolt 131

The Atonement in early Christianity 133

The two goats, Jesus and Barabbas 135

The triumphal entry into Jerusalem 136

The origin of the Lord's Supper 137

Jesus in Hades .. 139

A refrigerium? .. 140

The supper of the gods 141

CHAPTER TWELVE

Rome .. 145

Isis ... 146

A Roman prophecy 151

The good news comes to Rome 152

Clement, bishop of Rome 153

The Jewish Christians in Rome 154

Christian "unity" means Gentile Christian "unity" 158

Paul the lawless one 159

The parable of the wedding banquet 159

Paul's revelation ... 161
The failed prediction 162

CHAPTER THIRTEEN
The Gospels .. 165
The Christians in Rome 166
When were the gospels written 167
The order of writing 168
Matthew, originally a Jewish Christian gospel 169
Jesus, the good man who meets the worst fate 169
Jesus as the new Moses 170
Where was the Jewish version of Matthew written? 171
When was the Jewish Matthew written? 172
The illusion of age .. 172
Not from Judea ... 174
Koine Greek .. 175
Hebraism in the gospel of Matthew 175
Paul and the Jewish version of Matthew 177
The impetus for publication of the Gentile version 177
Appropriation of the Jewish Matthew 179
Why the legends surrounding the deaths of
 Peter and Paul are important 180
Peter the symbol of unity 180

CHAPTER FOURTEEN
Luke and Josephus .. 182
The impetus for the writing of Luke–Acts 186
John the Baptist in the gospels 187
Luke's other sources 188
Augustus and Jesus ... 189
Rabbinic parables .. 190
The sermon on the mount 191
Moral precepts from Cicero 192
Mark ... 195

CHAPTER FIFTEEN

The early history of the gospels 198
How the literature was used 199
Persecution 199
The noble lie 201
The gospels and the ostrich effect 202
How to lie effectively 202
The Great Apostasy 203
Heresies 204
The gospel of John 205
Bringing the sacred ideas to Rome 205
The Timeline 208

PART 2

The Late Appearance of Christianity 217
Evidence from church fathers
1 Jesus living into his fifties 218
2 The list of Jerusalem bishops 219
3 The unbelievable longevity of some early
 Christian leaders 219
4 Polycarp is instructed by the apostles 220
5 The testimony of Quadratus 221
6 The Temple destroyed FIRST 221
7 Jerusalem falls, then Christians appear first
 in the 'Decapolis' 222
8 Those "raised" by Jesus alive after 117 223
9 Aphrahat: "from the time... the old was abolished" . 223
10 Clement of Rome 224
11 The evidence of Jerome 225
12 Heresies mentioned by Paul 226
13 The first persecution of Christians 227
14 Daniel, Tertullian and the coming of the "Leader" ... 229

Evidence from astronomy

15 The sign of a star ... 232
16 The sign of the sword 233

Evidence from the New Testament

17 Paul wrote after the Jews were punished 235
18 Paul wrote after the Temple was destroyed 236
19 Paul and the prominent Gospel character,
 John the Baptist .. 238
20 The witness of James as recorded in Acts 239
21 The parable of the widow and the unjust judge 239
22 Save us from the Romans 240
23 The gate of Nain .. 242
24 Jesus reports the murder of Zechariah
 which occurred in 69 243
25 Jesus and familial division 243
26 Baptised by fire ... 245
27 Poverty in Palestine 247
28 Taking the kingdom by force 247
29 I will destroy this temple 248
30 The consolation of Israel 248
31 The Acts of the Apostles is out of sync
 with its literary setting 249
32 Paul quotes from a text that was written after 70 249
33 Christ is "born" when Titus reigns 250

Evidence from extracanonical works

34 The Epistle of Barnabas written after 70 252
35 Peter comes after Simon Magus 253
36 Jesus died in 58 ... 254

Numismatic evidence

37 For the redemption of Jerusalem 256
38 Mary gives birth to Jesus under a date palm 257

Jewish evidence

39 The witness of the Jewish Aggadah, Part 1 260
40 The witness of the Jewish Aggadah, Part 2 261

xvii

41 The Evangelium: "since the day that you were
exiled from your land" 262
42 The witness of Maimonides 263

Evidence from Roman historians

43 Messianic hopes were highest just prior to 66 264
44 Titus, the destruction of the Temple, Judaism
and Christianity .. 265
45 Paul, circumcision and the poll tax 265

Evidence from Josephus

46 A new Roman religion predicted by the
high priest Ananus in 69 CE 268
47 Praying for those in authority 268
48 There is no mention of Paul (or Christians)
in Josephus' histories 269
49 The Father and the Son 270

Arguments from theology

50 Domitian hates the shedding of sacrificial blood 273
51 Paul wrote after the law was ended 274
52 The believers are the spiritual stones of a new Temple 275
53 The destruction of the temple in 70 CE
left a prophetic vacuum 276
54 The punishment of Jews not delayed 277
55 The Jerusalem survivors are called by God 277
56 The Way ... 278

Conclusion .. 280
Afterword, The Story of Moses Al-Dar'i 283

Appendix 1

 The Problem of the Bishops of Jerusalem 287

Appendix 2

 Objections answered 290

 Flavius Josephus and Eusebius 290

 Aretas 296

 Tacitus 298

 Suetonius 311

 The relatives of Jesus 312

 Pontius Pilate 316

Appendix 3

 Miscellaneous 317

 An academic orthodox summary 317

 The Apostles' Creed 318

 Cicero and Jesus 319

Ancient Sources 323

References 327

Illustrations

1 'Jerusalem from the Road Leading to Bethany'
 19th century engraving xxiv
2 The Baptism of Jesus. Fresco art of hidden cave church.... 8
3 The Ryland papyrus P52 19
4 Wall Painting of the Temple from the Synagogue at
 Dura-Europos .. 33
5 The Huldah Gates and excavations, Jerusalem 33
6 Subterranean vaults underneath the Temple Mount 37
7 Romans breaching the walls in the siege
 of Jerusalem. ... 39
8 Roman triumphal procession with spoils
 from the Temple ... 40
9 Hilltop location of ancient Yodfat (Jotapata) 59
10 Wall painting of Jesus miracle from the house
 church at Dura-Europos 63
11 A still from the silent movie, War Neuroses:
 Netley Hospital, 1917 .. 64
12 "Allah" in Arabic .. 68
13 Painting of Mount Tabor, 1855 68
14 John Frum Cargo Cult movement parade 83
15 The Om Banna temple on the Jodhpur Highway 87
16 Sunday service in Methodist Church in Fiji 88
17 Plan of Mount Zion and the "Essene Gate" 103
18 Mount Zion – the ancient Essene quarter in Jerusalem 103
19 Staircase of the Mikveh (or Mikvah) ritual immersion bath 104
20 The Islamic Dome of the Rock 108
21 Temple of Jupiter, Damascus 117
22 Marble relief showing a refrigerium 141
23 The Last Supper by Andrea del Sarto 143
24 Hellenistic relief depicting the Twelve Olympians 143
25 The Temple of Isis on Delos 147
26 The Worship of Isis from a fresco in Herculaneum 148
27 Peter and Paul mosaic, Cappella Palatina 155

28 The two-church solution depicted
 in the Basilica of Santa Sabina 157

29 Bust of Roman emperor Nero 163

30 Characters invented by Joseph Smith 173

31 Bust of Marcus Tullius Cicero 194

32 Cybele enthroned 207

33 Balaam (?) pointing to the Star of Bethlehem 231

34 The warning tablet 236

35 The Siege and Destruction of Jerusalem 244

36 Gamla Coin .. 256

37 'Judea Capta' sestertius of Vespasian 257

38 Bust of Vespasian 264

39 Stones from the Temple 274

40 The great fire of London 302

Tables

1 Matthew and Jeremiah 62

2 Doctrines reinforced by war time experiences 106

3 The Epistle of Barnabas, Jesus and the Scapegoat 134

4 Jesus, Barabbas and the goats 135

5 The Timeline ... 208

6 Ciceronian ideas adopted by the gospel writers 319

Notes

Wars of the Jews and *Antiquities of the Jews* are works of Flavius Josephus.

Ecclesiastical History is a work of Eusebius Pamphili.

All quotations from the Bible are in the NRSV version unless otherwise noted.

Italics which appear in Biblical quotations are added by the author.

All dates are understood as CE, Common Era, that is AD in the old system, unless otherwise indicated.

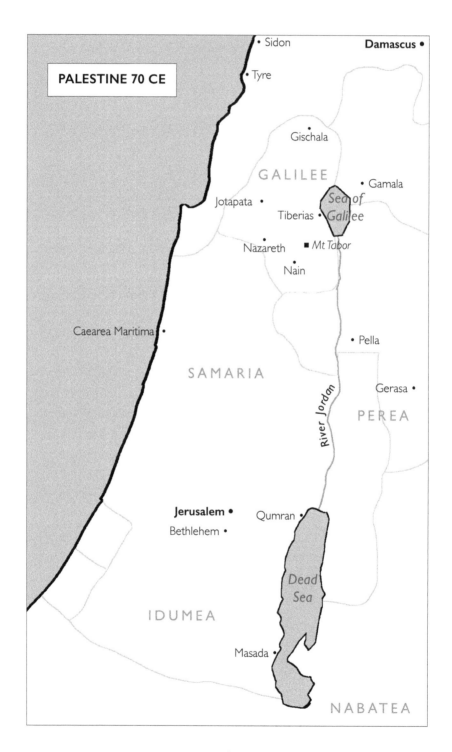

PALESTINE 70 CE

Sidon

Damascus

Tyre

Gischala

GALILEE

Gamala

Jotapata

Sea of Galilee

Tiberias

Nazareth

Mt Tabor

Nain

Caearea Maritima

Pella

SAMARIA

Gerasa

River Jordan

PEREA

Jerusalem

Qumran

Bethlehem

Dead Sea

IDUMEA

Masada

NABATEA

THE EASTERN ROMAN EMPIRE 70 CE

xxv

Fig. 1: *'Jerusalem from the Road Leading to Bethany' 19th century engraving.* The New York Public Library: Digital Collections, 1842–1849.

Introduction

THE RELIGION OF CHRISTIANITY BEGAN AS A JEWISH CULT. MOST scholars are agreed on this point. But despite the assurances of apologists, there is a problem with the historicity of the central figure, Jesus. Burkitt in his preface to Schweitzer's *Quest for the historical Jesus*, calls it "the greatest historical problem in the history of our race."[1]

Says one nineteenth century critic,

> Originally Christianity was purely a socio-religious or socio-ethical movement of the masses, and so free from individualism that the notion of a personal founder was itself wanting. An individual by the name of Jesus may have lived about the opening of our era, but he had no unique significance for the rise of the new religion. Not Judea but Rome was the seat of its origin; Jewish messianism, Stoic philosophy, and the communistic clubs of the time supplied its source elements; its literature was a poetic creation projecting into the past the more immediate experiences of the present, as when the picture of a suffering, dying, and rising Christ typified the community's own life of persecution and martyrdom. The gospel Jesus was created for practical purposes, thus giving a concrete and so a more permanent form to the principles and ideals of the new faith.[2]

Since Celsus in the second century and Porphyry in the third, skeptics have declared the gospels to be myths.[3]

The best and earliest documentary evidence for Jesus are the letters of the apostle Paul. But Paul does not mention that Jesus had any specific followers, family or even enemies except in a general

1 Schweitzer & Montgomery, 1911, p. vi.
2 Case, 1912, p. 41.
3 "More and more the myths put about by these Christians are better known than the doctrines of the philosophers. Who has not heard the fable of Jesus' birth from a virgin or the stories of his crucifixion and resurrection?" Celsus, *On the True Doctrine*

spiritual sense. Indeed, these aspects of an ordinary person's career were irrelevant to Paul and his theology.[4] The only thing that was needed for the religion to be effective in Paul's schema was a belief in the sacrificial death and the vindicated resurrection of the divine figure.[5] That belief, which was advanced as faith without evidence, was the virtue which could be rewarded with salvation.

The teachers of the new sect were intelligent persons who felt a special calling to save the world. It is my contention that it is unnecessary to postulate the existence of *another teacher* besides the apostles to explain where the religion came from.[6]

Methodology

In this study I have applied a mode of inference which the American logician-philosopher Charles Sanders Peirce, described as *abduction*.

> "The surprising fact, C, is observed;
> But if A were true, C would be a matter of course.
> Hence, there is reason to suspect that A is true."[7]

Putting this in terms relevant to our discussion,

> I have found many surprising facts (especially in ancient documents) about early Christianity.
> If my hypothesis is correct, these surprising facts would be a matter of course.
> Hence, there is reason to suspect that my hypothesis is correct.

I have also aimed at finding not just the *likeliest* explanation for

4 Schweitzer & Montgomery, 1911, p. 342, see 1 Corinthians 2:2

5 Romans 10:9

6 The role of the Jewish Christians will be explained subsequently

7 See https://en.wikipedia.org/wiki/Abductive-reasoning

the origin of Christianity but as Lipton would have it *the loveliest* explanation, "the one which would, if correct, be the most explanatory or provide the most understanding." [8]

It is sometimes better to work backwards, that is, to apply the *histoire regressive* technique as the great French historian Marc Bloch called it. This is to,

> Read the texts in the reverse direction of their canonical order, beginning with the safe anchor of the period of their compilation and reading back. [9]

If we apply this method to *all the relevant documents* (that is both religious and secular) we begin with the existence of Christians at the beginning of the second century. Before that time, it gets very hazy. The letters and the gospels contain few clues as to the exact dates of their compilation. And even more speculative is the task of deciding what was going on in the churches when the documents were written. In this study I have endeavored to avoid oversimplifying a complex problem, while at the same time making the arguments accessible to the general reader.

My contention is that the paucity of evidence for Jesus or Christians in the middle of the first century is no mere aberration. What Brandon described as a hiatus in the development of Christianity[10] is in fact an absence. Christianity, I assert, did not linger for forty years after its legendary inception; it bolted from the starting blocks as all successful religions do. One has only to consider the first twenty years of the Mormon religion, or Islam to see evidence of this. There is no reason to suppose Christianity was any different.

Early Christianity was initially successful because there was a powerful *intellectual reason* for accepting the Christian message—its

8 Campos, 2011, p.434.

9 Finkelstein & Mazar, 2007, p. 15.

10 Brandon, 1951, p. 249.

scriptural foundation and appealing internal logic. However, there was also a powerful *emotional element* that motivated and bound together the early Christians. This was the undeserved punishment of the innocent, a phenomenon no doubt witnessed and experienced by the first Christians. Each week when the Christians met, the central rite[11] of the Lord's Supper, a proxy for the crucifixion of Jesus was performed and with it was recreated the mental state that is at the core of Christianity. In a real sense, there were probably early believers who could identify with this state, and like Paul point to the "marks of Jesus" on their own bodies.[12]

By comparing the founding of ancient Christianity with modern cults I hope to show that belief in Jesus arose according to the same psychological and sociological rules as those religions did; that is, in a manner consistent with normal human behaviour, and given similar circumstances, a similar sociological landscape and similar dramatic events, another religion like Christianity would arise.

The organisation of this book

The book is divided into two parts. In Part 1 the Jewish War is covered in some detail as this is the key to understanding the psychological and sociological factors that led to the new religion. We also look at modern research in belief formation and apply this to the first century situation. Finally, after some theological considerations we put it all together in some form of a definitive history, at least as far as the sources will allow us to go. In Part 2, I look specifically at some of the documentary and other evidence for the late arrival of Christianity. Objections which are sure to be raised by orthodox historians I have dealt with in the Appendices.

11 Durkheim, 1915, p. 10.

12 Galatians 6:17

PART 1

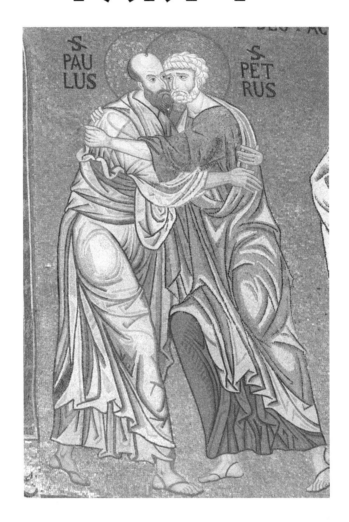

CHAPTER ONE

The Great Commission

Go therefore and make disciples of all nations, baptizing them in the name of the Father and of the Son and of the Holy Spirit, and teaching them to obey everything that I have commanded you.

<div align="right">Matthew 28:19-20</div>

The Baptism of Jesus

JESUS' MINISTRY BEGAN WITH HIS BAPTISM. THE RITUAL OF BAPTISM signifies a new beginning, the beginning of a life dedicated to God, and it was fitting that Jesus, as the first of many brethren, should lead by example. In the third chapter of the gospel of Matthew we learn that Jesus was baptised by John.

But who was this John that baptised Jesus? According to the Jewish historian Josephus, there was in the first century, a person called John, who preached baptism. He had a substantial following and was active sometime in the period 34 to 37 CE.[13] If we are talking about the same John, and it seems that we are, this reference

13 *Antiquities of the Jews*, Book 18.5.2.

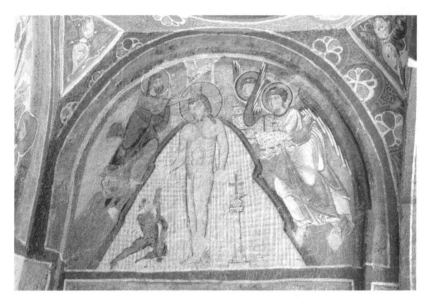

Fig. 2: *The Baptism of Jesus. Fresco art of hidden cave church (Elmali Kilise) of Cappadocia, Turkey. 11th or 12th Century.* VPC Travel Photo / Alamy Stock Photo

places Jesus and the origins of Christianity in the first half of the first century, or more precisely in the last years of the reign of the Roman emperor Tiberius.

But Josephus makes no mention of an encounter between John and the greater prophet Jesus. In fact, he never mentions Jesus at all. This is odd because according to Matthew, Jesus was more popular than John.[14]

Early Christian art depicts a naked Jesus submitting to baptism. A third century text known as *The Apostolic Tradition*, has whole families being admitted into the faith on the same occasion—men, women and children—and these catechumens were also baptised naked.[15]

14 Matthew states that John attracted people from Jerusalem and all Judea and all the region along the Jordan. (3:5) But of Jesus we read, his fame spread *throughout all Syria* (4:24) and great crowds followed him from Galilee, the Decapolis, Jerusalem, Judea, and from beyond the Jordan. (4:25)

15 *The Apostolic Tradition*, 21:2-5

No good evidence

The problem with the popular hypothesis of Christian origins is that, leaving aside certain *religious* documents, there is *no good evidence* that *any of the stories* about Jesus as related in the gospels really transpired.

In fact, it is not until we get to the year 79 that we find unequivocal evidence for *the existence of Christians*; that is people who believed that there had been a divine prophet called Jesus.[16]

But after discounting what many people regard as untenable, for example the tales of miracles such as walking on water and turning water into wine, *was there a person called Jesus of another ilk*, an ordinary preacher perhaps who initiated Christianity? It must be admitted that it is manifestly more difficult to prove such a character did not exist. Jesus was a common name. But this entails the problem of explaining how a first century itinerant who left no trace in the historical records could have initiated a world shattering religion. His early followers apparently also left no trace.

The renowned Biblical scholar, Bart Ehrman admits that,

- … there is no hard, physical evidence for Jesus.
- We … also do not have any writings from Jesus.
- … no Greek or Roman author from the first century mentions Jesus.
- We do not have … a single reference to Jesus by anyone—pagan, Jew, or Christian—who was a contemporary eyewitness, who recorded things he said and did.
- The Dead Sea Scrolls … do not mention or allude to Jesus [17]

Despite this dearth of evidence, Ehrman and many other academic scholars of Christianity hold that a non-divine Jesus once walked the

16 See Appendix 2 for the refutation of common arguments used to support mid first century Christianity.

17 Ehrman, 2013, pp. 42, 43, 46, 56.

earth. There is however a small but growing number of dissenters, and the present author is one of them, who find no evidence that a Jesus *of any description*, as the source of Christianity, ever existed. That the religion started without Jesus fits the evidence better and is more likely from what we know about human religious behaviour.

How religions arise

How could Christianity have arisen without a Christ? Is it possible for religious beliefs to arise *spontaneously*?

Religions can arise without a charismatic teacher or cult leader and there are documented cases which illustrate this. There is, for example, the religion of Om Banna which arose in 1991. This religion had no cult leader. It began when a motorcyclist was allegedly involved in an accident on a highway in the Indian province of Rajasthan. The out of control machine ran into a tree which instantly killed the rider Om Banna. Miraculously the Royal Enfield, despite being impounded by the police, continued to reappear at the site of the accident. Today, the practice of the religion includes singing hymns and making offerings to the god Om Banna who is said to protect travellers on this dangerous stretch of road.

After Om Banna's demise, it is reported that,

> One day Om Banna showed miracle to his grandmother by appearing at night and saying I am not dead, I am alive. He also requested his grandmother to donate two bigha land to Hemraj Purohit which was done. They say only after six months of death Om Banna started showing miracles to village people and faith developed among them. Many truck drivers driving at National Highway 65 said they felt that someone sitting with them during night hours and many stories how Om Banna saved few accidents.[18]

18 Accessed at http://wikimapia.org/14857526/Bullet-Baba-Shrine

Om Banna, the man, was unknown to the world prior to his death. The religion named after him arose as a consequence of his death, and Om Banna was neither a cult leader nor a divine teacher.

In New Guinea, the Pomio Kivung, a kind of cargo cult, started around 1964, which was when other major cults emerged on the island of New Britain. Pomio is a district on the island. Central to Kivung theology is the *Tenpela Lo* which is a modified version of the Biblical Ten Commandments. Although the Pomio Kivung can trace their earthly origins to a man named Koriam Urekit, the true source of their wisdom was a mysterious white man who appeared briefly to Koriam while he was out fishing in his canoe. This white man wished to be called *Brata*. After this encounter, Koriam is said to have gone missing for many years and was presumed dead. Many suspect he was secretly in Rome being schooled in the moral-ritual work of the *Tenpela Lo* whose posts are carved in Roman numerals.[19]

How religions are defended

The defenders (or apologists) of religious tenets will often appeal to reasoning, in the face of contrary evidence.

An example of this phenomenon is the famous Church controversy concerning the geostatic model of the universe—the belief that the sun and other heavenly bodies move around a stationary Earth. This appeared intuitively obvious to those 17th century observers, as it still does to us today, and certain physical arguments were advanced to support it, but the idea received ecclesiastical blessing because this was the opinion expressed in the scriptures and confirmed by the church fathers.[20] We read for example in Genesis,

19 Cargo cults and cognitive science: the dynamics of creativity and repetition in the Pomio Kivung, in Trompf, Cusack & Hartney, 2010, p. 105.

20 "The heavens, revolving under His government, are subject to Him in peace." Clement of Rome, *Letter to the Corinthians* 20, c. 97 CE.

And God said, "Let there be lights in the dome of the sky to separate the day from the night; and let them be for signs and for seasons and for days and years, and let them be lights in the dome of the sky to give light upon the earth." (1:14-15)

The invention of the telescope in 1608 changed everything. The principles of optics however had been discussed since at least 300 BCE with the publication of Euclid's *Optics*.[21] In the first century, Seneca wrote: "Letters, however small and indistinct, are seen enlarged and more clearly through a globe or glass filled with water."[22] Nero is said to have watched the gladiatorial games using an emerald as a corrective lens.[23] Ptolemy (c. 100-c. 170 CE) whose interests included mathematics, astronomy and geography wrote a work on Optics[24] in which he explained optical illusions, but surprisingly and tragically more than a thousand years passed before anyone made use of the properties of lenses for studying the natural world.

The new students of the heavens, including Kepler and Galileo, saw things that did not accord with Christian dogma. Undeterred, the Church argued on logical grounds that "since God is all-powerful, He could have created any one of a number of different worlds, including one in which the earth is motionless; therefore, *regardless of how much evidence there is in support of the earth's motion*, one can never assert that this must be so, for such an assertion would be an attempt to limit God's power to do otherwise."[25] [italics added]

The Sacred Congregation of the Most Eminent and Most Reverend Cardinals of the Holy Roman Church suspended Nicolaus Copernicus's treatise *On the Revolutions of the Heavenly Spheres*

21 Darrigol, 2012, p. 20.

22 Seneca, *Physical Science*, Book 1.6.

23 Pliny the Elder, *Natural History*, 37.16.

24 Darrigol, 2012, p. 25.

25 Finocchiaro, 2005, p. 62.

because it asserted "that the terrestrial globe is in motion but the sun is motionless and is the center of the world, which is an opinion contrary to Sacred Scripture."[26]

The matter came to a head in the year 1633. The previous year Galileo's *Dialogue of the Two World Systems* had been published. To combat the implications of these scientific findings, the Church employed three theologians to assess Galileo's work and one of those chosen for this task was Melchior Inchofer, a Jesuit priest, and a teacher of mathematics, natural philosophy and theology. He had been born into a Lutheran family in Hungary and later converted to Catholicism.

But Inchofer himself was suspect. While teaching in Sicily, he became convinced that a locally held church document and blatant forgery purporting to be a letter from the Virgin Mary to the city of Messina in 62 CE, was genuine. Inchofer went so far as to publish a book in defence of the authenticity of the letter. In an ironic twist, *this book* was placed on the *Index of Prohibited Books* while Inchofer was at the same time denouncing the works of Galileo and Copernicus, and recommending *them* for the *Index*.[27]

Inchofer's findings and arguments against Copernicanism were published in the *Tractatus syllepticus* which a modern scholar sums up as follows.

> The overall impression throughout the book is that it is a blizzard of quotations from scripture and the church fathers, as Inchofer employs the standard theological method of his time in arguing by the citation of authorities... Out of this blizzard of texts comes a long list of *de fide* truths, which include the following: (1) God created the firmament in the middle of the waters. (2) The heavens are up, and the earth is down.

26 Finocchiaro, 2005, p. 30.

27 Blackwell, 2008, p. 32. In defence of Inchofer's character a posthumously (1653) published booklet was his *De eunuchismo dissertatio* in which he argued on moral grounds against the practice, then in use, of castrating young boys to prepare them for later service as singers in church choirs.

(3) God suspended the earth above the void. (4) During the suffering of Christ the sun experienced a miraculous disappearance for three hours. (5) The sun moves in a circle around the earth. (6) The heavens have a circular motion and a spherical shape. (7) The earth is at rest at the center of the universe.[28]

The Copernicus/Galileo-Inchofer affair points to the folly of relying on holy books, and their interpretation to establish scientific facts. Today we laud those Renaissance heroes of old, people like Copernicus and Galileo who stood firm and whose names have continued to echo down the ages, while the name of Inchofer, who was sincere but mistaken, has largely been forgotten.

These three examples provide clues as to how Christianity could have arisen. Firstly, we might look for an event—a tragedy perhaps, as in the case of Om Banna—that triggered belief in Jesus and secondly, sacred writings from which specific doctrines about Jesus could have been formulated—something like the way scripture was used by Inchofer in the *Tractatus syllepticus*, to refute erroneous views and establish theological truths.

It was Galileo who said, "In questions of science, the authority of a thousand is not worth the humble reasoning of a single individual."

28 Blackwell, 2008, p. 57.

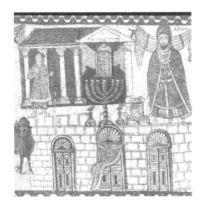

CHAPTER TWO

The official church historian Eusebius

EUSEBIUS PAMPHILI (C.260–340) WAS THE AUTHOR OF SEVERAL works in Christian exegesis. However, he is best known for writing in ten books his Ecclesiastical History which spanned the alleged time of Christ to his own day. He is the sole source for much information about the early history of the church. He lived during the reign of Constantine and was active in eulogising the emperor and presenting him as the saviour of Christianity after the severe persecution instituted by the emperor Diocletian.

Eusebius lived in Caesarea Maritima, which was an important seaside town in Palestine with a population of about 100,000. This city was founded by Herod the Great and boasted "a vast harbor, a temple dedicated to Rome and Augustus, a theater and an amphitheater, a royal palace, market places, dwellings, and an underground sewer system."[29] It was a cosmopolitan city with archaeology confirming its status as an important hub of international trade. Although it was ruled by the Romans it became a centre of Greek learning. Eusebius' teacher Pamphilus established

29 Inowlocki, 2011, p. 1.

a school and a library which contained 30,000 scrolls. Its *scriptorium* produced copies of scriptures for the use of scholars, disciples and pious women.[30]

From this vast library of resources Eusebius compiled his history though he admitted that the result was flawed and incomplete. He claimed to be the first to attempt such an enterprise, and found it "a lonely and untrodden path."[31] He says his purpose was to show how God had instituted the dispensation of the Saviour-Christ and had guarded it against the dangers of secular authorities, pagans and heretics. Eusebius was also anxious to put before his readers some theological arguments about the divine nature and pre-existence of Jesus, which he does by quoting verses from the Old and New Testaments. These questions exercised the minds of the believers at that time. Eusebius was above all else an orthodox theologian/ apologist.

The account that Eusebius gives of the ecclesiastical events in the first century follow the accounts given in the gospels with parts of the writings of the Jewish historian Josephus quoted as background material as occasion demanded. As such Eusebius, with his avowed bias and selective use of sources, is not totally a reliable guide in our quest to discover the origins of Christianity.[32]

The earliest evidence

In the early 1860s, a Latin graffito was discovered in ancient Pompeii that seemed to refer to the presence of Jesus followers in the city.[33] This writing is reproduced below.

30 Inowlocki, 2011, p. 5.
31 *Ecclesiastical History*, Book 1.1.
32 See Appendix 2 *Flavius Josephus and Eusebius*
33 Wayment & Grey, 2015, p. 103ff.

VINA
MARIA
ADIA · A·V
BOVIGSAVDICHRISTIANOS
SEVOSO ONIS [34]

This writing on a wall in the doomed city was in charcoal and only partially decipherable. It also deteriorated rapidly but the lettering was transcribed by several archaeologists before it faded completely. This graffito provides evidence for the existence of Christians in 79 CE, the year of the eruption of Mount Vesuvius.

This is the earliest archaeological (epigraphic) evidence for the existence of Christians.[35]

The earliest and best secular *documentary* evidence for the existence of Christians is provided by one of the letters of Roman governor Pliny to the Emperor Trajan (c. 111 CE).

Pliny who lived from 61 to about 113 is better known as Pliny *the Younger*. His uncle Pliny *the Elder* was the renowned naturalist and author of the encyclopaedic *Naturalis Historia*. He died tragically attempting to rescue survivors of the Vesuvian eruption.

The letters of Pliny the Younger are an important source of information about the history of the period. He was appointed governor of Bithynia and Pontus province (modern North-Western Turkey) in the year 110. Shortly after his appointment Pliny sought the advice of the emperor Trajan on how to deal with adherents of a new religious sect who called themselves Christians, and who had been brought to his attention as enemies of the state. He begins his letter,

> Having never been present at any trials concerning those who profess Christianity, I am unacquainted not only with the nature of their crimes, or the measure of their punishment, but how far it is proper to enter into

34 "Wine . . . Mary . . .Bovi(o)s is listening to the Christians . . ."

35 Other references to Christ or Christians which seem to predate this are dealt with in Appendix 2.

an examination concerning them. Whether, therefore, any difference is usually made with respect to ages, or no distinction is to be observed between the young and the adult; whether repentance entitles them to a pardon; or if a man has been once a Christian, it avails nothing to desist from his error; whether the very profession of Christianity, unattended with any criminal act, or only the crimes themselves inherent in the profession are punishable.[36]

He then goes on to describe the results of his research into their beliefs and practices, and after interrogating two female slaves under torture, concludes that

> ... all I could discover was evidence of an absurd and extravagant superstition.

In this same letter, Pliny mentions Christian apostates who stated that they had abandoned the new religion 20 years previously. As Pliny's letter is dated around 111 CE, this provides evidence for the existence of Christians around 90 CE.

In 1920, Bernard P. Grenfell acquired in Egypt, for the John Rylands University Library, Manchester, the lot of papyrus fragments that included P52. The fragment contains John 18:31–33 on the recto and 18:37–38 on the verso. The findings were published in 1935 amid much excitement as this appeared to be the earliest written evidence of any New Testament text. Nongbri has studied the handwriting on the fragment and concluded that "any serious consideration of the window of possible dates for P52 must include dates in the later second and early third centuries."[37]

36 Letter 96.
37 Nongbri, 2005, p.29.

The Absence of Evidence

What evidence is there that Christ or Christians existed before 70 CE? We now turn to writers who should have mentioned Jesus or Christians but failed to do so.

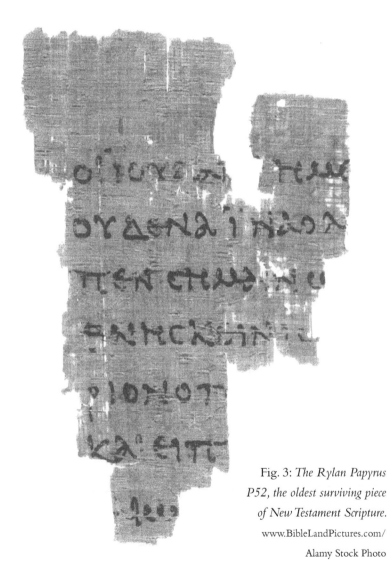

Fig. 3: *The Rylan Papyrus P52, the oldest surviving piece of New Testament Scripture.*
www.BibleLandPictures.com/
Alamy Stock Photo

The big three: Philo, Seneca and Josephus

Philo of Alexandria (c. 25 BCE–c. 50 CE)

Philo, a Jew, was a prolific writer of philosophy and Jewish history. Philo's description of the Therapeutae, a Jewish sect famous for contemplative asceticism is used by Eusebius to argue for the existence of Christians in Egypt during the reign of Claudius (41-54), but despite a lengthy discussion of the theology and practices of these people Philo fails to mention the prophet from Galilee.[38] This sect, which Eusebius noted as having similar practices to early Christians also existed outside of Egypt.[39] Rather than being Christians it is more likely that this sect inspired the first Christians.

Seneca (c. 4 BCE–65 CE)

Seneca, the stoic philosopher, statesman and dramatist, and tutor and adviser to Nero wrote extensively on morals and the good life, but never mentions the great moral teacher from Galilee, or the chief apostle to the Gentiles and moralist, Paul. This oversight was corrected by early Christians who forged letters purporting to be written by the two men to each other.[40]

The Jewish historian Flavius Josephus (37–c. 100)

In all his extensive and detailed history of the affairs of the Jews in the first century, Josephus makes no mention of Jesus or any of his entourage or followers.[41]

Eusebius was a great fan of Josephus, and said, "I marvel greatly that Josephus, in these things as well as in others, so fully agrees with the

38 *Ecclesiastical History*, Book 2.17.

39 Philo, *De Vita Contemplativa*, section 3.

40 James, 1924, *The Correspondence of Paul and Seneca*.

41 Acts states that thousands converted to Christianity at Pentecost around the year 30. (2:41) And, "The word of God continued to spread; the number of the disciples increased greatly in Jerusalem, and a great many of the priests became obedient to the faith." (6:7) These events which could never have escaped the notice of Josephus are nowhere mentioned by the historian.

divine Scriptures."[42] This is hardly surprising as the New Testament narratives were written with one eye on Josephus' histories. However, when Josephus failed to mention Jesus or Christians, someone (probably the bishop from Caesarea) set about creating a passage that did.[43]

Other writers

Justus of Tiberias

This Jewish historian, and contemporary of Josephus makes no mention of Jesus. We read in the *Bibliotheca* of the renowned Photius, Patriarch of Constantinople (9th century) that,

> Justus's style is very concise, and he omits a great deal that is of the utmost importance. Suffering from the common fault of the Jews, to which race he belonged, he does not even mention the coming of Christ, the events of His life, or the miracles performed by Him.

The emperor Claudius (10 BCE–54 CE)

Claudius was a serious scholar and a prolific writer[44] who wrote an autobiography and a history of the Roman Empire which was still extant when Suetonius wrote his history about 50 years later.[45] If Claudius had mentioned Christ or Christians we can be sure that Christian apologists would have preserved those texts, but none have been preserved. In his letter to the Alexandrians dated 41 CE giving directions to the populace about the religious and ethnic affairs of the city, Claudius discusses the plight of Jews but makes no mention of

42 *Ecclesiastical History*, Book 2.10.

43 See Appendix 2.

44 To conclude, he [Claudius] even wrote books in Greek: twenty volumes of Etruscan history, and eight of Carthaginian. The City of Alexandria acknowledged these works by adding a new wing to the Museum called 'The Claudian' in his honour. *Suetonius*, 2003, p. 210 [Claudius, 42].

45 *Suetonius*, 2003, p. 209 [Claudius, 41].

Jesus or Christians. Apollos, who was Paul's co-worker, and a successful missionary and apostle, was said to be a native of this city. (Acts 18:24)

Tacitus (c. 56–c. 120)

This well-known Roman historian reports in his *Histories* that regarding the Jews, "Under Tiberius all was quiet." There are very good grounds for doubting the oft quoted incident of the persecution of Christians by Nero which appears in his other work *Annals*.[46]

Pliny the Elder (23–79)

In his *Natural History* published in the year 77, Pliny mentions the Jewish sect, the Essenes but not the Christians. Pliny says that a commune of Essenes existed west of the Dead Sea. He describes them as living apart from the world, free from desire and attracting multitudes of strangers, who are driven there "by the tempests of fortune, and wearied with the miseries of life."[47]

Plutarch (c. 50–c. 120)

Plutarch lived most of his life in the small town of Chaeroneia in Greece, about 80 kilometres by road from the famous oracle site of Delphi, and about 150 kilometres from Athens, where Paul, we are told, famously debated with the Epicurean and Stoic philosophers in the Areopagus, converting "Dionysius the Areopagite and a woman named Damaris, and others with them." (Acts 17:16-34)

In later life, probably about the year 90, Plutarch went to Rome and Italy on political business and to teach philosophy.[48] He wrote extensively about the lives of eminent Greeks and Romans, both past and present, and essays on a wide range of subjects. Plutarch commented on the beliefs and habits of the Jews and the Egyptians, and at this time, we know that Christians inhabited Pompeii and Bithynia. The letters of Paul and Clement show that there was

46 See Appendix 2 for a comprehensive discussion of this topic.
47 *Natural History* Book 5.15.
48 *Life of Demosthenes*, 2.

a thriving and troubled ecclesia in Corinth. Christians certainly existed in Rome which Plutarch visited. Yet we have nothing in the material that has come down to us of any mention of Jesus as a religious leader/philosopher or even Christians as followers of Jesus. Either Christians were too few to attract his attention (but they *did* attract the attention of Domitian) or what he did write about them, being counter to the official church history, has unfortunately been "lost."

Cremutius Cordus and Ancient Censorship

Under the emperor Tiberius the Roman historian Cremutius Cordus was charged with treason for writing a history of the previous century's civil wars which ran afoul of the official version of events. Cordus gave a spirited defense of his work before the Roman Senate but to no avail. Tacitus informs us that the Senate decreed that the city magistrates should find and burn all copies of his books. The author we are told then committed suicide by self-starvation, but copies of his history were hidden and the books survived.[49] Later in the century the rhetorician Quintilian reports that the history was available but that the offending passages "which brought him [Cordus] to his ruin have been expurgated." [50]

The story of Cremutius Cordus and editorial censorship in the Roman period is relevant in considering an important question. How much should we rely on the so-called *argumentum ex silento*, or 'argument from silence' [51]. In the fourth century when Christianity was declared the official religion of the empire, the church gained the power to control public education.[52] We have no complete manuscripts earlier than this time, so we cannot tell what is missing

49 Tacitus, *Annals*, Book 4.34

50 Quintilian, *Institutes of Oratory*, Book 10.104.

51 Duncan, 2012, p.86ff.

52 Three Christian emperors issued edicts ordering the burning of all Christian critic Porphyry's 'impious' works. Magny, 2014, p.12.

in these documents or what has been altered.

A similar fate can be assigned to the writings of Paul. We do not have all of his letters, (1 Corinthians 5:9) and of those we do have any unpalatable passages could have been scratched out by church censors or simply omitted by scribes. There are discontinuities in his writings (for example, Romans 15:33) and these possibly mark the places where some other text used to be, or the following text has been added from another source which could be from Paul or someone else. [53]

Other sources that fail to mention Jesus or Christians

The Dead Sea Scrolls (first discovered in 1946)

Nearly 1000 manuscripts have been discovered hidden in caves near the settlement of Qumran, in the Judean desert, about 50 km east of Jerusalem. Experts date them from the third century BCE to the first century CE, and it seems likely they were hidden just prior to the Roman destruction of Qumran in 70 CE. About 30% of these manuscripts are sectarian in nature describing the rules and tenets of an ascetic Jewish sect called the Essenes.[54] However, these documents are completely silent regarding the teacher from Galilee[55] who had, so it is claimed, delivered the lengthy sermon on the mount to great crowds who had come "from Galilee, the Decapolis, Jerusalem, Judea, and from beyond the Jordan." (Matthew 4:25)

53 Adjusting writings for theological reasons was a practice that was noted by Bishop Dionysius of Corinth who complained that his letters were tampered with by his theological opponents. "As the brethren desired me to write epistles, I wrote. And these epistles the apostles of the devil have filled with tares, cutting out some things and adding others." *Ecclesiastical History*, Book 4.23.

54 Pixner, 1989, p. 97.

55 Sandmel, 1962, p. 12. "I for one would willingly trade in the sectarian documents and the Hodayoth for just one tiny Qumran fragment that would mention Jesus, or Cephas, or Paul."

The Jewish literature – the Talmud and Mishnah.

Hyam Maccoby observes,

> The Jews of this period (second and third centuries CE) had no independent information about Jesus . . . only Christians had kept alive the memory of Jesus.[56]

However, Jews did keep alive the memory of Jewish first century miracle workers such as Hanina ben Dosa, and Honi, the Circle Drawer.[57] Jesus, the author of a new, heretical and very popular Jewish sect, it seems escaped their notice.

Artefacts

There are no physical artefacts (genuine relics, monuments, inscriptions, coins or documents) verifying the claim that a Jesus of Nazareth as described in the Gospels lived and died under Pontius Pilate around the year 30.

We visit museums, we collect objects associated with famous people or events, and we place sentimental value on objects associated with loved ones and special moments in our personal lives. Even children appear to understand that the historical path of an object affects its nature. For all people, history adds meaning beyond the material or functional worth of an object.[58] The ancients also valued objects that had belonged to famous people in the hope that some of their magic might rub off.

56 Maccoby et al., 2006, p. 27. (It should be noted that the Talmud contains no reference to some other would-be messiahs such as Judas of Galilee and Athronges, who are mentioned either by Josephus or the New Testament).

57 "In Josephus and in the Talmud, the *Hasid* ('Pious One') 'Honi the Circle Drawer' was remembered for bringing rain by prayer. Another *Hasid*, Hanina ben Dosa, was remembered for healing by prayer. When the son of Yohanan ben Zakkai became ill, Yohanan said, 'Hanina, my son, pray for him that he may live.' He put his head between his knees and prayed; and he lived. (Babylonian Talmud, *Berakot* 34b)" Duling et al., 1994, p. 84.

58 Frazier & Gelman, 2009, p. 284-5.

From the pen of the satirist and skeptic, Lucian of Samosata (c. 160) we note,

> I believe the man is still alive who paid £120 for the earthenware lamp of Epictetus the Stoic. I suppose he thought he had only to read by the light of that lamp, and the wisdom of Epictetus would be communicated to him in his dreams, and he himself assume the likeness of that venerable sage. And it was only a day or two ago that another enthusiast paid down £250 for the staff dropped by the Cynic Proteus when he leaped upon the pyre.[59]

The first objects documented as prized by early Christians appear to be the bones of martyrs, and these came from the second century. The first mention of this practice is found in the account of the martyrdom of Polycarp (c. 150 CE).

> Thus we, at last, took up his bones, more precious than precious stones, and finer than gold, and put them where it was meet. (19:2)

According to the Orthodox Wiki website, the gold plated right arm of Polycarp had been kept at the Monastery of Panagia Ambelakiotissa-Saint Polycarp, outside Nafpaktos, Greece, from 1475 until it was stolen on March 14, 2013. "Although the three thieves were apprehended, the relic has not been returned to the monastery."[60]

By the law of beneficent contagion, touching the remains of dead holy men or objects that had touched them conferred special powers.[61] In the Old Testament, we read that "as soon as the [dead] man touched the bones of Elisha, he came to life and stood on his feet." (2 Kings 13:21) In the New Testament, the living could also

59 *Remarks addressed to an illiterate book-fancier* in Lucian, 1905, p. 272.

60 Accessed at https://orthodoxwiki.org/Polycarp_of_Smyrna

61 Nickell, 2007, p. 13.

pass on their power by touch.[62] We are asked to believe that the mere shadow of Peter was enough to obtain a cure. (Acts 5:15) The psychological effect of beneficent contagion was well understood by the church authorities and they legislated to take full advantage of it.[63]

> In the year 410, the Council of Carthage ordered local bishops to destroy any altar that had been set up as a memorial to a martyr and to prohibit the building of any new shrine *unless it contained a relic or was built on a site made holy by the person's life or death* (Woodward 1990, 59). By 767, the cult of saints had become entrenched, and the Council of Nicaea declared that all church altars must contain an altar stone that held a saint's relics. To this day, the Catholic Church's Code of Canon Law defines an altar as a "tomb containing the relics of a saint" (Woodward 1990, 59). The practice of placing a relic in each church altar continued until 1969 (Christian relics 2004).[64] [my emphasis]

The collection and veneration of special objects is a basic human foible and the absence of genuine Christian relics from the first century makes it less likely that the religion existed at that time. The indifference to the tomb of the first Christian martyr Stephen is particularly noteworthy[65] and, as investigation after investigation has shown, not a single, reliably authenticated relic of Jesus exists.[66]

62 Many references, including healing and conferring the power of the Holy Spirit—the laying on of hands, see Acts 8:19.

63 The Council of Trent (1545–1563), "The sacred bodies of the holy martyrs and of the other saints living with Christ, which have been living members of Christ and the temple of the Holy Spirit, and which are destined to be raised and glorified by Him unto life eternal, should also be venerated by the faithful. Through them, many benefits are granted to men by God."

64 Nickell, 2007, p. 19.

65 Acts 8:2, "Devout men buried Stephen and made loud lamentation over him."

66 Nickell, 2007, p. 191.

Archaeology

It has been shown from archaeological surveys that the alleged town of Jesus childhood, the town of Nazareth did not exist in the first half of the first century.[67] Salm asserts that, "not a single artefact, tomb or structure at Nazareth can be dated with certainty before 100 CE— that is, unless we go back to the Iron Age (MoN:205)."[68]

No archaeological sites were associated with the gospel stories until Constantine gave orders to build a church at the site of a pagan temple in Jerusalem around 326. Jerome (late 4th century) states that many Christian sites, considered sacred in his time, were once pagan places of worship. He remarks,

"From the time of Hadrian (117-138) to the reign of Constantine—a period of about one hundred and eighty years—the spot which had witnessed the resurrection was occupied by a figure of Jupiter; while on the rock where the cross had stood, a marble statue of Venus was set up by the heathen and became an object of worship. The original persecutors, indeed, supposed that by polluting our holy places they would deprive us of our faith in the passion and in the resurrection. Even my own Bethlehem, as it now is, that most venerable spot in the whole world of which the psalmist sings: the truth has sprung out of the earth, was overshadowed by a grove of Tammuz, that is of Adonis; and in the very cave where the infant Christ had uttered His earliest cry lamentation was made for the paramour of Venus."[69]

It does not seem likely that these pagan places of worship had been deliberately set up to pollute Christian sites. It is more likely that they had been installed to cater for the new Roman population of Judea following the first Roman-Jewish War and especially after the

67 Murdock, 2014.

68 *The Archaeology of Nazareth: A History of Pious Fraud?* René Salm / SBL: November 17, 2012. Accessed at http://www.nazarethmyth.info/SBL_2012_Salm_%28Nazareth%29.pdf

69 Letter 58, To Paulinus.

second War in 132 to 136 when Jerusalem was effectively made a Roman city, and renamed Aelia Capitolina. The pagan sites were later converted to Christian use, in the time of Constantine, a practice that was not unknown.[70]

The quest for confirmation is a key feature of religious pilgrimage and has been since humans first discovered religion. Sites ranging from major cathedrals and temples right down to local wells, caves, rocks and trees are considered as destinations for pilgrimage.[71] Believers leave offerings to the god of Om Banna at the tree where he met his untimely death. But these sites are conspicuously absent in the early history of Christianity.

The Testimony of the Emperor Julian

The emperor Julian (361-363) alleges that the pagan writers of the period of Tiberius and Claudius make no mention of the events or the key persons described in the gospels and Acts. In his *Against the Galileans* he says,

> Yet Jesus, who won over the least worthy of you, has been known by name for but little more than three hundred years: and during his lifetime he accomplished nothing worth hearing of, unless anyone thinks that to heal crooked and blind men and to exorcise those who were possessed by evil demons in the villages of Bethsaida and Bethany can be classed as a mighty achievement. As for purity of life you do not know whether he so much as mentioned it; but you emulate the rages and the bitterness of the Jews, overturning temples and altars, and you slaughtered not only those of us who remained true to the teachings of their fathers, but also men who were as much astray as yourselves,

70 Destroying pagan temples or converting them into churches was a normal missionary strategy towards the end of the fourth century and well into the fifth and sixth. Skarsaune & Hvalvik, 2007, p. 562.

71 Raj & Griffin, 2015, p. 61–2.

heretics,[72] because they did not wail over the corpse in the same fashion as yourselves. But these are rather your own doings; for nowhere did either Jesus or Paul hand down to you such commands. The reason for this is that they never even hoped that you would one day attain to such power as you have; for they were content if they could delude maidservants and slaves, and through them the women, and men like Cornelius[73] and Sergius[74]. But if you can *show me that one of these men is mentioned by the well-known writers of that time—these events happened in the reign of Tiberius or Claudius—then you may consider that I speak falsely about all matters.*[75]

72 For the massacres of heretics by the Christians see Julian's letter *To the Citizens of Bostra,* Julian, 1913, p. 129.

73 *Acts* 10, the story of Cornelius the centurion.

74 *Acts* 13:6-12; Sergius was the proconsul.

75 Julian, 1913, p. 377.

CHAPTER THREE

The Jewish Legacy

AROUND THE END OF THE FIRST CENTURY JOSEPHUS WROTE A BOOK called *Against Apion* defending his heritage and people against attacks from certain Greeks. In that book, he referenced his previous work *Antiquities of the Jews*, in which he declared that he had proved, that

- their nation was ancient,
- they had an historical right to inhabit the land of Palestine,
- their source of information and justification was to be found in their sacred books—their Bible (which is our Old Testament).

Of the sacred writings Josephus says,

> For we have not an innumerable multitude of books among us, disagreeing from and contradicting one another, [as the Greeks have,] but only twenty-two books, which contain the records of all the past times; which are justly believed to be divine; and of them five belong to Moses, which contain his laws and the traditions of the origin of mankind till his death.

31

These books placed the nation of Israel in the centre of world affairs. The Jews were God's special people. He gave them laws. He might punish them occasionally for disobedience, but he would never completely abandon them.[76]

The Temple

The centre of religious activity for Jews in the centuries leading up to the invention of Christianity was the Jewish Temple in Jerusalem. Berger states that,

> The Jewish Temple in Jerusalem, the "Holy House" first built by Solomon, destroyed by the Babylonians, modestly rebuilt by Zerubbabel and then reconstructed and aggrandized by Herod, was the largest religious structure in the ancient world.[77]

Philo of Alexandria (c. 20 CE) declares,

> The buildings of it are of most exceeding beauty and magnificence, so as to be universal objects of admiration to all who behold them, and especially to all foreigners who travel to those parts, and who, comparing them with their own public edifices, marvel both at the beauty and sumptuousness of this one.[78]

No expense was spared in the decoration.

> Now the outward face of the temple in its front wanted nothing that was likely to surprise either men's minds or their eyes; for it was covered all over with plates of gold of great weight, and, at the first rising of the

76 Micah 7:18-19.

77 Berger, 2012, p. ix. See https://www.youtube.com/watch?v=HHLD6RXVLaM for a *Virtual Reconstruction of the Second Temple*.

78 *The Special Laws*, 1.13.73.

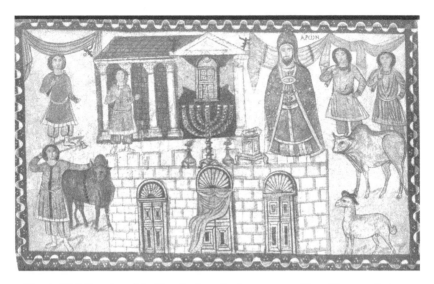

Fig. 4: *Wall Painting of the Temple, from the Synagogue at Dura-Europos, Syria, c. 250 CE.* www.BibleLandPictures.com / Alamy Stock Photo

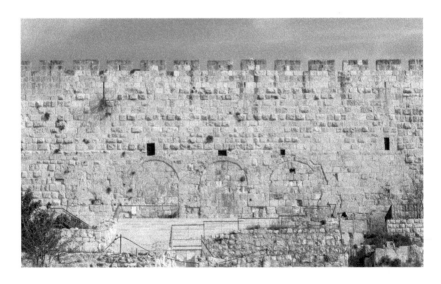

Fig. 5: *The Huldah Gates and excavations, Jerusalem. These gates, now blocked off in the southern wall of the Temple, date from the time of Herod.*

Design Pics Inc/Alamy Stock Photo

sun, reflected back a very fiery splendor, and made those who forced themselves to look upon it to turn their eyes away, just as they would have done at the sun's own rays.[79]

From a military perspective, Tacitus says,

> The temple resembled a citadel, and had its own walls, which were more laboriously constructed than the others. Even the colonnades with which it was surrounded formed an admirable outwork. It contained an inexhaustible spring; there were subterranean excavations in the hill, and tanks and cisterns for holding rain water. The founders of the state had foreseen that frequent wars would result from the singularity of its customs, and so had made every provision against the most protracted siege.[80]

Archaeological findings have confirmed the reports of the ancients.[81] Apart from a coin minted in 132, the most ancient picture of the structure comes from a wall painting in a Syrian synagogue dated to the third century (see Figure 4).

How was a Jew to Live?

Josephus says,

> Our principal care of all is this, to educate our children well; and we think it to be the most necessary business of our whole life to observe the laws that have been given us, and to keep those rules of piety that have been delivered down to us.[82]

79 *Wars of the Jews*, Book 5.5.6.
80 *Histories*, Book 5.
81 Mazar, 1978, p. 231.
82 *Against Apion*, Book 1.12.

It is noteworthy that these people saw no distinction between political and religious affairs. Their ideal state was a theocracy.

What did the Jews in general think about *innovations*? Josephus says,

> But while we are ourselves persuaded that our law was made agreeably to the will of God, it would be impious for us not to observe the same; for what is there in it that anybody would change? and what can be invented that is better? or what can we take out of other people's laws that will exceed it?[83]

The Jewish Law was regarded as the apogee of all laws. Hence the resistance of the Jews to the innovation that was Christianity.[84]

Why is this?

Psychologists call it *the endowment effect*, or the tendency to value what we own more than what we do not. We humans are motivated by *loss aversion*, where we are twice as motivated to avoid the pain of loss as we are to seek the pleasure of gain.[85] *The endowment effect* applies to all kinds of private property, including belief systems. What was necessary for the spread of the new religion was a cohort of people who had *nothing to lose*.

The Critical Event

I suggested in chapter one that we might look for a precipitating event that could explain the emergence of the religion of Christianity. One first century event stands out above all others— the Jewish War of 66 to 73 CE. This event was certainly in the right place because we know that Christian thought was inspired

83 *Against Apion*, Book 2.22.

84 There was also resistance on the part of Jews who had come to believe in Jesus, to abandoning observance of the Mosaic Law. These Jewish Christians formed the first churches.

85 Shermer, 2012, p. 316.

by events in Judea.[86] It was also, according to our thesis, at the right time.

By far the most detailed account of this period in the history of the Jews is provided by the Jewish historian Josephus. His chief works were the *Wars of the Jews* in seven books, and *Antiquities of the Jews* in twenty books. The former covered the period to 75 CE and the latter to 93 CE. In the Middle Ages, Josephus' books were the chief guide to the sites of the Holy Land for pilgrims and Crusaders. The popularity of Josephus in Christian circles is demonstrated by the fact that since 1737 when Whiston's English translation was first published, it has been reprinted or re-edited 217 times. It has achieved almost canonical status.[87] Feldman states that, "Indeed, among strict English Protestants only the Bible and Josephus were permitted to be read on Sundays."[88]

For an overview of the War we turn to the Roman historian Cassius Dio who wrote a synopsis of events in his book *Roman History*. This was published about the year 220. The relevant passage is reproduced in full below. The siege of Jerusalem proceeded from the year 68. The first two years of the War were taken up with subduing Galilee (see map page xxii).

> Titus [the son of Vespasian], who was assigned to take charge of the war with the Jews, undertook to win them over by certain conferences and offers; as they would not yield, he proceeded to direct hostilities. The first battles he fought were rather close; finally he prevailed and took up the siege of Jerusalem. This town had three walls including that surrounding the temple.[89] The Romans accordingly heaped up mounds against the fortifications and brought their engines to bear: then collecting in a dense force they repulsed all sallying parties and with their slings and

86 Christianity "a most mischievous superstition, ... broke out not only in Judaea, the first source of the evil, but even in Rome." Tacitus, *Annals*, Book 15.44.

87 Feldman & Hata, 1987, p. 317.

88 Feldman & Hata, 1987, p. 14.

89 The full circumference of the city was 33 furlongs (stadia) or close to 6km. The walls and towers that Josephus describes are no longer extant. *Wars of the Jews*, Book 5.4.3.

Fig. 6: *Subterranean vaults underneath the Temple Mount, prints made in 1864 by Pierotti, from his own photographs from a collection entitled,* Jerusalem explored, being a description of the ancient and modern city.

The New York Public Library: Digital Collections, 1864.

arrows kept back all the defenders of the wall. Many persons that had
been sent by some of the barbarian kings they kept prisoners. The Jews
who came to the assistance of their countrymen were many of them
from the immediate region and many from kindred districts, not only in
this same Roman empire but from beyond the Euphrates, and they, too,
kept directing missiles and stones with considerable force on account of
the higher ground, some being flung from the hand and some hurled
by means of engines. They likewise made night and day sallies as often
as occasion offered, set fire to the engines, slew numerous combatants,
and by digging out under the wall took away earth from beneath the
mound. As for the rams, they lassoed some of them and broke the ends
off, others they seized and pulled up with hooks, while by means of
thick boards well fastened together and strengthened with iron, which
they let down against the face of the wall, they turned aside the assaults
of the remainder. The Romans' chief cause of discomfort was the lack
of water; their supply was of poor quality and had to be brought from
a distance. The Jews found their underground passages a source of
strength. They had these affairs dug from within the city out under the
walls to distant points in the country, and going out through them they
would attack parties in search of water and harass scattered detachments.
Consequently Titus stopped them all up.

In the course of these operations many on both sides were wounded
and killed. Titus himself was struck on the left shoulder by a stone, and
as a result of this accident the arm was always weaker. After a time the
Romans managed to scale the outside circle, and, pitching their camps
between the two encompassing lines of fortification, assaulted the second
wall. Here, however, they found the conditions confronting them to be
different. When all the inhabitants had retired behind the second wall, its
defence proved an easier matter because the circuit to be guarded was so
much less. Titus, accordingly, made anew a proclamation offering them
immunity. They, however, even under these circumstances held out. And
the captives and deserters from the enemy so far as they could do so
unobserved spoiled the Roman water supply and slew many men that
they could cut off from the main force, so that Titus refused to receive
any of them. Meantime some of the Romans, too, growing disheartened,

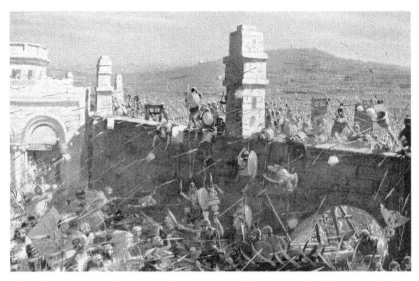

Fig. 7: *Romans breaching the walls in the siege of Jerusalem, 70 CE, during the first Jewish-Roman War, from Hutchinson's* History of the Nations. *Published 1915.*

Classic Image / Alamy Stock Photo

as often happens in a prolonged siege, and furthermore suspecting that the city was really, even as report declared, impregnable, went over to the other side. The Jews although they were short of food treated them kindly, in order to be able to exhibit deserters to their own ranks.

Though a breach in the wall was effected by engines, still the capture did not immediately follow; the defenders killed great numbers that tried to crowd through the opening. Next they set fire to some of the buildings near by, expecting in this way to check the onward progress of the Romans, even should the latter make themselves masters of the entire circuit. In this way they damaged the wall and unintentionally burned down the barrier encompassing their sacred precinct. The entrance to the temple was now laid open to the Romans. The soldiers on account of their superstition would not immediately rush in, but at last, as Titus forced them, they made their way inside. Then the Jews carried on a defence much more vigorous than before, as if they had discovered a rare and unexpected privilege in falling near the temple, while fighting to save it. The populace was stationed in the outer court, the senators on the steps, and the priests in the hall of worship itself. And though they

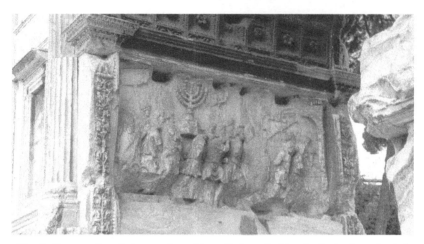

Fig. 8: *Roman triumphal procession with spoils from the Temple, depicted on the Arch of Titus in Rome.* www.BibleLandPictures.com / Alamy Stock Photo

were but a handful fighting against a far superior force they were not subdued until a section of the temple was fired. Then they went to meet death willingly, some letting themselves be pierced by the swords of the Romans, some slaughtering one another, others committing suicide, and others leaping into the blaze. It looked to everybody, and most of all to them, apparently, that so far from being ruin, it was victory and salvation and happiness to perish along with the temple.

Even under these conditions many captives were taken, among them Bargiora, the commander of the enemy: he was the only one punished in the course of the triumphal celebration. Thus was Jerusalem destroyed on the very day of Saturn, which even now the Jews reverence most.[90] To commemorate the event it was ordered that the conquered, while still preserving their own ancestral customs should annually pay a tribute of two denarii to Capitoline Jupiter. As a reward for this success both generals received the title of imperator, but neither had that of *Iudaicus*, although all the other privileges (including arches bearing trophies) that were proper after so great a victory were voted to them.[91]

90 The ninth day of Av, a fast day in the Jewish calendar that commemorates the destruction of the two Temples.

91 Dio's *Roman History*, Volume 5, 66.4–7.

From this brief description of the campaign, we should note the following:

- Jews from beyond Judea, from the diaspora, came to the assistance of their brethren. Other "barbarians" also came. The War attracted foreign fighters. No doubt there were Jews who saw this as fulfilment of the prophecy of Zechariah.

> See, a day is coming for the Lord, when the plunder taken from you will be divided in your midst. For *I will gather all the nations* against Jerusalem to battle, and the city shall be taken and the houses looted and the women raped; half the city shall go into exile, but the rest of the people shall not be cut off from the city. Then the Lord will go forth and fight against those nations as when he fights on a day of battle. (14:1-3)

This battle was to herald the end of history.

> And the Lord will become king over all the earth; on that day the Lord will be one and his name one. (v. 9)

- The resistance of the Jews was fierce and cunning and the attachment of the Jews to their temple was fervent. This behaviour we have explained as the result of the human tendency to overvalue what we already possess—the endowment effect. The memory of the loss was (and still is) commemorated by Jews.[92]
- An annual poll tax on all Jews was instituted which was only abolished by the Emperor Julian in the year 362.[93] Wilson declares that, "the amount, estimated to be about the value of one week's wages for every taxpayer, became a considerable burden, especially in large households."[94]

92 Tisha B'Av (lit. "the ninth of Av") (Hebrew: באב העשת or ט׳ באב) is an annual fast day in Judaism which commemorates the anniversary of a number of disasters in Jewish history, primarily the destruction of both the First Temple by the Babylonians and the Second Temple by the Romans in Jerusalem. (Tisha B'Av wiki accessed at https://en.wikipedia.org/wiki/Tisha_B%27Av)

93 Letters of Julian, *To the community of the Jews*.

94 Wilson, 1995, p.3.

CHAPTER FOUR

The Causes of the War

SOME JEWS WANTED TO RID THEMSELVES OF THE ROMAN YOKE.
These politically or theocratically motivated individuals wanted
to be independent, in control of their land and free to practise their
religious customs without interference. But practically speaking this
was an idle fantasy because the Romans demanded obedience to the
State and had proved themselves capable of enforcing obedience by
virtue of their superior military acumen, discipline and resources.
They were also tenacious. Josephus says that the impetuosity of
the Jewish youth, and their misguided enthusiasm for religion
were major factors in the troubles that preceded the War.[95] For
their part, the synagogue incident in Caesarea in the year 65 was
a deliberate provocation by the Romans. While the War was being
waged, various tribes including the Jews took advantage of the

95 "Those that were for innovations, and were desirous of war, by their youth and boldness, were
too hard for the aged and prudent men." *Wars of the Jews*, Book 4.3.2. The great part played by
the youth in the Jewish insurrection is evidence of a demographic shift that had been fostered
by peace and prosperous economic conditions two or three decades previous, during the reign
of Claudius.

tumult in Rome following the death of Nero. This tumult buoyed up the hopes of the insurrectionists. 69 CE was the year of the four emperors.[96] Some Jews saw the coming War as an opportunity to profit financially.[97]

The Jews had the Maccabees for examples of righteous courage. They had staged a coup against the Hellenists and won a state of quasi independence in the second century BCE. But this was not wholly successful. There was ongoing strife until the half Jew Herod the Great as client king of Rome restored order in 40 BCE. Herod embarked on an ambitious building program and died in 4 BCE leaving the kingdom to his sons. Without a strong unifying leader, the first century saw several Messianic pretenders arise. These movements were brutally and swiftly crushed, until a more extreme and violent sect arose. These were the Sicarii, an offshoot of the Zealots. They carried concealed weapons and their modus operandi was to murder their opponents in crowded places and escape detection by feigning indignation. Thus, they spread terror amongst the populace. They were particularly active in the late fifties and sixties and had made Masada their stronghold.

The Jewish insurrection was also a civil war[98] fought between Jewish factions who sought control of the province, probably using religion as a cover for their political ambitions.[99]

The Romans had economic reasons to pursue the War. When Vespasian came to power in 69 the state treasury was severely depleted.[100] The fire of 64 had seriously damaged the economy of Rome and the region. Tacitus reports,

96 "Now at the time when this great concussion of affairs happened, the affairs of the Romans were themselves in great disorder...The Gauls also, in the neighborhood of the Romans, were in motion, and the Geltin were not quiet; but all was in disorder after the death of Nero." *Wars of the Jews*, Preface, 2.

97 *Wars of the Jews*, Preface, 2.

98 "The Jews are vexed to pieces every day by their civil wars and dissensions," (Vespasian), *Wars of the Jews*, Book 4.6.2.

99 John of Gischala was the leader of one faction, Simon ben Giora of another. *Wars of the Jews*, Book 4.3.9.

100 Feldman, 2001, p. 30.

Meanwhile Italy was thoroughly exhausted by contributions of money, the provinces were ruined, as also the allied nations and the free states, as they were called. Even the gods fell victims to the plunder; for the temples in Rome were despoiled and the gold carried off, which, for a triumph or a vow, the Roman people in every age had consecrated in their prosperity or their alarm.[101]

The Jews were known to be wealthy.[102] They were also a source of trouble in the Empire, disturbing the *Pax Romana* and had been since 63 BCE when Pompey the Great took Jerusalem and forced his way into the Temple. This assault had been made easier by the Jews insistence on keeping the Sabbath.[103] In obedience to the ancient ordinance forbidding work of any kind, they did not interfere with the Romans building siege works on these days.[104] If the Romans were hoping for another easy victory they were mistaken. Under Herod the Great, the city was fortified making a future military defeat of this nature much less likely.

The attachment of the Jews to their religion at the expense of worthwhile civic projects is illustrated by the following example. Pontius Pilate of gospel notoriety built an aqueduct to improve the flow of water to Jerusalem and when the Jews discovered that this was paid for from money from the temple treasury, they protested loudly. In the ensuing melee, many Jews were beaten by Roman soldiers and some were killed.[105]

There were a considerable number of Jews in the Roman diaspora, and it was said that it was hard to find a city that did not have a contingent.[106] It has been estimated that the number of Jews

101 Tacitus, *Annals*, Book 15.45.

102 And let no one wonder that there was so much wealth in our temple, since all the Jews throughout the habitable earth, and those that worshipped God, nay, even those of Asia and Europe, sent their contributions to it, and this from very ancient times. *Antiquities of the Jews*, Book 14.7.2.

103 *Antiquities of the Jews*, Book 14.4.

104 Genesis 2:3, Exodus 16

105 *Antiquities of the Jews*, Book 18.3.2.

106 *Antiquities of the Jews*, Book 14.7.2.

outside Palestine outnumbered those inside by a factor of six.[107] The insurrectionists looked to them for help, but only limited help came.

Anti-Jewish sentiment

Anti-Jewish feelings were prevalent throughout the Empire in the first century. There was a pogrom against the Jews in Alexandria in the year 38.[108] Just prior to the War there were a series of Roman procurators in Judea, who through corruption and maladministration inflamed ethnic tensions and provoked the Jews into insurrection. Gessius Florus (64-66) was the chief amongst this class of ruler, whose notoriety inspired the parable of the unjust judge. (Luke 18:1-8)

Tacitus, no doubt echoing popular sentiment, describes the Jews and their customs as "at once perverse and disgusting" whose wealth was augmented from the contributions and presents brought to them from other races of people. Included in these presents would have been the trade generated from the temple rituals. Josephus says that people from all over the country were caught up in the siege of Jerusalem, because they had been there performing religious sacrifices.[109] The Jews may have been generally despised, but they still had supporters amongst the Gentiles. They had also won concessions from the Roman rulers. These included,

- liberty of worship
- freedom from military service and from certain taxes
- the recognition of the Sabbath as a day of rest
- the right of living according to the customs of their forefathers, *and*
- full jurisdiction over their own members.[110]

107 Edmundson, 1913, p. 7.

108 See Philo, *Flaccus* and *Embassy to Gaius*.

109 The greater part of whom were indeed of the same nation [with the citizens of Jerusalem], but not belonging to the city itself; for they were come up from all the country to the feast of unleavened bread, and were on a sudden shut up by an army. *Wars of the Jews*, Book 6.9.3.

110 Edmundson, 1913, p. 5.

These concessions probably contributed to the public ill will. Tacitus also says that, "among themselves they are inflexibly honest and ever ready to shew compassion, though they regard the rest of mankind with all the hatred of enemies."[111]

Jewish refusal to integrate with the general populace in the diaspora galled Tacitus. The points of difference were:

> They sit apart at meals, they sleep apart, and though, as a nation, they are singularly prone to lust, they abstain from intercourse with foreign women; among themselves nothing is unlawful. Circumcision was adopted by them as a mark of difference from other men. Those who come over to their religion adopt the practice, and have this lesson first instilled into them, to despise all gods, to disown their country, and set at nought parents, children, and brethren.[112]

The scale of the War

This was no footnote in history. The Jewish War of the first century must rank among the most significant military events in the history of the Roman Empire. Josephus with some hyperbole says *in the history of the world*.[113] It also had far reaching long term social and political consequences.

Limiting our analysis to the first century the Jewish War stands out for the number of casualties, the immense transfer of wealth, and arguably the greatest source of slaves from a single campaign.

111 Tacitus, *Histories*, Book 5.5.

112 Hence we see that the preaching of Jesus about religious separation from one's unbelieving family was a Jewish standard. Matthew 12:46-50. Tacitus, *Histories*, Book 5.

113 The multitude of those that therein perished exceeded all the destructions that either men or God ever brought upon the world. *Wars of the Jews*, Book 6.9.4.

Deaths

Comparing other events that we know of:

1. 9 CE. Three Roman legions (5000 in a legion) were ambushed and destroyed at Teutoberg Forest by Germans under the leadership of Arminius.[114]
2. 60 CE. The revolt of Boudicea in Britain, resulted in an estimated 80,000 Britons killed.[115]
3. 58-63 CE. The Roman-Parthian War. This war was inconclusive, and probably encouraged the Jews to revolt. The number of casualties is not recorded.
4. 69 CE. Sarmatian invasion of Mysia (modern north-west Turkey) and subsequent expulsion. Josephus says, "many of them perished."[116]
5. 66-70 CE. The Roman-Jewish War. The number of those that perished during the whole siege according to Josephus was *1.1 million.*[117]

Schwartz disagrees with Josephus when he says that the number of deaths was 1,100,000. He puts *the total population of Palestine* in the middle of the first century at about one million based on the carrying capacity of the land.[118] However, we should note that there were many pilgrims in the city when it was besieged.[119] We also know that food was transported in great quantities around the Empire. Even if Josephus was wrong by a factor of 10 the number killed still exceeds all other military conflicts around that time.

It is also noteworthy that thousands were killed in conflicts in

114 Tacitus, *Annals*, Book 1.59.

115 Tacitus, *Annals*, Book 14.37.

116 *Wars of the Jews*, Book 7.4.3.

117 *Wars of the Jews*, Book 6.9.3.

118 Katz, 2008, p. 23.

119 The Roman army encompassed the city when it was crowded with inhabitants. *Wars of the Jews*, Book 6.9.4.

Galilee before the city of Jerusalem was besieged in the year 68. Josephus says that the Jordan River was filled with dead bodies.[120]

Transfer of wealth

The riches looted from Judea and Jerusalem were used to build the Colosseum (the Flavian Amphitheatre) in Rome. A stone found near the site and reused has been reconstructed to spell the following words.

<div align="center">

IMP [T] CAES VESPASIANVS AVG

AMPHITHEATRVM NOVVM

EXMANVBIS FIERI IVSSIT

</div>

In translation this reads,

> "The Emperor [Titus] Caesar Vespasian Augustus ordered the new amphitheater to be made from the (proceeds from the sale of the) booty."[121]

The letter T for Titus was squeezed in later. The first dedication was made by his father Vespasian.

Feldman notes that,

> . . . the Colosseum was not the only structure built from the money of the spoils. According to a sixth-century Christian historian, John Malalas, out of the spoils from Judea Vespasian built in Antioch, outside the city gate, what are known as the Cherubim, so called because he placed there the cherubim that Titus had taken from the Temple in

120 Jordan could not be passed over, by reason of the dead bodies that were in it. *Wars of the Jews*, Book 4.7.6.

121 Feldman, 2001, p. 25.

Jerusalem. He also built in Antioch the theater of Daphne, inscribing on it "Ex praeda Iudaea," that is, "from the Judean booty," having destroyed a synagogue that was located at the site, in order to insult the Jews. Malalas also notes that Vespasian built in Caesarea, likewise from the spoils from Judea, a very large odeum, or concert hall, the size of a large theater on a site of what had formerly been a synagogue.[122]

Finally, the Church indirectly benefitted from the sacking of Jerusalem and the Temple as stones from the Colosseum were used to construct Catholic buildings in Rome. Feldman states that the great structure was subject to plunder until the 18th century. "Indeed, whole palaces, such as the Cancelleria (the papal chancellery, an enclave in Vatican City completed in the 16th century) and the Palazzo Farnese (a magnificent palace in Rome completed in the 16th century by Cardinal Alessandro Farnese), as well as much of St. Peter's Cathedral in Vatican City, were built from its spoils."[123]

Slaves

Josephus states that,

> The number of those that were carried captive during this whole war was estimated to be ninety-seven thousand.[124]

No doubt some of these slaves were used as manual labour to construct the Roman buildings financed by the sacking of Jerusalem and the Temple.

122 Feldman, 2001, p. 60.
123 Feldman, 2001, p. 22.
124 *Wars of the Jews*, Book 6.9.3.

Economic benefits lost

The Jewish temple, which had just recently been enlarged and refurbished by Herod the Great and his sons, was a famous tourist attraction and pilgrimage site for Jews and Gentiles. Katz remarks that,

> . . . the Temple made Jerusalem a wealthy city, while the demands of its elaborate cult created a demand for animals and agricultural products that provided constant economic stimulus for the surrounding countryside. The city and its shrine were the jewel in Israel's crown. [125]

Implications for the diaspora Jews

There was a massacre of Jews in Damascus in 66. After the failed attempt by the Roman commander Cestius to quell the Jewish uprising and his subsequent rout in Judea, the citizens of Damascus couped up 10,000 Jews in the city's gymnasium and cut their throats. According to Josephus they were careful to hide this crime from their wives who were, according to the historian, "addicted to the Jewish religion."[126] As predicted by the Jewish king Agrippa, in his speech to the Jews in Jerusalem, a short time before this incident,

> . . . the danger concerns not those Jews that dwell here only, but those of them which dwell in other cities also; for there is no people upon the habitable earth which have not some portion of you among them, *whom your enemies will slay, in case you go to war.*[127] [my emphasis]

125 Katz, 2008, p. 193.
126 *Wars of the Jews*, Book 2.20.2.
127 *Wars of the Jews*, Book 2.16.4.

The human cost

These events had profound human costs. Much property was looted or destroyed. Land was confiscated. Businesses were ruined. Families were torn apart. Religion made the Jews proud, hence the destruction of the Temple and large parts of the city was a national religious disaster. There were also wider ramifications beyond Palestine as this place was "adored by the habitable world, and honored by such as only know it by report, as far as the ends of the earth."[128] And politically, Judea ceased to be a Jewish state.

For a people steeped in religion this event was a clear manifestation of God's punishment, through the agency of the Roman multi-ethnic legions—"the nations".

Well might the Psalmist lament,

O God, the nations have come into your inheritance; they have defiled your holy temple; they have laid Jerusalem in ruins.

They have given the bodies of your servants to the birds of the air for food, the flesh of your faithful to the wild animals of the earth.

They have poured out their blood like water all around Jerusalem, and there was no one to bury them.

We have become a taunt to our neighbours, mocked and derided by those around us.

How long, O Lord? Will you be angry forever? Will your jealous wrath burn like fire?

Pour out your anger on the nations that do not know you, and on the kingdoms that do not call on your name. For they have devoured Jacob and laid waste his habitation.

Help us, O God of our salvation, for the glory of your name; deliver us, and forgive our sins, for your name's sake.

Why should the nations say, "Where is their God?"[129]

128 *Wars of the Jews*, Book 4.4.3.
129 Psalm 79:1-7, 9-10

The End of Temple Judaism

One of the most important consequences of the Jewish War was the assistance it gave to the emergence of a new kind of Judaism, independent of the Temple in Jerusalem.[130]

Josephus reports that when the end was in sight, some diehard defenders of the city showed no concern for the temple or their city, and preferring death to slavery, said "that they would do all the mischief to the Romans they could while they had breath in them."[131]

The Jewish War exposed the weaknesses of Temple Judaism, in particular its reliance on a central temple where God dwelt, and a holy city where rites were performed.[132] The old religion was deficient. New religions were the order of the day. The sociologist Rodney Stark correctly avers,

"It is obvious that people do not embrace a new faith if they are content with an older one. New religions must always make their way in the market openings left them by weaknesses in the conventional religion(s) of a society."[133]

There were extant ideas, expressed in the proto-Christian books[134] such as *The Wisdom of Solomon* and in near contemporary writers like Philo of Alexandria (c. 25BCE-c. 50CE) which would have resonated with the religiously dispossessed. Philo's vision of a city of

130 Curran, 2007, p. 91.

131 *Wars of the Jews*, Book 5.11.2.

132 There was another Jewish temple at Leontopolis in Egypt (*Antiquities of the Jews*, Book 13.3.1), established on the back of prophecies (Isaiah 19:19-22) but the Jerusalem temple commanded the bulk of the written prophecies.

133 Stark, 1996, p. 37.

134 See Schürer, E. (1972). *The literature of the Jewish people in the time of Jesus.*

God is remembered as Revelation's "new Jerusalem."[135]

Almost two thousand years later, this event still resonates in Jewish liturgy, literature and practice. The daily and weekly prayer services, as well as the traditional grace after meals, express hope for the restoration of the temple and its sacrificial cult. On the ninth day of the Hebrew month of Av, many Jews observe a day of fasting; they gather in synagogues, where they sit on the floor, read the biblical book of Lamentations by candlelight, and mourn the loss of the temple, as one of the most important of many national tragedies.[136]

The reader is directed to a painting by Wilhelm von Kaulbach, 1846, entitled *Die Zerstörung Jerusalems durch Titus* (Titus destroying Jerusalem) for an excellent depiction in art of this tragedy.[137]

135 "And I saw the holy city, the new Jerusalem, coming down out of heaven from God, prepared as a bride adorned for her husband." Rev 21:2

136 Reinhartz, *The Destruction of the Jerusalem Temple as a Trauma for Nascent Christianity*, in Becker, Dochhorn & Holt, 2014, p. 275.

137 Accessed at https://commons.wikimedia.org/wiki/File:Kaulbach_Zerstoerung_Jerusalems_durch_Titus.jpg

CHAPTER FIVE

God's Punishment

And can we then be at a loss for a reason of God's righteousness in his thus punishing England, by beginning thus furiously with London? When were there so many atheists about London, and in the land, who denied the very being of God; when so many gentlemen (who looked upon it as one piece of their breeding to cast off all sentiments of a Deity) did walk our streets, and no arguments would work them to a persuasion of the truth of God's being, shall we wonder, if the Lord appears in a terrible way, that he might be known by the judgments which he executeth?

Thomas Vincent, the English Puritan minister and author,
on the Great Fire of London, 1666[138]

POPE PIUS XI ASSIGNED THE CAUSES OF THE GREAT WAR TO MEN WHO, "have forsaken God and Jesus Christ, [and] . . . have sunk to the depths of evil."[139] Paul declares, "For those who are self-seeking and who obey not the truth but wickedness, there will be wrath and fury." (Romans 1:18)

138 Vincent, 1667, p. 75.
139 *Ubi Arcano Dei Consilio*, 28.

The *Letter of Mara bar Serapion*[140] assigns divine punishment to sinners.

> For what benefit did the Athenians obtain by putting Socrates to death, seeing that they received as retribution for it famine and pestilence? Or the people of Samos by the burning of Pythagoras, seeing that in one hour the whole of their country was covered with sand? Or the Jews by the murder of their Wise King, seeing that from that very time their kingdom was driven away from them?

The Greek pagan Plutarch composed *On the delays of divine vengeance* in answer to the question of God's slowness in punishing the wicked.[141]

The belief in *a just world* was first described by Melvin Lerner in the 1960s. He proposed "that people have the need to believe in *a just world* in which all people, including themselves, get what they deserve and deserve what they get."[142] We are naturally attracted to plays and cinema in which a positive outcome attends the morally good character and the bad are punished.[143] The underlying theme of the gospels is that the unjustly treated, exemplified by Jesus, will finally be vindicated, and the evil get their deserts. Justin Martyr maintains, "these things have happened to you [Jews] in fairness and justice, for you have slain the Just One."[144]

The Bible is premised on the notion that all the world is just, and

140 Probably from the later second or early third century, see Merz & Tieleman, 2012, p. 34.

141 This special notion of precisely fitting retribution, a commonplace of Greek historiography from the classical period onwards, pervades the writings of Josephus' contemporaries, Luke and Plutarch. At times Plutarch seems so preoccupied with this notion of retribution that he distorts well-known historical facts to illustrate what he believes is an exemplum. In the Erotikos, for example, Vespasian's execution of the Gallic chieftain Sabinus and his wife, who had just borne him a son, brings upon the emperor divine retribution, which destroys his whole line in a short time (770d – 771d). That Vespasian died in peace and Domitian survived some twenty years afterwards, Plutarch fails to note. Feldman & Hata, 1987, p.104.

142 Lerner, Ross & Miller, 2002, p. 365.

143 Jose, 1990, p. 1025.

144 *Dialogue with Trypho*, 16

Jerusalem does not escape.

> "For thus says the Lord of hosts: Cut down her trees; cast up a siege ramp against Jerusalem. This is the city that must be punished." (Jeremiah 6:6)

Jeremiah mentions punishment more than any other Jewish prophet, and Matthew makes conspicuous use of the prophet.

The table below shows the references Matthew makes to Jeremiah.

Incident/saying	Matthew	Jeremiah
The disciples' confession: Jesus is Jeremiah, or one of the prophets	16:14	
the massacre of the innocents	2:16-18	31:15
the thirty pieces of silver	27:8-10	32:9 with Zechariah 11:12-13
woe to those who are pregnant	24:19	4:31
suddenly the destroyer will come	24:44	6:26
no figs on the fig tree	21:18-21	8:13
house left desolate	23:38	22:5
I will give you rest	11:28	6:16
a den of robbers	21:13	7:11

Table 1. Matthew and Jeremiah

The Jewish Encyclopedia notes that,

> The lofty mission for which Jeremiah was destined was evident even at his birth; for he not only came into the world circumcised . . . but as soon as he beheld the light of day he broke out into loud cries, exclaiming with the voice of a youth: "My bowels, my bowels! I am pained at my very heart; my heart maketh a noise in me," etc. (Jer. iv. 20). He continued by accusing his mother of unfaithfulness; and as the latter was greatly astonished to hear this unbecoming speech of her new-born infant, he said: "I do not mean you, my mother. My prophecy does not refer to you; I am speaking of Zion and Jerusalem. They deck out their

daughters, and clothe them in purple, and put golden crowns on their heads; but the robbers shall come and take these things away."[145]

Jeremiah is primarily concerned with the coming punishment to be meted out to the Jews by the Babylonians. This happened in 586 BCE.[146] In the same way as the gospels and the book of Daniel were composed, the book of Jeremiah was doubtless written after the events that it pretends to predict. However, a Jew in the latter half of the first century could easily be forgiven for interpreting the prophecy as being fulfilled *in their own day* as they saw the Romans threaten and then accomplish the destruction of Judea and Jerusalem. The insane prophet Jesus ben Ananus was one such first century Jew. The streets of the old city echoed with his cries;

> A voice from the east
> a voice from the west,
> a voice from the four winds,
> a voice against Jerusalem and the holy house,
> a voice against the bridegrooms and the brides, and
> a voice against this whole people![147]

As the prophet Jeremiah had foretold,

> I am going to bring upon you a nation from far away, O house of Israel, says the Lord. It is an enduring nation, it is an ancient nation, a nation whose language you do not know, nor can you understand what they say. (5:15)

As the table above shows, sayings of Jesus and acts of gospel characters

145 Accessed at http://jewishencyclopedia.com/articles/8586-jeremiah

146 Finkelstein & Mazar, 2007, p. 167.

147 Jesus ben Ananus, whipped by order of the procurator Albinus "till his bones were laid bare" and dismissed as a madman, preached the imminent destruction of Jerusalem and the Temple, for four years from 62 CE. His lamentation could be heard all over Jerusalem—a paraphrase of Jeremiah 16:9. *Wars of the Jews*, Book 6.5.3.

can be aligned with the words of the Old Testament prophet. This suggests that the theme of *divine punishment* was salient and current when Matthew was written.

In Josephus, we read that the besieged Jews saw "chariots and troops of soldiers in their armour . . . running about among the clouds."[148] Jeremiah says, "Look! He comes up like clouds, his chariots like the whirlwind; his horses are swifter than eagles—woe to us, for we are ruined!" (4:13) But the Romans did not use chariots in warfare—the collective vision was inspired by Jeremiah.

The Jewish War as Trauma

'A soul in trouble is near unto God', saith Peter somewhere— a marvellous utterance.

Gregory of Nazianzus, *ep.* 16. (4th century)

Considering the havoc caused by the War and the lead up to the War from pillaging, looting, assaults, murders, public executions, torture and famine, the War fits the bill as a source of severe and widespread trauma.[149]

A graphic description of trauma occasioned by siege warfare is provided by Josephus in his account of the Roman assault upon the town of Jotapata which took place in 67 CE. During this siege Josephus was himself the commander of the Jewish forces, so the account we have is that of an eyewitness.

And any one may learn the force of the engines by what happened this very night; for as one of those that stood round about Josephus was near the wall, his head was carried away by such a stone, and his skull was

148 *Wars of the Jews*, Book 6.5.3.

149 The New Testament and patristic writers steered their audiences away from viewing the temple's destruction as traumatic. See Reinhartz, in Becker, Dochhorn & Holt, 2014, p. 286.

Fig. 9: *Hilltop location of ancient Yodfat (Jotapata), showing excavated remains of fortifications. Vespasian gave orders that the city should be entirely demolished, and all the fortifications burnt down.* Gabriel Rif / Alamy Stock Photo

flung as far as three furlongs.[150] In the day time also, a woman with child had her belly so violently struck, as she was just come out of her house, that the infant was carried to the distance of half a furlong, so great was the force of that engine.

The noise of the instruments themselves was very terrible, the sound of the darts and stones that were thrown by them was so also; of the same sort was that noise the dead bodies made, when they were dashed against the wall; and indeed dreadful was the clamor which these things raised in the women within the city, which was echoed back at the same time by the cries of such as were slain; while the whole space of ground whereon they fought ran with blood, and the wall might have been ascended over by the bodies of the dead carcasses; the mountains also contributed to increase the noise by their echoes…[151]

And now the trumpeters of the several Roman legions sounded together, and the army made a terrible shout; and the darts, as by order, flew so fast, that they intercepted the light. However, Josephus's men remembered the charges he had given them, they stopped their ears at the sounds, and covered their bodies against the darts.[152]

150 A furlong is a Roman *stadium*—about 185m.

151 *Wars of the Jews*, Book 3.7.23.

152 *Wars of the Jews*, Book 3.7.27.

The Jewish War and mental disorder

We would expect in the aftermath of such a brutal and traumatic campaign a high incidence of mental disorder. In agreement with this conjecture we find that Jesus in the synoptic[153] gospels "cast out many demons." (Mark 1:34) Other conditions cured by Jesus such as blindness and deafness can also be traced to psychotrauma.

Birmes et al. (2010) states,

> According to the *Diagnostic and Statistical Manual of Mental Disorders…* acute stress disorder (ASD) and post-traumatic stress disorder (PTSD) are anxiety disorders that can develop following a trauma or a life-threatening event. Such stressful events may occur in particular during natural disasters or wars. As battles and wars were part of everyday life in ancient times, it is likely that psychotraumatology was not infrequent in antiquity.[154]

The Bible contains graphic descriptions of people psychologically afflicted by disaster from military defeat, or the ravages of natural calamities. The book of Deuteronomy says that these effects would be felt by the Jews as a consequence of national disobedience.

> [If you disobey,] the Lord will afflict you [Jews] with madness, blindness, and confusion of mind; you shall grope about at noon as blind people grope in darkness, but you shall be unable to find your way; and you shall be continually abused and robbed, without anyone to help. (28:28-29)

153 "synoptic" refers to the three gospels, Matthew, Luke and Mark which when placed together in parallel columns exhibit interesting similarities. The problem of explaining the similarities and differences is called "the Synoptic Problem."

154 Birmes et al., 2010, p. 21.

CHAPTER FIVE

Psychotrauma in the New Testament

The gospel of Mark appears to record at least two cases of psychotrauma.

▋ Psychotraumatic blindness—the blindman of Bethsaida
Mark reads as follows,

> They came to Bethsaida. Some people brought a blind man to him and begged him to touch him. He took the blind man by the hand and led him out of the village; and when he had put saliva on his eyes and laid his hands on him, he asked him, "Can you see anything?" And the man looked up and said, "*I can see people, but they look like trees, walking.*" Then Jesus laid his hands on his eyes again; and he looked intently and his sight was restored, and he saw everything clearly. (Mark 8:22-25)

In ancient times, the semi-divine Asclepius was the physician who heals and saves. He, like Jesus, was the product of a union between a god (Apollo) and a human mother (Coronis).[155] Aelian describes him as "the god most loving towards humanity."[156] A Greek inscription describing a healing by Asclepius, reads, "The blind man saw a dream. It seemed to him that the god came up to him and with his fingers opened his eyes, and that *he first saw the trees in the sanctuary.* At daybreak, he walked out sound."[157] [my emphasis]

Mott has described the phenomenon of psychotraumatic blindness and blurred vision in traumatised soldiers from World War 1.

> Shortly after shell shock the patient may complain of *blurred vision* or *as if everything were seen through smoked glass.* The blindness may come on after a period of "meditation," and persist, as in this case, for months...

155 Rice & Stambaugh, 1979, p. 52-3.
156 Cotter, 1999, p. 14.
157 Cotter, 1999, p. 18. Asclepius is killed by Zeus for the crime of raising the dead. We see a parallel in the life of Jesus in John 11, the raising of Lazarus.

Another case under my care was of interest. A shell burst near a man while he was attending to a wounded comrade. He managed to drag the wounded man into a culvert, but then found he was quite unable to see. Another wounded man came into the culvert and helped him to get out. The emotional shock was the primary cause of the blindness, but it did not come on till the darkness of the culvert suggested it.[158] [italics added]

A case of psychic traumatic blindness was also recorded by the Greek historian Herodotus (c. 484–425 BCE). He says that, during the battle of Marathon, an Athenian soldier was fighting bravely when "he suddenly lost the sight in both eyes, though nothing had touched him anywhere . . . in speaking about what happened to him he used to say that he thought he was opposed by a man of great stature in heavy armour, whose beard overshadowed his shield; but the phantom passed him by, and killed the man at his side."[159]

▮ Psychotraumatic paranoid delusion—the Gerasene demoniac

The demoniac from Gerasa shows symptoms consistent with complex PTSD.

In Mark we read,

> He lived among the tombs; and no one could restrain him anymore, even with a chain; for he had often been restrained with shackles and chains, but *the chains he wrenched apart, and the shackles he broke in pieces; and no one had the strength to subdue him. Night and day among the tombs and on the mountains he was always howling and bruising himself with stones.* When he saw Jesus from a distance, he ran and bowed down before him; and he shouted at the top of his voice, "What have you to do with me, Jesus, Son of the Most High God? I adjure you by God, do not torment me." For he had said to him, "Come out of the man, you unclean spirit!" (Mark 5:3-8)

158 Mott, 1919, p. 187.
159 Birmes et al., 2010, p. 26.

We can discern in the symptomatic description provided by Mark, possible avoidance of stimuli associated with the trauma (activities, places or people that arouse recollections of the trauma), feeling of detachment or estrangement from others, difficulty falling or staying asleep, hypervigilance, and exaggerated startle response.[160] Dyer et al from their studies conclude that high levels of physical aggression and self-harm emerged as characteristic sequelae of complex PTSD.[161]

Mott observed that in the cases he saw paranoia—systematised delusional insanity—was not infrequent, and was usually characterised by delusions of persecution and self-accusations, generally having some relation to war experiences, and often based upon hallucinations and illusions.[162]

When Jesus asks the demon what his name is, the demoniac replies using the Roman word for "legion" (Λεγιων in Greek). But there had been no legions in Palestine since the death of Caligula in 41 until the outbreak of the Jewish revolt in 66.[163] We know that under Tiberius "all was quiet."[164]

Fig. 10: *Wall painting from the house church at Dura-Europos, Christ healing the paralytic (c. 240 CE).* Filson, 1939, p. 108. Yale University Art Gallery

160 Birmes et al., 2010, pp. 24, 28.
161 Dyer et al., 2009, p. 14.
162 Mott, 1919, p. 214.
163 *Wars of the Jews*, Book 2.10.1.
164 Tacitus, *Histories*, Book 5.9.

▌ General psychotrauma
Cures conducted by Jesus

So [Jesus'] . . . fame spread throughout all Syria, and they brought to him all the sick, those who were afflicted with various diseases and pains, demoniacs, epileptics, and paralytics, and he cured them. (Matthew 4:24)

Cures conducted by World War I therapists

Mott declares,

A man was sent down from the clearing station on February 10th, 1916; he had been blown up and buried; *he was blind, deaf, and mute.* He was sent from the St. John Ambulance Hospital, France, to the 4th London, and admitted on February 29th. When I saw him he was lying in bed on his side, with his legs curled up. He took no notice of any sounds however loud, he did not speak, and he could not see. . .

The next day while suffering from the pain of an enema, which was relieving the bowels, he somewhat *suddenly regained his sight.* He looked around in a bewildered manner, then burst into tears. The next day he was able to write. His powers of recognition were good, but he had a

Fig. 11: *A still from the silent movie,* War Neuroses: Netley Hospital, 1917.

complete gap in his memory of the whole time he was in France.

Two days later he had a sort of hysterical fit and recovered his speech and hearing.

I suggested that his speech would come back to him on a certain day, and, although this did not happen yet he began to whisper the vowel sounds and whisper words of one syllable.[165] [italics added]

Cinematic records of the wide range of mental disabilities and cures conducted by World War 1 therapists can be found at the Wellcome Library website. Clinical features shown include a variety of ataxic and "hysterical" gaits; hysterical paralyses, contractures and anaesthesias, facial tics and spasms, loss of knee and ankle-jerk reflexes, paraplegia, "war hyperthyrodism", amnesia, word-blindness and word-deafness.[166] Cures were effected by physiotherapy and hypnotic suggestion. One cure took only two and a half hours.

The emperor Vespasian also effected cures of psychotraumatic conditions. Tacitus reports,

One of the common people of Alexandria, well known for his loss of sight, threw himself before Vespasian's knees, praying him with groans to cure his blindness, being so directed by the god Serapis, whom this most superstitious of nations worships before all others; and he besought the emperor to deign to moisten his cheeks and eyes with his spittle. Another, whose hand was useless, prompted by the same god, begged Caesar to step and trample on it.[167]

I submit that the reason these kinds of miracles are reported in the synoptic gospels is because the mental conditions and the seemingly miraculous curing of those conditions by Jesus followers and others[168] though not unknown at other times, were common when the first gospel was written; that is in the immediate post War period.

165 Mott, 1919, p. 185.

166 The Summary from *War Neuroses: Netley Hospital, 1917* accessed at http://wellcomelibrary.org/

167 Tacitus, *Histories*, Book 4.81.

168 John answered, "Master, we saw someone casting out demons in your name, and we tried to stop him, because he does not follow with us." Luke 9:49.

Naturally the fictional character of Jesus would have been imbued with the same powers as his followers possessed.[169]

The name "Jesus" was invoked by ancient Jewish exorcists, who were not associated with the Christians. An extract from a papyrus book from Egypt now in the Bibliothèque Nationale de France calls on Jesus together with other gods of the period.

> Standing opposite, adjure him [the man possessed]. The adjuration is this : "I adjure thee by the god of the Hebrews Jesu, Jaba, Jae, Abraoth, Aia, Thoth, Ele, Elo, Aeo, Eu, Jiibaech, Abarmas, Jabarau, Abelbel, Lona, Abra, Maroia, arm, thou that appearest in fire, thou that art in the midst of earth and snow and vapour, Tannetis. [170]

It is noteworthy that the Gospel of John records no such cures suggesting that the epidemic had passed by the time John was written.

169 "The signs of a true apostle were performed among you with utmost patience, signs and wonders and mighty works." 2 Corinthians 12:12

170 Deissmann, 1910, p.255.

CHAPTER SIX

Human Pattern Seeking Strategy

SHERMER ASSERTS THAT,

> The brain is a belief engine. From sensory data flowing in through the
> senses the brain naturally begins *to look for and find patterns*, and then
> infuses those patterns with meaning.[171] [italics added]

The ancients seemed to understand this principle, and the gospel has
Jesus say,

> For everyone who asks receives, and *everyone who searches finds*, and for
> everyone who knocks, the door will be opened. (Matthew 7:8)

Paraphrasing Jesus—those who look for a pattern will find one.

171 Shermer, 2012, p. 6.

Finding Jesus on toast

Face pareidolia is the illusory perception of non-existent faces. A decade-old toasted cheese sandwich said to bear an image of the Virgin Mary has sold on the eBay auction website for $28,000.[172] Liu *et al* studied the phenomenon of face pareidolia and concluded that "human face processing has a strong top-down component whereby sensory input with even the slightest suggestion of a face can result in the interpretation of a face."[173]

The perception of religious imagery in natural phenomena has also been observed in Islam.

> In the Muslim community, a frequently-reported religious perception is the image of the word "Allah" in Arabic on natural objects. Again, the discovery of such an object may attract considerable interest among believers who visit the object for the purpose of prayer or veneration. Examples of this phenomenon have been reported on fish, fruit and vegetables, plants and clouds, eggs, honeycombs, and on the markings on animals' coats.[174]

Fig. 12: *"Allah" in Arabic*

172 Accessed at http://news.bbc.co.uk/2/hi/4034787.stm

173 Liu et al., 2014, p. 1.

174 Accessed at https://en.wikipedia.org/wiki/Perceptions_of_religious_imagery_in_natural_phenomena

Magical thinking

The incidence of magical thinking increases with *increasing* danger and situational uncertainty.

The anthropologist Malinowski (1954) reported that Melanesian islanders did not engage in magical rituals when fishing in closed and safe lagoons, or when performing familiar tasks like boat building, but did engage in various magical rituals when sailing to the open sea and exposed to the dangers of sea and weather. Malinowski concluded that the incidence of magical thinking increases with increasing danger and uncertainty of the situation.[175]

The War provided a fertile environment for magical thinking. Josephus reports that the Jewish priests continued to go about their ministrations as the war raged around them.

> ... those darts that were thrown by the engines came with that force, that they went over all the buildings, and reached as far as the altar, and the temple itself, and fell upon the priests, and those that were about the sacred offices; insomuch that many persons who came thither with great zeal from the ends of the earth, to offer sacrifices at this celebrated place, which was esteemed holy by all mankind, fell down before their own sacrifices themselves, and sprinkled that altar which was venerable among all men, both Greeks and Barbarians, with their own blood.[176]

The priests' confidence in God was not diminished by the imminent danger. Magical thinking increased as they went about their duties. We see the same effect in the practice of Om Banna which serves the truck drivers on their hazardous highway and the leader of the Pomio Kivung had his vision while fishing alone in a flimsy canoe. Early Christians as members of a banned organisation regularly flirted with danger and some even provoked

175 Keinan, 1994, p. 49.
176 *Wars of the Jews*, Book 5.1.3.

the authorities in order to achieve a martyr's death.[177] It seems counter-intuitive to us, but more severe persecution actually bolstered the faith of the first believers, and goes part way to explaining the success of the new sect. Without the danger of persecution it is possible that Christianity would have gone the way of Mithraism, and quietly faded away.

Illusory pattern perception and lack of control

The combatants and victims of the War lacked control in the situation they found themselves in. We can surmise that this provided the right milieu for the perception of illusory patterns.

Whitson & Galinski conducted six experiments to test the thesis that lacking control motivates pattern perception. They found that, "Experiencing a loss of control led participants to desire more structure and to perceive illusory patterns. The need to be and feel in control is so strong that individuals will produce a pattern from [auditory or visual] noise to return the world to a predictable state."[178]

Josephus records that during the siege of Jerusalem, ". . . chariots and troops of soldiers in their armour were seen running about among the clouds."[179]

Worshipping in high places

Certain places have always been regarded as holy and containing special features which make communication with God more

177 When Arrius Antoninus was driving things hard in Asia, the whole Christians of the province, in one united band, presented themselves before his judgment-seat; on which, ordering a few to be led forth to execution, he said to the rest, "O miserable men, if you wish to die, you have precipices or halters." Tertullian, *To Scapula*, 5.

178 Whitson & Galinski, 2008, p. 117.

179 *Wars of the Jews*, Book 6.5.3.

effective. Mount Olympus was the home of the twelve Olympian gods, the Dodekatheon of the ancient Greek world. The original "high place" in Jerusalem was the piece of bedrock that is now housed under the Dome of the Rock, on the Temple Mount. The ancient Jews, we are told,

> … were sacrificing at the high places, … because no house had yet been built for the name of the Lord."(1 Kings 3:2)

We have Matthew setting the disciples' visions of the risen Lord specifically on a mountain.[180] Mountain mist is typically visual white noise, presenting an ideal environment for perceiving illusory patterns.

Paul says,

> Then he [Jesus] appeared to more than five hundred brothers and sisters at one time, most of whom are still alive, though some have died. (1 Corinthians 15:6)

Fig. 13: *Painting of Mount Tabor (Tobin, 1855)* British Library, *Shadows of the East*, p. 261
Paul Fearn/Alamy Stock Photo

180 "Now the eleven disciples went to Galilee, to the mountain to which Jesus had directed them." (Matthew 28:16)

This communal hallucination was most likely seen in the clouds, from a misty mountain top. Galilee—probably Mount Tabor—was the most likely stage for the collective vision. Jesus says, "After I am raised up, I will go ahead of you to Galilee." (Matthew 26:32) And Galilee hosted other Jewish miracle workers, such as *Hanina ben Dosa*.

The sensed presence

The sensed-presence effect experienced by climbers, explorers, and ultra-endurance athletes, was noted by T.S. Eliot in his poem *The Waste Land*. Eliot says in his commentary on this poem, that during one of the Antarctic expeditions it was related that "the party of explorers, at the extremity of their strength, had the constant delusion that there was one more member than could actually be counted."[181]

Indian truck drivers—devotees of Om Banna—report a comforting presence sitting with them in their cabs during the lonely night hours. Luke records an incident which ostensibly occurred on the road to a village called Emmaus. In this account two disciples are talking and discussing recent events, when a mysterious third man appears. They talk with this man. When they stop for a meal they suddenly recognize him as Jesus, and he disappears.[182] The story of the origin of the Pomio Kivung bears similar features—a lonely fisherman, a mysterious visitor who imparts wisdom and his sudden departure.

Suedfeld and Mocellin have noted that stress is neither sufficient nor necessary for a presence to occur.

> Contemporary Antarctic crew members do not evidence stress levels significantly higher than normal . . . Yet, people in this environment,

181 Sarker, 2008, p. 103.
182 Luke 24:13-35

coming from a variety of cultural backgrounds, have reported sensed presence phenomena.[183]

However, where the presence gives advice or comfort, it seems that stress is a factor, and that would have been supplied by the War and its aftermath. Suedfeld and Mocellin explain.

> In contemporary annals, the reliable antecedent conditions seem to involve the environmental variables of monotony, isolation, and ambient cold. Contributory factors include physical debilitation, sleeplessness, exhaustion, and the cognitive/affective variables of fear, perceived danger, and uncertainty. These and perhaps other factors, such as expectancy and cultural norms, bring about certain as yet unspecifiable physiological changes that in turn generate the sensed presence.[184]

In the gospel incident known as *the transfiguration*, three disciples climb a high mountain, and Jesus appears to them as a dazzlingly bright image. Two other figures appear whom the disciples recognize as Moses and the prophet Elijah. The mountain is covered in cloud and from this cloud they hear the voice of God. The voice commands them to listen to Jesus.[185] The *Gospel of Barnabas* identifies this mountain as Mount Tabor. (42.5)

The phenomenon of the sensed presence which imparts wisdom was recorded in ancient times. Dodds provides examples of Greek cults that were initiated by these experiences—gods speaking in waking visions—and draws attention to the role of the Greek terrain in facilitating the required psychological conditions. He says,

> I believe with Professor Latte that when Hesiod tells us how the Muses spoke to him on Helicon this is not allegory or poetic ornament, but

183 Suedfeld & Mocellin, 1987, p. 47.

184 Suedfeld & Mocellin, 1987, p. 49.

185 "This is my son, the beloved, with whom I am well pleased." Matthew 3: 17, 17: 5, 2 Peter 1:18, Hebrews 2:3.

an attempt to express a real experience in literary terms. Again, we may reasonably accept as historical Philippides' vision of Pan before Marathon, which resulted in the establishment of a cult of Pan at Athens; and perhaps also Pindar's vision of the Mother of the Gods in the form of a stone statue, which is likewise said to have occasioned the establishment of a cult, though the authority in this case is not contemporary. These three experiences have an interesting point in common: they all occurred in lonely mountainous places, Hesiod's on Helicon, Philippides' on the savage pass of Mount Parthenion, Pindar's during a thunderstorm in the mountains.[186]

The auditory verbal hallucination

Josephus describes a collective auditory hallucination, which occurred while Jerusalem was besieged. He relates that,

> Moreover, at that feast which we call Pentecost [May-June], as the priests were going by night into the inner [court of the temple,] as their custom was, to perform their sacred ministrations, they said that, in the first place, they felt a quaking, and heard a great noise, and after that they heard a sound as of a great multitude, saying, "Let us remove hence."[187]

The auditory verbal hallucination (AVH) has been studied by McCarthy-Jones, who states that one causative model is based on the idea that cognitive biases exist in voice-hearers for detecting certain personally salient words in the environment, resulting in them hearing these words in ambiguous noise.[188] The roar of the sea, the rush of the wind, or the hum of engine noise, have been identified

186 Dodds, 1951, p. 117.

187 *Wars of the Jews*, Book 6.5.3. This seems to have happened in the year 70. This sign resurfaces in the gospels as the great earthquake and renting of the temple curtain, symbolising the end of the old dispensation, which occurs at the death of Jesus. See Matthew 27:51.

188 McCarthy-Jones, 2012, p. 275.

as effective media.[189] Stress, bereavement, loneliness and isolation are associated factors.[190]

Imagining a saviour

The authoritative figure with magical powers

Experiments have confirmed that failure-induced threat affects "authoritarian behaviors such as impulsive closure [the imposition of meaning and pattern on ambiguous stimuli], rejection of dissimilar persons, and hostility toward members of experimentally created outgroups."[191]

Christianity like Judaism was successful in the creation of outgroups, such that the reputation of Christians was, as elucidated by Tacitus, that they had a general "hatred for humankind."[192] Luke has Jesus admit, "Whoever comes to me and does not *hate* father and mother, wife and children, brothers and sisters, yes, and even life itself, cannot be my disciple."(14:26)

Real life behaviour confirms this thesis. Sales studied membership of authoritarian and nonauthoritarian churches in the Great Depression years (1930–1939) and found that conversions to authoritarian churches substantially increased while conversions to nonauthoritarian churches considerably decreased.[193]

In the realm of popular literature, the same effect was observed. "Only 2 of 20 comic strips initiated during the 1920s (Buck Rogers and Tarzan) stressed the power of the main character. However, 12 of the 21 comic strips started in the 1930s emphasized the protagonist's power."[194] The creation of Superman in 1933 is particularly noteworthy, with clear resemblance to the mission and powers of Jesus.

189 McCarthy-Jones, 2012, p. 274.
190 McCarthy-Jones, 2012, p. 133.
191 Sales, 1973, p. 44.
192 *Annals*, 15.44.
193 Sales, 1973, p. 45.
194 Sales, 1973, p. 46.

After his arrest and before the Jewish council Jesus says, "Do you think that I cannot appeal to my Father, and he will at once send me more than twelve legions of angels?" (Matthew 26:53) In Luke the murderous crowd take him to the edge of a cliff but he "passed through the midst of them and went on his way." (4:30) Jesus is renowned for his deeds of power. (Matthew 13:54) The centurion in Capernaum says, "For I too am one who has men under him [under command], and I say to one 'Come' and he comes, and to another 'Go' and he goes, and to my servant 'Do this' and he does it." (Matthew 8:9, Powell's translation) The crowds were enthusiastically impressed by Jesus' authority, and welcomed it. (Matthew 9:8)

In times of stress, moral questions become important. Jesus teaches morals, going beyond some pre-existing rules such as "love your neighbour", and introduces mental sin. ("Everyone who looks at a woman with lust has already committed adultery"[195])

Sales observes a notable difference between pre-Depression and Depression tolerance of crime. President Hoover, when running for re-election in 1932, devoted an entire speech to a condemnation of crime and criminality. In 1928, when national crime rates were similar to those which obtained in 1932, the same candidate made relatively little mention of crime during his campaign.[196] Motion picture censorship led by the Catholic Legion of Decency, was more successful in the thirties.[197]

Morale boosting stories

The rumour that the saviour had appeared (1 Corinthians 15:5-7) was an *unconscious* device to boost morale in the straitened circumstances

195 Matthew 5:28. "Thus, thoughts themselves became suspect, were given a moral character, and had to be vigorously monitored. You were now morally responsible for what happened in your head. The binding of the inner world had begun." McCarthy-Jones, 2012, p. 24.

196 Sales, 1973, p. 49.

197 Sales, 1973, p. 50.

of the siege. The legend of the angels in the sky at Mons in World War I followed a similar pattern. It was invented by Arthur Machen, a Welsh novelist who was working as a journalist in 1915, with the aim of entertaining the public. But so hungry were his readership for hope at this dismal time that members of the public accepted his story as fact and some clergymen even delivered sermons on that basis.

Machen declares that,

> It seemed that my light fiction had been accepted by the congregation of this particular church as the solidest of facts; and it was then that it began to dawn on me that if I had failed in the art of letters, I had succeeded, unwittingly, in the art of deceit. This happened, I should think, some time in April, and the snowball of rumour that was then set rolling has been rolling ever since, growing bigger and bigger, till it is now swollen to a monstrous size.[198]

But the story did not retain its original form. As Machen relates "variants of my tale began to be told as authentic histories." Parallels can be seen with the stories about Jesus that soon circulated and which can now be read in the canonical and apocryphal gospels. The Islamic prophet Mohammed suffered the same fate.

> Of al-Bukhari—the most proficient and celebrated hadith hunter—it was said that he had collected 600,000 supposed sayings of the Prophet, and dismissed all but 7225. His collection of hadiths—along with those of five other great scholars—was, in effect, what constituted the Sunna.[199]

Whether true or not the stories of Machen were seen as useful. One woman signing herself 'A Daughter of the Church' wrote to the Anglican priest and skeptic Hensley Henson as follows:

198 Machen, 1915, p. 10.
199 Holland, 2014, p. 35.

If our dear lads who are giving their lives for England can visualize our Saviour and His angels come to help and comfort them in that hell of carnage . . . who shall be so cruel, CRUEL, as to tell them they are wrong? And they are NOT wrong, for where shall the aid and ministry of Heaven be found if not there? God works miracles of help and salvation even in our time.[200]

Signs of God's providence were seen in many unrelated events at that time. The day after the Armistice in 1918, Bishop Moule said in a thanksgiving address that since August 4, when at last the nation knelt down in prayer, they had not sustained a reverse.[201]

Rationalizing beliefs

Jewish society of the first century was the relevant population and the Jewish War was the context which facilitated the formation of certain beliefs. After the Jewish Christians had formed their beliefs they justified and rationalized them with intellectual arguments. Jesus was discovered in the holy texts, "partly in parables, partly in enigmas, partly expressly and in so many words."[202] "As it is written..." became the mantra of the new religion. Paul's letter to the Romans, for example, contains the phrase no less than 16 times.

This agrees with Shermer who says, "after forming our beliefs we then defend, justify, and rationalize them with a host of intellectual reasons, cogent arguments, and rational explanations. Beliefs come first, explanations for beliefs follow."[203]

200 Wilkinson, 2014, p. 194.
201 Wilkinson, 2014, p. 194.
202 Clement of Alexandria, *Stromata,* Book 6.15.
203 Shermer, 2012, p. 6-7.

CHAPTER SIX

The Persistence of False Beliefs

People rarely give up on their moral attachments and ideological commitments just because they're shown to be out of alignment with reality.[204]

A variety of evidence suggests that people tend to believe what they should not.[205]

Gilbert et al. have found that,

1. Repeated exposure to assertions for which there is no evidence increases the likelihood that people will believe those assertions.
2. Once such beliefs are formed, people have considerable difficulty undoing them.
3. Several studies have suggested that under some circumstances people will believe assertions that are explicitly labelled as false.[206]

As Shermer has noted the default position for humans is to assume that "all patterns are real; that is, assume that all rustles in the grass are dangerous predators and not the wind."[207] Once the religion of Christianity had gained a foothold, it was very difficult to stamp it out.

204 The Conceptual Penis as a Social Construct: A Sokal-Style Hoax on Gender Studies by Peter Boghossian, Ed.D. (aka Peter Boyle, Ed.D.) and James Lindsay, Ph.D. (aka, Jamie Lindsay, Ph.D.). Accessed at http://www.skeptic.com/reading_room/conceptual-penis-social-construct-sokal-style-hoax-on-gender-studies/
205 Gilbert et al., 1993, p. 222.
206 Gilbert et al., 1993, p. 222.
207 Shermer, 2012, p. 70.

CHAPTER SEVEN

The Spontaneous Belief

IF BELIEF IN JESUS AROSE SPONTANEOUSLY LIKE BELIEF IN OM BANNA, Jesus could also have been unknown to the world prior to his supposed death. The religion named after him could also have arisen as a consequence of his death, or even as we assert, the simple *belief* that he had died.

How the catastrophic event helped religious recruitment

Deviance from accepted religious norms is expected when social attachments break down. Dislocation and death disrupted the social attachments of thousands of Jews and other races who had been caught up in the conflict in Judea in the years 66 to 70.

In seeking to understand how the new religion emerged we do well to consider modern movements and the science of sociology. As Stark explains,

> Rather than asking why people deviate, why they break laws and norms, control theorists ask why anyone ever does conform. Their answer is

posed in terms of *stakes in conformity.* People conform when they believe they have more to lose by being detected in deviance than they stand to gain from the deviant act. Some people deviate while others conform because people differ in their stakes in conformity. That is, some people simply have far less to lose than do others. A major stake in conformity lies in *our attachments to other people.* Most of us conform in order to retain the good opinion of our friends and family. But some people lack attachments. Their rates of deviance are much higher than are those of people with an abundance of attachments.[208] [italics added]

A contest of opinions

When Joseph Smith introduced his new religion to the world in 1830 there was a Christian revival in motion in Western New York.[209] This was accompanied by discord among the believers, "so that all their good feelings one for another, if they ever had any, were entirely lost in a strife of words and a contest about opinions."[210] This theological warring was set against the backdrop of a recently concluded war with the United Kingdom and its allies. The city of Washington including the White House was burned by the British in 1814; the Battle of New Orleans was fought later that year, debates about slavery raged and there was conflict with native Americans. America suffered its first major peacetime financial crisis—the panic of 1819. These were disturbing times for Americans.

Given the prevailing social conditions around the time of the Jewish War, we can rightly surmise that this event would also have fuelled religious debate, strife, and experimentation. This agrees with what we know from Paul's letters and later Christian historians who

208 Stark, 1996, p. 17.

209 "Sometime in the second year after our removal to Manchester [c. 1820], there was in the place where we lived unusual excitement on the subject of religion." Church of Jesus Christ of Latter-day Saints., & Roberts, B. H., 1902, p. 2. See also the Second Great Awakening in Meyer, 2011, p. 143.

210 Church of Jesus Christ of Latter-day Saints., & Roberts, B. H., 1902, p. 3.

refer to numerous heresies that surfaced in the closing decades of the first century.[211] We can also posit the emergence of a religious awakening. This is consistent with Pliny the Younger who characterizes Christianity as being particularly successful, at least in Asia Minor.

> For it appears to be a matter highly deserving your [Trajan's] consideration, more especially as great numbers must be involved in the danger of these prosecutions, which have already extended, and are still likely to extend, to persons of all ranks and ages, and even of both sexes. In fact, this contagious superstition is not confined to the cities only, but has spread its infection among the neighbouring villages and country.[212]

In similar circumstances, there was an increase in unregulated religious debate and fervour during the English Civil Wars of the 1640s when the government lost control of public preaching and printing. Jenkins declares;

> The result was an upsurge of every kind of extreme and heretical belief. The crisis reached its blasphemous climax in 1656 when Quaker James Nayler staged a messianic entry into the city of Bristol with himself as Christ, mounted on a donkey, while faithful women followers strewed his path with branches and cried, "Hosanna to the son of David."[213]

Early Christian practices mimic the Roman Army

There is some evidence which suggests that primitive Christianity as a kind of cargo cult modelled its practices on those of the Roman Army. It is noted by Harrison that a conquered people respond to imperial power, either by strategies of resistance, accommodation, or mimicry[214]

211 See item 12, Part 2 of this book.
212 *Letters*, To the Emperor Trajan, XCVII.
213 Jenkins, 2000, Kindle Location 447-51.
214 Harrison, 2013, p.3.

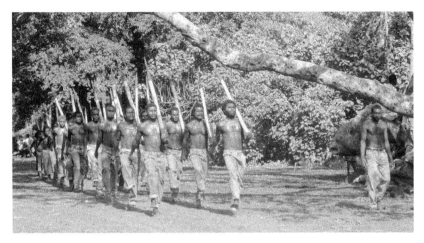

Fig. 14: *Tanna island, Sulphur Bay village, Vanuatu - Tannese army of the John Frum Cargo Cult movement parade - 15th Feb celebration.* incamerastock/Alamy Stock Photo

and this is an example of mimicry. We see the same phenomenon in the cult of John Frum on the island of Tanna in Vanuatu, where American troops came in large numbers during World War II.[215]

Of the early Christians, Pliny, who was a governor in Asia, says,

> They [the Christians he interrogated] affirmed the whole of their guilt, or their error, was, that they met on a stated day before it was light, and addressed a form of prayer to Christ, as to a divinity, binding themselves by a solemn oath, not for the purposes of any wicked design, but never to commit any fraud, theft, or adultery, never to falsify their word, nor deny a trust when they should be called upon to deliver it up; after which it was their custom to separate, and then reassemble, to eat in common a harmless meal.[216] [my emphasis]

From Pliny we see that a Christian practice in Asia in about the year 110 was to hold two meetings, on the same day. The first meeting before dawn was for the purpose of prayer. The warrant for this meeting can be found in the Wisdom of Solomon which was a

215 Accessed at https://www.topic.com/who-is-john-frum
216 Letter 96

very popular book in the early church—"one must rise before the sun to give you [God] thanks, and must pray to you at the dawning of the light". (16:28) The Christians according to Pliny also bound themselves by a solemn oath, which mirrors the Roman military custom of administering an oath to all newly enlisted men.[217] Luke may be alluding to this meeting when he has Jesus say, "Be dressed for action and have your lamps lit." (12:35)

The reassembly meeting mentioned by Pliny could have been at midday or in the evening later that day. It is not unreasonable to suppose that the purpose of this meeting was for fellowship and to discuss with their 'commanders' and fellow soldiers the outcome of the day's or week's spiritual battle. This may have been the meal which Paul refers to in 1 Corinthians 11 as the Lord's Supper, or it may have been something else.

The Romans would never have allowed any type of overt military mimicry, hence the Christians met in secret, and under cover of darkness. Their mimicry response was muted and spiritualised. We find evidence of this in the New Testament. Paul says to the believers in Asia,

> Put on the whole armour of God, . . so that you may be able to withstand on that evil day, and having done everything, to stand firm. Stand therefore, and fasten the belt of truth around your waist, and put on the breastplate of righteousness. As shoes for your feet put on whatever will make you ready to proclaim the gospel of peace. With all of these, take the shield of faith, with which you will be able to quench all the flaming arrows of the evil one. Take the helmet of salvation, and the sword of the Spirit, which is the word of God. (Ephesians 6:11-17)

217 'The roll having been completed in this manner, the tribunes belonging to the several legions muster their men; and selecting one of the whole body that they think most suitable for the purpose, they cause him to take an oath that he will obey his officers and do their orders to the best of his ability. And all the others come up and take the oath separately, merely affirming that they will do the same as the first man.' Polybius, *The Histories*, Book 6.21.

Early in the second century Ignatius, bishop of Antioch says,

> My heart warms to men who are obedient to their bishop and clergy
> and deacons, and I pray for *a place in heaven* at their side.

Here the three layers of military command of a legion, that is military tribune, centurion and decanus[218] are mirrored in the church hierarchy of bishop, clergy and deacons. It is also noteworthy that the famous Roman Cicero had said more than a century before that "a place in heaven" was reserved for all who died defending their native country.[219]

Ignatius continues, in a style more graphic than Paul,

> For everyone must work together in unison at this training of ours;
> comrades in its wrestling and racing, comrades in its aches and pains,
> comrades in its resting and in its rising, like God's good stewards and
> coadjutors and assistants. Make every effort to satisfy the Commander
> under whom you serve, and from whom you will draw your pay; and
> be sure that no deserter is found in your ranks. For a shield take your
> baptism, for a helmet your faith, for a spear your love, and for body-
> armour your patient endurance; and lay up a store of good works as a
> soldier deposits his savings, so that one day you may draw the credits
> that will be due to you.[220]

Pliny's response was to ban these secret meetings.

Early Mormons were also addicted to a military interpretation of the gospel, and Joseph Smith raised an actual army. Brodie relates that,

> Joseph [Smith] had always been fascinated by military lore which
> perhaps accounted for the innumerable battles in the Book of Mormon.

218 Decanus means "chief of ten" in Late Latin. The term originated in the Roman army and became used thereafter for subaltern officials in the Byzantine Empire, as well as for various positions in the Church, whence derives the English title "dean". Accessed at https://en.wikipedia.org/wiki/Decanus

219 *Dream of Scipio*, XIII.

220 The Epistle to Polycarp, 6 in *Early Christian Writings*.

He carried a rifle, an elegant brace of pistols, and the best sword in the army. . .Permeating the military atmosphere was the stern discipline of the gospel. Every night before retiring Joseph blew a blast upon a sacred ram's horn, and his men knelt in prayer for succor and guidance. [221]

Likewise, the Salvation Army, founded in 1865 by William Booth, adopted the military ethos in dress and organisational structure, including military ranks. They have also in a similar way to militant Islam renounced the rites of baptism and the Eucharist.

Symbols and Power

In the religion of Om Banna, the motorcycle and tree which occasioned the death of Om Banna are revered. In Christianity Jesus dies on the cross. Both the motorcycle-tree and the cross are associated with the death of the god, and both embody power. The Christian cross was chosen as a symbol of power because crucifixion was the Roman form of punishment for those who defied the state. In Om Banna the powerful—by Indian standards—English motorcycle suggests the days of the British Raj. In John's gospel Pilate is made to say, "I have power to release you, and power to crucify you." (John 19:10)

Paul links the cross to power in his first letter to the Corinthians.

For Christ did not send me to baptize but to proclaim the gospel, and not with eloquent wisdom, so that the cross of Christ might not be emptied of its power. (1:17)

Power underpinned everything. Paul says bluntly in the same letter,

For the kingdom of God depends not on talk but on power. (4:20)

On campaign when faced with military defeat the emperor

221 Brodie, 1963, p. 148ff.

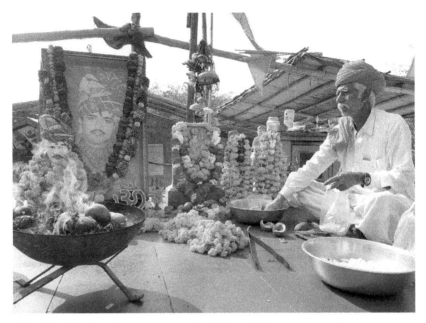

Fig. 15: *The Om Banna temple on the Jodhpur Highway.* A to Z/Alamy stock photo.

Constantine witnessed a vision of the cross. His subsequent victory, we are told led to his conversion to Christianity. The Christian god was powerful, and his power was displayed through the cross.

> And while he [Constantine] was thus praying with fervent entreaty, a most marvelous sign appeared to him from heaven. . . He said that about noon, when the day was already beginning to decline, he saw with his own eyes the trophy of a cross of light in the heavens, above the sun, and bearing the inscription, Conquer by this. At this sight he himself was struck with amazement, and his whole army also, which followed him on this expedition, and witnessed the miracle. [222]

Prisoners for God

Prison confinement under certain conditions can facilitate delusions. Paul wore his beatings and imprisonments as a badge of honour.

222 Eusebius, *Vita Constantini*, Book 1.28

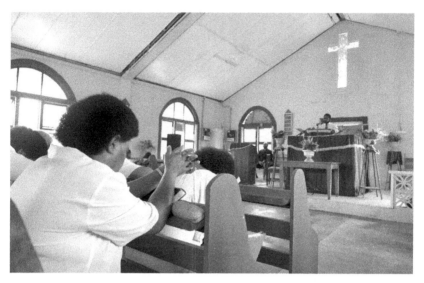

Fig 16: *Sunday service in Methodist Church in Fiji.* Rafael BenAri/Alamy Stock Photo

> Are they ministers of Christ? I am talking like a madman—I am a better one: with far greater labors, far more imprisonments, with countless floggings, and often near death. (2 Corinthians 11:23)

Paul's prison experiences (seven times according to Clement[223]) did not seem to deter him. This could have been because in a perverse way they served to facilitate his delusions. The following clinical case from the recent past points to this possibility.

> Imprisoned in the 1980s, Mr B. was able to withstand the interrogations by the Staatssicherheit [East German Secret Police] for a long time. The psychological breakdown appeared as a *delusional decompensation*, in which *he succeeded, by creating a 'double reality'*, to hide his delusion from others. During imprisonment he behaved adaptively and quietly; *secretly he imagined himself as chosen by God* to fulfil a secret mission in prison that made it necessary to talk to others on a nonverbal level, to communicate from soul to soul. Thus, he heard what he was told, but he was convinced that people wanted to tell him something completely different on the level of thoughts;

223 Letter to the Corinthians, 5.

he just had to try to interpret the signs in the right way to understand. The whole thing developed into a significant system of delusion.

Colours, numbers and letters got a two-fold meaning. Mr. B was extraordinarily proud to be the only person entrusted with this secret mission. Simultaneously, he completely retreated because he feared to be called a lunatic, if other people would notice his strange behaviour. His immense worry was that as a 'bearer of secrets' he would not be transferred to the West any more. This delusional system stayed after he was bought out by the Federal Republic of Germany.

His tragic dilemma caused by experiencing brute violence during imprisonment comes down to a paradox: to survive, 'I have to partly destroy myself'.[224]

Paul's authorship of the letter to the believers at Colossae has been questioned for several reasons, among them its out-of-character language and Christology.[225] However, the change in style and possibly thinking can be explained by observing that delusional ideation can be induced by confinement, where it is associated with psychological and physical abuse. Paul ends his letter,

> I, Paul, write this greeting with my own hand. Remember my chains. Grace be with you. (Colossians 4:18)

Paul's delusion manifest as a kind of psychological dualism akin to the experience of Mr. B. Elsewhere he says,

> I have been crucified with Christ; and it is no longer I who live, but it is Christ who lives in me. (Galatians 2:19–20)

The allure of imprisonment was not limited to the apostle. The pagan Lucian, writing about the year 165 remarks that,

224 Hölter, 2005, p. 531.
225 Duling et al., 1994, p. 105.

The poor fools have persuaded themselves above all that they are immortal and will live forever, from which it follows that they despise death and many of them willingly undergo imprisonment.[226]

Who was attracted to the new faith?

The final greetings that Paul writes in his letter to the Romans is instructive in showing how the movement spread. A proportion of those he greets appear to have been family members of Paul, or whole family groups.

Paul says,

> Greet Andronicus and Junia, my relatives who were in prison with me; they are prominent among the apostles, and they were in Christ before I was. . .Greet my relative Herodion. . . Greet those in the Lord who belong to the family of Narcissus. (Romans 16:7-11)

The sociologist Stark after studying various groups concludes that,

> The basis for successful conversionist movements is growth through social networks, through a *structure of direct and intimate interpersonal attachments.*[227] [italics added]

What social class did the early Christians belong to? Celsus says that

> they want and are able to convince only the foolish, dishonorable and stupid, and only slaves, women and little children... And while there are a few moderate, reasonable, and intelligent people who are inclined to interpret its beliefs allegorically, yet it thrives in its purer form among the ignorant.[228]

226 Lucian of Samosata, *The passing of Peregrinus.*
227 Stark, 1996, p. 20.
228 *On the True Doctrine.*

Stark disagrees and using the analogy of the Mormon religion notes that, "a consensus has developed among New Testament historians that Christianity was based in the middle and upper classes. . . Those who first accepted Joseph Smith's teachings were better educated than their neighbors and displayed considerable intellectualism."[229] Hutson states, "Research shows little correlation between people's levels of rationality or intelligence and their susceptibility to magical thinking."[230] An ancient argument for acceptance of the new stories was that similar implausible stories were already believed by both Jews and Greeks.[231]

> If those who dispute these things are Hebrews, the stories that are contained in their books and are believed are much more unbelievable than these—marching in the sea, water forming a wall, . . . If, on the other hand, those who do not accept this marvel are Greeks, I can cite many things which I do not wish to speak about—how many prophecies the oracle-mongers proclaimed for Alexander, . . .

Adoption of the ideas was based on the good feeling, the experience of "the grace of Christ" that the new religion offered. It was also advertised as "a medicinal remedy and a source of healing."[232] As already noted Paul's message with its relatively progressive theology particularly attracted the middle classes, the wealthy and the educated. Hence the words put into the mouth of Jesus, "Blessed are the poor *in spirit*..." (Matthew 5:3) and the disciples' surprise expressed by, "Then who can be saved? [if not the rich]" (Mark 10:23-27) As whole households were converted the religion would have filtered down to the slave and servant classes.[233]

229 Stark,1996, p. 37.

230 Hutson, 2013, p. 6.

231 Philip of Side, *Fragment* 5.2.

232 Philip of Side, *Fragment* 5.2.

233 "So he himself believed, along with his whole household." (John 4:53) The Book of Acts records many instances of household conversion.

As already noted whole families were baptised at the same time. Baptism would have been regarded as unremarkable because it was practised by Jews when inducting proselytes,[234] and ritual washing formed part of pagan worship.[235]

The distinction between Gentile and Jewish Christians should be noted. Luke, the Gentile Christian gospel writer, has rich women providing for the disciples out of their resources. (8:1-3) But the Jewish Christian, James, in his letter says rich people killed Jesus. (5:1-6)

The social disruption caused by the War would have left many Jews and others vulnerable to forming attachments to deviant groups. The rewards for enduring the unfairness and capriciousness of society were touted as "seeing God", "inheriting the earth", and possessing "the kingdom of heaven."[236] By joining the congregation of the saints[237], the believer was promised peace on earth in this life when the saviour came a second time (which was expected as imminent), or if not in this life, in the life to come after a physical reconstitution and resuscitation of his or her body—the resurrection of the dead. (See Mark 12, 1 Corinthians 15)

A Christian conspiracy theory

The gospel writers present the destruction of Jesus as a Jewish conspiracy, orchestrated by the Pharisees and finally by the chief priests and elders. In Matthew we read,

234 Neusner, 1990, p. 218.

235 Justin Martyr complains that demons had introduced the custom to pagans in anticipation of Christian practices. *First Apology*, 62. The Greeks performed ritual washing by bathing or sprinkling and removed their shoes before entering their shrines. Hence the seemingly incongruous mention of *carrying the sandals* of the Lord in Matthew 3:11. In later versions it becomes untie the thong of his sandals. (Luke 3:16 and Mark 1:7)

236 The beatitudes, Matthew 5:1-11

237 All Biblical believers are *saints* (sanctified or holy ones). Later the church introduced a superior class of believer and appropriated the word as a title.

But the Pharisees went out and conspired against him, how to destroy him. (12:14)

Then the chief priests and the elders of the people gathered in the palace of the high priest, who was called Caiaphas, and they conspired to arrest Jesus by stealth and kill him. (26:3-4)

The plots of the Jews to kill Paul is a recurrent theme in the book of Acts. These dangers were probably real. But when Justin Martyr accuses the Jews of deleting passages of scripture with the intention of hiding references to Jesus,[238] we are entering the territory of the conspiracy theorist. Barkun explains the difference between a conspiracy and a conspiracy theory.

Conspiracies are actual covert plots, planned and/or carried out by two or more persons. Conspiracy theories, on the other hand, are intellectual constructs. They are modes of thinking, templates imposed upon the world to give the appearance of order to events. In their simplest form, conspiracy theories sometimes seek only to explain a single event, for example, a plane crash or an assassination. However, many conspiracy theories are far more ambitious and seek to impose order on a wide range of phenomena that may encompass entire countries, whole regions, or decades of history.[239]

Barkun observes that, "Believers in one form of stigmatized knowledge are likely to also believe in or at least be sympathetic to other forms of stigmatized knowledge as well."[240] Early Christians were known to subscribe to the Nero Redivivus legend. (For more detail, see Chapter 12) They were also eager to assign reverses to the operation of cosmic conspiracies.

238 *Dialogue with Trypho*, 71-73.
239 Barkun, 2016, p. 1.
240 Barkun, 2016, p. 2.

And we do this so that we may not be outwitted by Satan; for we are not ignorant of his designs. (2 Corinthians 2:11)

For we wanted to come to you—certainly I, Paul, wanted to again and again—but Satan blocked our way. (1 Thessalonians 2:18)

We have already seen that Tacitus expressed an intolerance of Jewish customs, which was probably widespread, though not necessarily universal, throughout the Empire. This sentiment would have made it easier for early Christians to believe that the Jews were likely to have killed their Messiah. The consequences of this judgement have persisted through history. Berger notes that,

> Nevertheless, if ancient paganism had been replaced by a religion or ideology without an internal anti-Jewish dynamic, it is likely that the anti-Semitism of the classical world would have gradually faded. Instead, it was reinforced. The old, pedestrian causes of anti-Jewish animus were replaced by a new, powerful myth of extraordinary force and vitality.[241]

The Gospel forgeries—a reinterpretation of events

The reformulation of the story of the founding of Christianity as a series of events that had occurred decades before the Jewish War was both necessary for the survival of the religion and sociologically inevitable. The earliest Christians had a remembered past in which they were unaware that Jesus had lived and died under Tiberius. Logic demanded that he had died in the year 70, when the temple sacrifices ceased. How was the transition made to the new model?

The initial conception that Jesus had died in the year 70 could be described as a half-belief. Price remarks,

241 Berger, 1997, p. 5.

Let us begin with the most important case of all, religious half-belief. Here is a man who half-believes the basic propositions of Theism. . . What makes us say that he only half-believes them? The position seems to be that on some occasions he acts, feels and thinks (draws inferences) in much the same way as a person who does believe these Theistic propositions. But on other occasions he acts, feels and thinks in much the same way as a person who does not believe them, or even as a person would who had not heard of them at all.[242]

Another way to think about this problem is to consider conversion from one variety of Christianity to another. A Protestant considering Mormonism is not expected to give up his pre-existing beliefs about Jesus and the Old Testament prophets. The Book of Mormon does not claim to replace those beliefs but rather to enhance or complete them. The subtitle of the Mormon book is *Another Testament of Jesus Christ*. Islam makes the same claim.[243] The death of Jesus under Pilate who ruled Judea from about 26 to 36CE, became an essential element of the Christian statement of faith,[244] precisely because there was no evidence that this had occurred. And as Strabo the Greek philosopher/geographer noted in the first century, "It is ever the case that a person lies most successfully when he intermingles (into the falsehood) a sprinkling of truth."[245]

242 Price, 1969, Lecture 4.

243 'The unbelievers say, "We will not believe in this Koran, nor in the Books which preceded it."' Koran, Sura 34, 'Each one believeth in God, and His Angels, and His Books, and His Apostles: we make no distinction between any of His Apostles.' Koran, Sura 2:109

244 "...who was crucified under Pontius Pilate," Apostolic Tradition 21:15. For the mention of Pilate in Paul's first letter to Timothy at chapter 6:13 see the discussion in Appendix II. An early version of *The Apostles' Creed* is quoted in Appendix III.

245 *The Geography*, Vol 1.1.2.9

Accommodating the Change Psychologically

Berger and Luckmann in *The Social Construction of Reality* discuss individual accommodation to conversion, but it applies equally to the reinterpretation of the founding myth of Christianity. They state that *to forget completely is notoriously difficult*. They explain that,

> What is necessary, then, is a radical reinterpretation of the meaning of these past events or persons in one's biography. Since it is relatively easier *to invent things that never happened* than to forget those that actually did, the individual may fabricate and insert events wherever they are needed to harmonize the remembered with the reinterpreted past. Since it is the new reality rather than the old that now appears dominatingly plausible to him, he may be perfectly 'sincere' in such a procedure— subjectively, he is not telling lies about the past but bringing it in line with the truth that, necessarily, embraces both present and past. *This point, incidentally, is very important if one wishes to understand adequately the motives behind the historically recurrent falsifications and forgeries of religious documents.*[246] [italics added]

Saving the World

The synoptic gospels, Matthew, Luke and Mark and probably the Revelation were written before the gospel according to John. They looked forward to a supernatural political kingdom to right the wrongs of the present order.[247] When nothing transpired this hope was abandoned. The second coming was disconnected from its Jewish roots. The eternal church against the world became the embodiment

246 Berger & Luckmann, 1966, p. 180.

247 "The kingdom of the world has become the kingdom of our Lord and of his Messiah, and he will reign forever and ever." Revelation 11:15

of the kingdom.[248] We read, "My kingdom is not from this world" John 18:36. This same phenomenon has been observed in modern cults.

Stark concludes from his research,

> Having surveyed a large number of such [religious] movements, I noticed that it was typical for the founding generation to apparently lose hope of saving the world, and to turn their movements inward, as they neared the end of their lives. That is, unless something comes along to renew hope and commitment, as the first generation evaluate the results of thirty or forty years of conversion efforts and see that they have succeeded in attracting only two or three thousand members (if that many), they are inclined to lose heart. As this takes place, often a new rhetoric is voiced; this de-emphasizes the importance of growth and explains that the movement has succeeded in gathering a saving remnant, which is all that was ever intended, actually."[249]

248 "The Church, or, in other words, the kingdom of Christ now present in mystery, grows visibly through the power of God in the world." Vatican Council II, n.d., Lumen Gentium, 1.3.

249 Stark, 1996, p. 185.

CHAPTER EIGHT

Essenes, Jewish Christians and Ebionites

With reference to the New Testament and patristic literature, . . . Toland [in 1718] argued strongly for the view that in origin Christianity consisted of two parties, the Jewish Christian party or the Nazarenes/ Ebionites, characterised by their adherence to Jewish laws, and the Pauline party.[250]

T HE ACTS OF THE APOSTLES IS THE OFFICIAL STATEMENT OF church history commonly accepted by the orthodox.[251] Even though this book is a revision or imaginative reconstruction of the church's early history[252] it does point to some actual developments. Acts is probably correct when it says that persecution of (Jewish) Christians by Jews forced them to flee "as far as Phoenicia, Cyprus, and Antioch, and *they spoke the word to no one except Jews*." (11:19) [my emphasis]

250 Skarsaune & Hvalvik, 2007, p. 26 referring to *Nazarenus* (1718) by Tolland.
251 The Acts contains internal contradictions that should cause the reader to question its overall reliability. The most blatant contradictions concern accounts of the conversion of Saul/Paul.
252 Schoeps, 1969, p. 3.

After Paul's conversion and vision to take the message to non-Jews a new dynamic was created. Acts describes contact between Paul and the Jewish Christians at Jerusalem and Antioch.[253] But these accounts are at odds with Paul's accounts which we find in his letter to the Galatians. The Galatians accounts seem more plausible. The Galatians accounts are also in harmony with what we know about Jewish Christians from other sources.[254]

Paul honoured the Jewish Christians in Jerusalem as being the originators of the movement, and the first to suffer persecution at the hands of fellow Jews[255] but was adamant that their theology was deficient. He was content if they believed in Jesus and kept practising a form of Judaism, as long as they did not attempt to proselytise Gentiles. Paul's letter to the Galatians informs us about the theological battle lines. At the Jerusalem conference which is recorded in Galatians an agreement was reached to divide the missionary territory between Jews and non-Jews. (2:9)

The name Ebion

It was the habit of heresy hunters such as Hippolytus (c. 170–c. 235) to nominate a ring leader for each of the many heresies they identified. Hippolytus called "followers" of Ebion, *Ebionaeans*.[256] Another name for them was *Ebionites*.

Scholars agree that this sect did not originate with the teachings of a leader called Ebion. Rather they took their name from the Hebrew word for "poor."[257] It is likely that there was more than one group and their theology changed over time, and from place to place.[258] We can reasonably conclude that a group with these tendencies are the

253 Acts 15:1-35

254 The *Pseudo-Clementine Homilies* and *Recognitions* are one source. Epiphanius is another source.

255 1 Thessalonians 2:14

256 *Refutation of all heresies*, Book 7.22.

257 Cook, 2013, p. 17.

258 Cook, 2013, p. 16.

Jerusalem Christians that Paul opposes in Galatians. Epiphanius states plainly that, "Their origin came after the fall of Jerusalem."[259]

James the leader of the Jewish Christians

The apocryphal Gospel of Thomas nominates James as the head of the (Jewish) church.

> The disciples said to Jesus: "We know that you will depart from us. Who (then) will rule [lit., 'be great'] over us?" Jesus said to them: "No matter where you came from, you should go to James the Just, for whose sake heaven and earth came into being." (12)

It seems it was James who was the paramount leader of the Jewish Christians and one might say the first leader of the universal church.[260] If we accept the New Testament Epistle of James as genuine we are presented with an educated articulate Jew who could write excellent Greek.[261]

Several themes in the book make it most likely to be the work of a leader with Ebionite tendencies.
- It praises the Law (1:25)
- It disparages the rich. (5:1-6)
- It enjoins silence on initiates. (1:26-7, 3:6-7)
- It praises practical works of charity. (1:27)
- It describes Jesus as *the righteous one.* (5:6, Acts 7:52)[262]

In the *Mishnah*, we have from Rabbi Nehunya ben Hakanah (c. 100),

259 *Panarion*, Book 1.30.2.7.

260 Brandon, 1951, p. 52-3.

261 The passage James 1:5-8 appears to come from Philo of Alexandria, (Special Laws IV, 8.50) See also *The Apocalypse of Elijah.*

262 Schoeps, 1969, p. 61.

> One who accepts upon himself the yoke of Torah is exempted from the yoke of government duties and the yoke of worldly cares; but one who casts off the yoke of Torah is saddled with the yoke of government duties and the yoke of worldly cares.[263]

These ideas are echoed in the teaching of Jesus.

> Take my yoke upon you, and learn from me; for I am gentle and humble in heart, and you will find rest for your souls. For my yoke is easy, and my burden is light.[264]

Matthew, as we shall see later, was originally written by and especially for Jewish Christians.

The Essene connection

Cook suggests that "the Essenes were, at least in some respects, the spiritual ancestors of the Ebionites. It may be that the Essenes 'seeped into' the Ebionites after disappearing around 70 C.E."[265]

Josephus says that Essenes washed after touching foreigners.[266] We find various regulations forbidding contact with Gentiles in the Qumran scroll *Covenant of Damascus*.[267] Peter in the *Clementine Homilies* declares,

> We worship one God, who made the world which you see; and we keep His law, which has for its chief injunctions to worship Him alone, and to hallow His name, and to honour our parents, and to be chaste, and to live piously. In addition to this, we do not live with all indiscriminately;

263 Accessed at http://www.chabad.org/library/article_cdo/aid/2019/jewish/Chapter-Three.htm
264 Matthew 6:25–34 and 11:28–30.
265 Cook, 2013, p. 17.
266 *Wars of the Jews*, Book 2.8.10.
267 Dead Sea Scrolls CD 11, 14 and 12, 6-11.

JESUS OF THE BOOKS

nor do we take our food from the same table as Gentiles, inasmuch as we cannot eat along with them, because they live impurely. . ."[268]

The Essenes rejected oaths as a means of confirming the veracity of a statement.[269] Matthew has Jesus discourse on the same teaching.

Let your word be 'Yes, Yes' or 'No, No'; anything more than this comes from the evil one.[270]

It is noteworthy that the Essenes, a strict ascetic sect, and the group closest to primitive Christianity get no mention in the Gospels, while the other main Jewish sects, the Pharisees and Sadducees, as theological opponents of Jesus, do. It seems clear that the Qumran community were Essenes.[271] Essenes numbered about 4000 adherents[272] and were to be found in all the cities in Palestine.[273]

Essenes lived in Jerusalem

A gate for Essenes existed in the wall surrounding Jerusalem. Josephus declares,

"But if we go the other way westward [from the west cloister of the temple], it [the first wall] began at the same place, and extended through a place called 'Bethso' to the gate of the Essenes..."[274]

There are phrases in the Dead Sea Scrolls which show that the Essenes had a strong love for the ancient city. In one scroll the phrase

268 *Clementine Homilies* 13.4.3. Compare Galatians 2:11-12
269 Vermes et al, 1989, p. 5.
270 Matthew, 5:33–37; 23:16–22
271 Atkinson & Magness, 2010.
272 *Antiquities of the Jews*, Book 18.1.5.
273 "They have no one certain city, but many of them dwell in every city." *Wars of the Jews*, Book 2.8.4.
274 *Wars of the Jews*, Book 5.4.2.

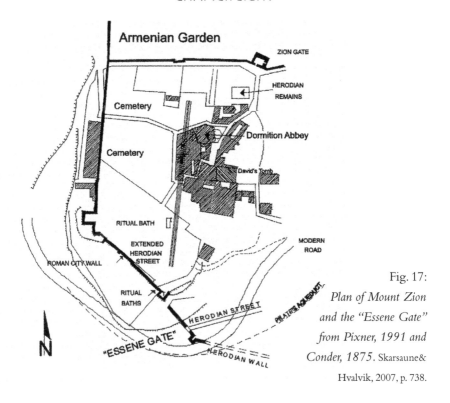

Fig. 17:
*Plan of Mount Zion
and the "Essene Gate"
from Pixner, 1991 and
Conder, 1875.* Skarsaune&
Hvalvik, 2007, p. 738.

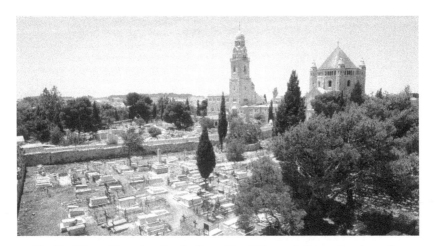

Fig. 18: *Mount Zion, showing the Dormition Abbey and Cemeteries, the ancient
Essene quarter in Jerusalem.* Matthias Wassermann/Alamy Stock Photo

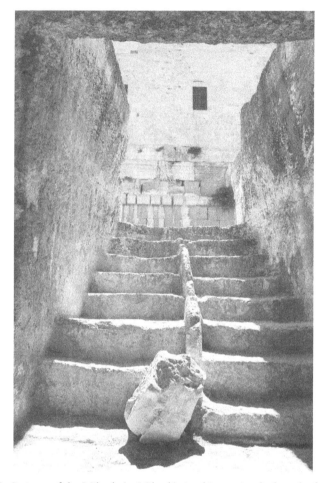

Fig. 19: *Staircase of the Mikveh (or Mikvah) ritual immersion bath at the foot of the western retaining wall of the Temple built by Herod the Great.* Hemis/Alamy Stock Photo

"the Congregation of Jerusalem" is used, implying that Essenes lived in the city.[275]

At least three ritual baths have been found on Mt. Zion.

Two of them are found beneath the tower just south of the extension of the Herodian street found beneath the Dormition Abbey. The other is today covered by a steel, roofed structure just west of that street in

275 Skarsaune& Hvalvik, 2007, p. 737.

the Greek Orthodox property south of the Dormition. The presence of these ritual baths, the first two of which resemble those found at Qumran, tends to confirm, in Pixner's view, that Mt. Zion was an Essene quarter in the Herodian Period.[276]

Doctrines of the Ebionites

What did the Ebionites believe? Irenaeus (c. 160) says,

> Those who are called Ebionites agree that the world was made by God; but their opinions with respect to the Lord are similar to those of Cerinthus and Carpocrates. *They use the Gospel according to Matthew only*, and repudiate the Apostle Paul, maintaining that he was an apostate from the law. As to the prophetical writings, they endeavour to expound them in a somewhat singular manner: they practise circumcision, persevere in the observance of those customs which are enjoined by the law, and are so Judaic in their style of life, that they even adore Jerusalem as if it were the house of God.[277] [my emphasis]

Jewish Christianity was forged in the Jewish War

Animal sacrifice at the Temple in Jerusalem was abolished by the Jewish War, the Temple itself was destroyed, and the priests were scattered or killed.[278] The Gospel of the Ebionites claimed that Jesus said, "I came to abolish the sacrifices, and if ye cease not from sacrifice, wrath will not cease from you."[279]

276 Skarsaune& Hvalvik, 2007, p. 739.

277 Irenaeus, *Works*, Book 1.26.2.

278 Titus ordered the priests to be executed, because "it was agreeable to their office that priests should perish with the house itself to which they belonged." *Wars of the Jews*, Book 6.6.1.

279 Epiphanius, *Panarion*, Book 1.30.16.5.

Making virtues out of necessity

Frequently an ideology is taken on by a group because of specific theoretical elements that are conducive to its interests.[280]

Religious doctrines could have been formulated or at least reinforced during the siege of Jerusalem—doctrines which were consonant with the straitened circumstances inside the city.

Doctrine	*Reason*
antipathy to the sacrificial cult	the temple was polluted
Ebionites are vegetarians[281]	no meat was available during the siege
pacifism	those armed were more likely to be slain[282]
religious silence	speaking out was dangerous[283]
ritual water use and baptism	there was a reliable water supply in Jerusalem due to underground springs[284]
charity	The famine in the city and survival instinct extinguished all human feeling[285]

280 Berger & Luckman, 1966, p. 141.

281 Epiphanius, *Panarion*, Book 1.30.15.4.

282 "And now, since his soldiers were already quite tired with killing men, and yet there appeared to be a vast multitude still remaining alive, Caesar gave orders that they should kill none but those that were in arms, and opposed them, but should take the rest alive." *Wars of the Jews* Book 6.9.2.

283 "Upon the whole, nobody durst speak their minds, but tyranny was generally tolerated; and at this time were those seeds sown which brought the city to destruction." *Wars of the Jews* Book 2.14.1.

284 "It [the temple] contained an inexhaustible spring; there were subterranean excavations in the hill, and tanks and cisterns for holding rain water." Tacitus, *Histories*, Book 5.

285 "Now of those that perished by famine in the city, the number was prodigious, and the miseries they underwent were unspeakable; for if so much as the shadow of any kind of food did anywhere appear, a war was commenced presently, and the dearest friends fell a fighting one with another about it, snatching from each other the most miserable supports of life." *Wars of the Jews* Book 6.3.3.

preaching against riches................the rich escaped Jerusalem,
the poor were slain[286]

Table 2: Doctrines reinforced by war time experiences

There is congruence between many of the doctrines of the Essenes and those of the Ebionites.[287] I think it is reasonable to conclude that the earlier sect influenced if not completely merged into the latter. Communal property was another doctrine they had in common, and this is also recorded in Acts as held by the earliest Christian believers. (2:44, 4:32)

As time went on the Ebionites, the strictest sect of the Jewish Christian movement, found themselves in a spiritual no man's land, rebuffed by the Jews[288] and eventually declared heretical by the Church. The last Jewish Christian bishop of Jerusalem died in 149.[289] Schoeps says,

> The Ebionites finally disappeared in the fifth century in eastern Syria. Many of their central doctrines, however, appear to have survived in the conglomeration of religions of that time and then, in the period of Monophysite quarrels, to have entered Arabia by means of the Nestorians.[290]

In the Ethiopic church circumcision on the eighth day after birth is still practised according to the Mosaic law and they read the Song of Songs on Holy Saturday morning, just as it occurs in the synagogue during Passover.[291]

286 "So the upshot was this, that the rich purchased their flight by money, while none but the poor were slain." *Wars of the Jews*, Book 4.6.3.

287 *Antiquities of the Jews*, Book 18.1.5.

288 The Jewish Christians, or Ebionites, are included among the *minim* (heretics), of whom it was once said that they were worse than idolaters, for the latter deny God without knowing him while the former know him yet nevertheless deny him (Rabbi Tarphon, about A.D. 100 according to Tosefta Tractate Shah. 13.5). Schoeps, 1969, p. 13.

289 See Appendix 1.

290 Schoeps, 1969, p. 136.

291 Puin & Ohlig, 2010, p. 58.

The paramount theological principle of the Essenes was an absolute belief in Fate in preference to human free-will.[292] The idea of submission to the will of God (the meaning of *Islam* in Arabic) came from the teachings of the Ebionites/Essenes.[293]

> And thus we have a paradox of world historical proportions, viz., the fact that Jewish Christianity indeed disappeared within the Christian church, but was reserved in Islam and thereby extended some of its basic ideas even to our own day. According to Islamic doctrine, the Ebionite combination of Moses and Jesus[294] found its fulfillment in Mohammed; the two elements, through the agency of Jewish Christianity, were, in Hegelian terms, "taken up" in Islam.[295]

Fig. 20: *The Islamic Dome of the Rock, on the Temple Mount in the old city of Jerusalem*. Photo: Andrew Shiva/Wikipedia Creative Commons License.

292 Vermes et al, 1989, p. 6.

293 James 4:13–17

294 See Chapter 14, *Jesus as the new Moses*.

295 Schoeps, 1969, p. 140. See also Epiphanius, *Panarion*, Book 1.30.18.6. "Christ alone, they would have it, is prophet, man, Son of God, and Christ—and as I said before he is a mere man who has come to be called Son of God owing to the virtue of his life."

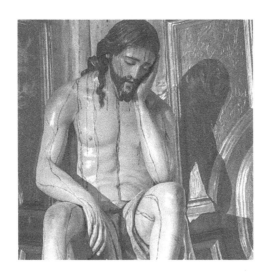

CHAPTER NINE

The Messiah King

BELIEF IN THE COMING OF THE MESSIAH KING IS FUNDAMENTAL in Judaism and indeed the present hope of orthodox Jews. In Maimonides' *Principles of Faith*, the twelfth principle is "I believe with perfect faith in the coming of the messiah (*mashiach*), and though he may tarry, still I await him every day."

Due to the costs sunk into the belief that a political Messiah *would appear* (a psychological product of the War and religious expectation), the minds of the first believers were channelled into accepting that Jesus *had appeared*. The lack of physical evidence in the confusion and chaos of the War was no hindrance to that belief. The War itself proved that *he had come*. This was the interpretation of a minority of traumatised Jews who expected their brothers to follow, and were genuinely surprised and disappointed when they didn't.

The mission of Jesus

The purpose of the (first) coming of Jesus[296] was simple. His mission was to die, rise and live again. This is the essence of Christianity.[297]

> For to this end Christ both died, and rose, and revived, that he might be Lord both of the dead and living. (Romans 14:8 KJV)

These actions were ALL THAT WAS REQUIRED to effect salvation for the believers.

Paul says,

> If you confess with your lips that Jesus is Lord and believe in your heart that God *raised him from the dead*, you will be saved. (Romans 10:9)

> Remember Jesus Christ, *raised from the dead*, a descendant of David— *that is my gospel.* (2 Timothy 2:8)[298]

The message of Paul and the other apostles was a revised version of what had been expected. The earliest Christians still believed that Jesus would come as a visible political king, to restore the kingdom to

296 *Jesus* is the Latin form of the Greek name Ιησους (*Iésous*), a rendition of the Hebrew Yeshua (עשׁוי), also having the variant *Joshua*. The name means YHWH (that is God) saves, is salvation etc. The angel instructs Joseph; "You are to name him Jesus, for he will save his people from their sins." Matthew 1:21

297 Duling et al., 1994, p. 507.

298 Many Biblical scholars hold the view that the letters of Paul to Timothy are pseudonymous writings written under Paul's name. (Duling et al., 1994, p. 485-6) One of the reasons cited for this conjecture is that they appear to refer to ecclesiastical concerns more likely to be present at the turn of the century or even later. However, these letters were regarded as genuine by Eusebius, *Ecclesiastical History*, Book 2.22. Other church fathers writing about 180 CE quoted them or earlier writers such as Ignatius alluded to them. (Gregory, 2005, p. 172) If we accept that Paul's ministry spanned about a decade from 75 CE, there is no good reason to reject Pauline authorship on that ground. Johnson states, "I interpret 1 and 2 Timothy from the perspective of Pauline authorship, which means, at the very least, that they were composed under his authority during his lifetime." (Johnson, 2001, p. xi).

Israel, as did all believing Jews. God had not changed his mind on that score. What had now been appended to that belief was the concept of the suffering, dying, rising Christ—the suffering servant of Isaiah 53, and Acts 8:26-39. The Jews' mistake was misunderstanding the first duty of the Messiah.

After the ascension of Jesus, Peter makes a speech to the recalcitrant Jews, which describes the shift from the basic Jewish hope to the Christian statement of faith—that the Messiah had come.

> And now, friends, I know that *you acted in ignorance*, as did also your rulers. In this way God fulfilled what he had foretold through all the prophets, *that his Messiah would suffer.* Repent therefore, and turn to God so that your sins may be wiped out, so that times of refreshing may come from the presence of the Lord, and *that he may send the Messiah appointed for you*, that is, Jesus, who must remain in heaven until the time of universal restoration that God announced long ago through his holy prophets. (Acts 3:17-21)

According to Justin Martyr,

> And this the Jews who possessed the books of the prophets did not understand, and therefore did not recognise Christ even when He came, but even hate us who say that He has come, and who prove that, as was predicted, He was crucified by them.[299]

The nondescript slave

The Jews could be forgiven for failing to recognize the Messiah as he came, according to Paul, in the form of a nondescript slave.

> Jesus Christ, . . . emptied himself, taking the form of a slave, being born in human likeness. (Philippians 2:6-7)

299 *First Apology*, 36.

The word rendered "form" is *morphé* (Greek: μορπη). This word, unlike our "form" in its popular meaning, connotes reality along with appearance.[300]

Paul does not mean semblance but manifestation. He, Jesus, became in reality and in appearance, a bondservant, or a slave.

This agrees with Isaiah 53:3.

> He was despised and rejected by others; a man of suffering and acquainted with infirmity; and as one from whom others hide their faces, he was despised, and we held him of no account.

Another ancient text declares,

> And the god of that world will stretch forth his hand against the Son, and they will crucify Him on a tree, and will slay Him *not knowing who He is.* And thus His descent, as you will see, *will be hidden even from the heavens, so that it will not be known who He is.*[301] [my emphasis]

A brief life of Paul (c.48–c.83)

Paul was born in Gischala, the last of the fortress-towns of Galilee which held out against Rome. When this town was taken in the year 67 or 68 he fled to Tarsus with his parents.[302]

From this scant information provided by Jerome we can reasonably surmise that Paul received his primary education in northern Galilee, and his secondary in Damascus which was a large city much closer to Gischala than Jerusalem. The study of rhetoric, much prized by the ancients, would have featured in his advanced education, which may have been completed in Tarsus. Ferguson points out that,

300 The Cambridge Bible for Schools and Colleges accessed at http://biblehub.com/commen-taries/cambridge/philippians/2.htm

301 *Ascension of Isaiah* 9:14-15

302 Discussed in more detail in Part 2.

Greco-Roman rhetorical education is evident in the methods of Jewish instruction. Memorization was quite important in both systems of education. Quite un-Roman was the Jewish requirement that every boy, rich or poor, scholar or unlearned, acquire a trade.[303]

Paul's trade, according to tradition, was tent making,[304] and he supported himself while preaching his gospel.[305]

The third-century rabbi Judah b. Terna summarized the stages of education in Pirke Aboth 5:21:

At five years of age [one is ready] for Scripture; at ten, for Mishnah; at thirteen for [keeping] the commandments; at fifteen for Talmud; at eighteen for marriage; at twenty for pursuing [a trade].[306]

Original Christianity was Jewish Christianity. These believers continued to hold to the basic tenets of Judaism; circumcision, the Sabbath and the food laws. They probably also continued to honour the Jewish festivals. (Galatians 4:10) These are the Christians that Paul encountered in his brief career as persecutor of the new faith. His initial change of heart naturally would have been to this version of Christianity.[307] In the same way as it was revealed to the 12th century prophet Moses Al-Dar'i, it was also divinely revealed to Paul and the other apostles that the Messiah had come.[308]

After his conversion experience which probably occurred in or near Damascus in the year 72, Paul would have been rejected by his fellow Rabbis. Indeed, he flees to Arabia. (Galatians 1:17) Damascus would not have been fertile ground for anyone trying to persuade Jews

303 Ferguson, 1993, p. 103.

304 Acts 18:3.

305 1 Thessalonians 2:9.

306 Ferguson, 1993, p. 102.

307 "... there are several common factors leading to religious conversion—a specific unconscious conflict, a conscious conflict with which the individual is actively struggling, adolescence, and a fundamentalist religious belief." Allison, 1967, p. 61.

308 See the Afterword for the story of Moses Al-Dar'i.

JESUS OF THE BOOKS

that Jesus, the suffering servant was the Messiah.[309] After the massacre of Jews in that city in 66 we can assume that those who had survived the massacre or had recently returned to the city would be wary of any new sectarians. They would also have had philosophical reasons for rejecting his message. Philo of Alexandria explains the problem Jews would have had with the concept of a semi-divine Messiah.

> What, again, shall we say of the demi-gods? This is a matter which is perfectly ridiculous: for how can the same man be both mortal and immortal, even if we leave out of the question the fact that the origin of the birth of all these beings is liable to reproach, as being full of youthful intemperance, which its authors endeavour with great profanity to impute to blessed and divine natures, as if they, being madly in love with mortal women, had connected themselves with them; while we know gods to be free from all participation in and from all influence of passion, and completely happy.[310]

Neither Paul nor anyone else seems to have had any success in preaching Christianity in Damascus as we find no other references to the city or its church (Jewish or Gentile) in other writings of Paul or the early church fathers.

In Damascus there were many Gentile women who were attracted to the Jewish religion. Did this influence him or was his theological shift the result of frustration, careful study of the scriptures or a combination of all or some of these factors? We cannot be sure.[311] After Arabia he returned to Damascus before visiting James and Cephas[312] in Jerusalem.

309 The account in Acts 9 is pure fiction.

310 *De vita contemplativa*, 1.6.

311 Paul says, "For I want you to know, brothers, that the gospel that was proclaimed by me is not of human origin; for I did not receive it from a human source, nor was I taught it, but I received it through a revelation of Jesus Christ." Galatians 1:11-12

312 According to ancient sources Cephas was not Peter. (*Ecclesiastical History* 1.12.2) The use of both names (Peter and Cephas) in Galatians 2:7-9 seems to confirm this. John 1:40-42 attempts to conflate the two individuals by having Jesus name Peter as Cephas. Cults centred on different apostles arose in Paul's day. (1 Corinthians 1:12)

On his way to and from Jerusalem Paul would have passed through Galilee, and seen the destruction caused by the war. If he visited his home town, now in ruins, he may have attempted to preach there and been rejected. This could be what Mark is alluding to in words put into the mouth of Jesus, "Prophets are not without honor, except in their hometown, and among their own kin, and in their own house." (Mark 6:4)

Berger and Lukmann explain this rejection phenomenon as the rejection by significant others of the new role assigned to them by the "converted" individual.

> Persons, too, particularly *significant others*, are reinterpreted in this fashion. The latter now become unwilling actors in a drama whose meaning is necessarily opaque to them; and, not surprisingly, they typically reject such an assignment. This is the reason prophets typically fare badly in their home towns, and it is in this context that one may understand Jesus's statement that his followers must leave behind them their fathers and mothers.[313] [italics added]

One ancient source declares that Paul had a wife,[314] and if we accept that he wrote what is erroneously named the *First Epistle of Peter,* a son called Mark.[315]

Rather than Paul modelling his life on that of Jesus, ("Be imitators of me, as I am of Christ."[316]); it seems the life of Jesus was modelled on the life of Paul. Paul says that God "was pleased to reveal his Son *in me*" and "I carry the marks of Jesus branded on my body."[317] The "thorn in the flesh" he talks about in one of his

313 Berger & Luckmann, 1966, p. 180.

314 "And Pierius too, in his first discourse of those On the Pascha, asserts strongly that Paul had a wife and dedicated her to God for the sake of the Church, renouncing his association with her." (Philip of Side *Fragment* 4.5)

315 Barth, 1974, p.23. 1 Peter 5:13

316 1 Corinthians 11:1

317 Galatians 1:16, 6:17

letters was probably his poor eyesight.[318] He also used a secretary who may also have helped him compose his letters following the practice of Cicero.[319]

After visiting James and Cephas in Jerusalem for 15 days, Paul set off on his missionary endeavours to the Gentile lands of Syria and Cilicia—now southern Turkey. (Galatians 1:21) He abandoned his Jewish name *Saul* for the Gentile name Paul [320], and became the designated prophet to the nations, at least in his own estimation. The Old Testament prophet Jeremiah wrote,

> Before I formed you in the womb I knew you, and before you were born I consecrated you; I appointed you a prophet to the nations. (1:5)

Paul says,

> God . . . set me apart before I was born and called me through his grace, [and] was pleased to reveal his Son to [in] me, so that I might proclaim him among the Gentiles. (Galatians 1:15-16)

As self-proclaimed prophet to the *ethnoi* which is Greek for the nations or the Gentiles, Paul saw his mission as participating in a divine drama, as herald of the end of the age, by preaching and gathering in the full number of believers.[321] A supernatural kingdom ruled by Jesus and his followers was the hope and conviction of Paul. The choice was stark—death as a son of Adam or life as a spiritual brother of Jesus.

> For since death came through a human being, the resurrection of the dead has also come through a human being; for as all die in Adam, so all will be

318 2 Corinthians 12:7. "For I testify that, had it been possible, you would have torn out your eyes and given them to me." Galatians 4:15. "See what large letters I make when I am writing in my own hand!" (6:11)

319 "I Tertius, the writer of this letter, greet you in the Lord." Romans 16:22. Cicero made copious use of his freedman/secretary Tiro, who also helped in his compositions. Letter 4, To Tiro (at Patrae) Leucas, 7 November.

320 Jerome, *De Viris Illustribus*, 5.

321 Romans 11:25

Fig. 21: *Temple of Jupiter, Damascus*. Photograph courtesy of UNESCO.

made alive in Christ. But each in his own order: Christ the first fruits, then at his coming those who belong to Christ. Then comes the end, when he hands over the kingdom to God the Father, after he has destroyed every ruler and every authority and power. (1 Corinthians 15:21-24)

Paul never saw the kingdom he craved and worked for. Clement of Rome in a letter which can be dated about the year 97 says he eventually reached "the extreme limit of the west" which by Roman standards was Cadiz in Spain.[322] There according to the bishop he died a martyr "under the prefects." This agrees with his stated plan to visit Spain in his letter to the Romans.[323] Another tradition which may have more to do with church politics than history has Paul (and Peter) executed in Rome.

322 *The letter to the Corinthians*, 5. Similarly, "Moreover, the acts of all the apostles were written in one book (Acts). For 'most excellent Theophilus' Luke compiled the individual events that took place in his presence—as he plainly shows by omitting the martyrdom of Peter as well as the departure of Paul from the city (of Rome) when he journeyed to Spain." *The Muratorian Canon* 34-39

323 Romans 15:22-29. There were churches in Spain by the middle of the second century. Irenaeus, *Works*, Book 1.10.2.

One thousand years later the Jewish sage Maimonides expresses his interpretation of the person and his work as follows:

> After him [Jesus] arose the Madman[324] who emulated his precursor since he paved the way for him. But he added the further objective of procuring rule and submission, and he invented his well-known religion.[325]

Paul and the War

Paul seems to be on the side of Josephus; that is, he adopts the position of the ruling classes. He encourages obedience to Roman rule. (Romans 13:1-7) This agrees with his Herodian connections[326]. However rather than blaming the War on foolish innovations, banditry and zealotry as Josephus did, he fell in with the Christian explanation. (1 Thessalonians 2: 14-16) The War was an example of God's wrath visited upon the Jews for their treatment of Jesus.

What was Paul's involvement in the War? Jerome says he fled his hometown of Gischala before Jerusalem was taken, taking his parents with him.[327]

Hillel and Shammai

The division between Gentile and Jewish Christianity can be traced to the division in Judaism between the rival schools of Hillel and Shammai. Both scholars lived in the first century BCE, and early first century CE. Moore observes that, "More than three hundred

324 "A genuine first-hand religious experience like this is bound to be a heterodoxy to its witnesses, the prophet appearing as a mere lonely madman." James, 2015, p.226

325 Epistle to Yemen

326 Romans 16:11

327 *De Viris Illustribus,* 5

conflicting deliverances of the two schools on matters of law and observance are reported in one connection or another in the Talmud."[328] Paul claimed to be educated as a Pharisee.[329] But what kind of Pharisee? It seems that he followed the school of Hillel,[330] who preached tolerance and kindness. Hillel is known for the aphorism "What is hateful to you, do not do to your fellow: this is the whole Torah; the rest is the explanation; go and learn."[331]

Moore suggests that in the middle decades of the first century the Shammaites were more numerous, as well as more aggressive, and it was perhaps after the fall of Jerusalem that the Hillelites gained the ascendency.[332] This would agree with what we know about Christianity. The more tolerant Gentile version of Christianity absorbed (and tolerated) the stricter Jewish version. The adherents of Jewish Christianity that refused to be absorbed were made heretics, and called Ebionites.

328 Moore, 1970, p. 81.

329 Philippians 3:5

330 Hillel from Babylon is sometimes quoted in Aramaic. (Bivin & Blizzard, 2002, Kindle 1096) Paul uses Aramaic in 1 Corinthians 16:22—Maran atha—lit. Lord come.

331 In Jesus' sermon on the mount this saying becomes, "In everything do to others as you would have them do to you; for this is the law and the prophets." Matthew 7:12

332 Moore, 1970, p. 81.

CHAPTER TEN

What is faith?

WE SAW IN THE PREVIOUS CHAPTER THAT THE ESSENCE OF Christianity is faith in the suffering, dying, rising Messiah.[333] We cannot emphasis enough that ONLY THIS IS REQUIRED IN ORDER TO BE SAVED.

God can only work where there is faith, that is *belief without evidence.* (Hebrews 11) Reversing the logic, *God cannot work* where there is evidence.

Celsus says,

> Their [the Christians'] favourite expressions are 'Do not ask questions, just believe!' and: 'Your faith will save you!' 'The wisdom of this world,' they say, 'is evil; to be simple is to be good.'[334]

333 Old English *Crīst*, from Latin *Chrīstus*, from Greek *khristos* anointed one (from *khriein* – to anoint), translating Hebrew *mashīah* – Messiah.

334 *On the true doctrine*

Paul's bare Messiah

We note that Paul's Messiah,

- had no miraculous birth (and none is recorded in Mark)
- had no childhood (none is recorded in Matthew or Mark)
- had no family [335]
- had no earthly career after the resurrection (as in the shorter ending of Mark)
- performed no miracles [336]
- delivered no teaching [337]
- had no *disciples* [338]

Dykstra declares,

> We have no evidence at all that anything about Jesus' life and sayings was written down during his lifetime or even shortly thereafter. The earliest writings we have that mention Jesus are the New Testament epistles attributed to Paul, but the Apostle records almost nothing of the Lord's life and sayings. [339]

The Epistle to the Hebrews describes the Son of God as analogous to Melchizedek who is "without father, without mother, without genealogy, having neither beginning of days nor end of life." (Hebrews 7:3)

Maimonides, the renowned Jewish sage, says,

> Similarly, Isaiah referring to the arrival of the Messiah implies that

335 See Appendix 2 for explanation of "the Lord's brothers."

336 For Jews demand signs and Greeks desire wisdom, but we proclaim Christ crucified, *a stumbling block to Jews* [because there were no signs] and foolishness to Gentiles. [italics added] 1 Corinthians 1:22-23

337 Jesus teaching was revealed by the Spirit. 1 Corinthians 2:9-10

338 "Why are your robes red, and your garments like theirs who tread the wine press?" "I have trodden the wine press *alone*, and from the peoples no one was with me; ..." Isaiah 63:2-3

339 Dykstra, 2012, p.41

neither his father nor mother, nor his kith nor kin will be known, "For he will shoot up right forth as a sapling, and as a root out of the dry ground." (53:2)[340]

The secret Messiah

In the gospels, we read that Jesus demanded secrecy *until he had risen from the dead.*

And he ordered him to *tell no one.* (Luke 5:14)

Her parents were astounded; but he ordered them to *tell no one* what had happened. (Luke 8:56)

As they were coming down the mountain, Jesus ordered them, "*Tell no one* about the vision until after the Son of Man has been raised from the dead." (Matthew 17:9)

In Ignatius (probably early 2nd century), in his *Letter to the Ephesians,* we read

The virginity of Miriam [Mary] and her childbearing, and *also* the death of the Lord, were hidden from the Chief of the Age—three resounding mysteries wrought in the silence of God. (19)

Likewise, the pagan Celsus remarks on the *unnoticed* Jesus.

The Christians are fond of saying that Jesus wanted to be unnoticed, and point to places in their sacred books where Jesus enjoins silence on the demons and those he has healed.[341]

340 *Epistle to Yemen,* xvii.
341 *On the True Doctrine*

If we accept that Jesus rose from the dead *theologically* in 70 CE at the same time as the temple sacrifices ceased, then the preaching about Jesus would also have started at that time. Before this time Jesus must have been *unnoticed*. Direct evidence leading to the conclusion that this is what happened is presented in Part 2 of this book.

The lack of sustainable preaching success *before the resurrection* is explained in the gospels as the product of a fickle Jewry bewitched by their leaders and recalcitrant sects like the Pharisees. Despite having great crowds follow him, they all abandon him in the end. This is fictional. Other miracle working sages such as Hanina ben Dosa were revered by the Jews.[342] That the plot against Jesus is fiction is exemplified by the words of the Jewish mob, "We have no king but Caesar" (John 19:15). Religious Jews would never have uttered these words. Even apostate Jews who harboured a modicum of national pride would have found this sentiment distasteful.

The deliberately hidden message

The message was, according to the gospel of Matthew, *deliberately hidden from outsiders*.

> Then the disciples came and asked him, "Why do you speak to them in parables[343]?" He answered, "To you it has been given to know the secrets [OR mysteries] of the kingdom of heaven, but to them it has not been given. (13:10-11)

The apocryphal Jewish Book of Enoch which was very popular in the early centuries of Christianity, declares,

342 Agus, 2014, p. 89ff.

343 Parables were not limited to Jewish sages. The 2nd century Greek rhetorician Lucian of Samosata records a parable used as a form of philosophical teaching by the Cynics. Lucian, 1905, p. 175-6.

Then shall the kings, the princes, and all who possess the earth, glorify him who has dominion over all things, *him who was concealed*; for *from the beginning the Son of man existed in secret,* whom the Most High preserved in the presence of his power, and revealed to the elect. (Enoch 61:10) [my emphasis]

The Essenes took an oath to communicate their doctrines advisedly, to "no one any otherwise than as he received them himself" and to "preserve the books belonging to their sect, and the names of the angels."[344]

Paul's mystery Gospel

Paul says,

"Pray also for me, so that when I speak, *a message may be given to me* to make known with boldness *the mystery of the gospel…*" (Ephesians 6:19)

… surely you have already heard of the commission of God's grace that was given me for you, and how *the mystery was made known to me by revelation.* (Ephesians 3:2-3)

Yet among the mature we do speak wisdom, though it is not a wisdom of this age or of the rulers of this age, who are doomed to perish. But we speak God's wisdom, *secret and hidden,* which God decreed before the ages for our glory. *None of the rulers of this age understood this;* for if they had, they would not have crucified the Lord of glory. (1 Corinthians 2:6-8)

The lack of witnesses as evidence for Jesus was rationalized as being part of the divine plan to *hide the message* and the Messiah from outsiders and reveal it only to the elect few. This was doctrine formed by expediency.[345]

344 *Wars of the Jews*, Book 2.8.7.

345 Berger & Lukmann, 1966, p. 141.

—if you are a true **saveman** *then you must hide yourself*

Andrew Lattas relates that for the Kivung cult in New Guinea,

> Cultivated silences and intricate allusions to myths, proverbs and
> recognized allegories [the message hidden in parables, for Jesus] are
> evidence not just of individual intelligence but of the hidden influence of
> the dead...A truly knowledgeable person hides not just other meanings
> and realities with cryptic references, but also him or herself. [for Jesus,
> referring to himself as "the son of Man"] Thus Kivung politicians often
> cultivate a persona of humbleness, which for Francis meant maintaining
> a thatched-roof rather than a modern iron-roof house in his home
> village of Gugulena...Francis explained: 'if you are a true *saveman* then
> you must hide yourself.'[346]

The Messiah came but no one noticed

As Jesus was the secret, hidden Messiah there were *no eyewitnesses*.
Paul waits three years after his conversion to visit the Jerusalem
Christians because he knew they could add nothing to his
ministry.[347] Paul knew that they, like him, knew nothing of the
teachings of Jesus from first-hand experience; they *had not been
eyewitnesses*.[348]

346 Trompf, Cusack & Hartney, 2010, p. 108-9.

347 Galatians 1:15-17, 2:6 And from those who were supposed to be acknowledged leaders
 (what they actually were makes no difference to me; God shows no partiality)—those leaders
 contributed nothing to me.

348 The letter of Jesus to King Abgar says "Blessed art thou who hast believed in me without
 having seen me. For it is written concerning me, that they who have seen me will not believe
 in me, and that they who have not seen me will believe and be saved..." *Ecclesiastical History*,
 Book 1.13.

Where was the evidence?

All the evidence, as Justin Martyr states, was *in the writings*.

> *In these books*, then, of the prophets *we found Jesus our Christ* foretold
> as coming, born of a virgin, growing up to man's estate, and healing
> every disease and every sickness, and raising the dead, and being hated,
> and unrecognised, and crucified, and dying, and rising again, and
> ascending into heaven, and being, and being called, the Son of God.[349]
> [my emphasis]

The modern equivalent of an unwitnessed death and resurrection

Festinger and co-workers witnessed in 1954 a modern version of
the events that shaped Christianity. They studied a small apocalyptic
cult, the Seekers, which predicted that the end of the world would
occur on December 21, 1954. Their leader Dorothy Martin "claimed
to have received messages from 'the Guardians,' a group of superior
beings from another planet."[350]

When the divine visitor, the spaceman, failed to appear, the belief
arose spontaneously that another miracle had occurred; *only this
miracle was missed*. The dramatic aspect of the prophecy, the visitation,
got the believers' full attention and it could be explained that they
inadvertently missed a miracle that had occurred right under their
noses, due to *inattention*.

> The next two hours were consumed by what amounted to a diversion.
> As the Creator [a woman called Kitty] droned on, occasionally asking
> to have something "verified in writing" by Mrs. Keech, He gradually
> developed the point that the group had been gathered this night to

349 *First Apology*, 31.

350 Wikipedia, accessed at https://en.wikipedia.org/wiki/Leon_Festinger

witness a miracle, namely, *the death and resurrection of Marian's husband*. The appearance of such a curious matter on the agenda is perhaps best understood as *a reaction to the failure of the expected midnight visitor to appear*. If the attention of the group could focus on *so* spectacular a matter as the promised miracle, they could forget, at least temporarily, the terrible disappointment they had suffered. The Creator had once before predicted the demise of the nonbelieving Mr. Keech and perhaps the idea came quickly to mind. But this time, for a real miracle, his death was to be followed by a resurrection.

The elaborate exposition of the nature of miracles which accompanied the Creator's attempt to perform this one may have succeeded in making the believers forget temporarily the saucer, the cataclysm, and the midnight failure. Mr. Keech had retired to his bed before nine o'clock and the miracle required first finding him dead and then returned to life. Three times that early morning Thomas Armstrong and one of the observers were sent to Mr. Keech's room to see if he had died yet. Three times they returned, reporting that he was still alive and breathing normally. The miracle did not seem to be forthcoming, and finally the Creator, floundering for a solution, announced that *the miracle had already occurred—Mr. Keech had died earlier that evening but had been resurrected and was once again alive*. This solution was *so* inadequate, however, that even the authority of the Creator could not gain acceptance for it. It was quickly buried in silence.[351] [italics added]

The invisible saviour

Jehovah's Witnesses predicted the return of Jesus in 1914. When this failed, Russell's followers "reinterpreted the scheme to mean that Christ would have begun a period of 'invisible rule' in 1914 and that this would soon end."[352] It seems that psychological accommodation

351 Festinger at al., 1956, p. 164.
352 Court, 2008, p. 127.

of failed prophecies is a feature of human thinking as re-socialization or secondary socialization.

> "In re-socialization the past is reinterpreted to conform to the present reality, with the tendency to retroject into the past various elements that were subjectively unavailable at the time. In secondary socialization the present is interpreted so as to stand in a continuous relationship with the past, with the tendency to minimize such transformations as have actually taken place."[353]

A Jewish tradition states that the Messiah was born in the year 70 and lives in Rome *incognito* or *invisibly* until that city is a ruin.[354]

The first Christ was hidden, secret, and unrecognized. He came, was killed, was resurrected and taken back to the heavens. No human witnesses could vouch for these things.[355] But believing this would save you. This was the religion of the first Christians.

Paul explains to the Christians at Philippi,

> Let the same mind be in you that was in Christ Jesus, who, though he was in the form of God, did not regard equality with God as something to be exploited, but emptied himself, taking the form of a slave, being born in human likeness. And being found in human form, he humbled himself and became obedient to the point of death—even death on a cross. Therefore God also highly exalted him and gave him the name that is above every name, so that at the name of Jesus every knee should bend, in heaven and on earth and under the earth, and every tongue should confess that Jesus Christ is Lord, to the glory of God the Father. (Philippians 2:5-11)

353 Berger &Luckmann, 1966, p. 182

354 Maccoby, 2006, p. 117.

355 The angels did witness these events. See the discussion of the Lord's supper in Chapter 11.

The legacy of the origins of Christianity in Catholic doctrine

The Catholic Church believes in a *deposit of faith* and in the *development of doctrine*.

The *deposit of faith* is what Christ handed onto the apostles who in turn handed it onto successors by the laying on of hands. The *development of doctrine* is the belief that the Holy Spirit, over time, will help the Church more greatly appreciate the contents of the *deposit of faith*.[356]

The Church recognizes that doctrine can evolve when something is discovered that had formally been unrecognized. The formulation of the doctrine of the Trinity (a term foreign to Christians until Tertullian c. 200) illustrates this point. Seeing Christ in the Scriptures was the primary *recognition—the source of the religion.*

356 Landry, 2000, p. 2.

CHAPTER ELEVEN

The Death of Jesus as Atonement

THE DAY OF ATONEMENT (YOM KIPPUR IN HEBREW) WAS AN important festival in the life of the Jewish people. Without the Temple and the priests, it was impossible to perform this festival. Hieke points out that,

> The tragic loss of the all-important cultic center—Jerusalem's Second Temple—was and remains particularly heartfelt on Yom Kippur. This loss bereaved Jews . . . of the one and only cultic institution that could cleanse the people of their impurities, and thereby guarantee God's ever so needed succor amidst a perpetually hostile environment.[357]

The record of the founding of this festival is recorded in the Old Testament Book of Leviticus. The festival was held every year in late September early October, the Jewish month of Tishrei, which was also the seventh month of the ecclesiastical year. [Note that the Temple was captured and destroyed on the 9th of Av, the fifth month of the the ecclesiastical year, July or August in the Western calendar, in the year 70. Hence the last official atonement ritual was performed in the year 69.]

357 Hieke, 2011, p. 225.

The purpose of the statute

We read in Leviticus,

> For on this day atonement shall be made for you [Jews], to cleanse you; from all your sins you shall be clean before the Lord. It is a sabbath of complete rest to you, and you shall deny yourselves [or *shall fast*]; it is a statute forever. (16:30-31)

The basic rite

Two goats were chosen. One was sacrificed, and the other set free. The Levitical instruction regarding the *scapegoat* was as follows.

> Then Aaron [the high priest and brother of Moses] shall lay both his hands on the head of the live goat, and confess over it all the iniquities of the people of Israel, and all their transgressions, all their sins, putting them on the head of the goat, and sending it away into the wilderness by means of someone designated for the task. The goat shall bear on itself all their iniquities to a barren region; and the goat shall be set free in the wilderness. (16:21-22)[358]

Exemplars from the time of the Maccabean revolt

Written in Greek by an unknown author, the book of 4 Maccabees could have been composed at the end of the first century or even later.[359] It presents as exemplars of national sacrifice the Maccabean martyrs of the second century BCE who resisted Hellenization and

358 Many Greek cities had collective purification rites—which scholars term *"pharmakos* rites"— showing some parallels to the biblical scapegoat rite. Usually, the rite includes the expulsion (sometimes even the killing) of a marginal member of society, ideally a king or a virgin, in reality more likely a beggar or a stranger. Stokl, 2003, p. 171.

359 Stokl, 2003, p. 201.

refused to abandon their religion. It could have been written around 65 CE when some three thousand innocent inhabitants of Jerusalem were viciously massacred by soldiers under the command of Roman procurator Gessius Florus as punishment for an imagined slight—not being greeted appropriately as he rode into the city.[360]

Martyrs are rewarded with eternal life. (17:17)[361] They also die as a *ransom* for the collective[362]. The writer of 4 Maccabees describes the effect of the actions of Jewish martyrs as follows;

> These, then, who have been consecrated for the sake of God, are honored, not only with this honor, but also by the fact that because of them our enemies did not rule over our nation, the tyrant was punished, and the homeland purified—they having become, as it were, a ransom for the sin of our nation. And through the blood of those devout ones and their death as an atoning sacrifice, divine Providence preserved Israel that previously had been mistreated. (17:20–22)

We can imagine that the affair of the recent martyrs in 65 CE would have directed the Jews in Jerusalem to fully expect the tyrant (the Romans) to be overcome and punished, and the nation saved. This theme is exploited in the gospels. The high priest Caiaphas is reported to have said, "You do not understand that it is better for you to have one man die for the people [as an atonement] than to have the whole nation destroyed." (John 11:50)

360 Josephus also reports, "And what made this calamity the heavier was this new method of Roman barbarity; for Florus ventured then to do what no one had done before, that is, to have men of the equestrian order whipped and nailed to the cross before his tribunal; who, although they were by birth Jews, yet were they of Roman dignity notwithstanding." (*Wars of the Jews*, Book 2.14.6)

361 Paul says "to those who by patiently doing good seek for glory and honor and immortality, he will give eternal life." (Romans 2:7)

362 "For there is one God; there is also one mediator between God and humankind, Christ Jesus, himself human, who gave himself a ransom for all." (1 Timothy 2:5-6)

The Atonement in early Christianity

The key references to the Day of Atonement in the New Testament, are the following texts.

> Therefore he [Jesus] had to become like his brothers in every respect, so that he might be a merciful and faithful high priest in the service of God, to make a sacrifice of atonement for the sins of the people. (Hebrews 2:17)

And Paul says,

> For there is no distinction, since all have sinned and fall short of the glory of God; they are now justified by his grace as a gift, through the redemption that is in Christ Jesus, whom *God put forward as a sacrifice of atonement* [Or a place of atonement] by his blood, effective through faith. (Romans 3:22–25)

The Day of Atonement was also known as *the fast*.[363] Jesus gives instructions to his followers on how to fast on this day. (Matthew 6:16-18)[364] Stokl believes first century Christians observed Yom Kippur.[365]

There are good reasons to suppose that in the initial conception of Jesus, he died on the Day of Atonement. There are many parallels between the events described in the gospels and the ancient ritual performed by the Jews.

These parallels are listed by Barnabas.

363 "Since much time had been lost and sailing was now dangerous, because even the Fast had already gone by, Paul advised them…" (Acts 27:9) The Fast referred to would have been Yom Kippur which was held in Autumn. Sailing was dangerous in Winter.

364 Especially as Matthew was written for Jewish Christians.

365 Stokl, 2003, p. 214.

Table 3: The Epistle of Barnabas, Jesus and the Scapegoat

Cultic prototype	"Whosoever does not keep the fast shall die the death," (Epistle of Barnabas 7:3)
Christian Myth	Death of Jesus
Cultic prototype	Let all the priests alone eat the entrails unwashed with vinegar (7:4)
Christian Myth	Jesus drinks vinegar (Matthew 27:48)
Cultic prototype	The scapegoat is taken outside the city (Leviticus 16:21-22)
Christian Myth	Jesus was taken outside the city (Hebrews 13:12)
Cultic prototype	Abusing the scapegoat, pricking and spitting (Barnabas 7:8)
Christian Myth	Jesus is abused (Matthew 26:67)
Cultic prototype	Scarlet wool placed on the head of the goat (7:8)[366]
Christian Myth	Jesus decked in a scarlet robe (Matthew 27:28)
Cultic prototype	The goat placed on a thorny bush (7:8, 11)
Christian Myth	A crown of thorns placed on Jesus' head (Matthew 27:29)
Cultic prototype	The scapegoat pushed over a precipice (Mishna Yoma 6:6) "compelled to fall into inaccessible and wicked gulfs." [367]

366 The scarlet wool placed on the head of the goat signifies red hair. Plutarch tells us that Typhon, the Satan in Isis theology, had red hair, and for this reason devotees of Isis abused men who were red headed. They also broke the neck of an ass down a precipice because Typhon had an ass's complexion. (*Isis and Osiris*, 30)

367 Philo, *De Plantatione*, 6.1.

Christian Myth Jesus is thrown down from the pinnacle of the Temple in the story of James the Just. Also, the symbolic death of Jesus recorded in Luke 4:9. "They got up, drove him [Jesus] out of the town, and led him to the brow of the hill on which their town was built, so that they might hurl him off the cliff."[368]

The two goats, Jesus and Barabbas

Table 4: Jesus, Barabbas and the goats

Element	Cultic prototype	Christian Myth
The lottery of the two goats	Take two goats (Barnabas 7:6)	Whom do you want me to release for you (Matthew 27:17)[369]
The similarity of these goats	goodly and alike (7:6)	Jesus Barabbas and Jesus Christ (27:16)
Their contrasting destinations	the first goat is for the altar, but the other is accursed (7:9)	Barabbas is released, Jesus is crucified

368 Aesop suffered this fate. "Upon which the Delphians, laying their heads together, accused him [Aesop] of sacrilege, and then threw him down headlong from a steep and prodigious precipice, which is there, called Hyampia." (Plutarch, *On the delays of divine vengeance, 12*)

369 The so-called 'custom' of releasing a prisoner. "There is no evidence supporting this assertion. Also, it would be highly improbable under Pilate, who was well known to be rigorous against the religious authorities and would not have retreated in the face of local powers." (Stokl, 2003, p. 167)

Element	Cultic prototype	Christian Myth
The confession over the scapegoat	[Aaron] confesses over it all the iniquities of the people of Israel (Leviticus 16:21)	"His blood be on us and on our children!" (27:25)
The washing of the hands at the end of the ritual	He shall bathe his body in water in a holy place (16:23)	he [Pilate] took some water and washed his hands before the crowd (27:24)

The triumphal entry into Jerusalem

It follows that if Jesus died (outside the city walls) on the day of atonement he would enter Jerusalem in triumph five days later at the feast of Kradephoria[370]. And this is reported in the gospels.

> A very large crowd spread their cloaks on the road, and others cut branches from the trees and spread them on the road. The crowds that went ahead of him and that followed were shouting, 'Hosanna to the Son of David! Blessed is the one who comes in the name of the Lord! Hosanna in the highest heaven!' (Matthew 21:8-9)[371]

The Old Testament justification for this feast is found in Leviticus 23.

> On the first day you shall take the fruit of majestic trees, branches of palm trees, boughs of leafy trees, and willows of the brook; and you shall

370 Within a few days after they celebrate another feast, not darkly but openly, dedicated to Bacchus, for they have a feast amongst them called Kradephoria, from carrying palm-trees. (Kradephoria, κλαδοσ kladí branch) Plutarch, *Symposiacs* QUESTION VI. What God is Worshipped by the Jews.

371 In modern church law, this is celebrated as Palm Sunday.

rejoice before the Lord your God for seven days. (39-41)

The triumphal entry of the Messiah into Jerusalem to save the Jews from the Romans was the pious hope, a crucial element of the divine script to be played out as envisioned by the Old Testament prophets[372]. Unfortunately, it never happened. But the gospels report the scene anyway, and insert it anachronistically at a point just before Jesus' arrest. But it makes no sense theologically or psychologically.[373]

The origin of the Lord's Supper

The Christian rite of the Lord's Supper or Eucharist[374] is referred to as "the breaking of bread" in the book of Acts and it seems initially to have been performed on an ad hoc basis, before the custom was established to meet on the first day of the week. [375]

The tradition is described in Paul's letter to the wayward Corinthians who had allowed the occasion to become an opportunity for self-indulgence. Paul's argument is based on a proper understanding of the rite and his authority as the recipient of a specific revelation regarding its origin. Reading the passage carefully raises some interesting questions.

We note firstly that Paul's instruction comes directly from Jesus—

372 Malachi 3:1-2

373 Why would the crowd praise Jesus one minute and bay for his blood the next?

374 The Greek noun eucharistia (ευχαριστια), meaning "thanksgiving", is not used in the New Testament as a name for the rite.

375 "But Sunday is the day on which we all hold our common assembly, because it is the first day on which God, having wrought a change in the darkness and matter, made the world; and Jesus Christ our Saviour on the same day rose from the dead." Justin Martyr *First Apology* LXVII (Weekly Worship of the Christians) addressed to Emperor Antoninus Pius (138–161 CE)

not Peter nor any of the Christians who preceded him. [376] Secondly, Paul does not specify who Jesus' companions at the supper were or how many or where the supper took place. Thirdly, Jesus is *handed over* and not as tradition would have it, *betrayed*. Fitzgerald observes,

'Outside of the Gospels there are arguably no cases in the New Testament where the verb *paradidomi* means "betrayed." In every instance, it always means some form of "hand over" or deliver (in a hostile, neutral, or even positive sense)[377]

Rather than Judas, it is God the father who hands over his son to be sacrificed for the sins of the world, as the Prophet Isaiah had predicted. Paul never mentions a human betrayer.

[the] LORD delivered him up for our sins. (Isaiah 53:6 Septuagint)[378]

The Greek word paredōken (παρεδωκεν) for *deliver up* or *hand over*, is also used in Romans 8:32 where Paul says, "He [God] who did not withhold his own Son, but *gave him up* for all of us, will he not with him also give us everything else?"

The following is the full text of the passage from Paul's letter to the Corinthians.

For I [Paul] *received from the Lord* what I also handed on to you, that the Lord Jesus on the night when he was betrayed [handed over] took a loaf of bread, and when he had given thanks, he broke it and said, "This is my body that is [broken] for you. Do this in remembrance of me." In the same way he took the cup also, after supper, saying, "This cup is the new covenant in my blood[379]. Do this, as often as you drink it, in

376 "S. Paul's accounts of the Lord's Supper (1 Cor xi 23 ff) and of the Resurrection (1 Cor xv 3 ff) do not appear to have any literary connexion with what we read in our Gospels." Burkitt, 1906, p. 262.
377 Fitzgerald, 2010, Kindle Locations 1931-7
378 Κυριος παρεδωκεν αυτον ταις αμαρτιαις ημων
379 [Red] Wine is made from the blood of grapes, Deuteronomy 32:14

remembrance of me." (1 Corinthians 11:23-25)

Where is this happening and who are the companions of the Lord? It is only later interpreters who have superimposed an upper room meeting of twelve human disciples onto these verses. It is my contention that this passage signifies a memorial feast in the presence of angels. We note that angels appeared and waited on Jesus on another important occasion, the day he overcame the temptations of the devil. (Matthew 4:11; see Fig. 2: The Baptism of Jesus). Paul says,

> He [Jesus] was revealed in flesh,
>
> vindicated in spirit,
>
> seen by angels,
>
> proclaimed among Gentiles,
>
> believed in throughout the world,
>
> taken up in glory. [380]

Jesus in Hades

The "upper room" of the Last Supper (Luke 22:12) is analogous to the upper world of earthly affairs. Upon his death, we are told that Jesus visited the lower world and preached to the spirits in prison. (1 Peter 3:18-20)[381] Jews and others who had not had the opportunity of hearing the gospel in times gone by.

Heracles, the son of Zeus was the Greek equivalent.[382] Heracles

380 1 Timothy 3:16

381 For a long discussion on this subject, see Clement of Alexandria, *Stromata*, Book 6.6.

382 "Take Heracles, the best man that ever lived, a divine man, and rightly reckoned a God; was it wrong-headedness that made him go about in nothing but a lion's skin, insensible to all the needs you feel? No, he was not wrong-headed, who righted other people's wrongs; he was not poor, who was lord of land and sea. Wherever he went, he was master; he never met his superior or his equal as long as he lived. Do you suppose he could not get sheets and shoes, and therefore went as he did? absurd! he had self-control and fortitude; he wanted power, and not luxury." Lucian of Samosata (Lucian, 1905, p.178)

is both a phantom in the underworld who strikes fear in the dead, and simultaneously "among the immortal gods" taking "his joy in the feast...[383]" The paradox of being in two places at one time was parodied by Lucian in *Dialogues of the Dead*, Book XVI. For Christians Jesus goes to Hades *before* ascending to take his place among the immortal gods.

A refrigerium?

The passage in Corinthians does not specify when the death of Jesus occurs. Does Jesus pre-empt his death with a meal or is this meal a *refrigerium*[384]—the meal or banquet at the tomb arranged by the relatives of the dead at which the deceased was supposed to be present as host[385]. The pagan practice was continued by Christians to celebrate the lives and deaths of martyrs. Quasten asserts that the annual commemoration of the martyr was nothing but the customary and common anniversary of the dead, except that there was more solemnity[386]. Jesus as the first martyr would naturally play host at his own refrigerium.

Rather than the "last supper," the rite instituted by Paul is probably better described as the "first supper." Paul was simply drawing on an ancient custom and imbuing it with new meaning. Quasten notes,

> It was certainly a masterpiece of accommodation on the part of the early Church that, retaining the commemoration of the departed, she substituted the funeral mass for the pagan rite. Her missionary method illustrates the principle of preserving folk customs and explains the

383 Homer, 1919, Book 11. 601.

384 Refrigerium became synonymous with comfort and happiness, is used in the liturgy of the church and people continue to pray for spiritual rafraîchissement of the dead. Cumont, 1911, p. 61.

385 Quasten, 1940. p. 257.

386 Quasten, 1940. p. 256.

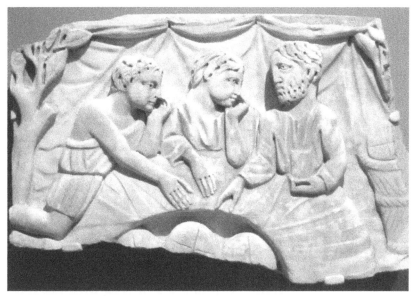

Fig. 22: *Marble relief showing a refrigerium (annual commemorative meal for the dead) from the vicinity of Ankara, Turkey, 3rd Century CE.* Honolulu Museum of Art

toleration of a very popular feature of the ancient cult, the *Refrigerium* or funeral repast.[387]

Cumont observes,

> The *refrigerii sedes*, which the Catholic Church petitions for the deceased in the anniversary masses, appears in the oldest Latin liturgies, and the Greeks, who do not believe in purgatory, have always expressed themselves along the same lines[388].

The supper of the gods

Tacitus speaks of a golden age, when poets and bards mingled with the gods. Jesus as God's son must have done likewise.

387 Quasten, 1940. p. 257.
388 Cumont, 1911, p. 149.

But the happy golden age, to speak in our own poetic fashion, knew neither orators nor accusations, while it abounded in poets and bards, men who could sing of good deeds, but not defend evil actions. None enjoyed greater glory, or honours more august, first with the gods, whose answers they published, and *at whose feasts they were present*, as was commonly said, and then *with the offspring of the gods and with sacred kings*, among whom, so we have understood, was not a single pleader of causes, but an Orpheus, a Linus, and, if you care to dive into a remoter age, an Apollo himself.[389] [italics added]

Jesus as *offspring of the gods*, that is God's son in the type of Apollo, was blessed beyond his companions, because, as Tacitus says, he did good deeds. The writer to the Hebrews makes this clear.

But of the Son he says, "… You have loved righteousness and hated wickedness; therefore God, your God, has anointed you with the oil of gladness *beyond your companions.*" (1:8-9)

Jesus was not competing with any earthly friends. Those companions seen through a Jewish lens must have been the angels.

In Greek mythology there is a supper of the gods. There are twelve guests (representing the twelve signs of the zodiac) at the supper. In the gospels, we are introduced to twelve disciples at the eucharistic feast. In the Christian text called the *Clementine Recognitions* we read,

The affair of the supper of the gods stands in this wise. They say that the banquet is the world, that the order of the gods sitting at table is the position of the heavenly bodies. Those whom Hesiod calls the first children of heaven and earth, of whom six were males and six females, they refer to the number of the twelve signs, which go round all the world[390].

389 *Dialogue on Oratory,* Book 1.12.

390 Clementine Recognitions, Book 10.41—in Anonymous (n.d.) Pseudo-Clementine literature.

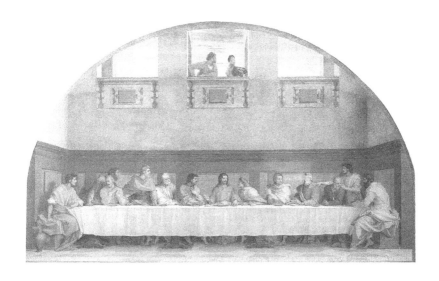

Fig. 23: The Last Supper *by Andrea del Sarto in the Museo del Cenacolo di Andrea del Sarto (1520-1525).* ART Collection / Alamy Stock Photo

Fig. 24: *Fragment of a Hellenistic relief (1st century BCE 1st century CE) depicting the Twelve Olympians.* Walters Art Museum

At these suppers, momentous events are initiated. The ancient text says,

> And hence it is that implacable wars arise, cities are destroyed, countries fall, even as Paris, by the abduction of Helen, armed the Greeks and the barbarians to their mutual destruction[391].

The handing over of God's son Jesus to the powers of darkness to suffer and die for the world would be such a momentous event, initiated at such a supper.

The god *Hades*, (Judas Iscariot in the Bible story) was not usually included among the Olympians because his realm was the underworld.

391 *Clementine Recognitions*, Book 10.41.

CHAPTER TWELVE

Rome

'The very great, the very ancient, and universally known Church' was 'founded and organized at Rome by the two most glorious apostles, Peter and Paul.'[392]

Irenaeus (late 2nd century)

ROME IN THE FIRST CENTURY WAS THE LARGEST CITY IN THE world.[393] All roads led to Rome. Naturally the head church of the new movement would be located in Rome. Paul's letter to the Romans is the longest of the Pauline epistles and is often considered his most important theological legacy. Paul would naturally write his longest and most important letter to the most important church.[394]

The Romans thought of themselves as highly religious, and attributed their success as a world power to their collective piety

392 Irenaeus, *Works*, Book 3.3.2.
393 Rome in the first century was the largest city in the world with an estimated population of 0.5 to 1 million. Accessed at https://en.wikipedia.org/wiki/List_of_largest_cities_throughout_history. Edmundson (1913, p. 3) says 1.3 million, of which more than one half were slaves.
394 Duling et al., 1994, p. 239.

(*pietas*) in maintaining good relations with the gods (*Pax deorum*).[395] The cult of the Emperor was formed under Augustus. (27 BCE– 14 CE) The first Pantheon, the "temple of every god," was built by Marcus Agrippa during the reign of Augustus. Tiberius revived the ancient customs and strengthened bans on impropriety.

> He abolished foreign cults at Rome, particularly the Egyptian and Jewish, forcing all citizens who had embraced these superstitious faiths to burn their religious vestments and other accessories.[396]

Tiberius died unloved.

> The first news of his death caused such joy at Rome that people ran about yelling: 'To the Tiber with Tiberius!' and others offered prayers to Mother Earth and the Infernal Gods to give him no home below except among the damned.[397]

Isis

The cult of the Egyptian god Isis spread to Rome from Alexandria in the first century BCE. An event which boosted the propagation of the religion was the sack of the island of Delos by Mithridates' general Archelaus in 88 BCE. Italian merchants forced to flee the island, took the religion to Campania in Italy.[398] Once there it then spread to all levels of society. Participants of the cult were women, children, slaves, freedmen, traders, veterans, soldiers, officers, and even members of the imperial family. Takacs states, "Leaders of municipalities, as documentation from Pompeii shows, seem to have embraced these gods as well."[399]

395 Momigliano, 1987, p.16.
396 Suetonius, *Lives of the Twelve Caesars,* Tiberius, 36.
397 Suetonius, *Lives of the Twelve Caesars,* Tiberius, 75.
398 Takacs, 1995, p. 5.
399 Takacs, 1995, p. 6.

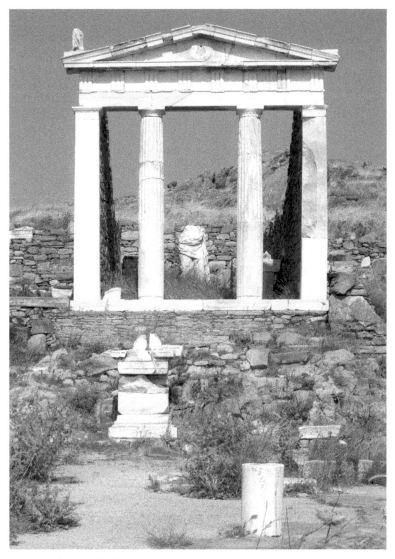

Fig. 25: *The Temple of Isis on Delos.* Hackenberg-Photo-Cologne/Alamy Stock Photo

The emperors Augustus and Tiberius attempted to prohibit the worship of the Egyptian gods but their measures were ineffectual. Caligula erected the great temple of Isis Campensis on the Campus Martius probably in the year 38. [400]According to Suetonius,

400 Cumont, 1911, p. 50.

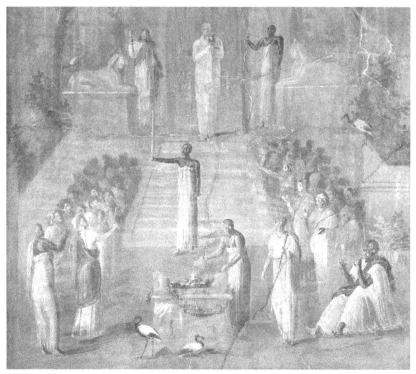

Fig. 26: The Worship of Isis *from a fresco in Herculaneum*.
PRISMA ARCHIVO/Alamy Stock Photo

Domitian as a young man disguised himself as a devotee of Isis to escape supporters of Vitellius in the year 69. Cassius Dio reports that hard on the disaster of the eruption of Vesuvius, in Campania in 79, another fire, this time above ground, spread over a very large portion of Rome. This occurred while Titus was absent on business connected with the catastrophe that had occurred in Campania. This fire,

> … consumed the temple of Serapis, the temple of Isis, the Saepta, the temple of Neptune, the Baths of Agrippa, the Pantheon, the Diribitorium, the theatre of Balbus, the stage-building of Pompey's theatre, the Octavian buildings together with their books, and the temple of Capitoline Jupiter with its surrounding temples. *Hence the disaster seemed to be not of human but of divine contrivance;* for anyone can

estimate, from the list of buildings that I have given, how many others must have been destroyed.[401] [my emphasis]

The destruction of so many pagan temples must have been viewed favourably by the new sect of the Christians. To their dismay Domitian restored many of these buildings,[402] and in commemoration of the restoration of the Iseum Campensis had an obelisk set up in the temple. On the east side of this obelisk is a picture of Isis crowning Domitian. The hieroglyphic text reads: "The autocrator loved by Isis and Ptah: may he live like Re."[403] From that time Isis and Serapis enjoyed the favour of every imperial dynasty, the Flavians as well as the Antonines and the Severi.[404]

Edmundson (1913) observes,

> In a city such as the Rome we have been describing it is not difficult to see a seed-plot ready prepared for the planting of a new religion like Christianity, oriental in its origin, an outgrowth of Judaism, akin in so many points to the Mystery-Religions of Egypt and Asia Minor then so much in vogue, and bearing, as it did, in its ethical teaching so striking a resemblance to the moral code of the Stoics. (p.8)

It is said that Paul met with the Jews of Rome and tried to "convince them about Jesus both from the law of Moses and from the prophets." (Acts 28:23) There is no reason to doubt the Jewish diaspora had spread to the west, and of course to Rome.[405] Jewish prisoners had been taken to Rome in 63 BCE.[406] In 19 CE, four thousand Jews of military age were dispatched from Rome to Sardinia as part of the contingent assigned to keep order on that island, the real reason

401 Book 66.24.

402 Suetonius, *Lives of the Twelve Caesars*, Domitian, 5.

403 Takacs, 1995, p. 100.

404 Cumont, 1911, p. 50.

405 *Antiquities of the Jews*, Book 14.10.8.

406 Edmundson, 1913, p. 4.

being that the emperor wanted to have them removed from Rome.[407] The expulsion of the Jews under Claudius recorded in Acts 18:2 was not effectual.

> "In the matter of the Jews, who had again increased so greatly that by reason of their multitude it would have been hard without raising a tumult to bar them from the City, he [Claudius] decided not to drive them out, but ordered them to follow that mode of life prescribed by their ancestral custom and not to assemble in numbers."[408]

No architectural remains of a synagogue have yet been found in Rome, but one has been found in the port of Ostia. Evidence of Jews in Rome has been found from funerary inscriptions.[409]

Logistically it would make sense to base the spiritual headquarters of the church in Rome. Rome had a large population (both slave and free) and hence a large pool of persons who could be converted to Christianity. The language of the church was Greek, as was the language of ordinary everyday life in Rome.[410] As well as good roads, several ports served the city including Portus constructed by Claudius and Puteoli mentioned in Acts 38:13. These made travel easier for missionaries, Christian tourists and Christian traders.

Rome and the Roman churches had resources—scribes, books, libraries and rich patrons—all the necessary facilities for supporting the reading, writing, copying and distribution of religious texts.[411] Not to downplay the importance of the two other cities that

407 Safrai & Stern, 1987, p. 119 *Antiquities of the Jews*, Book 18.3.5.

408 Cassius Dio, *Roman History*, 60.6

409 White, 1997, p. 24.

410 Edmundson, 1913, p. 4.

411 "However, when one has undertaken to compose a history based upon readings which are not readily accessible or even found at home, but in foreign countries, for the most part, and scattered about among different owners, for him it is really necessary, first and above all things, that he should live in a city which is famous, friendly to the liberal arts, and populous, in order that he may have all sorts of books in plenty, and may by hearsay and enquiry come into possession of all those details which elude writers and are preserved with more conspicuous fidelity in the memories of men." Plutarch, *Demosthenes*, 2.

rivalled her, Alexandria and Antioch, Rome remained at this time pre-eminent.[412]

In Rome, the Christian leaders could have access to and would more easily be able to influence and win concessions from the rulers of the Empire.[413] Despite centuries of Protestant proliferation, the Vatican in Rome remains the centre of the universal church.

A Roman prophecy

The Roman poet Virgil in his Fourth Eclogue (c. 40 BCE) has the Cumaean Sibyl predict the coming of a saviour. It is possible that Virgil adopted the idea from the sacred writings of the Jews (see Isaiah 9:2-7). Christians later interpreted the poem as referring to the birth of Christ.

> Now is come the last age of the Cumaean prophecy:
> The great cycle of periods is born anew.
> Now returns the Maid, returns the reign of Saturn:
> Now from high heaven a new generation comes down.
> Yet do thou at that boy's birth,
> In whom the iron race shall begin to cease,
> And the golden to arise over all the world,
> Holy Lucina, be gracious; now thine own Apollo reigns.
> And in thy consulate, in thine, O Pollio, shall this
> Glorious age enter, and the great months begin their march:
> Under thy rule what traces of our guilt yet remain,
> Vanishing shall free earth for ever from alarm.
> He shall grow in the life of gods,
> And shall see gods and heroes mingled

412 "And now Vespasian took along with him his army from Antioch, which is the metropolis of Syria, and without dispute deserves the place of the third city in the habitable earth that was under the Roman empire [after Alexandria]" *Wars of the Jews*, Book 3.2.4.

413 Paul says, "All the saints greet you, especially those of the emperor's household." Philippians 4:22

And himself be seen by them, and shall rule the world
That his father's virtues have set at peace.[414]

The good news comes to Rome

A certain report, taking its rise in the spring-time [the east], . . . gradually grew everywhere . . . became greater and louder, saying that a certain One in Judæa, beginning in the spring season, was preaching to the Jews the kingdom of the invisible God . . . and there was nothing which He could not do. And as time advanced, so much the greater, through the arrival of more persons, and the stronger grew—I say not now the report, but—the truth of the thing; for now at length there were meetings in various places for consultation and inquiry as to who He might be that had appeared, and what was His purpose.

And then in the same year, in the autumn season, a certain one, standing in a public place, cried and said, "Men of Rome, hearken. The Son of God is come in Judæa, proclaiming eternal life to all who will, if they shall live according to the counsel of the Father, who hath sent Him..."[415]

The natural bent of the populace in Rome where information was scarce was to believe. The popular rumour of the coming of the Messiah was something charismatic individuals could exploit, and Paul, although late in arriving at Rome, belongs to this class of self-proclaimed messengers of God. In Christian parlance, they were called apostles from the Greek apostolos (αποστολος) meaning "one sent." Each believed they were chosen by God and each preached their own "divinely inspired" version of the "gospel". .[416]

414 Accessed at https://en.wikisource.org/wiki/Eclogues/Eclogue_IV

415 *The Clementine Homilies,* 1.7.

416 The word *gospel* comes from the Greek *euangelion* (ευαγγελιον) and means *good* or *joyful news*. From this we get the English word *evangelize*. Paul talks about *his* gospel. (Romans 2:16, 2 Timothy 2:8) There was more than one gospel being taught in Paul's day. (1 Corinthians 1:11-13, 2 Corinthians 11:4, Galatians 1:6ff)

CHAPTER TWELVE

Clement, bishop of Rome

Clement in his time was the most prominent figure in the early church. The Clementine Homilies and Clementine Recognitions literature is evidence of his importance and legacy. According to Irenaeus he was also a contemporary of Peter and Paul.

> This man, as he had seen the blessed apostles, and had been conversant with them, might be said to have the preaching of the apostles still echoing [in his ears], and their traditions before his eyes.[417]

The only extant letter of Clement, written about the year 97 betrays *an authority* over the venerable church in *another city*, namely the church at Corinth, and by extension over all the churches. Clement says,

> We feel that we have been somewhat tardy in turning our attention to the points respecting which *you consulted us.* (1)

> These things, beloved, we write unto you, *not merely to admonish you of your duty,* but also to remind ourselves. (7)

Bishop Clement also proclaims that his authority within the universal church had been ordained by God, and directly imparted by the apostles.

> The apostles have preached the gospel *to us* from (or *by the command of*) the Lord Jesus Christ; Jesus Christ [has done so] from (or *by the command of*) God. (42)

The Syrian bishop Ignatius, (early second century) in his letter to the Romans, defers to the Roman church when he says that, "Never have any of you envied anyone; *all of you have taught others.*" (1:18) and "I do not command you, as Petros [Peter] and Paulus [Paul] did." (1:31)

417 Irenaeus, *Works*, Book 3.3.3.

Two other bishops are mentioned as exercising authority in Rome at this time—Linus and Cletus.[418] In the episcopal succession they were supposed to have served between Peter and Clement. The problem is that Clement was said to have been appointed by Peter.

Epiphanius declares that in the early days, Peter and Paul shared the episcopate in Rome.[419] Regarding the appointment of Clement, he says,

> I am not quite clear as to whether he [Clement] received the episcopal appointment from Peter while they were still alive, and he declined and would not exercise the office—for in one of his Epistles he says, giving this counsel to someone, 'I withdraw, I depart, let the people of God be tranquil,' (I have found this in certain historical works)—or whether he was appointed by the bishop Cletus after the apostles' death.

The Jewish Christians in Rome

Peter was a Jewish Christian and it seems the majority of the early Christians in Rome were also Jewish Christians. Epiphanius declares that "Ebion [the so-called father of the Ebionite sect] ... preached in Asia *and Rome...*"[420][my emphasis]

Peter's "conversion" to Gentile Christianity as depicted in Acts 11 is romantic invention. In the writings of Ambrosiaster (late 4th Century) we find this.

> It is established that there were Jews living in Rome in the times of the Apostles, and that those Jews who had believed [in Christ] passed on to the Romans the tradition that they ought to profess Christ but keep the

418 Eusebius, *Ecclesiastical History*, Book 5.6.

419 Epiphanius, *Panarion*, 27.6.2.

420 *Panarion*, Book 1.30.18.1.

law [Torah] ... One ought not to condemn the Romans, but to praise their faith, because without seeing any signs or miracles and without seeing any of the apostles, they nevertheless accepted faith in Christ, although according to a Jewish rite.[421]

This would explain Paul's extensive defence of *his version of Christianity* in his letter to the Romans. Paul takes great pains to ensure they understand that salvation is not just for Jews or those who keep the Jewish law. He says for example,

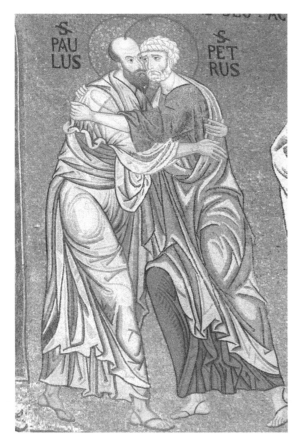

Fig. 27: The "amicable" relationship in art. Peter and Paul mosaic, Cappella Palatina, Palermo, Sicily, 12th century.
Melvyn Longhurst/Alamy Stock Photo

421 Ambrosius, *Works*, iii 373 quoted in *Epistle to the Romans* accessed at https://en.wikipedia.org/wiki/Epistle_to_the_Romans

> For a person is not a Jew who is one outwardly, nor is true circumcision something external and physical. Rather, a person is a Jew who is one inwardly, and real circumcision is a matter of the heart—it is spiritual and not literal. (Romans 2:28-29)

The tension between Paul and Peter, or Gentile and Jewish Christianity is manifest in Paul's letter to the Galatians. It seems that an uneasy truce between the apostles was brokered by James (Acts 15:19). The compromise position was that Paul was "entrusted with the gospel for the uncircumcised", and Peter "with the gospel for the circumcised." (Galatians 2:7-8) This was *the two-church solution.*

Paul fought for the adoption of Gentile Christianity. His letter to the Colossians appears to be aimed squarely at defeating the arguments of Jewish Christians. He says,

- you were circumcised with a *spiritual* circumcision (2:11)
- the record that stood against us with its legal demands. He set this aside, nailing it to the cross. (2:14)
- do not let anyone condemn you in matters of food and drink or of observing festivals, new moons, or sabbaths (2:16)
- Why do you submit to regulations, "Do not handle, Do not taste, Do not touch"? (2:20-21)

Paul names his Jewish co-workers as Aristarchus, Mark, Barnabas and "Jesus who is called Justus." (Colossians 4:10-11) He says these are "the only ones of the circumcision [that is, Jews] among my co-workers." The remainder must have been Gentiles.

In the Basilica of Santa Sabina, on the Aventine hill, there is a mosaic celebrating the establishment of the church sometime between 422 and 432. On either side of a large inscription are two female figures, each holding a book. Under the woman at the left we read: Ec[c]lesia ex circumcisione. On the right hand: Ec[c]lesia ex gentibus.[422]

422 Ecclesia is the Latin word for "church". Skarsaune & Hvalvik, 2007, p. 216.

Fig. 28: *The two-church solution depicted in the Basilica of Santa Sabina.*
Paolo Romiti/Alamy Stock Photo

As religious adherents rarely switch sides or modify their views,[423] it is likely that *the two-church solution* carried on well past the first century.

There is no good evidence that Peter had much to do with the church in Rome or if he did, it would have been to minister to the Jewish Christians. In another place it says that Peter was bishop of Antioch.[424] This city boasted a large Jewish population[425] and it

423 Example: Most Jews remained faithful to Judaism despite the massive upheaval caused by the loss of their Temple.

424 *Ecclesiastical History*, Book 3.36.

425 *Wars of the Jews*, Book 7.3.3.

figures prominently in the book of Acts. Paul mentions the city as the site of a doctrinal dispute with Jewish Christians. (Galatians 2:11-14)

Christian "unity" means Gentile Christian "unity"

The main theme of Clement's *Letter to the Corinthians* is unity and Clement insists on obedience to the appointed leaders (42). The Letter is clearly addressed to *Gentile Christians*. It praises Paul "the blessed apostle," in chapter 47 and makes no mention of Jews, Jewish affairs, Jewish customs or the views of Jewish Christians. Peter is only mentioned in passing.

Gentile Christianity in Rome, at least in the early days, seems to have avoided the problems of Corinth.[426] This is not say there were not serious threats to that unity and disagreements later.[427] Harnack studied the movement of notable Christians, and exchange of letters between Rome and other churches in the early centuries. He concluded that,

> Down to the age of Constantine, or at any rate until the middle of the third century, the centripetal forces in early Christianity were, as a matter of fact, more powerful than the centrifugal. And Rome was the centre of the former tendencies. *The Roman Church was the catholic church.* It was more than the mere symbol and representative of Christian unity; to it more than to any other, Christians owed unity itself.[428] [my emphasis]

426 This is probably the source of the myth of an original virgin church uncorrupted "by vain discourses" promoted by Hegesippus. Eusebius, *Ecclesiastical History*, Book 4.22.

427 "From them [various heretics in the second century] came false Christs, false prophets, false apostles, who divided the unity of the Church by corrupt doctrines uttered against God and against his Christ." *Ecclesiastical History*, Book 4.22.

428 Harnack, 1908, p. 376.

CHAPTER TWELVE

Paul the lawless one

According to Epiphanius, the Ebionites (the strict Jewish Christian sect) despised Paul. They claimed he was a Greek who had converted to Judaism in order to marry a daughter of the high priest.[429]

Anti-Pauline rhetoric is found in the Jewish gospel of Matthew. Matthew has Jesus say,

> Not everyone who says to me "Lord, lord" will enter the kingdom of heaven, but he that does the will of my Father in heaven. Many will say to me on that day, "Lord, lord, did we not prophesy by your name and cast out devils by your name and perform many mighty works by your name?" And then I shall declare to them, "I never knew you: depart from me, *workers of unlawfulness*." (7:21-23)[430]

The existence of false Christians performing *many mighty works* in the name of Jesus[431] points to the party of the theological opposition— the Gentile Christians—the *workers of unlawfulness*. They preached that the Mosaic law was void. [432]

The parable of the wedding banquet
(Matthew 22:1-14)

In this parable, a king (read God), gives a wedding banquet for his son (Jesus). But the invited guests (the Jews) refuse to attend, make light of it and even kill the king's servants (the prophets).

429 *Panarion*, Book 1.30.16.8-9.

430 Powell, 1994, p. 14.

431 Paul humbly declares, "For I will not venture to speak of anything except what Christ has accomplished through me to win obedience from the Gentiles, by word and deed, by the power of signs and wonders, by the power of the Spirit of God, so that from Jerusalem and as far around as Illyricum I have fully proclaimed the good news of Christ." Romans 15:18-9

432 Julian in *Against the Galileans* argues forcefully from the Books of Moses that the law was instituted for all time.

159

The result is that;

The king was enraged. He sent his troops [the Romans], destroyed those murderers, and burned their city [Jerusalem]. Then he said to his slaves [the apostles], 'The wedding is ready, but those invited were not worthy. Go therefore into the main streets [of other cities], and invite everyone you find to the wedding banquet.' Those slaves went out into the streets and gathered all whom they found, both good and bad; so the wedding hall was filled with guests." (vv. 7-11)

An interesting addendum to the parable is the following.

But when the king came in to see the guests, he noticed a man there who was *not wearing a wedding robe*, and he said to him, 'Friend, how did you get in here without a wedding robe?' And he was speechless. Then the king said to the attendants, 'Bind him hand and foot, and throw him into the outer darkness, where there will be weeping and gnashing of teeth.' For many are called, but few are chosen." (11-14)

The one *not wearing a wedding robe* has failed to honour the tradition. He wishes to be part of the divine wedding without abiding by the rules. This is Paul.

The apocryphal *Letter of Peter to James*, confirms this interpretation of the parable. In this letter we read,

For some from among the Gentiles have rejected my [Peter's] legal preaching, attaching themselves to *certain lawless and trifling preaching of the man who is my enemy* [that is, Paul]. And these things some have attempted while I am still alive, to transform my words by certain various interpretations, in order to *the dissolution of the law*, as though I also myself were of such a mind, but did not freely proclaim it, which God forbid! For such a thing were to act in opposition to the law of God which was spoken by Moses, and was borne witness to by our Lord in respect of its *eternal continuance*; for thus he spoke: "The heavens and the earth shall pass away, but one jot or one tittle shall in no wise pass from the law." [my emphasis]

Paul's revelation

Scholars are divided on the authorship and date of Paul's second letter to the Thessalonians. Those who think it was written by Paul date it to about the year 50; if pseudonymous about 80. Both sets of scholars are half right. When viewed in the correct historical context we can both date the letter accurately to about the year 80 and declare that Paul is indeed the author.

There are three "revelations" or prophecies about the end of the world in the New Testament. (The English word *revelation* is a translation of the Greek *apokalypsis* which means a 'disclosure' or 'uncovering'. The English word 'apocalypse' has come to mean the complete and final destruction of the world, as described in the Biblical book of Revelation.) In the New Testament we have,

1. The revelation of Jesus, which is recorded in the gospels (Matthew 24 and Luke 21)
2. The revelation of Paul which is recorded in Paul's second letter to the Thessalonians (2:1-12), and
3. The most famous revelation, the revelation of John, which is a separate book within the New Testament canon

The revelation of Jesus deals with the destruction of Jerusalem and the Temple. This occurred in the year 70. This revelation was based on actual events. (Of course, it was written AFTER the events it pretends to predict) Surprisingly or perhaps not surprisingly, Paul's revelation which is supposed to have been written BEFORE 70 CE makes no mention of the destruction of the Temple and Jerusalem.

Hence either,

- Paul was writing BEFORE 70 CE, and like so many others at the time, held that the event was not in God's plan and extremely unlikely OR
- He was writing AFTER 70 CE, the event had already occurred, and it would make no sense to predict something that had already happened.

According to our timeline Paul is active AFTER the year 70. Therefore, we can place him in early 79 in Athens writing his first

letter to the Christians in Thessalonica encouraging them to keep the faith. He specifically mentions in this letter *the wrath that is coming* on unbelievers. (1:10) Then quite by chance after writing this letter a widely known calamitous event occurs which seems to confirm Paul's prediction and causes the Thessalonians to believe that the end of the world *had happened*. Paul's response is to hurriedly pen a second letter to reassure them it had not! (2:1-2) The widely known calamitous event which prompted this belief was the eruption of Mount Vesuvius in Campania in October 79, thereby burying the cities of Pompeii and Herculaneum in metres of ash and affecting sunsets as far away as Syria and Egypt. The eruption and ensuing panic were witnessed and described by Pliny the Younger.[433] According to Cassius Dio there was a real sense throughout the empire that the event heralded the end of the world. Therefore, we can confidently date Paul's second letter to the Thessalonians to November or December of the year 79.

The failed prediction

After Nero's suicide in 68, there was a widespread belief, especially in the eastern provinces, that he was not dead and somehow would return. Three Nero imposters appeared between the years 69 and 89. The legend of Nero's return — the Nero Redivivus Legend — lasted for hundreds of years after Nero's death, beginning even before he was dead. It was even rumoured that he would return to Jerusalem.[434]Augustine of Hippo wrote of the legend as a popular belief after the sack of Rome in 410.[435]The number of the beast in Revelation (13: 17-8) is 666, and this according to the ancient science of Gematria can be found in the name "Neron Caesar" in

433 Letter LXV to Tacitus

434 "Yet some of the astrologers promised him, in his forlorn state, the rule of the East, and some in express words the kingdom of Jerusalem." Suetonius, *Lives of the Twelve Caesars*, Nero, 40.

435 Augustine, *City of God,* 19.

Hebrew. (The Greek version of the name and title transliterates into Hebrew as נרון קסר, and this yields a numerical value of 666.)

One such false Nero was Terentius Maximus. Cassius Dio reports that,

> In his [Titus's] reign [that is the years 79 to 81] . . . the False Nero appeared, who was an Asiatic and called himself Terentius Maximus. He resembled Nero in form and voice: he even sang to the zither's accompaniment. He gained a few followers in Asia and in his onward progress to the Euphrates he secured a far greater number and at length sought a retreat with Artabanus, the Parthian[436] chief, who, out of the anger that he felt toward Titus, both received the pretender and set about preparations for restoring him to Rome.[437]

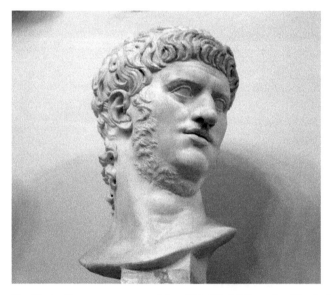

Fig. 29: *Bust of roman emperor Nero(37-68 AD) at the Capitoline Museums. Rome. Italy.* Lanmas / Alamy Stock Photo.

436 The Parthian Empire occupied territory that we today call Iran.

437 Cassius Dio, *Roman History*, Book 66, 19 "... the armies of Parthia were all but set in motion by the cheat of a counterfeit Nero." Tacitus, *Histories*, Book 1.

But this pretender whom Paul names "the man of lawlessness" in 2 Thessalonians 2:3-4 was captured and executed. Furthermore, as previously mentioned, the temple of the supreme god, the temple of Jupiter in Rome was destroyed in a catastrophic fire, making it impossible for Paul's prophecy to be fulfilled. Did this failed prediction lead to his rejection in Asia? — as noted in 2 Timothy 1:15. And did it also prompt the writing of a fuller and more future proof *revelation* specifically written for the Asian churches that had rejected Paul and which today stands in our Bibles as the Revelation of "John"?

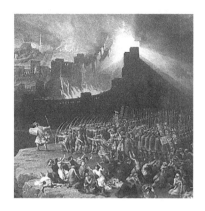

CHAPTER THIRTEEN

THE ORIGINS OF ISLAM AND ITS SACRED WRITINGS ARE obscure.[438] In a similar way, how exactly the key Christian literature, the Gospels and Acts of the Apostles, came to be was information that was lost or obscured by the Church. It did not enhance faith to know that the holy books were produced by fallible men toiling over manuscripts, and not, as preached by the church, by plenary inspiration of the Holy Spirit.[439]

The Gospels

What are they? An anonymous Christian of the second century summarised them thus.

> ... by the one sovereign Spirit all things have been declared in all [the Gospels]: concerning the nativity [of Christ], concerning the passion, concerning the resurrection, concerning life with his disciples, and concerning his twofold coming; the first in lowliness when he was

438 See Puin & Ohlig, 2010, *The hidden origins of Islam.*
439 2 Timothy 3:14-17.

despised, which has taken place, the second glorious in royal power, which is still in the future. [440]

A second century pagan critic proclaimed,

> It is clear to me that the writings of the Christians are a lie, and that your fables have not been well enough constructed to conceal this monstrous fiction. I have even heard that some of your interpreters, as if they had just come out of a tavern, are onto the inconsistencies and, pen in hand, alter the original writings three, four, and several more times over in order to be able to deny the contradictions in the face of criticism.[441]

The defective style of the gospels was noted by the ancients. Arnobius the fourth century apologist notes that a common criticism was that these narratives "were written by unlearned and ignorant men, and should not therefore be readily believed."[442] They were, it was asserted, "overrun with barbarisms and solecisms, and disfigured by monstrous blunders."[443] Arnobius does not deny these charges but turns them into a mark of unpolished honesty.

The Christians in Rome

Paul's magnum opus was his letter to the Roman church written in late 79 or early 80. The word *church* comes from the Greek word *ekklesia* meaning assembly (Greek εκκλησια) and it may refer to a single Christian congregation or the mother church as a whole. For example, Paul says in chapter 16 of his letter, "All the churches (that is *ekklésias*) of Christ greet you." While Matthew has Jesus say, "on this rock [Peter] I will build my church (or *ekklésia*)."

440 Muratorian Canon 19-26.

441 Celsus, *On the true doctrine*.

442 *Seven Books against the Heathen*, Book 1.58.

443 *Seven Books against the Heathen*, Book 1.59. See also Harnack, 1908, p. 379.

When Paul wrote to the Romans, he addressed his letter to "all God's beloved in Rome, who are called to be saints." He did not address his letter to a single congregation or *ekklésia* and he did not address a bishop[444]. Peter is not mentioned, as bishop of the Roman church, or in any other context.

The believers named by Paul in the valediction of his letter have Greek or Roman names, and Paul specifically mentions the churches of the Gentiles. (16 v.4) We know that there were Jewish Christians in Rome at this time. Although no direct reference to these is found in Paul's letter, he forcefully argues against their teachings, showing that he regarded them as a threat to the faith of the Roman (Gentile) Christians. (2:17ff)

When were the gospels written?

Modern text-based religions such as Scientology and Mormonism depended on writings which were published at the same time as the establishment of the religions. By analogy we can confidently say that for Christianity, at least some sacred texts, hymns, prayers and statements of faith must have been put down soon after the inception of the religion. The provenance of this material could have been anywhere in the empire. Paul shows some familiarity with this material.[445]

Paul never quotes from the Gospels or the direct words of Jesus as recorded in the Gospels.[446] It is possible that the reason for this is that they were written and published after he had passed off the scene. John appears to have been written when the religion was confident and well established. But what about the earlier works? What about Matthew?

444 The word *bishop* means *overseer*, Greek *episcopos* [επισκοπος].

445 Paul seems to be quoting them at, for example, Philippians 2:6-11, 1 Timothy 2:5-6, 3:16.

446 Even when doing so would have settled an argument. An example is the question of divorce, discussed in 1 Corinthians 7. Paul makes no reference to the teaching of Jesus recorded in Matthew 19:1-12.

The order of writing

Our Bibles contain four versions of the life of Jesus. These are commonly known as the gospels. Much material is common to the first three gospels, that is Matthew, Mark and Luke. Often the exact Greek words are used. Theologians refer to these gospels as the *synoptic* gospels. The word *synoptic* comes from the Greek *syn*, "together"; and optic, from the verb "to see." When these gospels are compared, that is the various common stories or anecdotes are seen together or lined up, side by side, it becomes clear that they were written in the order,

Matthew ⇨ Luke ⇨ Mark[447]

In general Mark always elaborates the anecdotes given in Matthew and these improvements show that it was written later. Eusebius says,

> Again, in the same books, Clement [of Alexandria, who flourished in the late 2nd century] gives the tradition of the earliest presbyters, as to the order of the Gospels, in the following manner: The Gospels containing the genealogies [that is, Matthew and Luke], he says, were written first.[448]

Classical scholar Enoch Powell also posits two other conclusions which should be stressed.

- Matthew, in virtually the form in which we possess it, was used by the writers of the two other [synoptic] gospels, and
- They had no other source or sources.[449]

447 Farmer, 1990, p. 558.
448 *Ecclesiastical History*, Book 6.14.
449 Powell, 1994, p. xi.

Matthew, originally a Jewish Christian gospel

The patron of the Jewish Christians in Rome was Peter, who was declared to be the rock upon which the universal church was to be built. Words put into the mouth of Jesus himself declare this to be so.

> And I [Jesus] tell you, you are *Peter* [Greek *Petros*], and on this rock [Greek *petra*] I will build my church, and the gates of Hades will not prevail against it. I will give you the keys of the kingdom of heaven, and whatever you bind on earth will be bound in heaven, and whatever you loose on earth will be loosed in heaven. (Matthew 16:18-9)

Only in Matthew do we read the following words:

> Do not think that I have come to abolish the law or the prophets; I have come not to abolish but to fulfil. For truly I tell you, until heaven and earth pass away, not one letter, not one stroke of a letter, will pass from the law — *until all is accomplished.* (Matthew 5:17-8)[450]

According to Powell, the phrase *until all is accomplished* is a later insertion in the text.[451]

Jesus, the good man who meets the worst fate

The story of Jesus is the story of the good man who meets the worst end. This theme was well known in the ancient world. Jesus as the perfect man fulfilled the type perfectly. From a discourse by Seneca,

450 Luke attempts to remove the incongruity in Matthew by having Jesus say, "The law and the prophets were in effect until John came." (16:16)

451 Powell, 1994, p. 81.

> There comes now a part of our subject which is wont with good cause
> to make one sad and anxious: I mean when good men come to bad
> ends; when Socrates is forced to die in prison, Rutilius to live in exile,
> Pompeius and Cicero to offer their necks to the swords of their own
> followers, when the great Cato, that living image of virtue, falls upon his
> sword and rips up both himself and the republic, one cannot help being
> grieved that Fortune should bestow her gifts so unjustly: what, too, can
> a good man hope to obtain when he sees the best of men meeting with
> the worst fates. . .[452]

Seneca comforts us with the assurance that eternal life awaits such
men.[453] Peter in the Book of Acts is made to say that it was impossible
for death to hold Jesus.[454] But we are not as good as Jesus. Matthew
is harsh and says that to achieve eternal life, we need to give up
everything we hold dear.[455] This teaching is somewhat softened in
John who says we only need to believe.[456]

Jesus as the new Moses

> The Lord your God will raise up for you a prophet like me [Moses] from
> among your own people; you shall heed such a prophet. (Deuteronomy
> 18:15)

The writer of the Letter to the Hebrews claims that Moses suffered
abuse "for the Messiah"[457] and points to aspects in the life of Moses

452 *On Tranquility of Mind*, 16.

453 "All these men discovered how at the cost of a small portion of time they might obtain
immortality, and by their deaths gained eternal life."

454 Acts 2:22-24.

455 "And everyone who has left houses or brothers or sisters or father or mother or children or
fields, for my name's sake, will receive a hundredfold, and will inherit eternal life." Matthew
19:29.

456 John 3:16.

457 Hebrews 11:26.

that parallel those of Jesus.[458] Grintz claims that the gospel of Matthew seems to be written as "a counterpoise to the Books of Moses."[459]

1. Jesus' birth like that of Moses (according to Aggadic sources) was foretold by magicians, i.e., astrologers.[460] (Matthew 2:1)
2. Pharaoh on the eve of Moses' birth, so Herod at the time of Jesus' birth commanded the execution of children.[461] (Matthew 2:16, cf. Exodus 1:16)
3. Jesus, like Moses, was called out of Egypt (Matthew 2:15, "Out of Egypt I have called my son.") and like Moses the divine Spirit descended upon him. (Matthew 3:16)
4. He too fasted for forty days (Exodus 34:28), and went up a mountain, and entered a cloud. (Matthew 17:1-8, Exodus 24:18)
5. Both Moses and Jesus performed deeds of power. (Deuteronomy 6:22, Matthew 13:54)
6. Moses was the mediator of the old covenant (Exodus 20:19, Galatians 3:19), Jesus of the new. (Matthew 17:5, Hebrews 8:6)

Where was the Jewish version of Matthew written?

In Matthew the death of Jesus is blamed on the Jews. The Roman governor is exonerated. Pilate is made to say, "I am innocent of this man's blood; see to it yourselves." This pro-Roman bias points to the document being compiled and edited in the west, that is most probably in Rome.[462]

458 Hebrews 11:23-28.

459 Grintz, 1960, p. 40.

460 "The child foretold by Pharaoh's dreams and by his astrologers was brought up and kept concealed from the king's spies." Ginzberg, 1909, Vol II, ch 4.

461 "Pharaoh's order ran as follows: 'At the birth of the child, if it be a man child, kill it; but if it be a female child, then you need not kill it, but you may save it alive.'" Ginzberg, 1909, Vol II, ch 4.

462 Powell, 1994, p.xxvii.

When was the Jewish Matthew written?

We know from Paul's letter to the Galatians that at the time of his conversion from Judaism about the year 72 there were Christians in Jerusalem. (Galatians 1:17) The Christians in Jerusalem practised circumcision which shows they were still practising the Law of Moses or at least parts of it. (2:3) These Jerusalem Jewish Christians had counterparts in Rome. Between the years 75 and 79 Josephus published in Rome the popular and prestigious *Wars of the Jews* which covers the period from the taking of Jerusalem by Antiochus Epiphanes (168 BCE) to the year 75. This book (or at least our version of it) contains no mention of Jesus or Christians, an omission which must have stunned Christians who saw themselves as heirs to an historical tradition.[463] However, we can assume that the writings of Josephus, a Jew, would not have been given much weight by the Gentile Christians and so this event would not have prompted much anxiety amongst the Gentile believers. But an altogether different reaction would have been produced in the Jewish Christian community. Hence, I conclude that the Jewish gospel of Matthew was written in Rome by a Roman Jewish Christian or Christians shortly after *Wars of the Jews* was published *as a response to the omission by Josephus of the history of the Christians.*

The illusion of age

The church fathers defined heresies as deviations from ideas that were old and established. In the second century Clement of Alexandria argued that,

> ...it is evident, from the high antiquity and perfect truth of the Church,

463 Another publication that failed to mention Christians was Pliny's *Natural History* which was completed and possibly available from 77.

Fig. 30: *Characters invented by Joseph Smith.*

> *Hebrew would have appeared as strange to Romans as these characters which were invented by Joseph Smith. According to Smith, they were "an altered or "reformed" Egyptian. At this time the Egyptian language was popularly believed to be indecipherable, for it was not until 1837 that the grammar worked out from the Rosetta stone by the French scholar Champollion was first published in England* (Brodie, 1963, p.50). *Knowledge of Hebrew seems to have been very poor in the Greek Diaspora.*
>
> (Skarsaune & Hvalvik, 2007, p. 690)

that these later heresies, and those yet subsequent to them in time, were new inventions falsified [from the truth].[464]

Josephus makes the same claim about the origins of the Jewish people in his book *Antiquities of the Jews*, defending the tradition that they had a history stretching back five thousand years. This was opposed to the Greek idea that their origin was more recent.[465]

Hence the true gospel had to have primacy, if not in reality at least in chronological setting. The story of Jesus' coming was pushed back from the original conception, not too far because that would be implausible but far enough to ensure any possible witnesses would most likely be dead. Forty years took the main story back to the career of the Roman

464 *Stromata*, Book 7.17.

465 *Against Apion*, 1.1.

governor of Judea, Pontius Pilate.[466] Pilate's attitude to Jesus also served as a proxy for all Romans or at least the Roman leadership.

Placing the literary character of Jesus in Palestine would not have been difficult for the writer of the first gospel as many Roman Jews would have visited and become familiar with Judean holy sites or traded with their kinsmen in the halcyon days before the destruction of the city and the Temple. A journey by sea would have taken a month or two, depending on the winds. In the other direction rabbis from Israel would have come to Rome, bringing books, information and philosophical ideas. In the libraries in Rome, Strabo could be found with his description of the Holy Land.

Not from Judea

The Jewish Matthew was not written in Israel. The inhabitants there would have immediately seen through the fiction. In a similar way Eratosthenes who was the chief librarian at Alexandria in the third century BCE concluded that Homer in the Odyssey had placed the scene of his marvels in distant lands (that is far from Greece) so that "he may lie the more easily."[467] Nevertheless, it was commonly held by the church fathers that the gospel of Matthew had originally been written in Hebrew and its source was Judea.[468] But this Hebrew document has never been found, and most scholars doubt it ever existed. It now seems more likely that the Roman writer or writers of the first gospel invented the tale, in the same way that Joseph Smith claimed to translate writings from an unknown language in the production of his historical fraud, the Book of Mormon.

466 The naming of Pontius Pilate in the *Apostle's Creed* is significant as the one historical anchor
 for the story. An early version can be found in Irenaeus. See *Heresies*, Book 3.4.2.

467 Strabo, *Geography* Vol 1 Book 1.2.19.

468 "Matthew, also called Levi, apostle and aforetimes publican, composed a gospel of Christ at
 first published in Judea in Hebrew for the sake of those of the circumcision who believed,
 but this was afterwards translated into Greek, though by what author is uncertain." Jerome, *De
 Viris Illustribus*, Matthew.

Koine Greek

When the Macedonian Alexander the Great died in 323 BCE he left behind an empire that covered a good part of the known world. The countries he conquered adopted to varying degrees his Greek culture and the Greek language. Greek became the lingua franca of this world and remained so after the Romans became the new masters of the region. The New Testament was written in a common form of Greek called *koine*. The Old Testament was translated into koine in stages from the third century BCE and this translation was known as the Septuagint, from the Latin *septuaginta* meaning "seventy" because of the tradition that the Torah (the first five books) were translated by seventy scholars, who working independently miraculously produced identical translations. This version of the Old Testament achieved canonical status and was quoted by Paul and the other writers of the New Testament more than the original Hebrew.

Hebraisms in the gospel of Matthew

Whoever wrote the Jewish Matthew knew Hebrew or at least knew how to imitate Hebrew in Greek translation. There are many Hebraisms in the text. Here are some examples.

1. The "kingdom of heaven" is a Hebrew phrase. In passages where Matthew has "kingdom of heaven," Mark and Luke use "kingdom of God"—a phrase quite unknown in Hebrew.[469]
2. "*For flesh and blood* has not revealed this to you, but my Father in heaven." (16:17) The expression *flesh and blood* is quite common

469 Grintz, 1960, p. 36-7, Matthew 3:2, 4:17, 5:3 and so on.

in Mishnaic Hebrew, but altogether unknown in Aramaic[470] or any other language.[471]

3. "Sons of the kingdom" (13:38), is a Hebraism meaning those who will enter the kingdom.[472]

4. Words used by Matthew such as Israel, Gentile and Canaanite woman are Hebrew and have no equivalent in Aramaic, or any other language.[473]

All three synoptic gospels, Matthew, Luke and Mark contain Hebraisms.

Horton points out that the Semitisms (that is features derived from Hebrew or Aramaic) in the Septuagint are intentional and do not reflect incompetence in the translators. Furthermore, he states that,

> So far as the written records show, there was no "Jewish Greek" in which Hebrew or Aramaic features were to be found with the single exception of religious texts.[474]

Wells concludes,

> ... Hellenistic Jews at their religious services used a Koine larded with Semitisms, as an appropriately solemn language, just as extemporaneous prayer today tends to be based on Biblical language.[475]

The use of this synagogue Greek in the Jewish Matthew may have helped persuade the Gentile Christians of its supposed Judean and hence divine origin. The Gentile version retained these features for cultic purposes.

470 Aramaic: an ancient language of the Middle East, still spoken in parts of Syria and the Lebanon, a branch of the Semitic family of languages, used as a lingua franca in the Near East from the 6th century BCE.

471 Grintz, 1960, p. 36.

472 Powell, 1994, p. 131.

473 Grintz, 1960, p.35.

474 Horton in Talbert (ed), 1978, p.4.

475 Wells, 1998, p.142ff.

In a similar way the Book of Mormon was written in faux archaic imitation of the King James Version of the Bible and not the language of the day, even though Smith claimed to be translating it from "reformed Egyptian" into English.

Paul and the Jewish version of Matthew

Paul did not visit Rome until the very end of his career, and from his letters it seems that he had limited contact with Jewish Christians. He was certainly opposed to their teaching. (Galatians 2:16) This may explain why he paid no attention to the Jewish book of Matthew, and he never quoted it. Or perhaps Paul regarded it as a collection of fables. Evidence of the latter is found in his personal letters to Timothy and Titus where he warns the brothers to be wary of certain myths which were currently perverting the truth and causing the faithful to err. (See 1 Timothy 1:4, 4:7, 2 Timothy 4:4, Titus 1:14) Note that an ancient document known to us as the second letter of Peter which is clearly accepting of the gospel stories defends the position that the new religion was NOT based on myths, (1:16) using the same Greek word *muthos* (μυθος) as Paul does. These are the only occurrences of the word in the New Testament.

The impetus for publication of the Gentile version

Our version of Matthew is the Gentile version. Powell says that our version of Matthew was composed in haste.[476] I think we can rightly surmise that the sudden departure of Paul around the year 83 was

476 " . . . the text of Matthew presents certain peculiar features, like contradictions, duplications, and abrupt breaks, which suggest that it has not itself been subjected to any smoothing or editorial treatment such as it was later to undergo at the hands of Mark and Luke. Those blemishes would most naturally be explained as traces of the manner in which the book came to be compiled or composed; they would be consistent with its having been produced in haste and under pressure and left without revision or any attempt to remove the blemishes." Powell, 1994, p. xviii.

the event that precipitated this haste. Peter the patron of the Jewish Christians in Rome may have passed off the scene about the same time[477]. John remained in Asia but that was a long way from Rome. For the Roman Christians this meant that the believers could no longer rely on the personal revelations of those who had "seen the Lord." It was then time to seal the revelatory period and fix the teaching of the apostles in the form of teachings from Jesus himself and anecdotes about his life.[478]

Paul insisted that Jesus was the physical son or descendant of David (Romans 1:3) and following the literary example of Josephus, this theology was incorporated into the Gentile version of Matthew. The genealogy which forms chapter one of our version has been prepended to an earlier version.[479] Josephus in *Wars of the Jews* is careful to record the names and number of the high priests from Aaron, the legendary first to Phanas, the last — from Herod to Titus, he notes twenty-eight names, two sets of fourteen.[480] Likewise, Matthew lists the ancestors of Jesus, going back to David as per the theology of Paul and then further to Abraham and noting the number of generations, three sets of fourteen.

The importance of Josephus in understanding how the gospels came to be cannot be overemphasised. More evidence of this can be seen in the re-discovery of Josephus by the fathers in later centuries. Schreckenberg notes that,

> Since the work of Origen [early third century] and of Eusebius of Caesarea, the judgment that Josephus is of incalculable value as source material forced its way increasingly into the Christian church, so that eventually one hears of Josephus as "a kind of fifth gospel" and as a "little Bible." [481]

477 1 Clement 5.

478 In the same way, the revelations of Joseph Smith ceased with his martyrdom in 1844. For Catholics, "The deposit of faith is generally regarded to have 'closed' with the death of the last apostle." Landry, 2000, p.2.

479 Powell, 1994, p.53ff. It was also lacking in the Ebionite version. Epiphanius, *Panarion*, Book 1.30.13.6.

480 *Wars of the Jews*, Book 7.10.

481 Feldman & Hata, 1987, p.317.

The reason Josephus was found to be so valuable and so much in accord with the gospels was that he had originally been the source, the inspiration and indeed almost the *raison d'être* for the gospels.

Appropriation of the Jewish Matthew

The Jewish sacred books, the books of Moses and the prophets, were appropriated by the Christians who saw in them references to their Jesus and his mission, and so it is not unreasonable to suppose that the Gentile Christians also appropriated the Jewish book of Matthew from their Jewish cousins. Paul's misgivings were put aside. The passage about the eternal usefulness of the Law in Matthew chapter 5 was altered slightly by the Gentile Christians[482] and after some other edits and additions, which are evident in the text, published their own version. The basic story as imagined by the Jewish Christians was kept intact as it had a proven track record of engendering faith. Its professed pedigree — Judea, would also have helped it to achieve acceptance. This would have been a year or two after Paul's demise, perhaps in the year 84 or 85.

Powell notes,

> Matthew discloses that an underlying text was severely re-edited, with theological and polemical intent, and that the resulting edition was afterwards recombined with the underlying text to produce the gospel as it exists.[483]

482 The pre-eminence of Peter in the story was not removed because Peter was integral to the story. His interactions with Jesus as spokesperson for the disciples, his denial of the Lord, were essential. He could not be replaced by Paul because it was commonly accepted and admitted by Paul that he came after the religion had been established.

483 Powell, 1994, p. xii.

Why the legends surrounding the deaths
of Peter and Paul are important

The geographical centre of the Christian religion was naturally Jerusalem. This city had been declared holy by the sacred Jewish texts. There are no predictions in these texts that make Rome, God's new earthly capital.[484] To shore up the legitimacy of Rome as heir to the title, the gospels are made to say that God had rejected Jerusalem. (Luke 19:41-44) The last words of Jesus recorded in Matthew 28:18-20, enjoin the believers to *make disciples of all nations*—that is to quit Jerusalem.[485] Indeed, the writer of Acts has persecution driving them out. (Acts 8:1)

Fr. Landry says,

> The fact [sic] that Peter and Paul both died in the city of Rome (when they could have been killed on countless other occasions in innumerable other cities) seems to show the hand of God in choosing Rome.[486]

Peter the symbol of unity

> Would it make any sense if this mission died with Peter, when future generations, further distant in time from Christ and the apostles, arguably would need an agent and symbol of unity even more than the early Church?[487]

Peter may have been chosen as the symbol of unity, but it was Paul who worked hardest and sacrificed most.[488] The fiction of the

484 Landry, 2000, p. 10.

485 The original ending of Matthew was probably v.10—*go and tell my brothers to go to Galilee; there they will see me.* The later verses, especially the great commission implies knowledge of the admission ritual (that is, the baptismal formula) in established (Catholic) churches. (Powell, 1994, p. 221)

486 Landry, 2000, p. 10.

487 Landry, 2000, p. 10.

488 1 Corinthians 15:10

pre-eminence of Peter in the Gentile church when he was really the leader of the Jewish Christians has remained a cornerstone of Catholic dogma since the first century. In a recent document of the Congregation for the Doctrine of the Faith, its Prefect, Cardinal Joseph Ratzinger, asserts:

> In Peter's person, mission and ministry, in his presence and death in Rome attested by the most ancient literary and archaeological tradition — the Church sees a deeper reality essentially related to her own mystery of communion and salvation: "Ubi Petrus, ibi ergo Ecclesia."[489]

Where Peter is, there is the Church.

489 Landry, 2000, p. 18.

CHAPTER FOURTEEN

Luke and Josephus

THE WORKS OF LUKE AND JOSEPHUS SHARE SOME COMMON FEATURES.
Bond states that,

> In general terms, both authors wrote Hellenistic histories with strong
> links to their eastern predecessors. They provided prologues, created
> appropriate speeches for their characters, and endeavored to make their
> work entertaining and lively (shipwrecks, for example, feature in both
> *Life of Josephus* and *Acts*). Both, too, sought to advance the standing of
> their own group by stressing its antiquity and virtues: they emphasize
> the harmonious history of their group, suggest that trouble came from
> outsiders (rebels for Josephus, Jewish authorities for Luke), and show that
> neither group is any threat to Roman peace and stability.[490]

There are also strong indications that Luke not only copied the
style and themes of Josephus, he also copied details from *Antiquities*,
making many careless or perhaps deliberate errors in the process.

490 Bond, 2015, p. 156. See also Downing, 1982.

1 Quirinius and the census

Luke states that,

> In those days a decree went out from Emperor Augustus that all the
> world should be registered. This was the first registration and was taken
> while Quirinius was governor of Syria. (Luke 2:1-2)

But the first census of Augustus was in 28 BCE,[491] and Quirinius was
not appointed governor of Syria and Judea until 6 CE when Herod
Archelaus was banished to Vienna. From Josephus we know that the
census of Quirinius was a local affair.[492]

2 Lysanias, and the territory that he once ruled

Luke's story of the public ministry of John the Baptist starts off
with a very elaborately given date:

> In the fifteenth year of the reign of Emperor Tiberius, when Pontius
> Pilate was governor of Judea, and Herod was ruler [tetrarch] of Galilee,
> and his brother Philip ruler [tetrarch] of the region of Ituraea and
> Trachonitis, and Lysanias ruler [tetrarch] of Abilene, during the high
> priesthood of Annas and Caiaphas, the word of God came to John son
> of Zechariah in the wilderness. (Luke 3:1-2)

This is impossible as the fifteenth year of Tiberias was 29 CE and
the tetrarch Lysanias was killed by Mark Antony during the reign
of Cleopatra.[493] Josephus refers to Abila as "which last had been the
tetrarchy of Lysanias."[494] A cursory reading of this passage (which
includes the names Philip and Trachonitis also mentioned by Luke)
might give one the impression that Lysanias occupied the throne

491 *Res Gestae Divi Augusti*, 8.
492 *Wars of the Jews*, Book 7.8.1. *Antiquities*, Book 18.20.1 and Book 20.5.2.
493 *Antiquities*, Book 15.4.1.
494 *Antiquities*, Book 20.7.1.

until it was added to the territory of Agrippa II in 53 C.E.[495]

But why does Luke mention Abilene anyway? Burkitt contends that,

> . . . the way that Josephus mentions Abila and Lysanias explains both difficulties on the hypothesis that the Evangelist derived his information from a somewhat careless perusal of the Twentieth Book of the Antiquities.[496]

3 the Judean famine and Paul's relief effort

In Acts we read,

> At that time prophets came down from Jerusalem to Antioch. One of them named Agabus stood up and predicted by the Spirit that there would be a severe famine *over all the world*; and this took place during the reign of Claudius. The disciples determined that according to their ability, each would send relief to the believers living in Judea; this they did, sending it to the elders by Barnabas and Saul. (Acts 11:27-30)

But Paul says,

> Now concerning the collection for the saints: you should follow the directions I gave to the churches of Galatia. On the first day of every week, each of you is to put aside and save whatever extra you earn, so that collections need not be taken when I come. And when I arrive, I will send any whom you approve with letters to take your gift to Jerusalem. If it seems advisable that I should go also, they will accompany me. (1 Corinthians 16:1-4)

Paul's version of this relief effort differs from Luke's in several important respects.

495 Bond, 2016, p. 156.
496 Burkitt, 1906, p.110.

a) This is Paul's initiative.[497] He has not been directed by any disciples or inspired by any prophecies.

b) This is a long-term project spanning many weeks, not emergency relief.

c) The collection is to be delivered by anyone whom the church approves, with letters from Paul, not necessarily Paul.

d) Paul makes no mention of food, famine, prophets from Jerusalem, Agabus or Antioch.

e) If the famine was "over all the world" as Luke says the believers in other provinces would hardly be in a position to help others.

The source of the story in Luke-Acts is Josephus. There was a local famine in Judea in the years 46 -48 when Tiberius Alexander was made procurator of Judea.[498] This famine was relieved by Queen Helena of Adiabene and her son Izates, who had converted to Judaism.[499] Josephus makes no mention of donations from any other sources.

4 Judas and Theudas

In Acts we read,

> Then he [Gamaliel] said to them, "Fellow Israelites, consider carefully what you propose to do to these men. For some time ago Theudas rose up, claiming to be somebody, and a number of men, about four hundred, joined him; but he was killed, and all who followed him were dispersed and disappeared. *After him* Judas the Galilean rose up *at the time of the census* and got people to follow him; he also perished, and all who

497 2 Corinthians 9:1-5.

498 Accessed at https://en.wikipedia.org/wiki/Tiberius_Julius_Alexander. See also *Antiquities*, Book 20.5.2.

499 *Antiquities*, Book 20.2.5. "Now her coming was of very great advantage to the people of Jerusalem; for whereas a famine did oppress them at that time, and many people died for want of what was necessary to procure food withal, queen Helena sent some of her servants to Alexandria with money to buy a great quantity of corn, and others of them to Cyprus, to bring a cargo of dried figs. And as soon as they were come back, and had brought those provisions, which was done very quickly, she distributed food to those that were in want of it, and left a most excellent memorial behind her of this benefaction, which she bestowed on our whole nation."

followed him were scattered. (5:35-37)

It is true that Judas fomented a revolt at the time of the census under Quirinius[500] but he came forty years before Theudas. Theudas revolted in the years 44 to 46.[501] Luke has carelessly reversed the order.

5 the Egyptian

Luke has Paul before a tribune in Jerusalem, where the tribune says,

> "Do you know Greek? Then you are not the Egyptian who recently stirred up a revolt and led the *four thousand assassins* out into the wilderness?" (Acts 21:38)

In Josephus *four hundred* of the Egyptian's prophet's followers are killed, when Felix is governor.[502] The "assassins" are the *sicarii* who are a different group of rebels, who appear at the time of his successor Porcius Festus. (c.59-62)[503]

The impetus for the writing of Luke-Acts

Josephus' *Antiquities of the Jews* was published in 93 CE. As already noted, about 15 years earlier, Josephus' other famous work *Wars of the Jews* covering the period to 75 CE had been published, and this book contained no reference to Christians or Jesus. This omission, I believe, prompted the Jewish Christians in Rome to write the

500 *Antiquities*, Book 18.1.1.

501 Burkitt, 1906, p. 106. "Now it came to pass, while Fadus was procurator of Judea, that a certain magician, whose name was Theudas, persuaded a great part of the people to take their effects with them, and follow him to the river Jordan; for he told them he was a prophet, and that he would, by his own command, divide the river, and afford them an easy passage over it; and many were deluded by his words." *Antiquities*, Book 20.5.1.

502 *Antiquities*, Book 20.7.6.

503 *Antiquities*, Book 20.8.10.

first version of Matthew. However, it is my contention that in the second prestigious tome by Josephus, his *Antiquities*, the Gentile Christians found not silence as before but something altogether alien, and it was this discovery that triggered an urgent need for a written response.

The Gentile Christians' anti-Jewish bias probably would have led them to conclude that Josephus had deliberately suppressed or lied about the origins of Christianity in both books, but this was a more serious blow that threatened the very foundations of the church — their recently constructed myth of origins.

In our version of the text of *Antiquities* Josephus says nothing about Christians. But we know that this version has been tampered with. The famous reference to Jesus in Book 18, which is known in scholarly circles as the *Testimonium Flavianum*, is an obvious Christian interpolation.[504] If there has been addition, then a possible subtraction should also be considered. Josephus diligently recorded the traditions of the various sects of the Jews and defended Rabbinical orthodoxy against the threat posed by Greek philosophy. Likewise, newly emergent Christianity, especially by the mid-nineties, must have been seen as an existential threat to Judaism.[505] It is more than likely in the opinion of this author that Josephus *did* say something about Christian origins, but what he did say has been edited out by Christians in a later century. And as Josephus wrote *Antiquities of the Jews* to correct misconceptions about the origins and history of the Jews[506], so Luke-Acts was published to correct the "mistakes" of Josephus.

504 This is discussed in more detail in the Appendix.

505 The Jews also opposed preaching Christianity to the Gentiles. 1 Thessalonians 2:14-16.

506 *Against Apion*, 1.1. See also Paul's letter to the Galatians in which he sets out to put right certain misconceptions about *his* origin, and the origin of *his* gospel.

John the Baptist in the gospels

Observe that Paul never mentions John the Baptist or in any way connects him to Jesus, and it seems that passages about John the Baptist in the text of Matthew did not form part of the original story but were inserted later.[507] Josephus does not mention John the Baptist in *Wars of the Jews*, only in the later publication *Antiquities*[508]. But what Matthew says about John is incompatible with Josephus, hence it appears he was using a different and earlier source as a basis for his account. That source could have been Justus of Tiberias, a rival historian whom Josephus regarded as a scoundrel and thoroughly unreliable.[509]

Luke contains details about the birth of John but leaves out the lurid story of the daughter of Herodias asking for John's head on a platter.[510] Luke's version of the story is compatible with Josephus whereas Matthew's is not.[511] In Josephus, Herod has John taken to the fortress of Macherus where he is executed away from the public gaze because he fears John might instigate an insurrection. Herodias is mentioned earlier in the narrative, but she has no dealings with John.

Luke's other sources

Luke did not always use Josephus. In Acts we read,

> On an appointed day Herod [Agrippa] put on his royal robes, took his seat on the platform, and delivered a public address to . . . [the people of Tyre and Sidon]. The people kept shouting, "The voice of a god, and not of a mortal!" And immediately, because he had not given the glory

507 Powell, 1994, p. xx, p. 133ff.

508 Book 18.5.2.

509 See *Life of Josephus*.

510 Matthew 14:1-12. Mark combines details of the stories from both Matthew and Luke, while leaving out the account of John's birth. (Mark 6:14-29)

511 Luke 9:7-9.

to God, an angel of the Lord struck him down, and he was eaten by worms and died.[512]

There are major discrepancies between this account and what we read in Josephus. The account in Josephus doesn't mention the king's chamberlain Blastus, posits a different reason for Agrippa's speech, is more charitable to the king and leaves out the theme of a gruesome death as divine punishment. Here Luke seems to have used a different source, a source that was much more critical of the Herodians than Josephus.

Augustus and Jesus

> In those days a decree went out from Emperor Augustus that all the world should be registered. (Luke 2:1)

Brent declares,

> The author of Luke-Acts clearly wishes to associate the birth of Jesus with Augustus, the mention of whose name in connection with the account of the birth of the true Messiah is evocative of many of the themes of the Imperial Cult.[513]

When the Republic ended in 27 BCE, Augustus became *princeps* (the first citizen), *imperator* (military commander-in-chief) and head of the Roman public religion, the *Pontifex Maximus*. Julius Caesar was declared a god by the Roman Senate (believed by many to undergo a literal apotheosis), hence Augustus, his adopted son[514], was declared Son of God (*Divi filius*) and, for his so-called restoration of

512 *Acts* 12:20-23 and *Antiquities,* Book 19.8.2.

513 Brent, 1997, p. 430.

514 The Ebionites held that Jesus was adopted. Epiphanius, *Panarion*, Book 1.30.16.3 Also "You are my Son, today I have begotten you" (Psalm 2:7) is quoted in Hebrews 1:5 and 5:5.

the Republic, also called Saviour.[515]

Scheid notes that,

> In Roman state, cult excess consisted in claiming direct cult during one's own lifetime. Only tyrants did this. A "good" emperor was content, at this level, with a cult to his Genius, his Numen, and his other virtues.[516]

Hence the cult of the deified Emperor developed after his death. In the same way, the cult of Jesus as a humble son of god developed after his "death." Augustus provided the model for the character of Jesus, by eschewing honours and adopting humility during his lifetime.

> All who exalt themselves will be humbled, and all who humble themselves will be exalted. (Matthew 23:12 and repeated twice in Luke)

Rabbinic parables

Rabbinic literature contains almost 5,000 parables.[517] The following is an example of a rabbinic parable:

> Rabbi Eliezer the son of Azariah would say . . . One whose wisdom is greater than his deeds, what is he comparable to? To a tree with many branches and few roots; comes a storm and uproots it, and turns it on its face. As is stated, "He shall be as a lone tree in a wasteland, and shall not see when good comes; he shall dwell parched in the desert, a salt land, uninhabited."[518] But one whose deeds are greater than his wisdom, to what is he compared? To a tree with many roots and few branches, whom all the storms in the world cannot budge from its place. As is stated: "He shall be as a tree planted upon water, who

515 The Roman emperor & the imperial cult: interactions with Greco-Roman religions & Christianity, accessed at http://www.ipso-facto.com/SalonLectureSeries.htm

516 Edmondson, 2009, p. 298.

517 Bivin & Blizzard, 2002, Kindle Loc 357.

518 Jeremiah 17:6.

spreads his roots by the river; who fears not when comes heat, whose leaf is ever lush; who worries not in a year of drought, and ceases not to yield fruit"[519]

The same idea is expressed by Jesus in Matthew 7:24-27, "Everyone then who hears these words of mine and acts on them will be like a wise man who built his house on rock, . . ." and so on. When Jesus speaks, he speaks with authority. (v 29) The proof texts which are a feature of the Rabbinical parables have been omitted by the gospel writers to imbue Jesus with an air of authority.

The total number of unique parables in the gospels is reckoned at 37.[520] Many parables are repeated in different gospels. Mark for example only contains two parables which are not contained in the other two gospels. There are no parables in the gospel of John showing that this gospel did not use the same source material as the other gospels.

The sermon on the mount

The sermon on the mount is found in chapter five of Matthew. Luke's version of the event has Jesus delivering the sermon on a plain.[521] There are structural differences between the two versions.

In Matthew there are eight "blessed are ..." units addressed in the third person. The ninth unit is in the second person and does not fit the pattern. This unit has been added later and borrowed from Paul's first letter to the Corinthians.[522] Luke is more consistent than Matthew and has four units addressed in the second person and he balances these with four "woe to you..." units which follow.

519 Jeremiah 17:8. Accessed at http://www.chabad.org/library/article_cdo/aid/2019/jewish/ Chapter-Three.

520 Accessed at https://en.wikipedia.org/wiki/Parables_of_Jesus

521 Luke 6:12-49.

522 1 Corinthians 4:12-13. See https://www.academia.edu/35974269/Jesus_quotes_Paul_ Comparing_a_passage_in_Matthew_5_with_a_passage_in_1_Corinthians_4

The apocryphal *Acts of Paul and Thecla* written in the second century contains a similar list of blessings.[523]

Moral precepts from Cicero

The moral precepts of the Christians can be derived from the writings of the Roman philosopher/statesman Cicero.

> He lives and will continue to live in the memory of the ages, and so long as this universe shall endure — this universe which, whether created by chance, or by divine providence, or by whatever cause, he, almost alone of all the Romans, saw with the eye of his mind, grasped with his intellect, illumined with his eloquence — so long shall it be accompanied throughout the ages by the fame of Cicero.[524]
>
> Roman Historian, Velleius Paterculus, 1st century.

Cicero was born in Italy in 106 BCE and rose to the rank of Consul in 63 BCE. He was famous for his rhetorical skills, his knowledge of the law and his extensive writings which encompassed speeches, personal letters and philosophical works. He introduced Romans to the chief schools of Greek philosophy and created a Latin vocabulary for many philosophical terms which are still in use today in English translation, words such as *evidence, humanity, quality* and *quantity*. He was executed in 43 BCE on the orders of Mark Antony.

The master architect and chief transmitter of *universalism* was Cicero, as Michael Grant points out in *The World of Rome*:

> The Renaissance of the fourteenth and fifteenth centuries was above all a Renaissance of Cicero, and even when, for purposes of communication,

523 (1.12-22) "Blessed are the bodies and souls of virgins; etc". This book promoted virginity.
524 Velleius Paterculus, *Roman History*, Book 2.66.

the national vernaculars superseded his language, they long remained, like the morality and oratory which they expressed, beneath Cicero's spell.[525]

What is in Cicero is in Matthew (and the other gospels) and what is even more telling, what is NOT in Matthew (or the other gospels) is also *NOT in Cicero*. Questions which dog the church today, for example the question of homosexuality was dealt with extensively by Paul but is absent from the gospels. It is also absent from Cicero. [526]

The question of abortion is absent from both Paul and the gospels. It is also absent in Cicero.[527]

I have listed in the Appendix twenty-four examples of teachings which are common to both the gospels and Cicero.

In the 19th century Trollope made the following observation.

I remember no passage in Livy or Tacitus indicating a religious belief. But with Cicero my mind is full of such; and they are of a nature to make me feel that had he lived a hundred years later I should have suspected him of some hidden knowledge of Christ's teachings.[528]

Cicero was famous in the first century as Livy attests.

525 Fishwick, 2007, p. 177.

526 When Pericles was associated with the poet Sophocles as his colleague in command and they had met to confer about official business that concerned them both, a handsome boy chanced to pass and Sophocles said: "Look, Pericles, what a pretty boy!" How pertinent was Pericles's reply: "Hush, Sophocles, a general should keep not only his hands but his eyes under control." *On duties*, Book 1.144.

527 The only reference I could find was in *Pro Cluentio* (On behalf of Aulus Cluentius), 32. "I recollect that a certain Milesian woman, when I was in Asia, because she had by medicines brought on abortion, having been bribed to do so by the heirs in reversion, was convicted of a capital crime; and rightly, inasmuch as she had destroyed the hope of the father, the memory of his name, the supply of his race, the heir of his family, a citizen intended for the use of the republic."

528 Trollope, 1880, p.322.

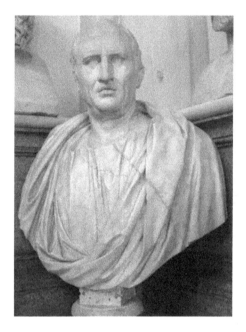

Fig. 31: *A sculpted bust of Roman Orator, Lawyer, Philosopher and Statesman Marcus Tullius Cicero. Featured in the Capitoline Museum in Rome, Italy.* Creative Commons License, Wikipedia.

> However, if any one will weigh accurately his virtues against his vices, he will come to the conclusion that he was a great, energetic, and remarkable man, and one who would require the eulogies of a second Cicero to do justice to his merit.[529]

Jerome in the fourth century had been addicted to Cicero and was accused in a divine vision of being a follower of Cicero and not of Christ.[530] Grant states that Erasmus, considered to have been one of the greatest scholars of the northern Renaissance, "insisted that this pagan's moral doctrines were more truly Christian than many a discussion by theologians and monks."[531]

The gospels leave out the subtlety of Cicero. The maxims are much abbreviated and simplified, but the claim that Jesus' teaching was in any way superior or unique must surely fail. In Cicero the inventors of the teachings of Jesus had a sure master and model.

529 Livy, Fragments of the *History of Rome*, Book 120.
530 Letter 22.30.
531 Cicero & Grant, 1971, p.41.

It is not unlikely that the writer of the first gospel could read Latin and hence Cicero, especially so if he were a native of the Latin West and Rome in particular. There are Latinisms in Matthew. [532] Claudius revoked the citizenship of a man who did not know Latin.[533] Paul changed his name from the Hebrew Sh'aul to the Latin, Paulus. (Acts 13:9)[534] We find that of the about 600 inscriptions from the Jewish catacombs in Rome 21% are in Latin.[535] It didn't take long for the Greek scriptures to be translated into Latin, a process that began in the late second century, if not before.[536]

Mark

In Eusebius, we have an account of the writing of Mark which contains some important comments. In our thesis, Peter was dead when the gospel was written. Eusebius reports on a tradition that Peter *through a revelation of the Spirit* learned of the writing of Mark, and that *the work obtained the sanction of his [Peter's] authority for the purpose of being used in the churches.*[537] This suggests a posthumous approval.

What Eusebius says about Mark could apply to any or all of the synoptic gospels; that is, the Roman church (represented by Peter) sanctioned the gospels and *authorized their use in the churches.* Papias, quoted in Eusebius, also says that Mark was not a disciple and "neither heard the Lord nor followed him," but got his information second hand as it were from Peter.[538] Its simple construction and the Aramaic

532 Powell, 1994, p.211. Especially Matthew chapter 27.

533 Cassius Dio, *Roman History* 60.17.

534 It is also noteworthy that the name Saul(os) does not appear among Diaspora Jews but does so quite often in Palestine. Lieu, 1992, p.31.

535 Horst, 2014, p.13.

536 Plater & White, 1926, p.3.

537 *Ecclesiastical History*, Book 2.15.

538 *Ecclesiastical History*, Book 3.39.

expressions[539] (with accompanying explanations) inserted throughout the text is a literary device aimed at generating authenticity. The author is unfamiliar with the geography of Palestine. (see Mark 7:31) Mark was written to be most economical with words. It is the shortest gospel containing 60% of the number of words occurring in Matthew and 57% compared with Luke.[540]

Mark appears to have been written as a summary or epitome of Matthew. Augustine of Hippo (c. 400 CE) asserts that Matthew was written first and that,

> Mark follows him closely, and looks like his attendant and epitomizer. For in his narrative he gives nothing in concert with John apart from the others: *by himself separately, he has little to record*; in conjunction with Luke, as distinguished from the rest, he has still less; but in concord with Matthew, he has a very large number of passages. Much, too, he narrates in words almost numerically and identically the same as those used by Matthew, where the agreement is either with that evangelist alone, or with him in connection with the rest.[541] [my emphasis]

Books in the ancient world were expensive. The writer of Acts makes special mention of the cost of the books burned by converted magicians. (19:19) A professionally produced copy of a single Gospel, even of second-quality scribal work, might well have cost the equivalent of $1,000 in today's money.[542]

Christians quickly adopted the new technology of the codex or leaf-form book in the first century as the proper medium of religious literature. The advantages were portability, ease of consultation

539 That Mark was written by one versed in Aramaic is clear from the citations of Aramaic expressions peculiar to this gospel. But that it was actually written in Greek and intended for Gentiles is attested by the explanatory glosses relating to specifically Jewish matters. Grintz, 1960, p.33.

540 Duling et al, 1994, p 14.

541 *The Harmony of the Gospels*, Book 1.2

542 Hull, 2010, p. 15.

and comparative cost vis-a-vis the scroll.[543] A shorter book would naturally be cheaper to produce. Mark omits superfluous sections such as the genealogies and improves some of the miracle stories such as the healing of the Gerasene demoniac.[544] The alternate endings of Mark attest to its use as a didactic work in a codex format. The final message is to preach the gospel.

Powell states that,

> The original beginning of 'Mark', like the end of it, has been lost, presumably a victim to the common fate which overtakes the first and last pages of books, more easily if in the form of a codex rather than a roll.[545]

It may also be true that the introduction contained information about the origin of the book that later authorities wished to suppress, or thought was unimportant. (for example, its provenance and its patron and its author).

Dykstra claims that Mark's primary purpose was to defend the vision of Christianity preached by Paul against his Jewish Christian opponents.[546] Mark's gospel he asserts borrows from Paul's epistles, and bolsters the authority of the epistles. [547]

Barnabas, Paul's co-worker and author of one extant letter, had a cousin called Mark. (Colossians 4:19) Paul says Mark was "useful in my ministry" possibly because he was a youth (2 Timothy 4:11) and the writer of 1 Peter has a son called Mark. (5:13) As the gospel of Mark was written quite late someone who was younger than the apostles would fit the bill. If 1 Peter was written by Paul, as Harnack believed, then the author could have been Paul's son.

543 Hull, 2010, p. 180.

544 In Luke the demons beg not be sent *back into the abyss*, in Mark it is *out of the country*.

545 Powell, 1994, p. 53.

546 Dykstra, 2012, p.23.

547 Dykstra, 2012, p.27.

CHAPTER FIFTEEN

The early history of the gospels

WHEN JUSTIN MARTYR (C. 150) MENTIONS THE GOSPELS, HE CALLS them the memoirs of the apostles. No names are assigned to them. Irenaeus (late second century) is the first writer to name them.[548] We can now understand why the name "Matthew" was chosen for the first Jewish version of the gospel. This was the Jewish name of its inspirer, Josephus.[549] We can reasonably surmise that the name Luke was chosen for the second gospel because Luke was associated with Paul, and this gospel was written for the Gentile ecclesias in Rome.[550]

Clement writing about 97 seemed to sanction all three gospels as when quoting the words of Jesus, he creates an amalgam of sayings from Matthew, Luke and Mark.

> Remember the words of our Lord Jesus Christ, how He said, "Woe to that man [by whom offences come]! It were better for him that he had never been born, than that he should cast a stumbling-block before one of my elect. Yea, it were better for him that a millstone should be hung

548 Ehrman, 2012, p. 225
549 Josephus, *Life of Flavius Josephus.*
550 Colossians 4:14, 2 Timothy 4:11, Philemon 1:24

about [his neck], and he should be sunk in the depths of the sea, than that he should cast a stumbling-block before one of my little ones."[551]

How the literature was used

The early Christians were encouraged to read the Old Testament as this provided proof that the newly minted Jesus was the predicted Messiah. (Luke 24:27, Acts 8:28, 2 Timothy 3:16) The Old and New Testaments were read at early church meetings, as Justin Martyr attests.

> And on the day called Sunday, all who live in cities or in the country gather together to one place, and the memoirs of the apostles or the writings of the prophets are read, as long as time permits; then, when the reader has ceased, the president verbally instructs, and exhorts to the imitation of these good things.[552]

Whether the 'memoirs of the apostles' included Paul's letters is a moot point, but another early document attributed erroneously to Peter includes Paul's letters in the canon of accepted scripture. (2 Peter 3:14-16)

Persecution

When the writer of 1 Peter addresses the believers, they are suffering persecution and abuse—both official (*the fiery ordeal*) and unofficial (*you are maligned*). He also says,

> Like a roaring lion your adversary the devil prowls around, looking for someone to devour. Resist him, steadfast in your faith, for you know that *your brothers in all the world are undergoing the same kinds of suffering.* (5:8–9)

551 *Letter to the Corinthians* 46. The gospel versions are in Matthew 18:6, 26:24, Luke 17:2 and Mark 9:42.

552 *The First Apology*, 67.

This could be a reference to persecution under Domitian, which also appears to be the persecution which the Book of Revelation alludes to.[553] This was a new development as Paul writing his second letter to the Corinthians, says that despite severe hardship and beatings none had been killed. (6:9) Eusebius says,

> Domitian, having shown great cruelty toward many, and having unjustly put to death no small number of well-born and notable men at Rome … finally became a successor of Nero (sic) in his hatred and enmity toward God. He was in fact the second that stirred up a persecution against us, although his father Vespasian had undertaken nothing prejudicial to us.[554]

Jones notes that,

> Pliny (*Ep.* 10.96.1) did claim that he had never attended a *cognitio* of Christians (i.e. a trial presided over by a magistrate with *imperium*): so, presumably, such examinations were conducted during Domitian's reign. [555]

Suetonius records that the news of Domitian's assassination was greeted with indifference by the general public. The senators, on the other hand,

> . . . were delighted, and thronged to denounce the dead Domitian in the House with bitter and insulting cries. Then, sending for ladders, they had his votive shields and statues hurled down before their eyes and dashed to the ground; and ended by decreeing that all inscriptions referring to him must be effaced, and *all records of his reign obliterated*.[556] [my emphasis]

553 "When he opened the fifth seal, I saw under the altar the souls of those who had been slaughtered for the word of God and for the testimony they had given." Revelation 6:9.

554 *Ecclesiastical History*, Book 3.17 and 20.

555 Jones, 1992, p.115.

556 *Domitian*, 23.

The noble lie

The admitted Christian fabrication called the *Acts of Paul and Thecla* was written in the middle of the second century by a presbyter in Asia Minor,[557] and the aim of the presbyter was a noble one. He wanted to present to his spiritual sisters the character of the virgin Thecla as an example of piety and courage. However, despite the writing being condemned by the church leader, Tertullian, belief in Thecla could not be contained—so much so that Thecla's popularity came to rival that of Mary.[558] Indeed, the cult of Thecla flourished, and Thecla was given a place among the pantheon of Christian martyrs[559]—even though no such person had ever existed.

The publication of the tale of Thecla is an example of an *other-oriented lie*. These lies are told "for other people's benefit (materialistic gain), to make others appear better (psychological gain), to avoid another person's materialistic loss/punishment, or to save the other person from psychological damage."[560]

Vrij notes that people "typically do not feel bad when telling such lies and therefore may not show any cues to deceit when telling them. Also since other-oriented lies contain information that . . . [others] want to hear, they may not be motivated to detect such lies."[561]

Vrij continues,

Finally, people tend to invest emotionally in their relationships, and some information can threaten the relationship. In those instances, people may not see through lies, because they do not want to—the ostrich effect.[562]

557 Tertullian, *On Baptism*, 17.

558 Davis, 2001, p. 4.

559 Davis, 2001, p. 5.

560 Vrij, 2008, p. 20.

561 Vrij, 2008, p. 154.

562 Vrij, 2008, p. 154.

For Plato, lying, as in the case of the noble lie, may be the most effective way to propagate truth.[563]

The gospels and the ostrich effect

One reason why lies remain unnoticed is that often people do not attempt to detect them, because they do not want to learn the truth.[564] There are at least three reasons why someone might not want to know the truth.

1 A fabrication might sometimes sound more pleasant than the truth, and in such cases ignorance may be preferable.

2 People sometimes do not investigate whether they have been lied to because they fear the consequences the truth may hold.

3 People sometimes do not want to detect lies because they would not know what to do if they came to know the truth.[565]

The church as it developed approved some stories (that is those which agreed with its central theme and passed a loose credibility test[566]) and discarded others (that is those which did not). The same process can be seen in the acceptance and rejection of Hadith (stories about Mohammed) by Muslims in the evolution of Islam.

The preaching of the gospel to households rather than individuals ensured that defecting from the faith had severe consequences. In such circumstances, it was safer for individuals to assent to the lie than question it.

563 Gill & Wiseman, 1993, p.55.

564 Vrij, 2008, p. 2.

565 Vrij, 2008, p. 3.

566 The well-known story of the woman caught in adultery (John 7:52-8:11) is a scribal addition which does not appear in the earliest versions of John's gospel. (Ehrman, 2006, p. 3)

How to lie effectively

Elaboration makes a lie more believable. Understanding a story facilitates believing it.[567] As we progress from the gospel of Matthew to the gospel of Mark, we find increasing amounts of elaboration. For example, if we compare the stories of the Gadarene/Gerasene demoniac in Matthew, Luke and Mark we can see that a clear process of elaboration and improvement of the earlier story has occurred.[568]

The Great Apostasy

Records show that Mormonism, after the first flush of revelation and purpose and success, passed through a period of disillusionment, apostasy and betrayal.[569] Likewise, Christianity was in crisis after the first wave of enthusiasm died down. The emperor Domitian took control of the empire in 81, and the imperial tolerance exercised by Vespasian and Titus faded.[570] Jesus had still not returned as political saviour as promised by the apostles and resistance to the new religion was growing. Doctrinal disputes about circumcision, the resurrection, marriage, and food shook the faith of some. Other believers for one reason or another decided to jump ship and were castigated for loving the present world, looking back after putting their hands to the plough or returning to their previous life as a dog "turns back to its own vomit." (2 Timothy 4: 9-16, Luke 9:62, 2 Peter 2: 21-22)

The younger Pliny records a Christian apostasy around the year 90 in one of his letters to Trajan (c. 111 CE).

567 "...the mere comprehension of a statement entails the tacit acceptance of its being true, whereas disbelief requires a subsequent process of rejection." (Shermer, 2012, p. 134)

568 Matthew 8:28-34 → Luke 8:26-39 → Mark 5:1-20.

569 Brodie, 1963, p. 245.

570 *Ecclesiastical History*, Book 3.17.

Others, whose names were given me by an informer, first said that they were Christians and afterwards denied it, declaring that they had been but were so no longer, some of them having recanted many years before, and *more than one so long as twenty years back.* [my emphasis]

Heresies

This era of crisis was the impetus for creating new literature to support the competing claims for authenticity. Hence, we have extant various gospels or Acts of Jesus which never made it into the Canon and various other documents found at Nag Hammadi in Egypt and elsewhere, which while pretending to be ancient and original are underpinned by very current anti-heresy polemic. Each group had their own sacred literature, claimed to represent the truth and regarded all other Christians as heretics.

One of the main heresies to be countered in the early days was the heresy of uncertain or substitutionary crucifixion. For example, Tertullian reports,

Afterwards broke out the heretic Basilides . . . Christ, moreover, he affirms to have. . . come in a phantasm, and been destitute of the substance of flesh: that it was not He who suffered among the Jews, but that Simon was *crucified in His stead.*[571] [my emphasis]

This heresy was carried forward into Islam, where we read in the Koran,

. . . they [the Jews] did not kill him, nor did they crucify him; but [another] was made to resemble him to them. And indeed, those who differ over it are in doubt about it. They have no knowledge of it except the following of assumption.[572]

571 *Against all heresies*, chapter 1.
572 Quran 4:157–158.

Epiphanius in his *Panarion* ("Medicine Chest") describes no less than 80 different heresies, many of which sprang up very early in the history of the religion.

The gospel of John

We know that the Gospel of John, the fourth witness, was written to thwart the teachings of heretics.[573] Jerome says,

> John . . . most recently of all the evangelists wrote a Gospel, at the request of the bishops of Asia, against Cerinthus and other heretics and especially against the then growing dogma of the Ebionites [or Jewish Christians], who assert that Christ did not exist before Mary.[574]

Bringing the sacred ideas to Rome

We have, in the bringing of the religion of Cybele to Rome in 204 BCE, some common features with the bringing of Christianity to Rome in the year 70. In 204 BCE, the second Punic War was raging, and Rome was in mortal peril. Hannibal had crossed the Alps and had defeated the Roman legions in three battles on the peninsula.

The Roman historian Livy (c. 60 BCE–c. 15 CE) states,

> The city was at that time suddenly engaged in a consideration respecting religion. Frequent showers of stones having fallen, the Sibylline books were on that occasion inspected; in which were found certain verses, importing, that "whensoever a foreign enemy shall have carried war into the land of Italy, he may be expelled and conquered, if the Idaan Mother be brought from Pessinus to Rome."[575]

573 Ebionite ritual baptisms are countered in John 13:1-11 See *Panarion*, Book 30.21.2-5.
574 *De Viris Illustribus*, John (9).
575 Livy, *History of Rome*, 29.10.

At Pessinos in Phrygia (modern Turkey), the mother goddess—identified by the Greeks as Cybele—took the form of an unshaped stone of black meteoric iron.[576] This was the aniconic stone that was removed to Rome in 204 BCE.[577]

After some deliberation, the senate chose the best man in the city for the important task of greeting the goddess. Publius Cornelius Scipio was "ordered to repair to Ostia, to meet the goddess, attended by all the matrons; to receive her himself from the ship, and then to deliver her to the said matrons, to be transported to the city." The goddess was warmly welcomed by the populace.

> "All the city poured out to meet her, censers being placed before the doors, wherever the procession passed, and incense burned in them; all praying that she would enter the city with good will, and a favourable disposition."[578]

The crisis of invasion in 204 BCE is analogous to the political crisis of 69, the year of the four emperors. At both times portents were observed, holy books were consulted, and sacred ideas were imported from a far-off land. At both times, a new religion was espoused—one was officially sanctioned, the other was not.

576 Accessed at https://en.wikipedia.org/wiki/Cybele
577 Is this the stone that the Arabs and now Muslims worship at Mecca?
578 Livy, *History of Rome*, 29.14.

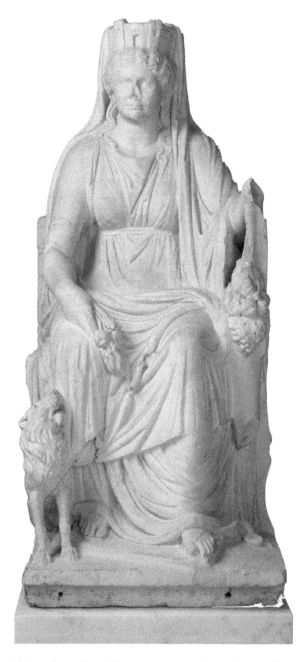

Fig. 32: *Cybele enthroned, with lion, cornucopia and mural crown. Roman marble,*
c.50 CE. Getty Museum.

THE TIMELINE

The following table highlights significant events in the development of Christianity.

Year	Event
66	The Roman-Jewish War begins.
68	Nero commits suicide. The year of the four emperors begins. Chaos in Rome. Paul, about 20 years old, flees from Gischala in Galilee and settles in Tarsus in Cilicia (in Modern Turkey), taking his parents with him. (Hence the traditional epithet "Paul of Tarsus" although he is really a Galilean by birth.)
68-71	Paul practises rhetoric and is given some authority in Tarsus, (perhaps as leader in the synagogue) which prepares him for an authoritative and persuasive position in the church. (Galatians 1:14)
69	Vespasian becomes emperor.
70	The Temple and Jerusalem destroyed in August. There is mass dislocation in the region as refugees flee war ravaged Palestine. The rumour that the Messiah has come spreads throughout the Empire. The idea attracts God fearing Gentiles as well as some Jews. Sometime after August the risen Jesus appears to Cephas, then the twelve (also known as *the brothers of the Lord*), then to 500, then James, then all the apostles except Paul. (1 Corinthians 15) These appearances occur in Galilee, probably at Mount Tabor.

71	Paul and other Rabbis (especially Pharisees) persecute the new sect of Jewish Christians, which has arisen partly spontaneously, partly by word of mouth. Paul is particularly zealous and beginning from Tarsus makes his way south by road to Damascus, persecuting the new sect as he advances towards Jerusalem.
72	Paul is affected by the stories of suffering and faith he hears along the road and finally in or close to Damascus, he changes his mind. (Galatians 1:17) He explains this as receiving a divine revelation from Jesus. He immediately sets off for Arabia where he stays for three years. (Compare the early life of Josephus, Paul's contemporary, who as a young man stayed with a desert dwelling ascetic for 3 years, before deciding on a life philosophy.)
73	The termination of the Roman-Jewish War with the capture of the last Jewish stronghold of Masada. Judea and Galilee are now completely subdued.
75	Paul who is now about 27 years old returns to Damascus, three years after his initial revelation. He then visits the former Essenes(?), James and Cephas in Jerusalem for 15 days. (Galatians 1:18-19) After receiving their blessing Paul begins his missionary work preaching to the Gentiles in Syria and Cilicia. He teams up with fellow Jew Barnabas. Despite quoting reams of Scripture they fail to convince Jews. (Acts 13:46)
75-79	Josephus publishes *Wars of the Jews* in Rome, making no mention of Christians.

76-80	The Jewish Gospel of Matthew, claiming Jesus was crucified under Pontius Pilate, is written in Greek by a member of the sect of Jewish Christians in Rome. The writer falsely claims to have obtained a document from Palestine written in Hebrew which he has translated. The book aims to explain the origins of Christianity and fill a perceived gap in the first century history of the Jews as portrayed by Josephus. Paul preaches in Galatia and is treated badly. (2 Timothy 3:11)
77	Pliny the Elder completes his *Naturalis Historia* (Natural History) without mentioning Christians.
78	Paul writes 1 Corinthians from Ephesus. Paul visits Macedonia in the summer. Paul is mistreated in Philippi. (1 Thessalonians 2:2)
79	Paul writes his first letter to the Thessalonians from Athens in the first half of the year. He cannot return to Macedonia due to a travel ban. ("Satan blocked our way") Vespasian dies in June. Titus becomes emperor. The eruption of Vesuvius in October destroys Pompeii and Herculaneum. Dust from the explosion is recorded in Syria and Egypt. (Cassius Dio, *Roman History*, 66.23) There is also "a plague, such as was scarcely ever known before". (Suetonius, *Titus*) Many including some Christians think it is the end of the world. The pseudo-Nero (Terentius Maximus) appears in Asia and Paul thinks his appearance heralds the end. He describes him as the "man of lawlessness". Paul writes to the Roman Gentile Christians from Corinth in the winter of 79/80, warning that there will be "affliction and distress upon every soul of man that doeth evil." (Romans 2:9) The eruption of Vesuvius is alluded to in the passage, "the wrath of God is revealed from heaven against all ungodliness." (1:18) Paul leaves Corinth for Jerusalem with monetary relief for the impoverished Jewish-Christians in Judea. (15:25-26)

80	The Jerusalem Conference is held in March/April the Jewish Passover. Paul attends the conference. Paul has a confrontation with Cephas in Antioch on his way back to Ephesus(?) after the conference. Paul resumes his missionary activities. He writes to the Galatians. He writes to Timothy from Corinth advising him to stay in Ephesus. In winter at the end of the year Paul is in Nicopolis, on route to Rome. He writes to the brother Titus who is in Crete.
81	Paul crosses the sea to Brundisium in Italy from Nicopolis in spring. This is the shortest route to Rome. Titus the emperor is more relaxed about stoic philosophers who had been expelled from Rome by his father Vespasian. Hence Paul seizes the opportunity to go to Rome. He writes the letter called 1 Peter to the churches in Asia. But Titus dies suddenly in September and his brother, the less tolerant Domitian begins his reign.
81-83	Paul is betrayed by the Jewish Christians in Rome who are envious of his prestige and success. He is put under house arrest. He writes to the Laodiceans in a letter called Ephesians in our Bible. Then a second letter to Timothy, written in autumn of 82 as winter is approaching. Finally, Philemon, Colossians, and Philippians are written in that order.

83	At his second trial after two years imprisonment Paul is unexpectedly released. His punishment probably includes banishment from Rome. He then leaves Rome for Spain, as he planned. In Gades or Cadiz he dies "under the prefects", but not as a martyr. He has accomplished his mission to preach to the whole world. The sudden departure of Paul creates a crisis in the Gentile church as the prophetic period must now be "sealed." Their response is to adopt the book accepted by the Jewish Christians as the explanation for the movement's origins and re-publish it with some changes even borrowing and paraphrasing a passage from one of Paul's letters (Matthew 5:11 and 1 Corinthians 4:11-13). This is the Gentile version of Matthew, or what is known today in our Bibles as simply *The Gospel according to Matthew*.
90?	James dies and Symeon is elected bishop of Jerusalem. The main Roman Gentile sect elects Clement as their bishop, replacing Linus.
93	Josephus publishes *Antiquities of the Jews*, in which he mentions Christians but not in a way that Christians approve.
94-95	As a counter to the perceived errors in Josephus, the *Gospel according to Luke* and the *Acts of the Apostles* are jointly written and published in Rome under the leadership of Clement. Luke-Acts while pretending to be an independent history is written to answer critics and overcome some of the defects of Matthew. It is more comprehensive than Matthew because it covers the apostolic period after Jesus had supposedly passed off the scene, and it reflects some developments in theology, for example the role of women in the church and the question of wealth/poverty.

96	The tyrant Domitian is assassinated. Nerva replaces him and relaxes but does not abolish the annual poll tax on Jews.
97	The respite from persecution under Domitian provides the setting for Clement's letter to the Corinthians, warning against sedition and advocating obedience to the church hierarchy. Mark is written as a harmonization of Matthew and Luke, with some improvements and elaborations. While sticking with the main narrative this 'back to basics' text omits contentious and "academic" passages and presents Jesus as a man of action. By making the story more believable and accessible, and adopting the codex format, this shorter work is well suited to evangelization.
98	Upon the death of Nerva, the moderate and capable Trajan becomes emperor.

PART 2

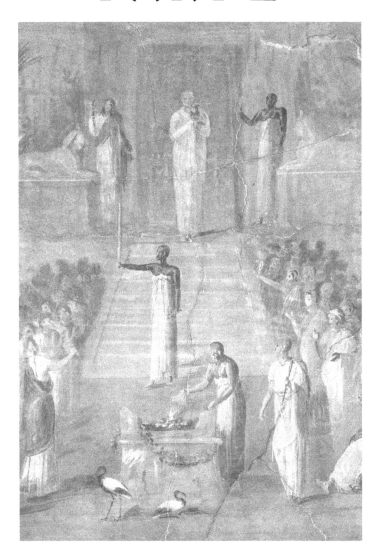

The Late Appearance
of Christianity

Explanatory Introduction

THERE ARE NO CHRISTIAN WRITINGS OF ANY ACCURATELY DATEABLE quality before Justin Martyr (circa 150[579]). The dating of all so called "early" documents before about 150 is speculative, and is usually based on a predetermined paradigm, leading to circular reasoning. We can often determine the *terminus a quo* – the limit from which a writing must proceed eg Matthew's gospel or the Epistle of Barnabas – from the year 70, however, the *terminus ad quem* – the point in time that the writing must have preceded – is often quite late, usually arrived at by noting a quotation in the work of an author who can be reliably dated. [580]

579 "And it is not out of place, we think, to mention here Antinous, who was alive but lately, [died 130 CE] and whom all were prompt, through fear, to worship as a god, though they knew both who he was and what was his origin." Justin Martyr, *First Apology*, 29.

580 The Pompeii Graffito is evidence for Christianity before 79, but not before 70. Wayment & Grey, 2015.

Evidence from church fathers

I *Jesus living into his fifties*

Jesus living into his fifties or later is an odd notion to those used to the orthodox image of Jesus, but understandable as an explanation in order to have him born under Augustus (according to some gospels) while not actually launching the new religion until much later. From Irenaeus, orthodox bishop of Lyon (late second century) we have,

> ...but from the fortieth and fiftieth year a man begins to decline towards old age, *which our Lord possessed while He still fulfilled the office of a Teacher,* even as the Gospel and all the elders testify; those who were conversant in Asia with John, the disciple of the Lord, [affirming] that John conveyed to them that information. And he [John or Jesus] remained among them up to *the times of Trajan* [98-117]. Some of them, moreover, saw not only John, but the other apostles also, and heard the very same account from them, and bear testimony as to the [validity of] the statement.[581] [italics added]

It is unclear which gospel Irenaeus is referring to. According to the chronology of Luke, Jesus was born in 6 CE when Quirinius took over from Herod Archelaus as governor of Judea. (Luke 2:2) And the gospel writer has him dying under Pontius Pilate who passed off the scene in 36 CE. This makes Jesus no older than 31 when his life ended.

The reason Irenaeus portrays Jesus as an elderly sage can possibly be explained if we consider the image of Heracles in Gaul, where Irenaeus was bishop. Here, if Lucian is to be believed, the locals made him out to be as "old as old can be: the few hairs he has left (he is quite bald in front) are dead white, and his skin is wrinkled and tanned as black as any old salt's." In the painted pictures, this Heracles

581 Irenaeus, *Works*, Book 2.22.

(or Ogmius as he was known to the locals) had a following of a vast crowd of men eager to hear him, "fastened by the ears with thin chains composed of gold and amber,"[582] and literally hanging on his every word.

2 *The list of Jerusalem bishops*

By examining the list of Epiphanius[583], we can see that all early Jerusalem bishops had short careers (average 3 to 5 years) with the sole exception of the second bishop named Symeon, who oddly has a career of at least 30 years, and lived according to Eusebius, to the age of 120. This anomaly has been caused by the early church historians attempting to fit a limited list of names into a long and artificial time frame. See Appendix 1 for a detailed discussion of this anomaly.

3 *The unbelievable longevity of some early Christian leaders*

John lives to a hundred plus (?)

John is recorded in Galatians 2:9 along with Cephas and James as being one of the pillars of the church in Jerusalem. Tradition would place John as being active from about 30, the supposed year of Jesus' death. Notwithstanding the fact that the average life expectancy in ancient Roman times was less than 30 years[584] we have John still active in the reign of Trajan, that is after the year 98.

Irenaeus says,

582 *Heracles, an introductory lecture*, in Lucian, 1905, p. 256.

583 *Panarion*, Book 2.v.20.

584 Stark, 1996, p. 155. "Historical demographers agree that "the average lifetime of the ancients was short" (Durand 1960:365). And although there have been some disagreements among those who have attempted to estimate life expectancies from Roman tomb inscriptions (Burn 1953; Russell 1958; Durand 1960; Hopkins 1966), none challenges that life expectancy at birth was less than thirty years-and probably substantially less (Boak 1955a)."

Then, again, the Church in Ephesus, founded by Paul, and having John remaining among them permanently until the times of Trajan, is a true witness of the tradition of the apostles.[585]

Eusebius records that John, after the death of Domitian in 96, was nimble enough to ride a horse and chase down a youth who was attempting to flee from him.[586]

The legendary longevity of John has echoes in the fourth gospel, where the writer of what appears to be an appendix, skilfully weaves the well-known "longevity" of John into the story (John 21:20-25). Also, it indicates that the gospel or at least the appendix was written after John's death.

Symeon, second bishop of Jerusalem, lives to a hundred and twenty(!)

According to Hegesippus, Symeon was betrayed by some heretics when he was 120 years old.[587] The number 120 seems to have been chosen for the lifespan of Symeon from the post-diluvian upper limit of age referenced in Genesis, "My spirit shall not abide in mortals forever, for they are flesh; their days shall be one hundred twenty years." (Genesis 6:3)

4 *Polycarp is instructed by the apostles*

Polycarp, the bishop of Smyrna, was martyred in the year 155 at the earliest.[588] Assuming he was 80 when he died, he would have been 20

585 Irenaeus, *Heresies*, Book 3.3.4.

586 *Ecclesiastical History*, Book 3.23.

587 'Some of these heretics, forsooth, laid an information against Symeon the son of Clopas, as being of the family of David, and a Christian. And on these charges he suffered martyrdom when he was 120 years old, in the reign of Trajan Caesar, when Atticus was consular legate in Syria.' Hegesippus, *Commentaries on the Acts of the Church*, quoted in Eusebius, *Ecclesiastical History*, Book 3.32.

588 Some have proposed later dates, for exsample Eusebius, 166–7 CE. Minns, 2010, p.1.

in the year 95. This dating places Polycarp *and the apostles* at the end of the first century.

Irenaeus, bishop of Lyons in the latter half of the second century writes,

> Polycarp, too, was not only instructed by the apostles, and conversed with many who had seen Christ, but was also appointed Bishop of the Church in Smyrna by apostles in Asia, whom I also saw in my early youth, for he tarried (with us on earth) a very long time.[589]

5 *The testimony of Quadratus*

Quadratus who wrote an apology for Christians to the emperor Hadrian (117-138) is quoted as saying,

> But the works of our Saviour were always present, for they were genuine—those that were healed, and those that were raised from the dead, who were seen not only when they were healed and when they were raised, but were also always present; and not merely while the Saviour was on earth, but also after his death, they were alive for quite a while, so that *some of them lived even to our day.*"[590] [italics added]

Jerome concurs and adds that Quadratus was *a disciple of the apostles.*[591]

6 *The Temple destroyed FIRST*

The Temple is destroyed FIRST, *then* AFTER THAT the gospel is preached to the Gentiles. Peter is reported to have said the following words to the recalcitrant Jews.

589 Irenaeus, *Against Heresies*, Book 3.3.
590 *Ecclesiastical History*, Book 4.3.
591 Jerome, *De Viris Illustribus*, 19.

. . . the temple shall be destroyed, and the abomination of desolation shall stand in the holy place [Daniel 9:27 and Matthew 24:15]; *and then the Gospel shall be preached to the Gentiles for a testimony against you, that your unbelief may be judged by their faith.*[592]

According to this witness the gospel was not preached to non-Jews till after 70. This runs counter to the accepted tradition that has Jesus commissioning the apostles about the year 30.

7 Jerusalem falls, then Christians appear first in the 'Decapolis'

We can reasonably surmise that the first Christians were Jewish Christians who were later labelled heretics—their name, *Ebionites* signifies "poverty."[593] There was no leader called "Ebion". But the other information provided by the Christian heresiologist, Epiphanius is instructive. Epiphanius says,

> Their origin [the Ebionites] came *after the fall of Jerusalem.* For since *practically all who had come to faith in Christ had settled in Peraea* then, in Pella, a town in the 'Decapolis' the Gospel mentions, which is near Batanaea and Bashanitis—as they had moved there then and were living there, this provided an opportunity for Ebion.[594]

However, the Acts and the gospels paint a different picture. They have Paul and the other apostles preaching and establishing churches all around the Mediterranean, converting swathes of Asia Minor well before Jerusalem was taken. But Epiphanius records that *practically all who had come to faith in Christ had settled in Peraea,* at the time of the

592 *Clementine Recognitions,* 64.

593 Blessed are the poor *in spirit.* Matthew 5:3. The original saying was probably, Blessed are the poor.

594 Epiphanius, *Panarion,* Book 30.2.7.

fall of Jerusalem in 70. And not only this—the Ebionites, that is the Jewish Christians, *came after* the Jewish War.

It is hardly coincidental that the region where Jesus allegedly preached and healed, the setting for the gospel stories, the Decapolis in Galilee, is the same region that the very first Christians called home.

8 *Those "raised" by Jesus alive after 117*

Philip of Side quoting Papias, says

> Concerning those who were raised from the dead by Christ, [he relates] that they lived until Hadrian.[595]

According to the gospel of Mark, Jairus' daughter who was raised from the dead by Jesus, was twelve-years-old. (5:42) Assuming Jesus performed the miracle in the year 30, she would have lived to be more than 99. Other adults such as Lazarus (John 11) and the young man from Nain (Luke 7) would have been well over a hundred when Hadrian became emperor in 117. While not accepting that anyone was actually *raised from the dead*, the passage speaks of people much more recently touched by Jesus, however that may be interpreted. It points to an origin or source for the stories much more recent than 30 CE.

9 *Aphrahat: "from the time... the old was abolished"*

Aphrahat, a Syriac-Christian monk (c. 280–c. 345) says,

> For the uses of the law are abolished by the advent of our Life-giver, and *He offered up Himself in the place of the sacrifices which are in the law*, and *He*

595 Philip of Side, *Fragment* 4.6.

was led as a lamb to the slaughter in the place of the lambs of propitiation, and He was killed for us (as) a fattened bull, that there might be no necessity for us to offer the offspring of cattle. He came and He was lifted up upon the cross; oblations and sacrifices are not required from us; He gave His blood in place of all men, that the blood of animals might not be required of us; He entered the sanctuary which was not made by hands, and He became the priest and minister of the holy place. *For from the time in which He came He abolished the observances which are of the law, and from the time that they bound Him the festivals were bound for them by chains; and because they wished to judge the innocent One He took the judges away from them;* and *because they rejected His kingdom He took away the kingdom from them,* . . ., and the works which are in the law have grown old and become antiquated and fit for destruction, for *from the time the new was given the old was abolished.*[596]

In another place Aphrahat says, "But Daniel testifies that, when Christ comes and is slain, Jerusalem shall be destroyed."[597] The sacrifices continued under the Mosaic Law right up to the year 70 therefore Jesus "came" in the year 70, the same year that Jerusalem was destroyed.

10 *Clement of Rome, his letter and Paul*

The letter to the Corinthians assigned to Clement of Rome (see Chapter 12) is dated to about 97CE. This bishop may be the same Clement mentioned by Paul in his letter to the Philippians (4:3).[598] Church historian Eusebius thinks so and equates the writer of the epistle with the bishop and co-worker of Paul.[599] Clement explains that the writing of the letter was delayed due to some "sudden and

596 *Demonstration* 2.6, On charity.

597 *Demonstration* 17.10, On Christ the Son of God.

598 Staniforth, 1968, p.18.

599 *Ecclesiastical History*, Book 3.4.

successive calamitous events" in Rome. He is probably referring to persecution under Domitian. (see Item 13) Clement says Paul and Peter are from "our own generation." Clement says Paul had recently been executed "under the prefects". (Chapter 5) Eusebius says,

> He [Clement] had seen and conversed with the blessed apostles, and their preaching was still sounding in his ears, and their tradition was still before his eyes. Nor was he alone in this, for many who had been taught by the apostles yet survived. [600]

If the letter is genuine, and Eusebius thought it was, Clement and Paul shared the same generation. In fact, they knew each other, and they both flourished late first century after the Jewish War.

11 *The evidence of Jerome*

Jerome intimates that Paul was active after the War. From Jerome's *Lives of Illustrious Men*, we have the following.

> Paul, formerly called Saul, an apostle outside the number of the twelve apostles, was of the tribe of Benjamin *and the town of Giscalis in Judea. When this was taken by the Romans* he removed with his parents to Tarsus in Cilicia.[601] [italics added]

NOTES:
1. Gischala is NOT in Judea. It is in Galilee. Palestine was annexed to the Roman Empire in 70 as an imperial province and given the name *Judaea*. [602]

600 *Ecclesiastical History*, Book 5.6

601 *De Viris Illustribus*, 5.

602 Katz, 2008, p.25.

2. Gischala was taken by the Romans under Titus in 67.[603] It was the last town in Galilee to be taken by the Romans.[604]

We can interpret this to mean that Paul was still a young man when he moved to Tarsus to escape the Romans. This is completely at odds with the Acts version of events. Note once again *the connection with Galilee*, as the provenance of Christianity. See Item 7 above.

12 *Heresies mentioned by Paul*

Heresies *mentioned by Paul* were invented late first century or early second century according to the church historians.

Irenaeus (c 130 - c 200) says,

> They [the heretics Basilides and Saturninus] declare also, that *marriage and generation are from Satan*. Many of those, too, who belong to his school, *abstain from animal food*, and draw away multitudes by a reigned temperance of this kind. [605]

Paul makes mention of the same heresies in his letter to Timothy.

> They forbid *marriage* and *demand abstinence from foods*, which God created to be received with thanksgiving by those who believe and know the truth. (1 Timothy 4:3)

The Cerinthians believed that Jesus was crucified and buried but not yet raised. Some believed that the dead will never rise.[606] Paul refuted these doctrines which were extant in Corinth in his day. (1 Corinthians 15:12-34)

603 Accessed at https://en.wikipedia.org/wiki/Galilee_campaign_(67)

604 See Josephus, *Wars of the Jews*, Book 4.2.

605 Irenaeus, *Against Heresies*, Book 1.24.

606 Epiphanius, *Panarion*, Book 1.28.6.1-8

Epiphanius says,

> Now this man [Cerinthus] is one of the ones who caused the trouble *in the apostles' time*, when James wrote the letter to Antioch and said, 'We know that certain which went out from us have come unto you and troubled you with words, to whom we gave no such commandment.' (Acts 15:24) [italics added]

Tertullian admits that the heresies existed in the time of Paul.

> Besides all this, I add a review of the doctrines themselves, which, existing as they did in the days of the apostles, were both exposed and denounced by the said apostles. [607]

If these heresies existed in 40 to 50 why are there no documents relevant to these heresies, either apologetic or polemic, from the mid first century? It is much more likely that the heresies arose at the same time as the orthodox version of Christianity, not 40 years later.

13 *The first persecution of Christians*

The first general persecution of Christians seems to have occurred during the reign of Domitian (81-96). This has been discussed in chapter 15. (The so-called first persecution under Nero is spurious – see Appendix II.)

In Suetonius we have,

> Domitian's agents collected the tax on Jews [the Fiscus Judaicus] with a peculiar lack of mercy; and took proceedings not only against those who kept their Jewish origins a secret in order to avoid the tax, but *against those who lived as Jews without professing Judaism.* [608][italics added]

607 *Prescription against Heretics* 33
608 *Lives of the Twelve Caesars,* Domitian in Graves & Grant, 2003, p.312.

From Philip of Side, we have,

> Domitian, the son of Vespasian, having demonstrated many wicked [qualities/acts] to the Romans who were governmental officials, was the second [sic] to conduct a persecution against the Christians. [609]

Church historian Orosius (c. 375- c. 418) declares,

> For fifteen years this ruler progressed through every degree of wickedness. Finally he [Domitian] dared to issue edicts for a general and most cruel persecution to uproot the Christian Church, *which was now very firmly established throughout the world.* [610][italics added]

In Eusebius we read,

> He [Domitian] was in fact the second [sic] that stirred up a persecution against us, although his father Vespasian had undertaken nothing prejudicial to us. [611]

The reason Vespasian (or Titus) did not persecute Christians may have been because the adherents were not numerous enough at that time (between 69 and 81) to attract imperial attention or they may have felt some sympathy for the plight of Jews and those with Jewish leanings in general. However, it is likely that there was initially local opposition, from Jews and pagans (Acts 17:1-9). Where only Jews were involved these matters may have been dismissed by Roman authorities as "questions about words and names and your own law." (Acts 18:15) The Romans would only have intervened if there were threats to public order. Various incidents are recorded in Acts which may be based on actual events. By analogy the Book of Mormon was published in 1830 and local persecution of Mormons began almost immediately. The

609 Fragment 4.3 Philip of Side.
610 *Historiae Adversus Paganos*, Book 7.10. But see Jones, 1992, pp 114-7.
611 *Ecclesiastical History*, Book 3.17.

persecutors were "composed of various religious parties, but mostly Campbellites, Methodists and Baptists."[612] These events did not escape the notice of the media, and the general populace. In the same fashion, we can rightly surmise that if Christians had existed between 30 and 70 the reaction of orthodox Jews to their presence would have been noted by Josephus, and other Jewish historians.

Paul records persecution in the late 70's which was probably local and not instituted by the emperor.

> We are hard pressed on every side, but not crushed; perplexed, but not in despair; persecuted, but not abandoned; struck down, but not destroyed. (2 Corinthians 4:8-9, perhaps written in 78)

> In fact, when we were with you, we kept telling you that we would be persecuted. And it turned out that way, as you well know. (1 Thessalonians 3:4, possibly written early 79)

Later in his career, Paul is on trial in Rome. (2 Timothy 4:16, Philippians 1:12-14, 4:22) Everything points to this occurring under Domitian. When Domitian was murdered in 96 all records of his deeds were destroyed by order of the Senate,[613] and this may explain why we do not have more information about persecution of Christians at this time.

14 Daniel, Tertullian and the coming of the "Leader"

Concerning the Old Testament Book of Daniel, Schurer says,

> The high estimation in which from the first this book was held by believing Israelites is best shown by the fact that it always continued to retain its place in the canon. [614]

612 Church of Jesus Christ of Latter-day Saints & Roberts, 1902, Vol 1, p.265.
613 Suetonius, *Domitian*, 23.
614 Schurer, 1972, p. 53.

Daniel was quoted and referenced by both Jews and Christians in the first century as predicting the imminent end-time.[615] For our purposes the relevant passage in the context of a somewhat obscure prophecy is,

> After the sixty-two weeks, an anointed one shall be cut off and shall have nothing, and the troops of the prince who is to come shall destroy the city and the sanctuary. (9:26)

The early Christian author, Tertullian (c. 155 – c. 240) in arguing against the Jews for the coming of Christ as a past event says that the "leader" is destroyed at the same time as the city is destroyed. Everyone agreed that the city had been destroyed. He says,

> Accordingly, the times must be inquired into of the predicted and future nativity of the Christ, and of His passion, and of the extermination of the city of Jerusalem, that is, its devastation. For Daniel says, that "both the holy city and the holy place are exterminated *together with the coming Leader*, and that the pinnacle is destroyed unto ruin."[616] [italics added]

He also says in another place,

> For the Scripture says thus, that "*the city and the holy place are simultaneously exterminated together with the leader,*"--undoubtedly (that Leader) who was to proceed "from Bethlehem," and from the tribe of "Judah." Whence, again, it is manifest that "the city must simultaneously be exterminated" at the time when its "Leader" had to suffer in it, (as foretold) through the Scriptures of the prophets. [617][italics added]

615 Quoted in Matthew as, "So when you see the desolating sacrilege standing in the holy place, as was spoken of by the prophet Daniel (let the reader understand)," (24:15)

616 *Adversus Judaeos*, 8.

617 *Adversus Judaeos*, 13.

Although Tertullian in a contradictory fashion goes on to argue for the orthodox chronology of the birth of the Christ it can be seen that an observer in the first century would quite naturally link the destruction of the sanctuary (that is, the Temple) with the death of the anointed one (that is, the Christ). There would have been no reason from the point of view of Daniel's prophecy to backdate the death of Jesus.

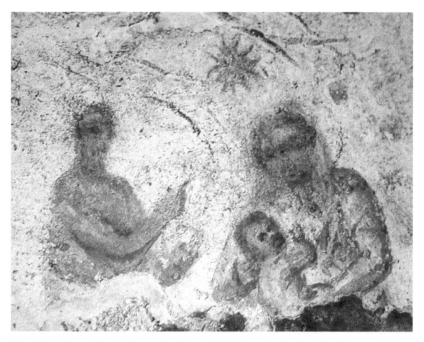

Fig. 33: *Balaam (?) pointing to the Star of Bethlehem in the Priscilla Catacomb, Rome (late 2nd to 4th Century).*

Evidence from astronomy

15 *The sign of a star*

The sign of a star (actually Halley's comet) appeared in 66 CE. Its previous appearance had been in 12 BCE.[618] Josephus says,

> ... they [the Jews in Jerusalem] did not attend nor give credit to the signs that were so evident, and did so plainly foretell their future desolation, ... Thus there was a star resembling a sword, which stood over the city, and a comet, that continued a whole year.[619]

Tacitus says that in Rome,

> At the close of the year [64] people talked much about prodigies, presaging impending evils. Never were lightning flashes more frequent, *and a comet too appeared*, for which Nero always made propitiation with noble blood. Human and other births with two heads were exposed to public view, or were discovered in those sacrifices in which it is usual to immolate victims in a pregnant condition. And in the district of Placentia, close to the road, a calf was born with its head attached to its leg. Then followed an explanation of the diviners, that *another head was preparing for the world*, which however would be *neither mighty nor hidden*, as its growth had been checked in the womb, and it had been born by the wayside.[620] [italics added]

An allusion to this portent is written into Matthew's gospel as the heavenly sign, the star that the wise men from the east followed. (Matthew 2:2). That Jesus was neither "mighty nor hidden" is also related in the second chapter of the gospel according to Matthew.

618 Accessed at https://en.wikipedia.org/wiki/Halley%27s_Comet
619 *Wars of the Jews*, Book 6.5.3.
620 *Annals*, 15.47.

Ignatius of Antioch says specifically that Jesus was revealed as a star, which heralded the ruin of the ancient kingdom.

> How then, was he [Jesus] revealed to the ages? A star, brighter than all other stars, shone in the heaven, and its brightness was ineffable and its novelty brought forth astonishment. But the rest of the stars, together with the sun and the moon, formed a choir around the star; but it exceedingly outshone them all with its light. Now it was perplexing to know the origin of this novelty *which was* unlike anything else. Thereupon all magic was dissolved, every bond of malice disappeared, ignorance was destroyed, *the ancient kingdom was ruined*, when God appeared in the form of a human to give us newness of an eternal life. (Letter to the Ephesians 19)

It would have been obvious to first century Jews that Old Testament prophecy had been fulfilled in the year 66. The divine seer Balaam[621] is reported to have said,

> I see him, but not now; I behold him, but not near—a star shall come out of Jacob, and a sceptre shall rise out of Israel. (Numbers 24:17)

The star prophecy was also mentioned in the War Scroll (11) found at Qumran.

16 *The sign of the sword*

Josephus says, "There was a star resembling *a sword, which stood over the city...*"[622] [italics added]

Jesus says,

> Do not think that I have come to bring peace to the earth; I have not come to bring peace, but *a sword*. (Matthew 10:34)

621 Puech, 2008, p. 25ff.

622 *Wars of the Jews*, Book 6.5.3.

The Old Testament prophet Ezekiel was instructed to warn Israel and Jerusalem. In chapter 21 we read,

> The word of the Lord came to me: Mortal, set your face toward Jerusalem and preach against the sanctuaries; prophesy against the land of Israel and say to the land of Israel, Thus says the Lord: I am coming against you, and *will draw my sword out of its sheath*, and will cut off from you both righteous [623] and wicked. (1-3)

> A sword, a sword is sharpened, it is also polished; it is sharpened for slaughter, honed to flash like lightning! (9-10)

> Remove the turban, take off the crown; things shall not remain as they are. Exalt that which is low, abase that which is high. A ruin, a ruin, a ruin—I will make it! (Such has never occurred.) *Until he comes whose right it is; to him I will give it.* (26-27)

The coming of the one whose right it was to govern is associated with the appearance of the sword over the city.

623 The Septuagint has "the lawless one and unjust one."

Evidence from the New Testament

17 *Paul wrote after the Jews were punished*

The humiliation and defeat of the Jews is a past event in Paul's writings. In Paul's first letter to the believers in Thessalonica, he writes

> ...the Jews ... killed both the Lord Jesus and the prophets, and drove us out; they displease God and oppose everyone by hindering us from speaking to the Gentiles so that they may be saved. Thus they have constantly been filling up the measure of their sins; *but God's wrath has overtaken them at last.*[624] (1 Thessalonians 2:14-16)

The letter to the Romans was written after 70. Paul says, regarding the Jews,

> I ask, then, has God *rejected his people*? (11:1)
> They *were broken off* because of their unbelief. (11:20)
> There will be anguish and distress for everyone who does evil, *the Jew first* and also the Greek. (2:9)

Four years after the end of the Great War in 1918, Pope Pius XI issued his first encyclical *Ubi Arcano Dei Consilio.* In this work of about 11,500 words the Great War is mentioned 14 times. Nine years later the same term gets only one mention in his much longer *Quadragesimo Anno.* Both encyclicals deal with similar themes.

Using the writings of the Pope as a guide and noting the indirect references to the War in Paul, we can reasonably speculate that he was writing about 10 years after the event.

624 "The interpretation suggested by Baur and others is still valid: I Thessalonians 2:16c refers to the destruction of Jerusalem in 70 A.D." Pearson, 1971, p. 83.

Fig. 34: *The warning tablet.*

Source: Istanbul Archeology Museum/Wikipedia Creative Commons License.

18 *Paul wrote after the Temple was destroyed*

Many New Testament scholars conclude that the letter to the Ephesians was written after 70CE, because it refers to the destruction of the dividing wall between the Court of the Gentiles and the Court of Israel in the Jerusalem Temple. [625] This letter was recognised by the early church as authored by Paul. [626] Irenaeus c. 170 declares it is the work of Paul. [627] Eusebius writing about 320 declared that *all* of Paul's fourteen epistles were well known and undisputed. [628]

According to Josephus [629] a five-foot wall separated the Outer Court of the Gentiles from a set of stairs that led to the sanctuary, the platform on which the Temple stood. Gentiles were warned by

625 Kitchen, 2002, p.65. Also "It has further been argued that the readers of Ephesians could understand the unique image of the broken wall in Eph 2:14 only if it is an allusion to the destruction of Jerusalem in A.D. 70." Barth, 1974, p.12.

626 Muratorian fragment dated c. 170.

627 *Against Heresies*, Book 5.

628 *Ecclesiastical History,* Book 3.3.

629 *Wars of the Jews*, Book 5.5.2.

Greek and Latin inscriptions fixed on pillars not to proceed beyond that point. [630] The Romans had given permission to the Jews to execute any who transgressed the prohibition. [631]

The warning tablet found in Jerusalem bears the following inscription in Koine Greek:

ΜΗΘΕΝΑ ΑΛΛΟΓΕΝΗ ΕΙΣΠΟΡΕΥΕΣΘΑΙ ΕΝΤΟΣ ΤΟΥ ΠΕΡΙ
ΤΟ ΙΕΡΟΝ ΤΡΥΦΑΚΤΟΥ ΚΑΙ ΠΕΡΙΒΟΛΟΥ ΟΣ Δ ΑΝ ΛΗΦΘΗ
ΕΑΥΤΩΙ ΑΙΤΙΟΣ ΕΣΤΑΙ ΔΙΑ ΤΟ ΕΞΑΚΟΛΟΥΘΕΙΝ ΘΑΝΑΤΟΝ

Translation: "No stranger is to enter within the balustrade round the temple and enclosure. Whoever is caught will be responsible to himself for his death, which will ensue."

In Ephesians we read,

For he [Christ Jesus] is our peace; in his flesh he has made both groups [Jews and Gentiles] into one and has broken down the dividing wall, that is, the hostility between us. (2:14)

Barth notes that, "the (aorist) tense 'he has broken down' reveals that Paul wants to speak of the factual, historical, completed destruction of the obstacle." [632]

The context of the passage is reconciliation of Jews and Gentiles and the constitution of a new temple. (v. 19-20) The author of Ephesians is clearly alluding to the wall which was broken down when the Romans destroyed the Temple at the conclusion of hostilities. Paul tells the believers that they now constitute a NEW temple, *a new dwelling place for God*. The passage in its context could only have been written after 70 CE.

630 Philo, *Embassy to Gaius*, 31.

631 "Have not you [Jews] been allowed to put up ... at due distances, and on it to engrave in Greek, and in your own letters, this prohibition, that no foreigner should go beyond that wall. Have not we given you leave to kill such as go beyond it, though he were a Roman?" *Wars of the Jews*, Book 6.2.4.

632 Barth, 1974, p. 263.

19 *Paul and the prominent Gospel character, John the Baptist*

Paul never mentions a forerunner to Jesus; he never mentions John the Baptiser, although he must have heard of him. John the Baptiser seems to have had no theological significance for Paul. This is odd because John the Baptiser is a central character in the Gospel narratives, and the baptism of John is also mentioned in Acts. We can explain the lack of interest by Paul by noting that John the Baptiser died about 36[633] and the rumour of Jesus appearance, in line with our argument, began about 70. Hence there would have been no reason for Paul and the earliest Christians to connect John to Jesus.

However, we read in the gospels that the disciples of John fasted while the followers of Jesus did not[634], so it may be true that John's teaching or a variation of it survived into the 90's. Arguments against the status of John can be found in the gospels. See John 5:36. The ancient sect of the Mandaeans honoured John and rejected Jesus as the Messiah.[635]

Matthew, the writer of the first gospel, was responsible for connecting the two lives as the contrived fulfilment of some passages from the prophets[636]—or perhaps Matthew was reporting what had become a common belief. Either way it served a theological purpose to have John meet Jesus so that the superiority of Jesus could be demonstrated. The existence of John in history also served as an anchor for stories about Jesus.

633 *Antiquities of the Jews*, Book 18.5.1.
634 Mark 2:18, Matthew 9:14
635 Buckley, 2002.
636 Matthew 3:1-3 from Isaiah 40:3.

20 *The witness of James as recorded in Acts*

The witness of James as recorded in Acts, makes the mission to the Gentiles contingent on the *rebuilding of Jerusalem.*

> After they finished speaking, James replied, "My brothers, listen to me. Simeon has related how God first looked favorably on the Gentiles, to take from among them a people for his name. This agrees with the words of the prophets, as it is written, 'After this I [the Messiah] will return, and I will *rebuild the dwelling of David, which has fallen; from its ruins I will rebuild it, and I will set it up, so that all other peoples may seek the Lord*—even all the Gentiles over whom my name has been called. Thus says the Lord, who has been making these things known from long ago.'" (15:13-18)

The rebuilding of the city of David (that is Jerusalem) can only occur after its destruction. It was destroyed in the year 70, hence the Gentiles were called after 70 CE.

21 *The parable of the widow and the unjust judge*

> He [Jesus] said, "In *a certain city* there was *a judge* who neither feared God nor had respect for people. In that city there was *a widow* who kept coming to him and saying, 'Grant me justice against my opponent.' For a while he refused; but later he said to himself, 'Though I have no fear of God and no respect for anyone, yet because this widow keeps bothering me, I will grant her justice, so that she may not wear me out by continually coming.'" And the Lord said, "Listen to what the unjust judge says. And will not God grant justice to *his chosen ones who cry to him day and night*? Will he delay long in helping them? I tell you, *he will quickly grant justice to them.* And yet, when the Son of Man comes, will he find faith on earth?" (Luke 18:2-8)

This parable contains many clues that show that it was based on events in the 60's. To confirm this, I recommend reading the original story in Josephus.[637]

- The city is Jerusalem
- The unjust judge is the procurator, Gessius Florus (64–66) who was renowned for being thoroughly unscrupulous, corrupt and impious.
- The widow is Berenice, widow of Alexander (44 CE) and widow of Herod of Chalcis (48 CE), who tried by constant efforts to relieve the plight of the Jews.[638]
- The chosen ones are the Jews, suffering injustice and oppression from the Romans under Florus.
- But they received no political justice, no political help from God. The Son of Man, Jesus, did come, but as the unexpected suffering servant – hence he was unrecognized. When he came as the parable says, he found *no faith on the earth.*

22 *Save us from the Romans*

At Jesus' supposed triumphal entry into Jerusalem the crowd celebrates. The gospel of Mark says,

> Then those who went ahead and those who followed were shouting, "Hosanna! Blessed is the one who comes in the name of the Lord! Blessed is the coming kingdom of our ancestor David! Hosanna in the highest heaven!" (Mark 11:9-10)

Hosanna

Hosanna means "Deliver [us] please!" or "Save [us] please!" It is the Greek transliteration of the Hebrew *hoshia-na,* or the Aramaic *hosha-na.* Ziffer notes that,

637 *Wars of the Jews,* Book 2.14.2ff.

638 Accessed at https://en.wikipedia.org/wiki/Berenice_(daughter_of_Herod_Agrippa)

It is used to this day in the synagogue in the special collection of Psalms found in all Jewish prayer books under the title of "Hallel!" that consists of Psalms 113-118. These psalms are chanted on certain festival days.[639]

Hosanna in the highest![640]

As it stands this phrase makes little sense. Why would the Jews in Jerusalem *on earth* be crying out for help "in the highest"?

Greek, "in the highest" is, *en tois hupsistois*. There could be, but there are no connecting words in the phrase such as "you who are", which would make the sentence meaningful. This would translate as "Please help, *you who are* in the highest."

The acclamation was probably made originally in Hebrew and translating back into that language, we get *bameromiym*. *ba* in Hebrew before another word means "in the". For example, in Job 16:19, we read, "Even now, in fact, my witness is in heaven, and he that vouches for me is on high (or in the heights) (Hebr. *bameromiym*)." *meromiym* is the plural of the noun *marom* which means "elevation, high place."

But the phrase still lacks an object. A useful solution to this problem presents itself, if we omit the *ba* altogether. We then get a different expression all together, but one which makes much more sense. Hence, we can safely say that the original expression was not *hoshia-na bameromiym*, but *hoshia-na meromiym*. *me* in Hebrew means "from." *romiym* means "Romans."

Now the phrase becomes "Please save us from the Romans!"

This urgent appeal to God makes sense as taking place between 66 and 70 CE as the Romans prosecuted their military action first in Galilee and then in Judea, and finally in the siege of Jerusalem.

639 Ziffer, 2006, p. 102.
640 Young's Literal Translation

23 *The gate of Nain*

We are told in the gospel of Luke that Jesus raised from the dead a young man who had lived in a town called Nain.

> Soon afterwards he [Jesus] went to *a town called Nain*, and his disciples and a large crowd went with him. As he approached *the gate of the town*, a man who had died was being carried out. He was his mother's only son, and she was a widow; and with her was a large crowd from the town. (7:11-12)[641]

Josephus describes Nain as a village in lower Galilee, which appears to agree with archaeological surveys. Conder and others who visited the site in 1882-8 say that "there are numerous traces of ruins extending beyond the boundary of the modern hamlet to the north, showing the place to have been once larger ...There is a small spring north of the village; a second, 'Ain el Baz, exists on the west, and beside it are rock-cut tombs, much defaced, and a tree."[642]

Prior to the Jewish War it appears that the town *had no wall* as Josephus says that the infamous leader of the revolt, Simon bar Giora "built a wall at a certain village called Nain, and made use of that as a fortress for his own party's security."[643] Luke says that Jesus and his party approached *the gate of the town.*[644] Clearly there could only have been a gate if there had been a wall. Hence the story appears to be set in a time after June 68 when, with Nero dead and the Roman campaign temporarily halted due to the confused state of affairs in Rome, the rebel leader Simon bar Giora set up a wall around the town and used it as a fortress.

641 This story bears many similarities to a story related by Apuleius; the saving of a man in a funeral procession, dressed ready for the funeral pyre and snatched from the jaws of death by the skill of the physician Asclepiades. (Florida 19)

642 Conder et al, 1998, p. 86.

643 *Wars of the Jews*, Book 4.9.4.

644 Cities were surrounded by walls, to defend them from their enemies. They were entered through "gates" placed at convenient distances from each other. In most cities it was not allowed to bury the dead within the walls; hence, they were carried to some convenient burial-place in the vicinity of the city. Barnes' Notes on the Bible, accessed at http://biblehub.com/commentaries/barnes/luke/7.htm

The Gospel of Barnabas connects the Roman occupation with this miracle. Barnabas says, "At that time the army of the Romans was in Judea, our country being subject to them for the sins of our forefathers." (48.1)

24 *Jesus reports the murder of Zechariah which occurred in 69*

Zechariah, the son of Baruch was murdered by Zealots in a show trial in the Temple court in the year 69.[645]

Jesus refers to this incident.

> Therefore I [Jesus] send you prophets, sages, and scribes, some of whom you will kill and crucify, and some you will flog in your synagogues and pursue from town to town, so that upon you may come all the righteous blood shed on earth, from the blood of righteous Abel to the blood of Zechariah son of Barachiah, whom you murdered between the sanctuary and the altar. Truly I tell you, all this will come upon this generation. (Matthew 23:34-36)

25 *Jesus and familial division*

Jesus preaches,

> Do you think that I have come to bring peace to the earth? No, I tell you, but rather division! *From now on* five in one household will be divided, three against two and two against three; they will be divided: father against son and son against father, mother against daughter and daughter against mother, mother-in-law against her daughter-in-law and daughter-in-law against mother-in-law." (Luke 12:51–53)

645 *Wars of the Jews*, Book 4.5.4.

Fig. 35: *David Roberts (1796-1864), The Siege and Destruction of Jerusalem by the Romans under the Command of Titus, A.D. 70*

Jesus says *from now on...* indicating that this generational division would come into effect immediately. However, when we search the gospels and Acts we do not find this. We do find division but it is never along the lines described in the prophecy. (Luke 12:13, John 10:19, Acts 14:4, Acts 23:7)

However, Josephus records demographic strife and division within families in Jerusalem about the year 68, as described by Jesus.

> There was also a bitter contest between those that were *fond of war*, and those that were *desirous for peace*. At the first this quarrelsome temper caught hold of *private families*, who could not agree among themselves; after which those people that were the dearest to one another brake through all restraints with regard to each other, and everyone associated with those of his own opinion, and began already to stand in opposition one to another; so that seditions arose everywhere, while those that were for innovations, and were desirous of war, *by their youth and boldness, were too hard for the aged and prudent men.*[646] [italics added]

Jesus' saying accurately describes the demographic strife (young versus old) that attended the period of turmoil in Jerusalem about the year 68.

26 *Baptised by fire*

In the gospel story, Jesus declares, "I came to bring fire to the earth, and how I wish it were already kindled!" (Luke 12:49) John the Baptist says of Jesus that he, "will baptize you with the Holy Spirit and fire." (Matthew 3:11)

It is significant that the outpouring of the Holy Spirit, the power that energised the first believers, is linked to the theme of fire.

To explain the link, the writer of Acts has Peter quote the Old Testament prophet, Joel. Peter allegedly spoke these words to

646 *Wars of the Jews*, Book 4.3.2.

explain the phenomena of Pentecost witnessed in Jerusalem after the ascension of the saviour.

> In the last days it will be, God declares, that I will pour out my Spirit upon all flesh, and your sons and your daughters shall prophesy, and your young men shall see visions, and your old men shall dream dreams. Even upon my slaves, both men and women, in those days I will pour out my Spirit; and they shall prophesy. And I will show portents in the heaven above and signs on the earth below, *blood, and fire, and smoky mist. The sun shall be turned to darkness and the moon to blood*, before the coming of the Lord's great and glorious day. (Acts 2:17-20)

The portents of blood, fire and smoke are designated signs of the last days and actually appeared when Jerusalem was consigned to the flames. Peter's speech refers to a contemporaneous event. The baptism by fire was experienced by believers who were trapped in Jerusalem.

Josephus says,

> Yet was the misery itself more terrible than this disorder; for one would have thought that the hill itself, on which the temple stood, was seething hot, as full of fire on every part of it, that the blood was larger in quantity than the fire, and those that were slain more in number than those that slew them; for the ground did nowhere appear visible, for the dead bodies that lay on it. ...but they [the Romans] ran everyone through whom they met with, and obstructed the very lanes with their dead bodies, and made the whole city run down with blood, to such a degree indeed that the fire of many of the houses was quenched with these men's blood. And truly so it happened, that though the slayers left off at the evening, yet did the fire greatly prevail in the night.[647]

Indeed, what Isaiah had prophesied was fulfilled.

And they shall go out and look at the dead bodies of the people who

647 *Wars of the Jews*, Book 6.8.5.

have rebelled against me; for their worm shall not die, their fire shall not be quenched, and they shall be an abhorrence to all flesh. (66:24)

27 *Poverty in Palestine*

Paul collected money from the diaspora Church to help the poor saints in Jerusalem.

> They [the Jerusalem elders] requested only that we remember the poor, the very thing I also was eager to do. (Galatians 2:10)

> For Macedonia and Achaia are pleased to make some contribution for the poor among the saints in Jerusalem. (Romans 15:26)

Poverty would have been the norm in Jerusalem and indeed throughout Palestine after the War. Wilson names economic collapse as one result of the War, "exacerbated by the awarding of lands to Roman veterans."[648]

28 *Taking the kingdom by force*

In Matthew we read,

> From the days of John the Baptist until now the kingdom of heaven has suffered violence, [OR has been coming violently] and the violent take it by force. (11:12)

There were several futile and violent attempts after John the Baptist (d. c.36 CE) to set up a Jewish kingdom.[649] These attempts culminated in the general insurrection of 66-70 and effectively ceased when the

648 Wilson, 1995, p. 3.
649 *Wars of the Jews*, Book 2.12.3, 17.6.

Temple was destroyed, and Jerusalem was taken. Other attempts at setting up a Jewish kingdom occurred after this, in 115 and 130, but assuming the gospel of Matthew was written before 115, we can adduce this passage to confirm that Jesus did not "appear" until after the rebellion was crushed in the year 70.

29 *I will destroy this temple*

At Jesus' trial before the Council, Matthew says,

> Now the chief priests and the whole council were looking for false testimony against Jesus so that they might put him to death, but they found none, though many false witnesses came forward. At last two came forward and said, "This fellow said, 'I am able to destroy the temple of God and to build it in three days.'" (26:59-61)

This so-called "false" testimony contains a kernel of truth. The destruction of the physical temple created the conditions for the building of a new temple, the church. [650] And the temple "made without hands" (Mark 14:58) was planted in the same place as the old temple was destroyed; Jerusalem. (Acts 6:7) The linking of the two events in time and place is significant.

30 *The consolation of Israel*

> Now there was a man in Jerusalem whose name was Simeon; this man was righteous and devout, looking forward to *the consolation of Israel*, and the Holy Spirit rested on him. (Luke 2:25)

This consolation would have been sought AFTER 70 CE, that is after the city, the temple and the country had been laid waste.

650 Paul says, "For God's temple is holy, and you [plural] are that temple." (1 Corinthians 3:17)

31 *The Acts of the Apostles is out of sync with its literary setting*

Luke has the disciples say,

"Lord, is this the time when you will *restore the kingdom to Israel?*" (Acts 1:6)

This passage would only have made sense in the 70's not the 30's, that is after Israel had been destroyed as a political state.

32 *Paul quotes from a text that was written after 70*

Paul quotes from an anonymous text called *Biblical Antiquities* that was written after the year 70, as it refers to the date Jerusalem was taken by Titus. [651]

This is Paul's quotation:

But, as it is written, "What no eye has seen, nor ear heard, nor the human heart conceived, what God has prepared for those who love him" — these things God has revealed to us through the Spirit.
(1 Corinthians 2:9-10)

651 "I will show thee the place wherein the people shall serve me 850 (MSS. 740) years, and thereafter it shall be delivered into the hands of the enemies, and they shall destroy it, and strangers shall compass it about; and it shall be on that day like as it was in the day when I brake the tables of the covenant which I made with thee in Horeb: and when they sinned, that which was written thereon vanished away. Now that day was the 17th day of the 4th month." Dr. Cohn's comment is: "These words are meant to signify that Jerusalem was taken on the 17th of Tamuz, on the same day on which the Tables of the Law were broken by Moses. The capture of Jerusalem by the Babylonians, however, took place on the 9th of Tamuz (Jer. 52:6; Cf. 2 Kings 25:3). The ... 17th of Tamuz can relate only to the second temple (*read* capture) as it is expressly mentioned in the Talmud (Taanith IV. 6, cf. *Seder Olam Rabbah*, cap. 6 and 30) that on that date the Tables of the Law were destroyed and Jerusalem was taken by Titus. Thus the author betrays himself by giving as the date of the capture of Jerusalem by the Babylonians what is really the date of the capture by Titus." *The Biblical Antiquities of Philo* – M. R. James, 1940.

This passage does not occur in the Old Testament [652], but does occur in *Biblical Antiquities*. [653]

The phrase as it stands could have been in common use before the year 70, but why would Paul say, *"as it is written"* if he did not have in mind a particular *written* text?

33 Christ is "born" when Titus is powerful

Counting from Augustus, the seventh emperor in Rome was Titus if we leave out the three who reigned briefly in 68-69. (Galba, Otho and Vitellius) The *great red dragon* of Revelation chapter twelve has seven heads and ten horns. The reference is clearly to Titus, who was responsible for the destruction of Jerusalem and the Temple. John says,

> His tail swept down a third of the stars of heaven and threw them to the earth. (v.4)

Then the dragon stands before a pregnant woman who is about to give birth in order to devour the child of the woman. The child is born and is snatched away to God and to his throne. It is clear from the context that the child is the potential political Messiah Jesus. Later we are told that

> . . . the dragon was angry with the woman, and went off to make war on the rest of her children, those who keep the commandments of God and hold the testimony of Jesus. (v.17)

652 A similar but different passage is found in Isaiah 64:4. "From ages past no one has heard, no ear has perceived, no eye has seen any God besides you, who works for those who wait for him."

653 And then will I take them and many other better than they, from that *place* which *eye hath not seen nor ear heard neither hath it come up into the heart of man*, until the like cometh to pass unto the world, and the just shall have no need for the light of the sun nor of the shining of the moon, for the light of the precious stones shall be their light." (26:12)

The woman's other children are Christians persecuted by the Roman authorities. The imagery suggests that Jesus is born during the reign of the dragon which has seven heads, that is Titus.

Evidence from extra-canonical works

34 *The Epistle of Barnabas written after 70*

The epistle of Barnabas is preserved complete in the 4th century *Codex Sinaiticus* where it appears at the end of the New Testament. Jerome (4th century) testifies that,

> Barnabas the Cyprian, also called Joseph the Levite, ordained apostle to the Gentiles with Paul, wrote one Epistle, valuable for the edification of the church, which is reckoned among the apocryphal writings.[654]

Barnabas, the very important companion of Paul and fellow apostle (Galatians 2:1ff) wrote the epistle *after the year 70.*

> Furthermore he says again, 'Behold, those who tore down this temple will themselves build it.' It is happening. For because of their fighting it was torn down by the enemies. And now the very servants of the enemies will themselves rebuild it. (16:3-4)

This letter was accepted as genuine by every early church father. One example is Clement of Alexandria.

> Barnabas, too, who in person preached the word along with the apostle in the ministry of the Gentiles, says, I write to you most simply, that you may understand.[655]

In his eschatology, Barnabas speaks of the three kings being subdued by one king. (4:4) This seems to indicate that he was writing in the time of the third king of the Flavian dynasty, Domitian (81-96), while awaiting the emergence of the resurrected Nero. (see Chapter 12)

654 *De Viris Illustribus,* 6.
655 *Stromata,* Book 5.10.

35 *Peter comes after Simon Magus*

Simon the Magician, or Simon Magus who flourished during the reign of Claudius Caesar (41–54) is portrayed as the arch-heretic, and he *preceded* Peter, according to the theological principle that darkness always precedes light. Peter says in one of the *Clementine Homilies*,

> It were possible, following this order, to perceive to what series Simon belongs, *who came before me* to the Gentiles, and to which I belong *who have come after him*, and have come in upon him as light upon darkness, as knowledge upon ignorance, as healing upon disease.[656]

Justin Martyr (mid second century) apprises us of this Simon.

> There was a Samaritan, Simon, a native of the village called Gitto, who in the reign of Claudius Caesar and in your royal city of Rome, did mighty acts of magic, by virtue of the art of the devils operating in him. He was considered a god, and as a god was honoured by you with a statue, which statue was erected on the river Tiber, between the two bridges, and bore this inscription, in the language of Rome—"Simoni Deo Sancto," "To Simon the holy God." And almost all the Samaritans, and a few even of other nations, worship him, and acknowledge him as the first god; and a woman, Helena, who went about with him at that time, and had formerly been a prostitute, they say is the first idea generated by him.[657]

It is recorded in Acts chapter 8 that Philip converted this individual to Christianity before the conversion of Paul.

656 *Clementine Homily* 2.
657 Justin Martyr, *First Apology*, 26.

36 *Jesus died in 58*

An ancient document written by the Christian theologian Clement of Alexandria (late 2nd century) asserts that Peter did not preach to the Gentiles until twelve years after the preaching to the Jews. Clement relying on the authority of an older document called *The Preaching of Peter*, says,

> Therefore Peter says that the Lord said to the apostles: If then any of Israel will repent, to believe in God through my name, his sins shall be forgiven him: (and) after twelve years go ye out into the world, lest any say: We did not hear. [658]

From the account in Acts, preaching to Israel, that is the Jews, commenced at Pentecost, fifty days after the resurrection, and we get the impression, although it is not specifically stated, that Peter's preaching to the Gentiles followed shortly after the other early events recorded there.

There is another ancient source, a fragment published by Muratori, which deserves serious consideration. (Ludovico Muratori was an eighteenth century Italian historian, notable as a leading scholar of his age, and for his discovery of the Muratorian canon, the earliest known list of New Testament books. [659]) The German theologian Von Dobschutz claims that this fragment is evidence of a tradition which rivals in antiquity and authority the chronology given by Luke. [660]

The fragment contains the following information for Jesus.

1. Year of Birth: Q. Sulpito Camerino and C. Poppaeo Sabino (Consuls) – 9 AD

658 *The Preaching of Peter* quoted in Clement of Alexandria, *Stromata*, Book 6.5.
659 Accessed at https://en.wikipedia.org/wiki/Ludovico_Antonio_Muratori
660 Chapman, 1907, p.590ff, and Dobschutz, 1893, pp.136-150.

2. Year of Baptism: Valerio Asiatico II. and M. Juno Silano
 (Consuls) – 46 AD

3. Year of Death: Nerone III. and M. Valerio Messala (Consuls) –
 58 AD[661]

There are twelve years between the baptism of Jesus and his death,
or to put it another way his ministry lasted twelve years. This may
explain the twelve years mentioned by Clement. Jesus dies at the age
of 49. We have already seen that another source, Irenaeus bishop of
Lyon, has Jesus living into his late forties or fifties. (Item 1)

In our hypothesis, the religion (or preaching to all comers) began
in the year 70. If we subtract twelve from 70 we get 58, which agrees
with Muratori. Preaching to the Gentiles did not commence till after
the Jewish War, which also agrees with Item 6. Our hypothesis neatly
explains both sets of data, Muratori and the Preaching of Peter.

661 Dobschütz, 1893, p.138.

Numismatic evidence

37 *For the redemption of Jerusalem*

The phrase *for the redemption of Jerusalem,* a catchcry during the revolt turns up in the gospel of Luke and also on a coin minted in Gamala, in northern Galilee, around 66 CE. The capture and destruction of Gamala and its inhabitants is reported in great detail in Josephus, *Wars of the Jews*, Book 4.1. Luke says,

> At that moment she [the prophetess Anna] came, and began to praise God and to speak about the child [Jesus] to all who were looking for *the redemption of Jerusalem*. (Luke 2:38)

Danny Syon, of Israel Antiquities Authority reports the following.

> Perhaps the most intriguing single find at Gamla is a coin. Only six of its kind are known, all of them found in the western quarters at Gamla, and all from the same pair of dies. It is a very crudely made bronze coin, obviously minted under improvised conditions and by an unskilled artisan. The obverse shows a cup, in clear imitation of the famous Jerusalem silver shekels which made their first appearance in the winter of 66 CE, which are generally accepted as showing one of the Temple utensils (AJC2:106–108). No doubt one of the Jerusalem coins served as a prototype for the Gamla coin, though no examples of the 'models' have been found to date.

> The inscription starts around the cup and ends on the reverse, which carries no design. It states, in a mixture of paleo-Hebrew (biblical) and Aramaic (square) characters: "For the redemption of Jerusalem the Holy." Ironically, a coin of 'Akko-Ptolemais was found together with one of these, minted in honor of Vespasian when he landed there some

Fig. 36: *Gamla Coin*

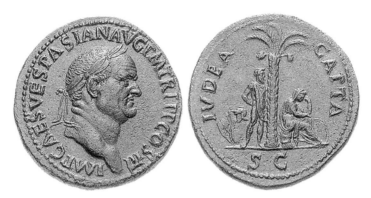

Fig. 37: 'Judea Capta' sestertius of Vespasian, struck in 71 to celebrate the victory in the Jewish Revolt. The legend on the reverse says: IVDEA CAPTA, "Judaea conquered." Accessed at https://en.wikipedia.org/wiki/Judaea_Capta_coinage

months earlier on his way to crush the revolt.

No doubt these coins were produced during the siege or immediately preceding it, more as a propaganda effort than as currency, to make a political statement to the Jews, and possibly to the Romans. This coin challenges the traditional view of a fragmented Jewish front that was preoccupied mainly with internal strife and the defense of isolated sites by pockets of rebels, presenting Vespasian with an easy prey of towns and strongholds instead of a unified front. It shows that even under the most difficult conditions, the people of Gamla still remembered the original aims of the revolt, symbolized by 'the redemption of Holy Jerusalem'.[662]

38 *Mary gives birth to Jesus under a date palm*

In the Koran at Surah 19, Surah Maryam we read,[663]

19. (The angel) said [to Mary]: "I am only a Messenger from your Lord, (to announce) to you the gift of a righteous son."

662 Accessed at http://www.antiquities.org.il/Article_eng.aspx?sec_id=17&subj_id=296&id=521

663 Accessed at http://dar-us-salam.com/TheNobleQuran/surah19.html

20. She said: "How can I have a son, when no man has touched me, nor am I unchaste?"

21. He said: "So (it will be), your Lord said: 'That is easy for Me (Allah): And (We wish) to appoint him as a sign to mankind and a mercy from Us (Allah), and it is a matter (already) decreed, (by Allah).' "

22. So she conceived him, and she withdrew with him to a far place.

23. And the pains of childbirth drove her to the trunk of a date-palm. She said: "Would that I had died before this, and had been forgotten and out of sight!"

24. Then [the babe 'Iesa (Jesus) or Jibrael (Gabriel)] cried unto her from below her, saying: "Grieve not! Your Lord has provided a water stream under you;

25. "And shake the trunk of date-palm towards you, it will let fall fresh ripe-dates upon you."

26. "So eat and drink and be glad, and if you see any human being, say: 'Verily! I have vowed a fast unto the Most Beneficent (Allah) so I shall not speak to any human being this day.'"

27. Then she brought him (the baby) to her people, carrying him. They said: "O Mary! Indeed you have brought a thing Fariya (an unheard mighty thing).

As interpreted by Islam, the angel Gabriel, the date palm, the water stream and Mary the mother of Jesus are depicted on more than one series of Roman coins first minted in the year 71. The winged angel did not appear in Christian art until the 4th century.

Another version of this story, also based on the coin motifs, is found in *The Gospel of Pseudo-Matthew*. This Latin text originated in the sixth or seventh centuries, about the same time as the Koran was written. In this version Mary is escaping to Egypt with the baby Jesus and being "fatigued by the excessive heat of the sun in the desert" rests under a palm tree. The man in the scene is not an angel but this time it is Joseph. In the story, the child Jesus commands the palm tree to bend down and provide fruit for his mother. When the tree rises again it

releases "a spring of water exceedingly clear and cool and sparkling."[664]

Both versions of the story as inspired by the coins tell of the coming of Jesus in the year 71.

That coins were used to settle questions of doctrine is illustrated by Matthew's use of the Roman denarius in the teaching of Jesus about paying taxes. (22:17-21) In Lucian's study of the religion of Astarte-Europa in Sidon he calls as witness the coinage of the district.[665]

664 *The Gospel of Pseudo-Matthew*, 20 accessed at www.gnosis.org/library/psudomat.htm
665 *The Syrian Goddess*, 4.

Jewish evidence

39 *The witness of the Jewish Aggadah, Part I*

Theological disputations between Christians and Jews took place in the Middle Ages and there are detailed records of three of these. The *Barcelona Disputation* of 1263 before King James of Aragon was recorded by Nahmanides, one of the greatest figures in the history of Jewish learning, and Jewish spokesman at the disputation. He reports as follows,

> Fray Paul [the Christian disputant] now resumed, and argued that it is stated in the Talmud that the Messiah has already come. He cited the Aggadah in the Midrash of Lamentations [II:57]: A certain man was ploughing and his cow lowed. An Arab passed by and said to him, "Jew, Jew, untie your cow, untie your plough, untie your coulter, for the Temple has been destroyed." He untied his cow, he untied his plough, he untied his coulter. The cow lowed a second time. The Arab said to him, "Tie up your cow, tie up your plough, tie up your coulter, for your Messiah has been born."[666]

From the same Aggadic text, one detail omitted is that the birth of the Messiah, at the time of the destruction, is located at Bethlehem in fulfilment of the prophet Micah at chapter 5v1.

According to Yehiel another disputant from that era, the Aggadic parts of the Talmud were not regarded as having the same authority as the Halakhic parts. 'You may believe them or disbelieve them as you wish, for no practical decision depends on them.'[667] Nevertheless, the Midrash shows that a Jewish tradition was supported at some time that the coming (or birth) of Jesus was tied to the destruction of the Temple.

666 Maccoby, 2006, p. 110.
667 Maccoby, 2006, p. 37.

40 *The witness of the Jewish Aggadah, Part 2*

A Jewish tradition has Jesus invisibly present in Rome, until he has caused its ruin. In the *Vikuah* of Nahmanides we read,

> Fray Paul asked me [Nahmanides] whether the Messiah of whom the prophets spoke has come, and I said that he has not come. And he cited an Aggadic book in which it is stated that on the day that the Temple was destroyed, on that very day, the Messiah was born.

Nahmanides admits this is true but goes on to say that he does not believe this. After some discussion the King asks; "Where is the Messiah at present?" And after further discussion, "But have you not said, in the Aggadah, that he is in Rome?" Nahmanides replies,

> I said to him, 'I did not say that he was permanently in Rome, but that he appeared in Rome on a certain day, for Elijah told that Sage that he would find him there on that particular day, and he did appear there; and his appearance there was for the reason mentioned in the Aggadah, but I prefer not to mention it before such throngs of people.' The matter which I did not wish to reveal to them was what is said in the Aggadah: that the Messiah would remain in Rome until he brought about its ruin. This is just as we find with Moses our teacher, on him be peace, that he grew in the household of Pharaoh until he called him to account and drowned all his people in the sea. [668]

The ruin of Rome is to be brought about by the Messiah as an act of revenge for the Roman treatment of the Jews and the destruction of Jerusalem. The appearance of the Messiah in Rome occurs after the Jewish revolt.

668 Maccoby, 2006, p. 117.

41 *The Evangelium: "since the day that you were exiled from your land"*

It is reported in the Babylonian Talmud (c. 200-500 CE)

> 'Since the day that you were exiled from your land [ie 70CE] the Law of Moses has been superseded [lit. *taken away*] and another book given. [The reading in Cod. Oxford is: *and the law of the Evangelium has been given.*]

The full context of the above passage follows. The philosopher or judge in the story appears to be a Christian Jew. The other actors in the story are Jews.

> Now, a certain philosopher [sectarian] lived in his vicinity, and he bore a reputation that he did not accept bribes. [he was a judge] They wished to expose him [lit. *make sport of him*], so she brought him a golden lamp, went before him, [and] said to him, 'I desire that a share be given me in my [deceased] father's estate.' 'Divide,' ordered he. Said he [R. Gamaliel] to him, 'It is decreed for us, Where there is a son, a daughter does not inherit.' [He replied], 'Since the day that you were exiled from your land the Law of Moses has been superseded [lit. *taken away*] and another book given [The reading in Cod. Oxford is: *and the law of the Evangelium has been given.*], wherein it is written, 'A son and a daughter inherit equally.' [There is no passage in any known Gospel that a son and daughter inherit alike. However, Paul in Galatians 3:28 says, *There is no longer Jew or Greek, there is no longer slave or free, there is no longer male and female; for all of you are one in Christ Jesus.*] [669]

The story illustrates the notion that the Law ended when the new law of the Christian Evangelium (the "good news" or gospel) began, that is in the year 70.

669 Babylonian Talmud: Tractate Shabbath, Folio 116, a,b. accessed at http://www.come-and-hear. com/shabbath/shabbath_116.html

42 *The witness of Maimonides*

The coming of Jesus (and Christianity) is linked with the destruction of Israel.

Maimonides in the Mishneh Torah (1170-1180) says,

> Jesus of Nazareth who aspired to be the Mashiach and was executed by the court was also alluded to in Daniel's prophecies, as ibid. 11:14 states: 'The vulgar among your people shall exalt themselves in an attempt to fulfill the vision, but they shall stumble.' Can there be a greater stumbling block than Christianity? All the prophets spoke of Mashiach as the redeemer of Israel and their savior who would gather their dispersed and strengthen their observance of the mitzvot [commandments]. In contrast, Christianity caused the Jews to be slain by the sword, their remnants to be scattered and humbled, the Torah to be altered, and the majority of the world to err and serve a god other than the Lord. [670]

It was not Christianity that caused the Jews to be slain but rather the slaying of the Jews that gave rise to Christianity.

670 Accessed at http://www.chabad.org/library/article_cdo/aid/1188356/jewish/Melachim-u Milchamot-Chapter-11.htm

Evidence from Roman historians

43 *Messianic hopes were highest just prior to 66*

Messianic hopes were highest just prior to the year 66, NOT during the reign of Tiberius. The destruction of the temples in Rome in the great fire of 64 would have been seen as paving the way for a new religion.[671]

Suetonius records a fervent Messianic expectation during the reign of Vespasian.

> A firm persuasion had long prevailed through all the East, that it was fated for the empire of the world, *at that time*, to devolve on some who should go forth from Judea. This prediction referred to a Roman emperor, as the event shewed; but the Jews, applying it to themselves, broke out into rebellion.[672] [italics added]

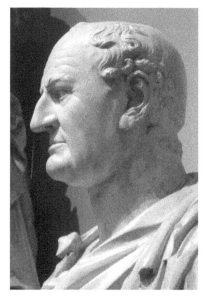

Also noteworthy is the fact that the prophecy recorded by Suetonius had traction with Gentiles as well as Jews. This would explain the appeal of Christianity to Gentiles who had absorbed these expectations; hence fertile ground for the preaching of Paul and others at that time.

Fig. 38: *A bust of Vespasian*, Pushkin Museum, Moscow. Wikimedia Commons.

671 "Nero is thus doubly bad: he does not know how to do religious ritual properly, as we shall see in his handling of the aftermath of the fire, nor can he preserve the temples that are reminders of how to do religious ritual properly." Shannon, 2012, p. 750.

672 Suetonius, *Vespasian*.

44 *Titus, the destruction of the Temple, Judaism and Christianity*

A fragment from Tacitus links the destruction of the temple, and the attempted annihilation of the religions of the Jews and the Christians.

> It is said that Titus first called a council and deliberated whether he should destroy such a mighty temple. For some thought that a consecrated shrine, which was famous beyond all other works of men, ought not to be razed, arguing that its preservation would bear witness to the moderation of Rome, while its destruction would for ever brand her cruelty. Yet others, including Titus himself, opposed, holding the destruction of this temple to be a prime necessity in order to wipe out more completely the religion of the Jews and the Christians; for they urged that these religions, although hostile to each other, nevertheless sprang from the same sources; the Christians had grown out of the Jews: if the root were destroyed, the stock would easily perish. [673]

This story seems to be another Tacitean invention as there is no other evidence that the Christians were persecuted by Titus, or that he regarded them as a threat. The Christians for their part would have had no interest in the Temple as a place of worship. But the passage does show that the emergence of Rabbinical Judaism and Christianity were linked to the same event, the destruction of the Temple.

45 *Paul, circumcision and the poll tax*

Paul disavows the Jewish custom of circumcision and sides with the Romans under Vespasian, Titus and Domitian, thus creating a theologically acceptable way for his Gentile followers to avoid paying the poll tax.

673 Tacitus, *Fragments* 2.1.

The Jewish poll tax was instituted by Vespasian to replace the temple tax after the temple was destroyed. Proceeds went instead to the Temple of Capitoline Jupiter in Rome. It seems to have continued until the year 362 when it was abolished by the emperor Julian. [674]

Suetonius reports that under Domitian, the scope of the tax was broadened.

> Besides the exactions from others, the poll-tax on the Jews was levied with extreme rigour, both on those who lived after the manner of Jews in the city, without publicly professing themselves to be such, and on those who, by concealing their origin, avoided paying the tribute imposed upon that people. I remember, when I was a youth, to have been present, when an old man, ninety years of age, had his person exposed to view in a very crowded court, in order that, on inspection, the procurator might satisfy himself whether he was circumcised. [675] [italics added]

Those who lived *after the manner of the Jews* would be *God-fearers* (Gentiles sympathetic to Judaism) or Jewish proselytes and could also be Jewish Christians or just ethnic Jews who didn't want to pay the tax. The distinguishing mark was physical circumcision. Gentile Christians who followed Paul would have been exempt. Paul says,

> A person is not a Jew who is one only outwardly, nor is circumcision merely outward and physical. No, a person is a Jew who is one inwardly; and circumcision is circumcision of the heart, by the Spirit, not by the written code. (Romans 2:28-29)

Promoting a promising sect that avoided a tax while reaping all the benefits of its parent religion would have suited the apostles to the Gentiles and their followers. Berger and Lukmann in the *Social Construction of Reality* explain how this works at the group level.

674 *To the Community of the Jews*, letter 51.

675 Suetonius, *Domitian*

Frequently an ideology is taken on by a group because of specific theoretical elements that are *conducive to its interests*. For example, when an impoverished peasant group struggles against an urban merchant group that has financially enslaved it, it may rally around a religious doctrine that upholds the virtues of agrarian life, condemns the money economy and its credit system as immoral, and generally decries the luxuries of urban living. The ideological 'gain' of such a doctrine for the peasants is obvious. Good illustrations of this may be found in the history of ancient Israel. [676] [italics added]

676 Berger & Lukmann, 1966, p.141

Evidence from Josephus

46 A new Roman religion predicted by the high priest Ananus in 69 CE

After robbers, zealots and renegades plundered Jerusalem, dishonoured the temple and killed the eminent citizens, the high priest Ananus (69 CE) predicted the emergence of a new, better religion *with Roman sensibilities*. Josephus, the Jewish historian, reports that Ananus said,

> How then can we avoid shedding of tears, when we see the *Roman donations in our temple*, while we withal see those of our own nation taking our spoils, and plundering our glorious metropolis, and slaughtering our men, from which enormities those Romans themselves would have abstained? to see those Romans never going beyond the bounds allotted to profane persons, nor venturing to break in upon any of our sacred customs; nay, having a horror on their minds when they view at a distance those sacred walls; while some that have been born in this very country, and brought up in our customs, and called Jews, do walk about in the midst of the holy places, at the very time when their hands are still warm with the slaughter of their own countrymen.
>
> For truly, if we may suit our words to the things they represent, it is probable one may hereafter find *the Romans to be the supporters of our laws*, and *those within ourselves the subverters of them*.[677] [italics added]

47 Praying for those in authority

Paul's instruction to pray for kings and all in authority (1 Timothy 2:1-2) echoes the moral imperative that Josephus stated in his history of the *Jewish Wars*. [678] It was during that time that certain of the seditious including Eleazar, the son of Ananias the high priest,

677 *Wars of the Jews*, Book 4.3.10.
678 Book 2.17.2

"persuaded those that officiated in the Divine service to receive no gift or sacrifice *for any foreigner*." According to Josephus this affront "was the true beginning of our war with the Romans; for they rejected the sacrifice of Caesar." This prohibition was seen as the highest form of impiety. Paul's instruction to the church to pray for Caesar makes more sense if given after the War. He didn't want the church to repeat the mistakes of the past.

48 *There is no mention of Paul (or Christians) in Josephus' histories*

There is no mention of Paul (or any other Christians) in Josephus' histories of the Jews. The book *Wars of the Jews* ends in 75 CE with the death of Catullus, the governor of the Libyan Pentapolis. The book *Antiquities of the Jews* ends in the 13th year of Domitian or 93 CE.

Josephus was a friend of Herod Agrippa II (c. 28–c. 95) who was the last client ruler of Rome from the Herodian dynasty. Josephus says that Agrippa wrote 62 letters to him, and "attested to the truth of what I [Josephus] had therein delivered" and that he, Josephus, used this information to compile his history of the Jews. Apparently in one of these letters, Agrippa wrote that he would inform Josephus of a great many things which he didn't know. The emperor Titus as the patron of Josephus also took a keen interest in the contents of the histories.[679]

In the Acts of the Apostles there is a long interview between this king and the apostle Paul, in which Paul is given every opportunity to defend himself and the new religion. (Acts 25:13, 26:32) The date of this interview is set around 59 when the Roman governor, Porcius Festus arrived in Caesarea to take over as the new procurator of Judea. According to the account in Acts the king expressed a great deal of interest in the philosophy of Paul and the career of Jesus, and Paul in the presence of the king and Festus says,

679 Josephus, *Life of Flavius Josephus.*

Indeed the king [Agrippa] knows about these things, and to him I speak freely; for I am certain that none of these things has escaped his notice, for this was not done in a corner. (Acts 26:26)

However, despite the alleged clear interest shown by the king in Paul and his theology, and his apparent prior knowledge of the new religion, *none of this appears in the history of Josephus,* who was the king's friend and confidante.

This indicates that either Josephus deliberately omitted any reference to Paul or Christianity or the account in Acts is partly or wholly fabricated. I favour the latter conclusion as it is most unlikely that the king Agrippa would have given audience to an itinerant preacher who had no standing within the Jewish community, and whose reputation as a trouble maker had been well established. It is also worth noting that Josephus never mentions Christians even though they existed on the Italian peninsula while he was in Rome after the year 70. This could be because their numbers were too small to attract his attention in so large a city or if he did write something about them those references have been redacted from his histories by Christian scribes or else lost.

49 *The Father and the Son*

Do you think that I [Jesus] cannot appeal to my Father, and he will at once send me more than twelve legions of angels? (Matthew 26:53)

The father-son motif, which is so strong in Christianity, was exemplified for all to see in the Vespasian-Titus partnership.

Church historian Orosius (4th century) declares,

The emperors Vespasian and Titus celebrated their victory over the Jews by a magnificent triumphal entry into Rome. Of all the three hundred and twenty triumphs that had been held from the founding of the City until that time, so fair and strange a sight had not been seen by man— father and son riding in the same triumphal chariot after their glorious

victory over those who had offended the Father and the Son.[680]

The son basks in the glory of the father

...of them the Son of Man will also be ashamed when he comes *in the glory of his Father* (Mark 8:38)

At the victory parade in Rome,

> And as soon as ever it was day, *Vespasian and Titus came out crowned with laurel*, and clothed in those ancient purple habits which were proper to their family. After these spoils passed by a great many men, carrying the images of Victory, whose structure was entirely either of ivory or of gold. After which Vespasian marched in the first place, *and Titus followed him*.[681] [italics added]

The son hands out punishments and blessings

For the Son of Man is to come with his angels in the glory of his Father, and then *he will repay everyone for what has been done.* (Matthew 16:27)

The Jews are punished by Titus, the son.

> Vespasian [the father] turned his thoughts to what remained unsubdued in Judea. However, he himself made haste to go to Rome, as the winter was now almost over, and soon set the affairs of Alexandria in order, *but sent his son Titus, with a select part of his army, to destroy Jerusalem.*[682] [italics added]

Josephus, the righteous one, receives his reward from Titus, the son.

> Titus was then present with his father, and said, "O father, it is but just that the scandal [of a prisoner] should be taken off Josephus, together

680 Orosius, *Historiae Adversus Paganos*, Book 7.9.

681 *Wars of the Jews*, Book 7.5.5.

682 *Wars of the Jews*, Book 4.11.5.

with his iron chain. For if we do not barely loose his bonds, but cut them to pieces, he will be like a man that had never been bound at all." [683]

The son copies the father

... the Son can do nothing on his own, but only what he sees the Father doing; for *whatever the Father does, the Son does likewise.* (John 5:19)

Vespasian [the father] accepted of these shouts of theirs; but while they were still disposed to go on in such acclamations, he gave them a signal of silence. And when everybody entirely held their peace, he stood up, and covering the greatest part of his head with his cloak, he put up the accustomed solemn prayers; the like prayers did *Titus put up also.*[684] [italics added]

The Holy Trinity

Josephus records,

But what made the most splendid appearance in Titus's opinion was, when his father met him, and received him; but still the multitude of the citizens conceived *the greatest joy* when they saw them *all three together,* [Vespasian and his two sons, Titus and Domitian] as they did at this time.[685]

And Jesus proclaims,

Go therefore and make disciples of all nations, baptizing them in the name of the *Father and of the Son and of the Holy Spirit.* (Matthew 28:19)

683　*Wars of the Jews,* Book 4.10.7.
684　*Wars of the Jews,* Book 7.5.4.
685　*Wars of the Jews,* Book 7.5.3

Arguments from theology

50 *Domitian hates the shedding of sacrificial blood*

Suetonius says that Domitian,

> Upon his first succeeding to power, . . . felt such an abhorrence for the
> shedding of blood, that, *before his father's arrival in Rome*, calling to mind
> the verse of Virgil, . . . he designed to have published a proclamation, "to
> forbid the sacrifice of oxen." [686]

The teachers of the new religion had said that Jesus' death put an end
to the Temple sacrifices. Paul says,

> They [the believers] are now justified by his grace as a gift, through the
> redemption that is in Christ Jesus, whom God put forward as a sacrifice
> of atonement by his blood. (Romans 3:24-25)

The writer to the Hebrews, who may have been Paul's co-worker
Apollos[687] declared that the cult of temple animal sacrifices had been
discharged in the shedding of the blood of one man, Jesus. He says,

> It is impossible for the blood of bulls and goats to take away sins. (10:4)

At least one Old Testament prophet could be wrested to support this
idea (Amos 5:21-22) and the famous pagan sage Apollonius of Tyana,
who was then active, preached the same message. [688]

It is significant fact that the opinion of the emperor agreed with
a basic tenet of the new religion. No doubt there were others who
shared these views. Whatever the extent of the feeling or the changes

686 Suetonius, *Domitian*

687 Mason, 2008, p.2

688 Philostratus, *The life of Apollonius of Tyana*, Book 1.1.

in sacrificial procedures, Christianity would benefit; the arguments of the apostles would make more sense in this milieu. Note that Domitian had this proclamation in mind before his father Vespasian came to Rome – that would have been in the year 70..

51 *Paul wrote after the law was ended*

Paul's attitude to the Mosaic Law was shaped by the events of 66-70. Paul says that:
- those under the Law lack freedom – as the Jews did in the siege of Jerusalem[689];
- those under the Law are under a curse;[690]

Fig. 39: *Stones from the Temple knocked onto the street below by Roman battering rams on the 9th of Av, 70 CE.* Wikimedia Commons.

689 Romans 7:25
690 Galatians 3:10.

- the Law brings the wrath of God; [691]
- the Law brings death; [692]
- the Law provokes sin; [693]
- the Law locks people up. [694]

All these things happened in the seminal period of the insurrection, due to the Jew's stubborn insistence on keeping the letter of the Law.

Now Paul says that God has *"abolished the law* with its commandments and ordinances." (Ephesians 2:14) This has been achieved by the sacrifice of Jesus. Paul says,

> For Christ is *the end of the law* so that there may be righteousness for everyone who believes. (Romans 10:4)

Christ is the culmination of the law τελος νομου (telos nomou) "the close of the Law," i.e. "He who brings it to an end." [695]

By an act of God through the agency of the Romans, the Law was ended dramatically in 70 CE, at the same time as Jesus appeared and was sacrificed for national sins.

52 *The believers are the spiritual stones of a new Temple*

Peter (or rather Paul) says,

> . . . *like living stones,* let yourselves be built into a spiritual house, to be a holy priesthood, to offer spiritual sacrifices acceptable to God through Jesus Christ. (1 Peter 2:4-5)

Paul says,

691 Romans 4:15.

692 2 Corinthians 3:7.

693 Romans 5:20.

694 Galatians 3:23.

695 See Cambridge Bible for Schools and Colleges accessed at http://biblehub.com/commentaries/cambridge/romans/10.htm

Do you not know that you [plural] are God's temple and that God's Spirit dwells in you [plural]? (1 Corinthians 3:16)

And,

So then you [Gentiles] are no longer strangers and aliens, but you are citizens with the saints and also members of the household of God, *built upon the foundation* of the apostles and prophets, with Christ Jesus himself as *the cornerstone*. In him the whole structure is joined together and grows into *a holy temple in the Lord*; in whom *you also are built together spiritually into a dwelling place for God*. (Ephesians 2:20-21)

The idea that the believers metaphorically fulfilled the functions of stones in a new temple would have more easily arisen after the stones of the physical temple had been thrown down in the year 70.

53 *The destruction of the temple in 70 CE left a prophetic vacuum*

The destruction of the temple and the Sanhedrin in 70 CE left a prophetic vacuum, that needed to be filled. Ananus, the good high priest had been murdered. The prophetic vacuum was filled *theologically* by Jesus.

Justin Martyr in his argument with the Jews asserts that,

But after the manifestation and death of our Jesus Christ in your nation, *there was and is nowhere any prophet*: nay, further, you ceased to exist under your own king, your land was laid waste, and forsaken like a lodge in a vineyard.[696]

A parallel situation had occurred 200 years before. In the first Book of Maccabees, we read,

696 *Dialogue with Trypho*, 52.

So they tore down the altar, and stored the stones in a convenient place on the temple hill *until a prophet should come to tell what to do with them.* (4:46)

The Jews and their priests have resolved that Simon should be their leader and high priest forever, *until a trustworthy prophet should arise.* (14:41)

54 *The punishment of the Jews not delayed*

Was there a forty-year delay between the killing of Christ and the punishment of the Jews? The writer of the second book of Maccabees says this is not how God deals with his people. In referencing recent events in the second century BCE, he says,

> Now I urge those who read this book not to be depressed by such calamities, but to recognize that these punishments were designed not to destroy but to discipline our people. In fact, it is a sign of great kindness not to let the impious alone for long, *but to punish them immediately.* For in the case of the other nations the Lord waits patiently to punish them until they have reached the full measure of their sins; but *he does not deal in this way with us,* in order that he may not take vengeance on us afterward when our sins have reached their height. (6:12-15) [italics added]

55 *The Jerusalem survivors are called by God*

There was not a total massacre of the besieged in Jerusalem as Titus sold many into slavery and spared some 40,000.

> And indeed the number of those that were sold was immense; but of the populace above forty thousand were saved, whom Caesar let go whither every one of them pleased.[697]

697 *Wars of the Jews,* Book 6.8.2.

In the continuation of the passage from the prophet Joel quoted by Peter in Acts 2:17-20, we read,

> Then everyone who calls on the name of the Lord shall be saved; for in Mount Zion and in Jerusalem there shall be *those who escape*, as the Lord has said, and *among the survivors shall be those whom the Lord calls*. (Joel 2:32)

The Jewish believers naturally read themselves into the prophecy as the survivors whom the Lord had called, and their physical baptism by fire did indeed empower the new religion. As Isaiah prophesied,

> Whoever is left in Zion and remains in Jerusalem will be called holy, everyone who has been recorded for life in Jerusalem, once the Lord has washed away the filth of the daughters of Zion and cleansed the bloodstains of Jerusalem from its midst by a spirit of judgment and by a spirit of burning. (Isaiah 4:3-4)

56 *The Way*

Early Christians were called people of *the Way*. This term would have gained currency in the aftermath of the War as it was linked to key prophecies, which cited Jerusalem.

Skarsaune and Hvalvik make the following observation.

> The way (η οδος): This was evidently the term the first Jewish Christians used for their form of Judaism. The absolute usage occurs five times in Acts (9:2; 19:9,23; 24:14,22; cf. 22:4: "this Way"), where we also find "the Way of the Lord" (18:25) and "the Way of God" (18:26).[698]

The Way is connected with the conclusion of God's punishment upon

698 Skarsaune & Hvalvik, 2007, p. 56.

the inhabitants of Jerusalem. The punishment ended in the year 70. Isaiah proclaims,

> Speak tenderly to *Jerusalem*, and cry to her that she has served her term, that *her penalty is paid*, that she has received from the Lord's hand double for all her sins. A voice cries out: 'In the wilderness prepare *the way of the Lord*, make straight in the desert a highway for our God.' (40:2-3)
>
> Truly, O people in Zion, *inhabitants of Jerusalem*, you shall weep no more. He will surely be gracious to you at the sound of your cry; when he hears it, he will answer you. Though the Lord may give you the bread of adversity and the water of affliction, yet your Teacher will not hide himself any more, but your eyes shall see your Teacher. And when you turn to the right or when you turn to the left, your ears shall hear a word behind you, saying, *"This is the way; walk in it."* (30:19-21)

The Teacher was Jesus. The new religion was called *the Way*.

Conclusion

It would indeed not be an exaggeration to say that Christianity was in a certain sense reborn *as a result of the Jewish catastrophe of A.D. 70.*

Brandon: *The fall of Jerusalem and the Christian church*, Epilogue

BRANDON HAS RIGHTLY SIGNPOSTED THE CATASTROPHE OF THE YEARS 66 to 70, the first Roman-Jewish War, as the crucial event in the evolution of Christianity. Unfortunately, his vision was limited by an inability to shake off a fundamental mistake. He accepted the founding myths of the second generation of Christians, the gospels and Acts, as being true. We have shown that there was no *hiatus* between the years 55 and 85 or 40 and 70. Christianity was not *re*born in 70. This is when Christianity was born.

We have shown that the first Jesus was the inevitable invention of disappointed Jewish religionists, who were reasoning and writing in the aftermath of the War. The rumour that the Messiah had appeared arose spontaneously in both Jewish and Gentile circles, the resulting half beliefs being channelled and moulded by the apostles who were guided by the Scriptures. Jerusalem was abandoned, and Rome became the centre of the universal Gentile church.

Many good arguments for rejecting the historical Jesus are presented in contemporary literature.[699] Some of those arguments have been repeated in this book. However, the main aim of this work has been to go one step further; to explain pragmatically the mechanics of *how belief in an historical Jesus arose.*

My method has been to examine as much as possible primary sources, apply concepts learned outside of theology and be bold enough to question the assumptions implicit in a lot of received scholarship. Blomberg, for example, by a process of circular reasoning wrongly asserts that the onus of proof is on disbelievers to prove Jesus is fictional.[700] But lately some progressive scholars have called the resurrection "a 'metahistorical' or 'trans-historical' occurrence, not an event within history."[701]

For centuries Christians have preached that the Jews killed Jesus, and this absurd conspiracy theory has been the wellspring of so much undeserved suffering for the Jewish people. According to Christians it is their *punishment* for the crime of killing a man that as we have shown was merely a theological conclusion and not a real person.[702] Controversy over the status of Jesus[703]—a standard feature of the religion since its inception—descended into violence and rioting in Antioch in the 4th Century, and was only suppressed by the threat of intervention from the emperor.[704] Today this quarrel is played out in the form of a proxy war between Islam and the West, at bottom a

699 For example: Fitzgerald, D. (2010). *Nailed: Ten Christian myths that show Jesus never existed at all.*

700 "Once one accepts that the gospels reflect attempts to write reliable history or biography, however theological or stylized its presentation may be, then one must immediately recognize an important presupposition which guides most historians in their work. Unless there is good reason for believing otherwise one will assume that a given detail in the work of a particular historian is factual. This method places the burden of proof squarely on the person who would doubt the reliability of a given portion of the text." (Blomberg, 1987, p. 240)

701 Siniscalchi, 2011, p. 363.

702 See Martin Luther, *On the Jews and Their Lies* (1543)

703 Famously unresolved at the Council of Nicaea (325 CE).

704 Heayn, 2008, p. 7.

dispute among theologians about the role and nature of Jesus.[705]

It is time to end the madness.

In this study I have attempted to expose the underpinnings of modern Christianity and I leave the reader to judge whether it is sufficient to denounce the religion as a philosophy. But is it worth so much time and effort clinging to a philosophy that is clearly derivative, dated and so very human? "More and more the myths put about by these Christians are better known than the doctrines of the philosophers," lamented Celsus. This tragedy has continued for 1900 years. If my study has taught me anything it is that we have neglected and continue to neglect the great thinkers of the past—here I propose Cicero for especial mention.

It is fitting that the French philosopher Volney should have the last word.

> ... in fine, you will see that the whole history of the spirit of religion is only the history of the errors of the human mind, which, placed in a world that it does not comprehend, endeavours nevertheless to solve the enigma ; and which, beholding with astonishment this mysterious and visible prodigy, imagines causes, supposes reasons, builds systems; then, finding one defective, destroys it for another not less so; hates the error that it quits, misconceives the one it embraces, rejects the truth it is seeking, composes chimeras of discordant beings, and always dreaming of wisdom and happiness, wanders in the labyrinth of illusion and of pain.[706]

705 As witness the anti-trinitarian Islamic inscription on the Dome of the Rock. "So, believe in God and his messengers, and do not say 'three'; cease (doing) that; (it would be) better for you." (Puin & Ohlig, 2010, p. 137)

706 *Ruins*, p. 160–161

Afterword

The story of Moses Al-Dar'i
(12th century)

'T HE FOLLOWING INCIDENT WE HAVE VERIFIED AND KNOW TO BE TRUE because it occurred in recent times. About fifty years ago or less, a pious and virtuous man and scholar by the name of Moses Al-Dar'i came from Dar'a to the province of Andalusia to study under Rabbi Joseph ha-Levi, of blessed memory, ibn Migash, of whom you very likely have heard. Later he left for Fez, the center of Maghreb. People flocked to him because of his piety, virtue and learning. He informed them that the Messiah had come, as was divinely revealed to him in a dream. Yet he did not pretend on the basis of a divine communication, as did the former lunatic, that he was the Messiah. He merely affirmed that the Messiah had appeared. Many people became his adherents and reposed faith in him. My father and master, of blessed memory, endeavored to dissuade and discourage people from following him. However only a few were influenced by my father, while most, nay nearly all clung to R. Moses, of blessed memory. Finally he predicted events which came true no matter what was going to occur. He would say: "I was informed

yesterday—this and this would happen," and it did happen exactly as he foretold. Once he forecast a vehement rain for the coming Friday and that the falling drops will be blood. This was considered a sign of the approaching advent of the Messiah, as was inferred from the verse, "And I will show wonders in the heavens and in the earth, blood and fire, and pillars of smoke." (Joel 3:3). This episode took place in the month of Marheshvan. A very heavy rain fell that Friday and the fluid that descended was red and viscous as if it were mixed with clay. This miracle convinced all the people that he was undoubtedly a prophet. In itself this occurrence is not inconsistent with the tenets of the Torah, for prophecy will return to Israel before the messianic advent, as I have previously explained. When the majority of the people put their trust in him, he predicted that the Messiah would come that very year on Passover eve. He advised the people to sell their property and contract debts to the Muslims with the promise to pay back ten dinars for one, in order to observe the precepts of the Torah in connection with the Passover festival, for they will never see them again, and so they did. When Passover came and nothing transpired, the people were ruined as most of them had disposed of their property for a trifling sum, and were overwhelmed with debt. When the Gentiles in the vicinity and their serfs learned of this hoax they were minded to do away with him, had they located him. As this Muslim country no longer offered him protection he left for Palestine where he died, may his memory be blessed. When he left he made predictions, as I was informed by those who saw him, concerning events both great and little in Maghreb which were later fulfilled.'

Maimonides, *Epistle to Yemen*, 12th century

The Problem
of the Bishops of Jerusalem

THE CHURCH HISTORIAN EPIPHANIUS OF SALAMIS WRITING ABOUT
375 CE lists all the bishops of Jerusalem up to his own day. The
following is taken from the beginning of his list.

1. James, who was martyred in Jerusalem by beating with a cudgel.
 [He lived] until the time of Nero.[707]
2. Symeon, was crucified under Trajan [98-117 CE].
3. Judah
4. Zachariah
5. Tobiah
6. Benjamin
7. John, bringing us to the ninth [or] tenth year of Trajan.

707 Acts records that a certain James, the brother of John, was "killed with the sword" by Herod
 (Acts 12:2) This is before the Jerusalem conference, at which James presides. (Acts 15).
 Eusebius (*Ecclesiastical History*, Book 2.1) explains the contradiction by positing that there
 were two "James."

8. Matthias
9. Philip
10. Seneca
11. Justus, bringing us to Hadrian.
12. Levi
13. Vaphres
14. Jose
15. Judah, bringing us to the eleventh year of Antonius. [149 CE] The above were the circumcised bishops of Jerusalem. The following were gentiles:...[708]

The following points are noteworthy.

Firstly, Epiphanius states that all fifteen bishops were *circumcised*, that is Jews, which points to the existence of Jewish Christianity. Church historian Eusebius (c. 300) concurs.[709]

Secondly, six bishops served under the reign of the Roman emperor Trajan. Trajan reigned from 98 to 117, a period of 19 years. Dividing this figure by the number of bishops, produces an average career life for each bishop of just 3.2 years. The stated martyrdom of James under Nero could not have been later than 68 CE. This is the date of Nero's death. So, the second bishop Symeon, who was crucified under Trajan, had a career of at least 30 years!

This seems odd. Between 98 and 117 six bishops were either deposed, killed or died of natural causes. It seems inconceivable that it

708 *Panarion* Book 2, 5, 20.

709 *Ecclesiastical History*, Book 4.5. "The chronology of the bishops of Jerusalem I have nowhere found preserved in writing; for tradition says that they were all short lived. But I have learned this much from writings, that until the siege of the Jews, which took place under Adrian, there were fifteen bishops in succession there, all of whom are said to have been of Hebrew descent, and to have received the knowledge of Christ in purity, so that they were approved by those who were able to judge of such matters, and were deemed worthy of the episcopate. For their whole church consisted then of believing Hebrews who continued from the days of the apostles until the siege which took place at this time; in which siege the Jews, having again rebelled against the Romans, were conquered after severe battles. (The Third Jewish War 132–136 CE) But since the bishops of the circumcision ceased at this time, it is proper to give here a list of their names from the beginning." This does not entirely agree with Epiphanius who says the last of the fifteen bishops died under Antoninus Pius (Antonius).

was far less risky to be a bishop or that the rules for appointment had changed that drastically under the earlier pagan emperors. Eusebius himself says they were *all short-lived.*

Following on from Bishop John, from the tenth year of Trajan to the eleventh year of Antoninus Pius is 41 years, in which time period there were eight bishops. The average career life is still relatively short at 5.1 years.

The problem with Symeon's anomalous and elongated career is solved by discounting the martyrdom story of James.[710] We can do this because it has been shown by Carrier and others that this story was taken from a misreading of the Jewish historian Josephus.[711]

By placing the active life of James in the period from 70 CE and having him occupy the bishop's seat for a generous twenty odd years from that date (that is when Christianity was relatively unknown and non-threatening to the Roman establishment) we can reduce the number of anomalous years to a respectable number. Symeon can then be bishop for about eight years from 90 to 98 CE.

This seems about right because Paul does not mention a changing of the guard in Jerusalem. His career would have ended about the same time as James'.

We know from Paul's letter to the Galatians that Paul, was a contemporary of James.[712] So, if James was active in the last third of the century so was Paul, and so was the new Jewish sect.

710 *Ecclesiastical History*, Book 2.1 "—this very James, whom the ancients also called by the surname of Just for excellence of virtue, is recorded to have been the first to be entrusted with the throne of the bishopric of the Church of Jerusalem. Clement, writing in Book 6 of the *Hypotyposes*, gives the following account. He says Peter and James and John, after the Ascension of the Saviour, as if preferred by the Saviour, did not struggle for glory, but chose James the Just as Bishop of Jerusalem. The same author, in Book 7 of the same work, says this also about him: 'To James the Just and to John and to Peter the Lord after the resurrection gave the tradition of knowledge; these passed it onto the other Apostles, and the other Apostles to the Seventy, of whom Barnabas also was one. But there were two Jameses, one the Just—he was cast down from the pinnacle of the temple and was beaten to death with a fuller's club—and the other who was beheaded.' Paul also makes mention of the Just himself, writing: 'But I saw none of the other apostles, except James, the brother of the Lord.'" Note the contradiction with the gospel which has Jesus appointing the seventy. (Luke 10:1)

711 Carrier, 2014, p. 337-42.

712 Galatians 1:19

APPENDIX II

Objections answered

I *Flavius Josephus and Eusebius*

D ID JOSEPHUS WRITE ABOUT JESUS? CHURCH HISTORIAN EUSEBIUS
says that he did.[713] Oddly, Eusebius writing about the year 300
is the first ancient doyen to make such a claim.

Irenaeus (c. 130–c. 200) wrote prolifically against heretics. He
cites and names Josephus, but in none of his writings does he cite the
Josephan passage about Jesus.[714]

Church father Origen (c. 184–c. 253) writing about 220 states
that Josephus did not believe in Jesus,[715] and in the very same passage,
while arguing against Celsus for the real existence of John the Baptist,
he *fails to mention* that Josephus also records *the real existence of Jesus.*

Can Eusebius be trusted? We have already seen that Eusebius
admits he produced a flawed and incomplete history, the aim of
which was to prove the spiritual *historical* victory of the church.

713 *Ecclesiastical History*, Book 1.11.
714 *Fragments* accessed at www.earlychristianwritings.com/irenaeus.html
715 *Contra Celsus*, Book 1.47.

He records events which we know to be unsubstantiated and even fanciful. Examples are the suicide of Pilate,[716] letters of Pilate to Tiberius and Tiberius himself adopting the role of public defender of the Christian faith. Apparently, according to Eusebius, Tiberius even introduced the gospel story to the Roman Senate and recommended that Jesus be worshipped as a god(!)[717]

We find a further example of Eusebius's naive or duplicitous use of material in the fraudulent letters which he includes in his work— the supposed written correspondence between Jesus and the king of Edessa.[718] No one regards these letters as genuine. They are most probably late third century forgeries written to enhance the claim of the city of Edessa to apostolic Christian provenance.[719] However, Eusebius living at the same time as these forgeries were produced, declared that he obtained the record of the correspondence from *ancient public registers* which "we have literally translated from the Syriac language." The inclusion of this material and Eusebius's bald warrant for their authenticity further calls into question his standing as a reliable unbiased historian.

The Jesus Passage

The passage as quoted by Eusebius and as it appears in *Antiquities of the Jews* is this.

> Now there was about this time Jesus, a wise man, if it be lawful to call him a man; for he was a doer of wonderful works, a teacher of such

716 *Ecclesiastical History*, Book 2.7.

717 *Ecclesiastical History*, Book 2.2.

718 *Ecclesiastical History*, Book 1.13.

719 "The Doctrina Addai or Abgar legend originated in the North Mesopotamian city of Edessa. It is the official, but fictional, report of the foundation of the Edessene church and relates how Christianity came to Edessa in apostolic times when King Abgar, surnamed Ukkama (4 BCE-7 CE.; 13 CE-50 CE) reigned over the city... The Doctrina Addai originated at the end of the third century, probably in reaction to the spread of Manichaeism in North Mesopotamia. It must be considered as a piece of Christian propaganda which emphasizes the fact that Christianity in Edessa went back to the time of Christ himself." (Drijvers, 1997, p. 301-2)

men as receive the truth with pleasure. He drew over to him both many of the Jews and many of the Gentiles. He was [the] Christ. And when Pilate, at the suggestion of the principal men amongst us, had condemned him to the cross, those that loved him at the first did not forsake him; for he appeared to them alive again the third day; as the divine prophets had foretold these and ten thousand other wonderful things concerning him. And the tribe of Christians, so named from him, are not extinct at this day. [720]

When we examine the placement of the Jesus passage in Josephus' history we notice that it interrupts the sense and flow of the narrative. The preceding text is this.

. . . there were a great number of them slain by this means, and others of them ran away wounded. And thus an end was put to this sedition.

< Jesus passage>

About the same time also *another sad calamity* put the Jews into disorder, and certain shameful practices happened about the temple of Isis that was at Rome.

The passage about Jesus is wedged between two disastrous events, and described as *another sad calamity.*

In the passage Josephus is made to say "Jesus, a wise man, if it be lawful to call him a man; for he was a doer of wonderful works, a teacher of such men as receive the truth with pleasure... *He was the Christ.* [that is, the Messiah]" This is a Christian confession of faith. Josephus lived and died a Jew.

Olson has examined the language of the passage and has found that,

Comparison of the *Testimonium* with the writings of Josephus and

720 *Antiquities of the Jews,* Book 18.3.3.

Eusebius ... reveals that while much of the content is unlikely to have originated with Josephus, none of it is inconsistent with Eusebius' beliefs. Further, except for two phrases peculiar to Josephus, the language is entirely consistent with Eusebius' normal usage. The three phrases "maker of miraculous works," "tribe of Christians," and "to this day" occur several times elsewhere in Eusebius, and never, elsewhere, in Josephus.[721]

Ehrman states that, "In the judgment of most scholars, there is simply no way Josephus the Jew would or could have written such things."[722]

We conclude quite reasonably that the Jesus passage in Josephus's *Antiquities of the Jews* is a Christian interpolation and probably by the hand of Eusebius himself.

James in the New Testament

There are four persons named James mentioned in the New Testament.

1. The disciple James, son of Zebedee (Matthew 4:21)
2. The disciple James, son of Alphaeus (Matthew 10:3)
3. James, the brother of Jesus (Matthew 13:55)[723]
4. James the author of the letter of James (James 1:1)

It seems Peter, James (son of Zebedee) and John (the brother of James) were the favoured three disciples. (Mark 5:37, Luke 9:28) Luke describes them as having been partners in the fishing business, before they met Jesus. (5:10)

In Acts 12:2 we are told that Herod killed James, the brother of John, with the sword. Later in Acts, James is still active and clearly a leader in the church. (Acts 15:13) Which James is this? It must be either James the son of Alphaeus or James the brother of Jesus.

Paul mentions the trio, James and Cephas (possibly Peter) and John in Galatians 2:9. These were pillars of the church. In Galatians

721 Olson, 1999, p.313.

722 Ehrman, 2012, p.60.

723 See *The relatives of Jesus* in this section.

1:9 Paul describes James as *the Lord's brother*. In 1 Corinthians 15:7 we are told that the risen Christ appeared to James, then to all the apostles. It seems likely that this James is also the one described as *the Lord's brother* and a leader in the church. He was probably also the same person as the author of the letter named after him.

The James passage in Josephus

This passage is not *prima facie* evidence for the view that Josephus stated that Jesus Christ was a historical figure and James was his brother. When it is read carefully and in context, it is seen to refer to the (political) appointment of high priests in the year 62, prior to the Jewish War. The passage in question follows:

> Festus [the Roman procurator] was now dead, and Albinus [the next Roman procurator] was but upon the road [that is on his way to Judea]; so he [the high priest Ananus] assembled the Sanhedrin of judges, and brought before them the brother of Jesus, *who was called Christ*, whose name was James, and some others, [or, some of his companions]; and when he had formed an accusation against them as breakers of the law, he delivered them to be stoned.[724]

Who is this Jesus? Jesus was a common Jewish name, and is used many times by Josephus. In none of those instances does it refer to the Christian "Jesus". Reading further, we find the following.

> Whereupon Albinus complied with what they said, and wrote in anger to Ananus, and threatened that he would bring him to punishment for what he had done [that is, assemble the Sanhedrin without the consent of Albinus]; on which king Agrippa took the high priesthood from him, when he had ruled but three months, and *made Jesus, the son of Damneus, high priest*.

Jesus, son of Damneus, was the brother of the James who was illegally

724 *Antiquities of the Jews*, Book 20.8.9.

stoned, so Albinus in reparation to the family made his brother Jesus high priest.

The phrase *who was called Christ* is clearly a scribal addition, or gloss. It probably started out as a marginal comment, which was later inserted into the text. Josephus a Jew would not have designated any Jesus as Christ, that is *the Messiah, and certainly not in an offhand way like this.*

This story is not mentioned in Acts. In Acts the last mention of James (the leader in the church) is in Acts 21:18, where he is painted as *dwelling safely in Jerusalem amongst Jews and Jewish Christians.* "You see, brother, how many thousands of believers there are among the Jews, and they are all zealous for the law."[725] This is not consistent with the picture described in Josephus, where there is open hostility between the individuals and groups named.

The source of the interpolation seems to be Origen who alludes to it, in the following passage.

> Now this writer [Josephus], although not believing in Jesus as the Christ, in seeking after the cause of the fall of Jerusalem and the destruction of the temple, whereas he ought to have said that the conspiracy against Jesus was the cause of these calamities befalling the people, since they put to death Christ, who was a prophet, says nevertheless—being, although against his will, *not far from the truth*—that these disasters happened to the Jews as a punishment for the death of James the Just, who was *a brother of Jesus (called Christ)*,—the Jews having put him to death, although he was a man most distinguished for his justice.[726]

Eusebius equates James the leader and bishop of Jerusalem with the one named *brother of the Lord.*[727] Origen and Eusebius also make a connection between a story of the stoning death of someone called

725 Acts 21:20

726 Origen, *Contra Celsus.*

727 *Ecclesiastical History,* Book 2.1.

"James the Just" as related by Hegesippus[728],to the incident related by Josephus. However, when both stories are compared we see that they are clearly unrelated.

2 *Aretas*

If Paul was alive when Aretas was king of Nabatea then he must be dated in the thirties of the first century. There is a verse in 2 Corinthians which seems to imply this.

Scholars are unanimous that Paul's second letter to the Corinthians is the work of the apostle Paul.[729] But was the letter tampered with? We have an example of a possible interpolation in 6:14-7:1.[730] The Aretas passage in question is at 11:32.

> In Damascus, the governor[a] under King Aretas guarded the city of Damascus in order to[b] seize me, but I was let down in a basket through a window in the wall,[c] and escaped from his hands.
> a. Gk *ethnarch*
> b. Other ancient authorities read *and wanted to*
> c. Gk *through the wall*

In Acts, we have *a different version of events.* Here *the Jews* were watching for Paul.

> After some time had passed, *the Jews* plotted to kill him, but their plot became known to Saul. They were watching the gates day and night so that they might kill him; but his disciples took him by night and let him down through an opening in the wall, lowering him in a basket. (9:23-25)

728 *Ecclesiastical History*, Book 2.23.
729 Harris, 2005, p. 1.
730 See Duling et al., 1994, p. 232.

This version of the story is more plausible. To have an Arabian ethnarch, who most probably had no authority in the city, chasing Paul, makes little sense. Burns highlights the problem of Nabatean control.

> If Damascus had been a Greek city state that passed easily under Roman control, why was it mentioned in the New Testament Acts [sic: not Acts, actually in Corinthians] as supervised by a Nabataean ethnarch when Paul hastily departed at the end of his second [?] visit?[731]

We know that Aretas IV (the last one) died in the year 40.[732] We also know that Aretas IV had no authority in Damascus. An inscription found in 2010 in the region of al-ussayniah, north of Maān, in southern Jordan lists the places where Aretas IV was active and Damascus is not mentioned.[733] It seems that around this time the Romans under Petronius and later Marcus were presidents of Syria and therefore had control of Damascus.[734]

Out of context

The subject of the previous and subsequent verses is *boasting*, and the Aretas passage does not fit the argument. Harris has observed that,

> Sometimes the account of Paul's escape from the clutches of Aretas (in vv. 32-33) is seen as being "out of context, out of style, quite out of connexion." But if the position of this pericope is so inappropriate, it is difficult to imagine what prompted Paul's amanuensis or a scribe to insert the story at this point.[735]

Linguistic analysis

The redundancy (repetition of the word *Damascus*) in the passage belies a crude hand.

731 Burns, 2005, p. 70.

732 al-Salameen, 2011, p. 215.

733 al-Salameen, 2011, p. 216.

734 *Antiquities of the Jews*, Book 19.6.4.

735 Betz and Windisch in Harris, 2005, p. 820.

In *Damascus* the ethnarch of Aretas the king was watching the city of
the *Damascenes*, wishing to seize me ...[736]

We conclude that the passage is a very early fictional interpolation
inserted into Paul's letter in order to place him in the acceptable
"apostolic" time period. The origin of the story could be based on
actual events as previously noted. (see Chapter 9, *A brief life of Paul*.)

3 *Tacitus*

There is a passage in *Annals* written by Tacitus which links the
emperor Nero, the Roman fire of the year 64 and Christians. This
passage is often quoted by orthodox historians as evidence that the
founding myth of Christianity as presented in the gospels has some
support. However, a close examination of this passage and its wider
context, reveals that there are major problems with this assessment.

Publius Cornelius Tacitus was a Roman historian and senator
writing about the year 120[737], some 56 years after the event under
consideration. The *Annals* covers the period 14 to 68 CE, but several
books and parts of books in the series are missing. Tacitus also
mentions Christians in a fragment which has been discussed at item
44 in Part 2 of this book. In his other work, *Histories* which covers
the period 69 to 96 there is no mention of Jesus or Christians, and
as with the *Annals* the documents in their entirety have not survived.

Fires in ancient Rome

Given the nature of the city, its architecture, building materials and
the goods housed there, fires both small and large in Rome were
common. From Plutarch we learn that in an earlier period Marcus
Crassus became the owner of the largest part of the city by buying for
a trifling sum individual houses that were either threatened with fire

736 Youngs Literal Translation
737 Syme, 1958, p.473.

or had caught fire then salvaging them with the aid of hundreds of slaves acquired for this purpose.[738] In reading the Roman historians,

> ". . . one comes upon numerous references to fires and losses by fire in ancient Rome, not only such as are to be expected in the ordinary course of an ancient city's life but conflagrations of very serious consequences, which devastated great areas and involved the partial or total loss of houses, tenements, markets, granaries, storehouses, and splendid public buildings."[739]

Five fires are recorded for the reign of Tiberius. One conflagration of major proportions marks the time of Claudius.[740] (There is no record of *this* fire being blamed on the Christians.) And,

> "under the Emperor Titus Rome was subjected to a violent conflagration, second in importance only to . . . [the fire of 64]. In the year 80 flames raged for three days and nights, burned a large section of the Campus Martius, and, moving thence in a southeasterly direction, devastated the Capitoline hill."[741]

The fire in the year 64

There is a popular belief, even today, that Nero was the instigator of the fire, but is this belief justified?

1. Tacitus admits that the fire which started at the height of summer on the 19th of July 64 could have been caused accidentally.

> A disaster followed, whether accidental or treacherously contrived by the emperor, is uncertain, as authors have given both accounts.[742]

738 *Parallel Lives,* Life of Crassus, *2.4.*

739 Canter, 1932, p. 270.

740 Suetonius, *Claudius,* 18.

741 Canter, 1932, p. 276.

742 *Annals,* Book 15.38.

2. Tacitus affords an explanation as to the cause of the fire.

> It had its beginning in that part of the circus which adjoins the Palatine
> and Caelian hills, where, amid the shops containing inflammable wares, the
> conflagration both broke out and instantly became so fierce and so rapid
> from the wind that it seized in its grasp the entire length of the circus.[743]

3. Nero himself was absent when the fire started and suffered personal loss in the fire.

> Nero at this time was at Antium [about 50km south of Rome, on the
> coast], and did not return to Rome until the fire approached his house,
> which he had built to connect the palace with the gardens of Maecenas.
> It could not, however, be stopped from devouring the palace, the house,
> and everything around it.[744]

4. Short-term relief was provided by Nero.

> ... to relieve the people, driven out homeless as they were, he [Nero] threw
> open to them the Campus Martius and the public buildings of Agrippa,
> and even his own gardens, and raised temporary structures to receive the
> destitute multitude. Supplies of food were brought up from Ostia and the
> neighbouring towns, and the price of corn was reduced to three sesterces.[745]

5. Long-term planning

> Nero instituted changes to building regulations to prevent further
> serious fires in the city, or at least mitigate the damage that they could
> cause. He also facilitated the removal of debris, appointed fire wardens
> and ensured that water was available to fight any future outbreaks.[746]

743 *Annals*, Book 15.38.
744 *Annals*, Book 15.39.
745 *Annals*, Book 15.39.
746 *Annals*, Book 15.43.

Suetonius writes,

> Nero introduced his own new style of architecture in the city: building
> out porches from the fronts of apartments and private houses to serve as
> fire-fighting platforms, and subsidizing the work himself.[747]

Despite these clear indications that Nero was not involved in firing
the city, was generous and prompt in relieving the populace and used
the disaster as an opportunity to improve safety and amenity in the
metropolis, there was, according to both Tacitus and Suetonius[748], no
stopping the malicious rumours. Tacitus remarks,

> Yet his measures, popular as their character might be, failed of their
> effect; for the report had spread that, at the very moment when Rome
> was aflame, he had mounted his private stage, and typifying the ills of
> the present by the calamities of the past, had sung the destruction of
> Troy[749]

Why then was Nero blamed for the fire? The answer lies in human
psychology. Barkun notes that there is a greater willingness to look
sympathetically at non-orthodox accounts of events where there is
a general distrust of authority.[750] Conspiracy theories can spring up
following major and unexpected disasters.[751] Following on from the
Roman case we find an analogy with another famous European fire
which occurred in the year 1666.

The Great Fire of London

A fervent expectation took shape before the fire that something
ominous was about to transpire. Protestant numerologists had singled

747 *The Twelve Caesars,* Nero, 16.
748 *The Twelve Caesars,* Nero, 38.
749 *Annals,* Book 15.39.
750 Barkun, 2016, p. 4.
751 See Chapter 7, *A Christian Conspiracy Theory* for a working definition of the term "conspiracy
 theory".

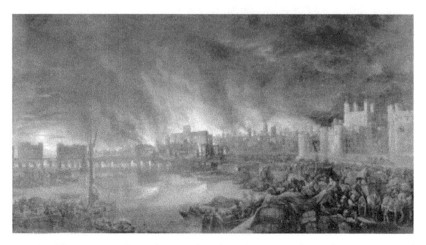

Fig 40: *This painting shows the great fire of London as seen from a boat in vicinity of Tower Wharf. The painting is not dated or signed.*

out the year 1666 as particularly worrisome because of its links with the prophecy in Revelation chapter 13. The end of the world was believed to be imminent. In Asia Minor a Jewish prophet named Sabbatai Zevi from Smyrna was being hailed as the Messiah.[752]

In London, a Parliamentary Committee was set up to enquire into the causes of the fire. They noted that it started "at one *Farryners* House, a Baker in *Pudding-Lane*, between the hours of one and two in the Morning", and that there were "Eighty nine Parish Churches, besides Chappels burnt... Houses burnt, thirteen thousand two hundred."[753] The Committee was persuaded that the fire was instigated by the French or by Papists directed from Rome. For example, the following evidence was put before them—

Mr. Cotman *did Inform, That one* Mr. Carpenter, *late a Preacher at* Colledge-Hill, *did in discourse tell* Cotman, That the Judgements of God upon this Kingdom, by the Plague last year, and lately by the Fire in *London*, were come upon this Land and People for their forsaking the

752 See https://en.wikipedia.org/wiki/Sabbatai_Zevi

753 Early English Books Online accessed at https://quod.lib.umich.edu/e/eebo/A63385.0001. 001?rgn=main;view=fulltext

true Roman Catholique Religion, and casting off obedience to the Pope.[754]

The London Gazette of September 8 reported that "Divers Strangers, Dutch and French were, during the fire, apprehended, upon suspicion that they contributed mischievously to it." A French watchmaker named Robert Hubert produced an incoherent and unconvincing confession, but he was duly hanged anyway for "not having the fear of God before his eyes, but moved and led away by the instigation of the devil." According to one account, he retracted his confession on the gallows, but by then it was too late.[755] After the hanging, Hubert's lifeless body was hacked and torn to pieces by the angry mob.[756]

In the case of the London fire, Rietveld remarks,

> I propose that the fire of 1666 erupted so dramatically in the manner of 'a thief in the night' upon Londoners, that all the repressed feelings of suspicion, of anger, and of discontent within the popular imagination, those thoughts usually kept in check either by fear of the authorities or for personal advantage, immediately rose to the surface and found expression through various mediums, especially in print culture. It is also important to note that the majority of these cause theories for the fire, which were incredibly varied in nature, were conjured up and then set in ink within the first year after the blaze; after which, it seems, the initial shock wore off and more conventional explanations took root.[757]

More conventional explanations did not take root in the Roman case because of the popular obsession with Nero—an obsession, I might add, which continues to the present day.

754 Early English Books Online accessed at https://quod.lib.umich.edu/e/eebo/A63385.0001.
 001?rgn=main;view=fulltext
755 Tinniswood, 2004, Kindle Loc 2908.
756 Hanson, 2001, p. 301.
757 Rietveld, 2012, Kindle Loc 45.

The *Christus* passage from Tacitus

We now turn to the relevant passage in Tacitus. He says,

> . . . all human efforts, all the lavish gifts of the emperor, and the propitiations of the gods, did not banish the sinister belief that the conflagration was the result of an order. Consequently, to get rid of the report, Nero fastened the guilt and inflicted the most exquisite tortures on a class hated for their abominations, called Christians by the populace. Christus, from whom the name had its origin, suffered the extreme penalty during the reign of Tiberius at the hands of one of our procurators, Pontius Pilatus,[758] and a most mischievous superstition, thus *checked for the moment*, again broke out not only in Judaea, the first source of the evil, but even in Rome, where all things hideous and shameful from every part of the world find their centre and become popular. Accordingly, an arrest was first made of all who [confessed] pleaded guilty; then, upon their information, *an immense multitude was convicted,* not so much of the crime of firing the city, as of *hatred against mankind.*[759] [my emphasis]

Why the story is untrue

The story does not receive support from sources that should have mentioned it.

1. The Nero story is not mentioned by any of the *early* church fathers.

(a) Nero is not mentioned as a persecutor of Christians in the *Epistle of Barnabas.* This letter written after the temple was destroyed in the year 70 describes the *current* Roman emperor as the *"worker of evil."* [760] Nero died in 68.

758 The Pontius Pilate inscription from Caesarea now confirms that the official Latin title of Pilate as governor of Judea was *praefectus.* Ferguson, 1993, p.42.

759 *Annals, Book 15.44.*

760 *Epistle of Barnabas* 2.1.

(b) Clement, bishop of Rome, writing about 97 [761] mentions recent "sudden and successive calamitous events," and despite naming Peter and Paul, and some women as "the most recent spiritual heroes [literally: those who have been athletes]" (5ff) makes no reference to Nero or any martyrs under Nero.

(c) There is no mention by Justin Martyr. There is no mention by Irenaeus despite discussing the subject of persecution. (Book 2.30) Origen mentions Nero and persecution, but never recalls any persecution under Nero.

(d) Tertullian in the early third century is the exception and appears to allude to Tacitus when he says, "We read the lives of the Caesars: At Rome Nero was the first who stained with blood the rising faith."[762] However, we should note that elsewhere Tertullian describes the historian as "most loquacious in falsehood."[763]

2. The incident is not mentioned by Josephus. On the contrary we note that the Jewish historian defends the character of Nero.

> . . . there have been a great many who have composed the history of Nero; some of which have departed from the truth of facts out of favor, as having received benefits from him; while others, out of hatred to him, and the great ill-will which they bare him, have so impudently raved against him with their lies, that they justly deserve to be condemned.[764]

761 Staniforth, 1968, p.17.

762 *Against Scorpion* 15:3.

763 *Ad Nationes,* Book *1.11.* We note that Tertullian also believed that Pilate repented after passing sentence on Jesus and converted to Christianity and that the emperor Tiberius himself took the matter of the new sect to the Senate and decided in its favor. (Apology 5 & 21) There is no evidence in the Roman histories to corroborate these assertions, and they are generally viewed as pious Christian inventions.

764 *Antiquities of the Jews,* Book 20.8.3

3. Suetonius while repeating the rumour that Nero was responsible for the fire[765] fails to mention Christians as the arsonists or accused arsonists responsible for the fire.

4. The Christian author Lactantius (c. 250–c. 325), who became an advisor to Constantine, carefully detailed the wrongs committed by tyrannical rulers against the Christians. But he says nothing at all about a fire under Nero. Instead, he connects Nero's attack on the Christians, and the killings of Peter and Paul, with the fact that people were abandoning traditional cult.[766]

5. Pliny the Younger, a contemporary and friend of Tacitus, in 111 has heard of Christians, but knows nothing of their beliefs or practices.[767] If the story of Tacitus were true, Christianity as a sect would have been widely known. Shaw argues,

> Pliny was about as highly educated a member of the Roman élite of the time as one could be. He certainly knew about his Roman past. If persons known as Christians had been responsible for setting the fire that almost destroyed the metropolis of the Empire—or who, at the very least, were firmly believed to have been the culprits—and had been punished for this act of monumental criminality, that Pliny knew nothing about these matters or about Christians is simply not credible.[768]

6. The silence of Pliny the Elder is also remarkable. Shaw observes:

> The elder Pliny's only explicit statement regarding the fire of 64 holds Nero to blame for it and, in consequence, for the destruction of an important rare species of tree. But nowhere in the more than 20,000 facts collected from 2,000 books and 100 different authors in his *Natural*

765 Nero, 38.
766 Shaw, 2015, p. 93. See Lactantius, *De Mortibus Persecutorum* "On the Deaths of the Persecutors."
767 *Correspondence*, Letter 97.
768 Shaw, 2015, p. 90.

History does Pliny so much as refer to any people called *Christians* or *Chrestiani*, much less does he make any connection of them with the fire that destroyed large parts of the imperial metropolis.[769]

7. The *Epistle to the Hebrews* (written about the year 90[770]) says "In your [the believers'] struggle against sin you have not yet resisted to the point of shedding your blood." (Hebrews 12:4)

Other difficulties with the story

1. Why were Christians *universally hated* as *enemies of mankind* if their numbers were so small no contemporary writers noticed them[771] while Jews with similar beliefs and who were much more numerous were tolerated?[772] Anti-Semitism, as already noted, was well established throughout the Empire. The Jews in Palestine were also at this time very close to open insurrection against Roman rule, and diaspora Jews were in a precarious position. I think there are good grounds for believing the entertainment provided by Nero, if it occurred at all, was really a punishment inflicted on Roman Jews, who are described elsewhere by Tacitus as being *haters of mankind*.[773]

2. Arnaldo Momigliano, famous for his work on historiography, argues that Tacitus is confused and has combined two separate stories into one.[774] In one version Christians are found guilty of setting the city on fire and they are duly punished. In another version Nero selects Christians as scapegoats, they are falsely accused of setting the

769 Shaw, 2015, p. 82.

770 Duling et al., 1994, p. 285.

771 Origen, *Contra Celsum*, Book 3.10. "That Christians at first were few in number, in comparison with the multitudes who subsequently became Christian, is undoubted."

772 The expulsion of the Jews under Claudius recorded in Acts was not effectual. "In the matter of the Jews, who had again increased so greatly that by reason of their multitude it would have been hard without raising a tumult to bar them from the City, he decided not to drive them out, but ordered them to follow that mode of life prescribed by their ancestral custom and not to assemble in numbers." Cassius Dio, *Roman History*, 60.6.

773 Tacitus, *Histories*, Book 5.5.

774 Syme, 1958, Note 5, p.533.

city on fire and punished for something completely different, being universally regarded as *haters of mankind*.

Tacitus got it half right

Tacitus says the religion gravitated to and became popular *in Rome*. This agrees with our thesis. Secondly, Tacitus says that there was *an immense multitude*[775] of Christians in Rome in the year 64. Tacitus has got the number right but the date wrong. The *immense multitude* of Christians in Rome wasn't observed until six or seven years later. But estimating numbers of adherents of religions is notoriously difficult.[776]

Some demography

In Acts we read that three thousand were added in one day in Jerusalem (2:41), and then another five thousand (4:4) and finally "many thousands" of Jews believed, and they were all zealous for the law, that is they were Jewish Christians. (21:20) But Acts, as we have noted previously, is unreliable. It also fails to mention the Jewish Christians in Rome.

We have an example from more modern history in the Mormon church which has maintained an average growth rate of 43% per decade over the past century.[777] Perhaps Christianity in the first 200 years was similar however we should be careful not to assume that the rate of growth was constant over the decades. An initial high rate may be imagined as the new religion filled a gap in the marketplace. The total population of the Empire has been estimated as 45.5 million in 14 CE and 61.4 million in 164 CE.[778]

If we begin with a figure of 10,000 Gentile and Jewish

775 In his book *Annals*, the term *immense multitude* (Latin: multitudo ingens) in respect of affairs in Rome seems to indicate that when he uses the term Tacitus has in mind a figure of at least several thousand. See Book 14.8.

776 Stark, 1996, p. 5. In 1984 a Toronto magazine claimed that there were 10,000 Hare Krishna members in that city. But when Irving Hexham, Raymond F. Currie, and Joan B. Townsend (1985) checked on the matter, they found that the correct total was 80.

777 Stark, 1996, p. 7.

778 Frier, 2000, p. 812, table 5, p. 814, table 6.

Christians[779] in all the Empire in the year 70 when the rumour of the Messiah's appearance first arose, we arrive at a figure of about 10 million in the year 313 when Constantine made the religion legal.[780] This would have represented about 15% of the entire population of the Empire at that time. This number seems about right.[781] For the situation in Rome, assuming a disproportionate one tenth of the Empire's Christians were in that city, that is about 1000 in the year 70, we should expect there to be about 11,250 in the year 110, when Pliny was writing to Hadrian about how to deal with the Christians in Bithynia and Tacitus was writing his *Annals*. The population of Rome at the turn of the century was probably in the range 0.5 to 1 million.

In the hurly burly of Rome for Christians to be noticeable as a distinct sect and not as isolated eccentric individuals they must have advertised their presence and exhibited solidarity. This would have been by means of distinct dress (1 Timothy 2:9), distinct methods of prayer (1 Timothy 2:8), public preaching (2 Timothy 4:2), communal isolation (1 Peter 4:4) and acts of civil disobedience (Pliny the Younger, letter 96). In this way a few thousand individuals can seem like tens of thousands—or as Tacitus asserts—an *immense multitude*.

Can we trust Tacitus?

Historians in the ancient world did not escape criticism from contemporaries. Seneca is on record in Book 7 of his *Quaestiones Naturales*, (in which he discusses comets), refuting the Greek historian Ephorus.

> It requires no great effort to strip Ephorus of his authority; he is a mere chronicler. Some of his class seek to recommend their narrative by incredible stories, and by their marvels try to interest the reader, who

779 Assume a 50/50 split between Gentile and Jewish Christians initially.

780 This assumes growth rates per decade of 200, 100, 50 and 25% thereafter for the decades beginning 70 to 310.

781 Stark, 1996, p. 6.

would probably soon find some other occupation if he were called on to wade through their tedious narrative of ordinary events. Some, again, are too credulous, some too careless, some are deluded, some delighted, by falsehood. The former do not shun it, the latter go in quest of it. The whole clan of them have this in common; they fancy their work cannot merit approval, and become popular unless they freely interlard it with lies.[782]

Lucian wrote an essay entitled *The Way to write History*, and in that work passed judgement on his fellows as follows.

There you have the origin of the present crowd of historians, intent only upon the passing day, the selfish interest, the profit which they reckon to make out of their work; execration is their desert—in the present for their undisguised clumsy flattery, in the future for the stigma which their exaggerations bring upon history in general.

For Lucian, "history, I say again, has this and this only for its own; if a man will start upon it, he must sacrifice to no God but Truth."

Ronald Syme, widely regarded as the 20th century's greatest historian of ancient Rome, wrote two volumes on Tacitus. Syme conceded that Tacitus made mistakes like any historian.[783] He wasn't fastidious in general about stating his sources but for Nero three authorities are certified — Pliny the Elder, Cluvius Rufus and Fabius Rusticus.[784] As already noted Pliny makes no mention of Christians. The passage under consideration is not referenced. When Tacitus was composing the *Annales*, it was not too late to question witnesses surviving from the last years of Nero.[785] However did the witnesses really know what happened or did they report what had been established by rumour?

782 Seneca, *Quaestiones Naturales,* Book 7.16.

783 Syme, 1958, p.378.

784 Syme, 1958, p.289ff. *Annales,* Book 13.20.

785 Syme, 1958, p. 300.

Conclusions

1. Nero did not start the fire—popular opinion to the contrary.

2. The fire was probably the result of an accident.

3. Some scapegoats were duly executed but they were not Christians.

4. Tacitus has reconstructed an event using some true elements and other elements from popular rumour and Christian confessions about their origins, information which was current when Tacitus was writing his histories.

5. The story as entertainment is masterful and would have pleased his pagan readership.

4 Suetonius

There is a passage in Suetonius, who was writing about the same time as Tacitus, which appears to link Christians and Nero.

> During his [Nero's] reign a great many public abuses were suppressed by the imposition of heavy penalties, and among the equally numerous novel enactments were sumptuary laws limiting private expenditure; the substitution of a simple grain distribution for public banquets; and a decree restricting the food sold in wine-shops to green vegetables and dried beans—whereas before all kinds of snacks had been displayed. *Punishments were also inflicted on the Christians, a sect professing a new and mischievous religious belief*; and Nero ended the licence which the charioteers had so long enjoyed that they claimed it as a right: to wander down the streets, swindling and robbing the populace. He likewise expelled from the city all pantomime actors and their hangers-on.[786]

786 *The Twelve Caesars*, Nero, 16.

In this sample of text, the reference to punishments inflicted on religious devotees seems out of context. The subject of the text is *public abuses in the streets of Rome.* The text reads better if the section is omitted entirely. If the passage is genuine we can argue that it reflects a popular misconception (as per the criticism of Tacitus) and is not good evidence for the existence of Christians before 70 CE.

Furthermore, there is no reason to suspect that Nero would have singled out Christians for punishment because they belonged to a new sect. Suetonius says,

> He [Nero] despised all religious cults except that of the Syrian Goddess, and showed, one day, that *he had changed his mind even about her,* by urinating on the divine image. He had come, instead, to rest upon a superstitious belief—the only one, as a matter of fact, to which he ever remained faithful—in the statuette of a girl sent him by an anonymous commoner as a charm against conspiracies. It so happened that a conspiracy came to light immediately afterwards; so he began to worship the girl as though she were a powerful goddess, and sacrificed to her three times a day, expecting people to believe that she gave him knowledge of the future. He did inspect some entrails once, a few months before his death, but they contained no omen at all favourable to him.[787] [my emphasis]

5 *The relatives of Jesus*

The brothers of Jesus
The term *Brothers of the Lord* seems to have originated within the early church, but could have been generated earlier from Genesis 27v29,

> Let peoples serve you [Jesus], and nations bow down to you. Be lord over your brothers, and may your mother's sons bow down to you.

787 *The Twelve Caesars,* Nero, 56.

Also, Numbers 27:8–9,

> You shall also say to the Israelites, 'If a man dies [that is, Jesus], and has
> no son, then you shall pass his inheritance on to his daughter. If he has
> no daughter, then you shall give his inheritance to his brothers.'

From the New Testament,

> For this reason Jesus is not ashamed to call them brothers, saying, "I will
> proclaim your name to my brothers, in the midst of the congregation I
> will praise you." (Hebrews 2:11 quoting Psalm 22:22)

Paul's gospel message was that at some time in the indeterminate past
at an indeterminate place Jesus had been crucified. In Paul's theology
and in the earliest church, details such as exactly when and where
Jesus had suffered and died seems not to have been formally fixed,
although *it must have been recently and probably in or near Jerusalem*[788]
because the destruction of the Temple and Jerusalem had just
occurred.[789] Further evidence that it was believed to have been a
recent event is to be found in the alleged existence of brethren of the
Lord who could be found scattered around the empire near the end
of the century.

In the Jerusalem church, James was the chief claimant[790] who gave
himself or was awarded the title of *brother of the Lord*. (Galatians 1:19)
Paul mentions other "brothers of the Lord" in a list of church leaders.
(1 Corinthians 9:5) James, in the tradition related by Paul also saw

788 Luke 13:33 "...it is impossible for a prophet to be killed outside of Jerusalem."

789 If the atonement was needed in an unbroken sequence then Jesus must have been crucified
the day of the tenth of Tishri (September-October), the great day of atonement. (Gane, 2005,
p. 34) Jerusalem fell in August-September in 70. NOTE: Paul does not mention the Passover
as signifying the time of Jesus' death. This was a later invention of the gospel writers.

790 Eduard Meyer, the eminent authority on ancient history, in his monumental study of Christian
Origins suggested that the rise of James to power in the Church was due to the supreme fact
of his blood relationship with Jesus [sic] and that in the primitive Christian movement there
were the beginnings of a caliphate, founded in the Prophet's own family, such as developed to
mature proportions in Islam, the other great Semitic world religion. (Brandon, 1951, p. 50)

the risen Lord, (1 Corinthians 15:7). [791] But note the apocryphal *First Apocalypse of James*,

> I [Jesus] have given you a sign of these things, James, my brother. For not without reason have I called you my brother, *although you are not my brother materially.* And I am not ignorant concerning you; so that when I give you a sign—know and hear." [italics added]

Kinship with the family of Jesus, improved the prospects of a career in *every* church, as Hegesippus reports, *in the reign of Domitian*:

> The same historian says that there were also others, descended from one of the so-called brothers of the Saviour, whose name was Judas, who, after they had borne testimony before Domitian, as has been already recorded, in behalf of faith in Christ, lived until the same reign. He writes as follows: "They came, therefore, and took the lead of every church as witness and as relatives of the Lord. And profound peace being established in every church, they remained until the reign of the Emperor Trajan... [792]

The following passage from Matthew (and repeated in substance in Luke and Mark) contradicts the view that physical lineage was of any importance.

> While he [Jesus] was still speaking to the crowds, his mother and his brothers were standing outside, wanting to speak to him. Someone told him, "Look, your mother and your brothers are standing outside, wanting to speak to you." But to the one who had told him this, Jesus replied, "Who is my mother, and who are my brothers?" And pointing to his disciples, he said, "Here are my mother and my brothers! For whoever does the will of my Father in heaven is my brother and sister and mother." (Matthew 12:46-50)

791 *The Gospel of Thomas* makes James the most important leader of the church.
792 Hegesippus quoted in Eusebius, *Ecclesiastical History*, Book 3.20.

The concept of non-genetic kinship emanated from the doctrines of the strictest Essenes of whom Josephus says, "They neglect wedlock, but choose out other persons' children, while they are pliable, and fit for learning, and esteem them to be of their kindred, and form them according to their own manners."[793]

Brothers of the Lord as a separate honoured sect within the Christian family of believers found expression in early monasticism. Philo describes the Jewish Therapeutae of Alexandria in the first century as pursuing a life separate from the world and dedicated to God.[794] Eusebius claims that "Philo, when he wrote these things, had in view the first heralds of the Gospel and the customs handed down from the beginning by the apostles."[795] It is not difficult to imagine that these special Christians amongst the early Christians were named or named themselves *brothers of the Lord*, without implying that they were physically related to the Messiah.

Indeed, it is likely that the brothers of the Lord and the twelve were the same people. In his first letter to the Corinthians, Paul writes,

> Do we not have the right to be accompanied by a believing wife, as do the other apostles and *the brothers of the Lord* and Cephas? (9:5)

Cephas is not included in the group named brothers of the Lord, and note that he is also excluded from the group of the twelve. As Paul says later in the epistle,

> ". . . that he [Jesus] was buried, and that he was raised on the third day in accordance with the scriptures, and that he appeared to Cephas, then to *the twelve*. (15:4-5)

If this is so we can see a parallel in the Roman institution of the Arval Brethren, which was an ancient college of priests, twelve in

793 *Wars of the Jews*, Book 2.8.2.
794 *De vita contemplativa*, 1.2.
795 *Ecclesiastical History*, Book 2.17.

number, and so prestigious that the emperor was always one of the set. Bomgardner asserts,

> The cult was based upon a grove sacred to the goddess Dea Dia, located at the fifth milepost on the *via Campana* outside the *porta Portuensis*. There a large series of inscriptions recording details about this cult were uncovered (the so-called *Acta Fratrum Arvalium*). Among them there was an inscription, assigned a date of AD 81, which recorded, in great detail, blocks of seats in the Colosseum that had been set aside for members of this college and their families.[796]

Constantine adopted the principle of the twelve in his mausoleum, which contained "twelve empty sarcophagi ringed round his own tomb, *one for each of the twelve apostles*; naturally enough his son and successor later took the step of securing some relics to place inside the empty containers."[797]

6 *Pontius Pilate*

Paul's first letter to Timothy at Chapter 6 mentions the Roman governor Pontius Pilate. The passage from v11 to v16 which mentions the prefect could be borrowed from 2 Peter and would fit between chapters 2 and 3 of that spurious letter. In Timothy, v17 of chapter 6 neatly follows v10 of the same chapter as they are dealing with the same theme of riches.

Another instance of passages migrating between books is the infamous story of the woman caught in adultery. This appears in John chapter 8 in our Bibles. But the most ancient authorities lack John 7.53—8.11. Other authorities add the passage after Luke 21.38, with variations of text and some mark the passage as doubtful.

796 Bomgardner, 2000, pp.18-19.
797 Bowman et al, 2005, p.101.

Miscellaneous

I *An academic orthodox summary*
of early Christian History[798]

Chronological Summary

From what has been said in the foregoing Lectures, it will be evident that no very definite date can be assigned to any of the Gospels, except S. Luke's. But we may distinguish four periods of 40 years each, reckoning from the Crucifixion.

I 30-70 AD. Oral Period. No written ' Gospel ' appears during this period, nor any formal shaping of the Gospel history as a whole. S. Paul's accounts of the Lord's Supper (1 Cor xi 23 ff) and of the Resurrection (1 Cor xv 3 ff) do not appear to have any literary connexion with what we read in our Gospels. To the end of this first Period we may assign the fly-sheet underlying Mk xiii (in Greek), and S. Matthew's Collection of Messianic Prophecies (in Hebrew).

798 Burkitt, 1906, p.262ff.

II 70-110 AD. Period of the writing of the Gospels.
Gospel of Mark, 70–80 AD.
Gospel of Luke (and Acts), 100 AD.
Gospel of Matthew, 90–100 AD., in any case before 110 AD.
Gospel of John, 100–110 AD.

III 110-150 AD. Period of the catholic reception of the Gospels.

IV 150-190 AD. Period of the canonization of the Gospels. By the
end of this period the Idea of the Fourfold Gospel (Irenaeus 192)
is fully established.

2 *The Apostles' Creed*

The following is a popular English translation of the ancient creed
which is regularly recited in church services.

I believe in God, the Father almighty, creator of heaven and earth.
I believe in Jesus Christ, his only Son, our Lord.
He was conceived by the power of the Holy Spirit and born of the
virgin Mary.
He suffered under Pontius Pilate, was crucified, died, and was buried.
He descended to the dead.
On the third day he rose again.
He ascended into heaven and is seated at the right hand of the Father.
He will come again to judge the living and the dead.
I believe in the Holy Spirit, the holy catholic Church, the communion
of the saints, the forgiveness of sins, the resurrection of the body, and
the life everlasting.
Amen.[799]

799 Accessed at https://en.wikipedia.org/wiki/Apostles%27_Creed

A primitive version of the creed is found in Tertullian (early third century).

> The rule of faith, indeed, is altogether one, alone immoveable and irreformable; the rule, to wit, of believing in one only God omnipotent, the Creator of the universe, and His Son Jesus Christ, born of the Virgin Mary, crucified under Pontius Pilate, raised again the third day from the dead, received in the heavens, sitting now at the right (hand) of the Father, destined to come to judge quick and dead through the resurrection of the flesh as well (as of the spirit). [800]

3 *Cicero and Jesus*

Theme	Cicero reference	Gospel reference
true glory	On duties, Book 2.43.	Matthew 6:28-29
children	The first book of the second pleading against Caius Verres, 153. *De finibus bonorum et malorum* ("On the ends of good and evil"), Book 5.43.	Matthew 19:13-14
a place in heaven reserved for the righteous	*Scipio's Dream*, 5. *Scipio's Dream*, 15.	Matthew 5:3,10,12
marriage	*De finibus bonorum et malorum* ("On the ends of good and evil"), Book 4.17.	Matthew 19:6-9
true law	*De re publica* (on the Republic), Book 3.22.	Matthew 5:18

800 *On the Veiling of Virgins*, 1.

the Universe is God's temple	*Scipio's Dream*, 15.	Acts 17:24-25
universal love	*De officiis* (On duties), Book 1.149.	Matthew 5:43-47
truth	*De officiis* (On duties), Book 1.13.	John 18:37
riches	*De officiis* (On duties), Book 2.56.	Matthew 19:23-25
the duty to invest	*De officiis* (On duties), Book 2.87.	Matthew 25:20-21, 27
charity	*De officiis* (On duties), Book 1.52.	Matthew 5:42
true worship	*De natura deorum* (On the nature of the gods), Book 2.28.	Matthew 15:7-9
Jewish religion condemned	*Pro Flacco* (in defense of Lucius Valerius Flaccus for extortion) 67.	Matthew 23:13-33
secret piety	*Tusculan Disputations*, Book 2, On bearing pain, 26.	Matthew 6:1-4
wisdom in the perfect man	*Tusculan Disputations*, Book 2, On bearing pain, 22.	Matthew 13:54
God is good	*De natura deorum* (On the nature of the gods), Book 1.43.	Luke 18:19
God is love	*De natura deorum* (On the nature of the gods), Book 1.44.	John 3:16
There is one god	*De legibus* (on laws) Book 2	Mark 12:29

In the beginning was the word	*De legibus* (on laws) Book 2	John 1:1-5
God is the judge	*De legibus* (on laws) Book 2	Matthew 7:1-2
God punishes wrongdoers	*De legibus* (on laws) Book 2	Matthew 25:46
God does not require costly sacrifices	*De legibus* (on laws) Book 2	Luke 21:1-3
God sees all	*De legibus* (on laws) Book 2	Matthew 6:4,6,18
Souls are immortal	*De legibus* (on laws) Book 2	Luke 16:19-31

Table 6: *Ciceronian ideas adopted by the gospel writers*

Ancient Sources

Anonymous (n.d.) *The Apostolic Tradition*. Translated by K. P. Edgecomb. Accessed at http://www.bombaxo.com/patristic-stuff/church-orders/hippolytus-the-apostolic-tradition/

Anonymous (n.d.) *Pseudo-Clementine Literature*. Translated by Thomas Smith. In Ante-Nicene Fathers, Vol. 8. Accessed at https://en.wikisource.org/wiki/Ante-Nicene_Fathers/Volume_VIII/Pseudo-Clementine_Literature

Anonymous (1987) *The Muratorian Fragment*. Translated by B. Metzger. In The Canon of the New Testament. Oxford: Clarendon Press. Accessed at http://www.bible-researcher.com/muratorian.html

Anonymous (2011) *The Dead Sea Scrolls*. Translated by G. Vermes. In The complete Dead Sea scrolls in English. London: Penguin.

Arnobius (1886) *Against the Heathen*. Translated by H. Bryce and H. Campbell. In Ante-Nicene Fathers, Vol. 6. ★

Augustine (1888) *The Harmony of the Gospels*. Translated by S.D.F. Salmond. In Nicene and Post-Nicene Fathers, First Series, Vol. 6. ★

Augustus (2010) *Res gestae divi Augusti*. Translation and commentary by A. Cooley. Cambridge: Cambridge University Press.

Barnabas (1968) *Epistle of Barnabas*. Translated by M. Staniforth. In Early Christian writings. Harmondsworth: Penguin.

Cassius Dio (2014) *The complete works of Cassius Dio* (Delphi Classics). Translated by H.B. Foster. Introduction by E. Cary. ★★

Celsus (1987) *On the true doctrine: A discourse against the Christians*. Translation and introduction by R.J. Hoffmann. New York: Oxford University Press.

Cicero (2014) *The complete works of Cicero* (Delphi Classics). Translated by C.D. Yonge and others. ★★

Clement of Alexandria (1885) *Works*. Translated by William Wilson. In Ante-Nicene Fathers, Vol. 2. ★

Clement of Rome (1968) *Clement of Rome*. Translated by M. Staniforth. In Early Christian writings. Harmondsworth: Penguin.

Epiphanius (1987) *The Panarion of Epiphanius of Salamis, Book I*. Translated by F. Williams. Leiden: BRILL.

Epiphanius (1994) *The Panarion of Epiphanius of Salamis, Books II and III*. Translated by F. Williams. Leiden: BRILL.

Eusebius (1890) *Church History*. Translated with prolegomena and notes by A.C. McGiffert. Accessed at https://www.ccel.org/ccel/schaff/npnf201.toc.html

Hippolytus (1886) *The Refutation of All Heresies*. Translated by J.H. MacMahon. In <u>Ante-Nicene Fathers</u>, Vol. 5. Buffalo, NY: Christian Literature Publishing Co. ★

Homer (1919) *The Odyssey* (Delphi Classics). Translated by A.T. Murray. ★★

Ignatius (1968) *The Epistles of Ignatius*. Translated by M. Staniforth. In <u>Early Christian writings</u>. Harmondsworth: Penguin.

Irenaeus (1885) *Against Heresies*. Translated by A. Roberts and W. Rambaut. In <u>Ante-Nicene Fathers</u>, Vol. 1. Buffalo, NY: Christian Literature Publishing Co. ★

Jerome (1892) *De Viris Illustribus* (On Illustrious Men). In <u>Nicene and Post-Nicene Fathers, Second Series</u>, Vol. 3. ★

Josephus (2016) *The Works of Josephus: Complete and Unabridged*. Translated by William Whiston. [includes *The Life of Flavius Josephus, The Antiquities of the Jews, The Wars of the Jews, Against Apion*] Kindle Edition: Delmarva Publications Inc.

Julian (1913) *The works of the Emperor Julian: III*. Translated by W.C. Wright. Loeb Classical Library. London: Heinemann.

Justin Martyr (1885) *Works*. Translated by M. Dods and G. Reith. In <u>Ante-Nicene Fathers</u>, Vol. 1. ★

Livy (2014) *The complete works of Titus Livius Patavinus* (Delphi Classics). Translated by B.O. Foster and W.A. McDevitte. ★★

Lucian (1905) *The Works of Lucian of Samosata*. Translated by H.W. Fowler and F. G. Fowler. Clarendon Press: Oxford.

Lucian (1913) *The Syrian goddess*. Translated by H.A. Strong. Notes and Introduction by J. Garstang. London: Constable.

Maimonides (n.d.) *Epistle to Yemen*. Translated by Boaz Cohen, notes by Abraham S. Halkin. Accessed at https://en.wikisource.org/wiki/Epistle_to_Yemen/Complete

Mara bar Serapion (n.d.) *A Letter of Mara*, Son of Serapion. Translated by B.P. Pratten. In <u>Ante-Nicene Fathers</u>, Vol. VIII. Accessed at https://en.wikisource.org/wiki/Ante-Nicene_Fathers/Volume_VIII

Origen (1885) *Contra Celsum*. Translated by F. Crombie. In <u>Ante-Nicene Fathers</u>, Vol. 4. Buffalo, NY: Christian Literature Publishing Co. ★

Orosius (n.d.) *Historiae Adversus Paganos*. (A History, against the pagans) In Christian Historical Documents. Accessed at https://sites.google.com/site/demontortoise2000/

Philip of Side (2010) *Fragments*. Translated by A. Eastbourne. Accessed at http://www.tertullian.org/fathers/philip_of_side_fragments.htm

Philo of Alexandria (2017) Complete Works of Philo of Alexandria (Delphi Classics). Translated by C. D. Yonge. ★★

Pliny the Elder (2015) *The Complete Works of Pliny the Elder* (Delphi Classics). Translated by J. Bostock and H.T. Riley. ★★

Pliny the Younger (2001) *Letters of Pliny*. Translated by W. Melmoth. Revised by F. C. T. Bosanquet. Accessed at http://www.gutenberg.org/ebooks/2811

Plutarch (2013) *The Complete Works of Plutarch* (Delphi Classics). *Parallel Lives* translated by B. Perrin. Moralia translated by F.C. Babbitt and W.W. Goodwin. ★★

Polybius (2014) *The complete works of Polybius* (Delphi Classics). Translated by E.S. Shuckburgh. ★★

Pseudo-Philo (1917) *The Biblical Antiquities of Philo*: Translated by M.R. James. Accessed at http://ccat.sas.upenn.edu/rak/publics/pseudepig/LAB.html

Quintilian (2015) *The Complete Works of Quintilian* (Delphi Classics). Translated by H.E. Butler. ★★

Seneca (2014) *The complete works of Seneca the Younger* (Delphi Classics). Translated by several hands. ★★

Strabo (2016) *The Complete Works of Strabo* (Delphi Classics). Translated by H.C. Hamilton and W. Falconer. ★★

Suetonius (1979) *The twelve Caesars*. Translated by R. Graves. Introduction by M. Grant. London: Penguin.

Suetonius (2016) *The Complete Works of Suetonius* (Delphi Classics). Translated by J.C. Rolphe. ★★

Tacitus (2014) *The complete works of Tacitus* (Delphi Classics). Translated by several hands. ★★

Tertullian (n.d.) *Latin Christianity: Its Founder, Tertullian*. Translated by P. Schaff et al. In <u>Ante-Nicene Fathers</u>, Vol. 3. Accessed at https://en.wikisource. org/wiki/Ante-Nicene_Fathers/Volume_III

Velleius Paterculus (1924) *The Roman History*. Translated by Frederick W. Shipley. Loeb Classical Library. Accessed at https://penelope.uchicago. edu/Thayer/E/Roman/Texts/Velleius_Paterculus/home.html

★ Revised and edited for New Advent by Kevin Knight. Accessed at https://www.newadvent.org/fathers/

★★ Hastings: Delphi Publishing Ltd.

References

Agus, A. (2014). *Binding of Isaac and Messiah: Law, Martyrdom, and Deliverance in Early Rabbinic Religiosity.* Albany: State University of New York Press.

Allison, G. (1967). Psychiatric implications of religious conversion. *Canadian Psychiatric Association Journal, 12*(1), 55-62.

Atkinson, K., & Magness, J. (2010). Josephus's Essenes and the Qumran community. *Journal of Biblical Literature, 129*(2), 317-342.

Barkun, M. (2016). Conspiracy theories as stigmatized knowledge. *Diogenes.*

Barth, M. (1974). *Ephesians: Introduction, translation and commentary on Chapters 1–3.* Garden City, N.Y: Doubleday.

Becker, E. M., Dochhorn, J., & Holt, E. (2014). *Trauma and Traumatization in Individual and Collective Dimensions: Insights from Biblical Studies and Beyond.* Göttingen: Vandenhoeck & Ruprecht

Berger, D. (1997). *History and hate: The dimensions of anti-Semitism.* Philadelphia: Jewish Publication Society.

Berger, P. (2012). *The Crescent on the Temple: The Dome of the Rock as Image of the Ancient Jewish Sanctuary.* Leiden: BRILL.

Berger, P. L., & Luckmann, T. (1966). *The social construction of reality: A treatise in the sociology of knowledge.* Garden City, N.Y: Doubleday.

Birmes, P. J., Bui, E., Klein, R., Billard, J., Schmitt, L., Allenou, C., ... Arbus, C. (2010). Psychotraumatology in antiquity. *Stress And Health, 26*(1), 21-31.

Bivin, D., Blizzard, R. B., & Center for Judaic-Christian Studies. (2002). *Understanding the difficult words of Jesus: New insights from a Hebraic perspective.* Shippensburg, Pa: Destiny Image Publishers.

Blackwell, R. J., & Inchofer, M. (2008). *Behind the scenes at Galileo's trial: Including the first English translation of Melchior Inchofer's Tractatus syllepticus.* Notre Dame, Ind: University of Notre Dame Press.

Blomberg, C. (1987). *The historical reliability of the Gospels.* Leicester, England: Inter-Varsity Press.

Bomgardner, D. (2000). *The Story of the Roman Amphitheatre.* Oxford. N.Y. Routledge.

Bond, H. (2015). Josephus and the New Testament. In Chapman, H. H., & Rodgers, Z. (2015). *A Companion to Josephus.* Chichester, UK: John Wiley & Sons, Ltd.

Bowman, A., Cameron, A., & Garnsey, P. (2005). The Reign of Constantine, a.d. 306–337. In *The Cambridge Ancient History* (Vol. 12, pp. 90–109). Cambridge: Cambridge University Press.

Brandon, S. G. F. (1951). *The fall of Jerusalem and the Christian church: A study of the effects of the Jewish overthrow of A.D. 70 on Christianity*. London: S.P.C.K.

Brent, A. (1997). Luke-Acts and the Imperial Cult in Asia Minor. *The Journal of Theological Studies* 48 (2): 411–38.

Brodie, F. M. K. (1963). *No man knows my history*. London: Eyre and Spottiswoode.

Buckley, J. J. (2002). *The Mandaeans: ancient texts and modern people*. Oxford: Oxford University Press.

Burkitt, F. C. (1906). *The Gospel history and its transmission*. Edinburgh: Clark.

Burns, R. (2005). *Damascus: a history*. Routledge. New York.

Campos, D. G. (2011). On the distinction between Peirce's abduction and Lipton's Inference to the best explanation. *Synthese, 180*(3), 419–442.

Canter, H. (1932). Conflagrations in ancient Rome. *The Classical Journal, 27*(4), 270-288.

Carrier, R. C. (2014). *On the historicity of Jesus: Why we might have reason for doubt*. Sheffield: Sheffield Phoenix Press.

Case, S. J. (1912). *The historicity of Jesus*.

Chapman, J. (1907). On an apostolic tradition that Christ was baptized in 46 and crucified under Nero. *The Journal of Theological Studies, 8*(32), 590-606.

Church of Jesus Christ of Latter-day Saints., & Roberts, B. H. (1902). *History of the Church of Jesus Christ of Latter-Day Saints. Vol 1*. Salt Lake City, Utah: Deseret News.

Cicero, M. T., & Grant, M. (1971). *Cicero on the good life. Translated with an introduction by Michael Grant*. Harmondsworth: Penguin Books.

Conder, C. R., & Palestine Exploration Fund. (1998). *The survey of Western Palestine, 1882-1888*: [2]. Slough: Archive Editions in association with Palestine Exploration Fund.

Cook, William J. Jr. (2013). The ebionites: Eccentric or essential early christians? *Journal of Arts and Humanities, 2*(7), 15-22.

Cotter, W. (1999). *Miracles in Greco-Roman antiquity: A sourcebook*. London: Routledge.

Court, J. M. (2008). *Approaching the apocalypse: A short history of Christian millenarianism*. London: I.B. Tauris.

Cumont, F. (1911). *The oriental religions in Roman paganism: With an introductory essay by Grant Showerman.* Chicago: Open Court Pub. Co.

Curran, J. R. (2007). The jewish war: Some neglected regional factors. *The Classical World*, 101(1), 75-91.

Darrigol, O. (2012). *A history of optics from greek antiquity to the nineteenth century.* Oxford: OUP Oxford.

Davis, S. (2001). *The cult of saint Thecla: A tradition of women's piety in late antiquity* (Oxford Early Christian Studies). Oxford: Oxford Univ. Press.

Deissmann, A. (1910). *Light from the ancient East: The New Testament illustrated by recently discovered texts of the Graeco-Roman period.* London: Hodder and Stoughton.

Dobschütz, E. (1893). *Das Kerygma Petri.* Leipzig: J.C. Hinrichs.

Dodds, E. R. (1951). *The Greeks and the irrational.* University of California Press.

Downing, F. (1982). Common Ground with Paganism in Luke and in Josephus. *New Testament Studies, 28*(4), 546–559.

Drijvers, J. W. (1997). The Protonike legend, the Doctrina Addai and bishop Rabbula of Edessa. *Vigiliae Christianae*, 51(3), 298.

Duling, D. C., Perrin, N., & Ferm, R. L. (1994). *The New Testament: Proclamation and parenesis, myth and history.* Forth Worth: Harcourt Brace College Publishers.

Duncan, M. (2012). The Curious Silence of the Dog and Paul of Tarsus; Revisiting the Argument from Silence. *Informal Logic, 32*(1), 83–97.

Durkheim, E. (1915). *The elementary forms of religious life.* London: Allen & Unwin.

Dyer, K. F.W., Dorahy, M. J., Hamilton, G., Corry, M., Shannon, M., MacSherry, A., ... McElhill, B. (2009). Anger, aggression, and self-harm in PTSD and complex PTSD. *Journal of Clinical Psychology*, 65(10), 1099.

Dykstra, T. E. (2012). *Mark, canonizer of Paul.* St. Paul, Minn: OCABS Press.

Edmondson, J. (2009). *Augustus* (Edinburgh readings on the ancient world). Edinburgh: Edinburgh University Press.

Edmundson, G. (1913). *The Church in Rome in the first century.* London: Longmans Green.

Ehrman, B. D. (2006) *New Testament Tools, Studies and Documents: Studies in the Textual Criticism of the New Testament.* Boston, NL: Brill.

Ehrman, B. D. (2012). *Forged: Writing in the name of God : why the Bible's authors are not who we think they are.* New York: HarperOne.

Ehrman, B. D. (2013). *Did Jesus Exist?: The historical argument for Jesus of Nazareth.* New York: HarperOne.

Farmer, W. R. 1990 The passion prediction passages and the synoptic problem: a test case, *New Test. Stud.* vol. 36, 1990, pp. 558-670.

Feldman, L. & Hata, G. (1987). *Josephus, Judaism, and Christianity.* Leiden: E.J. Brill.

Feldman, L. (2001). Financing the Colosseum. *Biblical Archaeology Review.* Washington: Biblical Archaeology Society.

Ferguson, E. (1993). *Backgrounds of early christianity.* Grand Rapids, Mich: W.B. Eerdmans.

Festinger, L., & American Psychological Association. (1956). *When prophecy fails.* Minneapolis: University of Minnesota Press.

Filson, F. (1939). The Significance of the Early House Churches. *Journal of Biblical Literature*, 58(2), 105-112.

Finkelstein, I. & Mazar A. (2007). *The quest for the historical Israel: debating archaeology and the history of early Israel.* Society of Biblical Literature, Atlanta.

Finocchiaro, M. A., & Ebrary. (2005). *Retrying Galileo, 1633-1992* (1st ed.). Berkeley: University of California Press.

Fishwick, M. W. (2007). *Cicero, classicism, and popular culture.* New York: Haworth Press.

Fitzgerald, D. (2010). *Nailed: Ten Christian myths that show Jesus never existed at all.*

Frazier, B.N. & Gelman, S.A. (2009). Developmental changes in judgments of authentic objects. *Cognitive Development*, 24(3), 284-292.

Frier, B. W. (2000). Demography. In A. Bowman, P. Garnsey, & D. Rathbone (Eds.), *The Cambridge Ancient History XI: The High Empire, A.D. 70–192.* Cambridge: Cambridge University Press.

Gane, R. (2005). *Cult and character : Purification offerings, day of atonement, and theodicy.* Winona Lake, Ind.: Eisenbrauns.

Gilbert, D. T., Tafarodi, R. W., & Malone, P. S. (1993). You can't not believe everything you read. *Journal of Personality and Social Psychology*, 65(2), 221-233.

Gill C. & Wiseman T.P. Ed. (1993) *Lies and fiction in the ancient world.* University of Exeter Press.

Ginzberg, L. (1909) *The legends of the Jews. Vol II*, ch 4. Retrieved from http://www.sacred-texts.com/jud/loj/index.htm

Gregory, A. T. C. (2005). *The Reception of the New Testament in the Apostolic Fathers.* Oxford: OUP Oxford

Grintz, J. (1960). Hebrew as the Spoken and Written Language in the Last Days of the Second Temple. *Journal of Biblical Literature,* 79(1), 32-47.

Hanson, N. (2001). *The dreadful judgement: The true story of the great fire of London, 1666.* London: Doubleday.

Harnack, A. (1908). *The mission and expansion of Christianity in the first three centuries.* London & New York.

Harris, M. J. (2005). *The Second Epistle to the Corinthians: A commentary on the Greek text.* Grand Rapids, Mich: W.B. Eerdmans Pub. Co.

Harrison, J. (2013). Augustan Rome and the Body of Christ: A Comparison of the Social Vision of the "Res Gestae" and Paul's Letter to the Romans. *The Harvard Theological Review,* 106(1), 1-36.

Heayn, D. (2008). Urban Violence in Fifth Century Antioch: Riot Culture and Dynamics in Late Antique Mediterranean Cities. *CONCEPT, 32.* Retrieved from https://concept.journals.villanova.edu/article/view/303

Hieke, T. (2011). *The day of atonement: Its interpretations in early Jewish and Christian traditions.* Leiden: Biggleswade.

Holland, T. (2014). *In the shadow of the sword: The battle for global empire and the end of the ancient world.* London: Abacus.

Hölter, R. (2005). Shadowed reality or the 'Prometheus-complex': Analytical psychotherapy after political imprisonment and persecution. *The Journal of Analytical Psychology,* 50(4), 521-537.

Horst, P. W. (2014). *Saxa Judaica Loquuntur : Lessons from Early Jewish Inscriptions - Radboud Prestige Lectures 2014.* Leiden: BRILL.

Hull, R. (2010). *The story of the new testament text: Movers, materials, motives, methods, and models* (Resources for biblical study, no. 58). Atlanta: Society of Biblical Literature.

Hutson, M. (2013). *The 7 laws of magical thinking: How irrational beliefs keep us happy, healthy, and sane.* New York: Plume.

Inowlocki, S. Z. C. (2011). *Reconsidering Eusebius.* Leiden: BRILL.

James, M.R. (1924). *The Correspondence of Paul and Seneca.* (The Apocryphal New Testament.) Oxford: Clarendon Press

James, W. (2015). *The varieties of religious experience: A study in human nature.* Being the Gifford Lectures on Natural Religion delivered at Edinburgh in 1901-1902, edited and annotated for the World Wide Web by LeRoy L. Miller.

Jenkins, P. (2000). *Mystics and messiahs: Cults and new religions in American history.* Oxford: Oxford University Press.

Johnson, L. T. (2001). *The first and second letters to Timothy: A new translation with introduction and commentary.* New York: Doubleday.

Jones, B. (1992). *The Emperor Domitian.* London: Routledge.

Jose, P. (1990). Just-World reasoning in children's immanent justice judgments. *Child Development,* 61(4), 1024-33.

Katz, S.T. (2008). *The Cambridge history of Judaism: Vol. 4.* Cambridge: Cambridge University Press.

Keinan, G. (1994). Effects of stress and tolerance of ambiguity on magical thinking. *Journal of Personality and Social Psychology,* 67(1), 48-55.

Kitchen, M. (2002). *Ephesians.* London: Routledge.

Landry, R.J. (2000) *Significance of Rome, the See of Peter, in the Early Church* accessed at http://www.catholicpreaching.com/wp/wpcontent/uploads/2013/07/PetrineSee.pdf

Lerner, M., Ross, M., & Miller, D. (2002). *The justice motive in everyday life.* Cambridge, U.K.: Cambridge University Press.

Lieu, J. (1992). *The Jews among pagans and Christians in the Roman Empire.* London: Routledge.

Liu, J., Li, J., Feng, L., Li, L., Tian, J., & Lee, K. (2014). Seeing Jesus in toast: Neural and behavioral correlates of face pareidolia. *Cortex,* 53(10), 60-77.

Maccoby, H., Nahmánides, Yehiel, & Salomón, I. V. (2006). *Judaism on trial: Jewish-Christian disputations in the Middle Ages.* Oxford: Littman Library of Jewish Civilization.

Machen, A. (1915). *The Angels of Mons. The Bowmen and other legends of the War.* 2nd Ed. London: Simpkin, Marshall & Co.

Magny, A. (2014). *Porphyry in Fragments* (New edition). Farnham: Routledge Ltd.

Mason, E. F. (2008). *'You are a priest forever': Second Temple Jewish messianism and the priestly christology of the Epistle to the Hebrews.* Leiden: Brill.

Mazar, B. (1978). Herodian Jerusalem in the Light of the Excavations South and South-West of the Temple Mount. *Israel Exploration Journal, 28*(4), 230-237.

McCarthy-Jones, S. (2012). *Hearing voices: The histories, causes, and meanings of auditory verbal hallucinations.* Cambridge: Cambridge University Press.

REFERENCES

Merz, A., & Tieleman, T. (2012). The letter of Mara bar Sarapion in context: Proceedings of the symposium held at Utrecht University, 10-12 December 2009 *Culture and history of the ancient near east, v. 58*. Leiden: Brill.

Meyer, N. (2011). Falling for the lord: Shame, revivalism, and the origins of the second great awakening. *Early American Studies*, 9(1), 142-166.

Minns, D. (2010). *Irenaeus: An introduction*. London: T & T Clark.

Momigliano, A. (1987). *On pagans, Jews and Christians*. Middletown, Connecticut: Wesleyan University Press.

Moore, G. F. (1970). *Judaism in the first centuries of the Christian era, the age of the Tannaim*. Cambridge: Harvard University Press.

Mott, F. (1919). *War neuroses and shell shock*. New York: Oxford University Press.

Murdock, D.M. (2014). *Was There a Historical Jesus of Nazareth?: The Use of Midrash to Create a Biographical Detail in the Gospel Story*. Stellar House Publishing.

Neusner, J. (1990). *Judaism and Christianity in the first century*. (Origins of Judaism, 3.) New York: Garland

Nickell, J. (2007). *Relics of the Christ*. Lexington: University Press of Kentucky.

Nongbri, B. (2005). The use and abuse of p 52: Papyrological pitfalls in the dating of the fourth gospel. *Harvard Theological Review*, 98(1), 23-48.

Olson, K. A. (1999). Eusebius and the testimonium flavianum. *The Catholic Biblical Quarterly*, 61(2), 305-322.

Pearson, B. (1971). 1 Thessalonians 2:13-16: A Deutero-Pauline Interpolation. *The Harvard Theological Review*, 64(1), 79-94.

Pixner, B. (1989). The History of the "Essene Gate" Area. *Zeitschrift des Deutschen Palästina-Vereins* (1953-) v105 (19890101): 96-104.

Plater, W. E., & White, H. J. (1926). *A grammar of the Vulgate: being an intr. to the study of the latinity of the Vulgate Bible*. Oxford: Clarendon Press.

Powell, J. E. (1994). *The evolution of the Gospel: A new translation of the first Gospel with commentary and introductory essay*. New Haven: Yale University Press.

Price, H.H. (1969). The Gifford Lectures, Lecture 4: Half-Belief. In *Belief*. Retrieved from http://www.giffordlectures.org/books/belief/lecture-4-half-belief-1

Puech, E. (2008). The prestige of the pagan prophet Balaam in Judaism, early Christianity and Islam. In *Bala'am and deir 'Alla* (pp. 25-47). Leiden - Boston: Brill, 2008.

Puin, G. R., & Ohlig, K.-H. (2010). *The hidden origins of Islam: New research into its early history.* Amherst Nueva York: Prometheus Books

Quasten, J. (1940). "Vetus superstitio et nova religio" the problem of refrigerium in the ancient church of north africa. *Harvard Theological Review, 33*(04), 253-266.

Raj, R., & Griffin, K. (Eds.). (2015). *Religious tourism and pilgrimage management: An international perspective* (2nd edition. ed.). Wallingford, Oxfordshire, UK: CABI.

Rice, D., & Stambaugh, J. (1979). Sources for the study of Greek religion. *Sources for biblical study, no. 14.* Missoula, Mont.: Published by Scholars Press for the Society of Biblical Literature.

Rietveld, J. D. (2012) *London in Flames: Apocalypse 1666.* Highland Loch Press. Kindle Edition.

Safrai, S., & Stern, M. (1987). *The Jewish people in the first century: Historical geography, political history, social, cultural and religious life and institutions.* Assen: Van Gorcum.

al-Salameen, Z. (2011). A new Ancient North Arabian inscription with a reference to the Nabataean king Aretas. *Arabian Archaeology And Epigraphy, 22*(2), 215-218.

Sales, S. M. (1973). Threat as a factor in authoritarianism: An analysis of archival data. *Journal of Personality and Social Psychology, 28*(1), 44-57.

Sandmel, S. (1962) "Parallelomania," *Journal of Biblical Literature* 81: 1-13.

Sarker, S. K. (2008). *T. S. Eliot: Poetry, plays and prose.* New Delhi: Atlantic Publishers and Distributors

Schoeps, H. (1969). *Jewish Christianity: Factional Disputes in the Early Church.* Philadelphia: Fortress Press.

Schürer, E., & Glatzer, N. N. (1972). *The literature of the Jewish people in the time of Jesus.* New York: Schocken Books.

Schweitzer, A., & Montgomery, W. (1911). *The Quest of the Historical Jesus.* 2nd English ed. Adam & Charles Black: London. (Preface by F.C. Burkitt)

Shannon, K. (2012). Memory, religion and history in Nero's great fire: Tacitus, "Annals" 15.41—7. *The Classical Quarterly, 62*(2), 749-765.

Shaw, B. (2015). The myth of the Neronian persecution. *Journal of Roman Studies, 105,* 73-100.

Shermer, M. (2012). *The believing brain: From ghosts and gods to politics and conspiracies--how we construct beliefs and reinforce them as truths.* New York: St. Martin's Griffin.

Siniscalchi, G. B. (2011), 'Resurrecting Jesus' and critical historiography: William Lane Craig and Dale Allison in dialogue. *The Heythrop Journal,* 52: 362–373.

Skarsaune, O., & Hvalvik, R. (2007). *Jewish believers in Jesus: The early centuries.* Peabody, Mass: Hendrickson Publishers.

Staniforth, M. (1968). *Early Christian writings: The Apostolic Fathers.* Harmondsworth: Penguin.

Stark, R., & Mazal Holocaust Collection. (1996). *The rise of Christianity: A sociologist reconsiders history.* Princeton, N.J: Princeton University Press.

Stökl, B. E. D. (2003). *The impact of Yom Kippur on early Christianity: The Day of Atonement from Second Temple Judaism to the fifth century.* Tübingen, Germany: Mohr Siebeck.

Suedfeld, P., & Mocellin, J. (1987). The "Sensed presence" in unusual environments. *Environment and Behavior,* 19(1), 33-52.

Syme, R. (1958). *Tacitus: Vol. 1.* Oxford: The Clarendon Press.

Takacs, S. A. (1995). *Isis and Sarapis in the roman world.* Leiden: E.J. Brill.

Talbert, C. H. (1978). *Perspectives on Luke - Acts.* Danville, VA: Edinburgh. Association of Baptist Professors of Religion.

Tinniswood, A. (2004). *By permission of heaven: The true story of the great fire of London.* New York: Riverhead Books.

Trollope, A. (1880). *The life of Cicero.* London: Chapman and Hall.

Trompf, G. W., Cusack, C. M., & Hartney, C. (2010). *Religion and retributive logic: Essays in honour of professor Garry W. Trompf.* Leiden: Brill.

Vatican Council II. (n.d.). *Dogmatic Constitution on the Church lumen gentium solemnly promulgated by His Holiness Pope Paul VI on November 21, 1964.* Retrieved from http://www.vatican.va/archive/hist_councils/ii_vatican_council/documents/vat-ii_const_19641121_lumen-gentium_en.html

Vermes, G., Goodman, M., & Oxford Centre for Postgraduate Hebrew Studies. (1989). *The Essenes: According to the classical sources.* JSOT Press. Sheffield.

Vincent, T. (1667) *God's Terrible Voice in the City.* Reprinted for James Nisbet, London, 1832.

Volney, C.-F. (1835). *Volney's Ruins: Or, meditation on the Revolutions of empires.* Boston: C. Gaylord.

Vrij, A. (2008). *Detecting lies and deceit: Pitfalls and opportunities* (2nd ed., Wiley series in the psychology of crime, policing and law). Chichester: John Wiley.

Wayment, T. & Grey, M. Jesus followers in Pompeii: The Christianos Grafitto and "Hotel of the Christians" reconsidered. *Journal of the Jesus Movement in its Jewish Setting No. 2* (2015): 102---146

Wells, G. A. (1988). *The historical evidence for Jesus.* Buffalo, N.Y: Prometheus Books.

White, L. (1997). Synagogue and society in imperial ostia: Archaeological and epigraphic evidence. *The Harvard Theological Review*, 90(1), 23.

Whitson, J., & Galinsky, A. (2008). *Lacking control increases illusory pattern perception. Science,* 322(5898), 115-117.

Whittaker, T., & Van, M. (1904). *The Origins of Christianity with an outline of van Manen's Analysis of the Pauline literature: (Iss. for the Rationalist Pr. Assoc., Ltd.).* London: Watts.

Wilkinson, A. (2014). *The Church of England and the First World War.* The Lutterworth Press

Wilson, S. G. (1995). *Related strangers: Jews and Christians, 70-170 C.E.* Minneapolis, MN: Fortress Press.

Ziffer, W. (2006). *The birth of Christianity from the matrix of Judaism: From Jewish sect to world religion.* Bloomington, IN: AuthorHouse.